Lee Marie
Campbell

The Traditional
Pottery of Guatemala

The Texas Pan American Series

The Traditional Pottery of Guatemala

By Ruben E. Reina and Robert M. Hill, II

University of Texas Press Austin and London

The Texas Pan American Series is published with
the assistance of a revolving publication fund established
by the Pan American Sulphur Company.

Library of Congress Cataloging in Publication Data
Reina, Ruben E
 The traditional pottery of Guatemala.
 (Texas Pan American series)
 Bibliography: p.
 Includes index.
 1. Mayas—Pottery. 2. Indians of Central America—
Guatemala—Pottery. 3. Pottery—Guatemala. I. Hill,
Robert M., 1952–
F1465.3.P68R44 738.3'097281 77-17455
ISBN 0-292-78024-9

Copyright © 1978 by the University of Texas Press

All rights reserved

Printed in the United States of America

Set in Sabon by G&S Typesetters, Inc.

To the memory of CHARLES ARROTT;

to his wife, Margaret Arrott,
who with her husband began this work;

to the hundreds of anonymous traditional
potters of Guatemala, working in small rural
communities, preserving their ancient heritage;

to those potters who shared their knowledge with us;

and to the members of the TIKAL ASSOCIATION
for their leadership in the preservation
of Guatemala's heritage

Contents

Maps, Figures, and Tables

Preface

This work is an introductory survey of contemporary Maya pottery economy within the political boundaries of Guatemala, Central America. Its beginning can be traced to the summer of 1970 when, under the auspices of the Anthropology Department and the University Museum of the University of Pennsylvania, Ruben E. Reina and a group of students conducted excavations in the colonial city of Antigua, once the capital of the audiencia of Guatemala under the vice-royalty of New Spain. The purpose of that summer project was to study some aspects of the colonial pottery technology as an extension of a larger ethnohistorical research program then in progress in collaboration with Professor Alfredo Jiménez, of the University of Seville, Spain, sponsored by the American Philosophical Society.

This book on contemporary pottery in Guatemala, however, owes its genesis more specifically to a very fortunate meeting with Margaret Arrott in Antigua. She and her late husband, Charles, after retiring to Antigua in the 1940s, undertook a survey of contemporary pottery production centers, under the inspiration and guidance of the late Dr. Alfred Kidder, Dr. Anna Shepard, and Mr. Edwin Shook. The combination of Mr. Arrott's interest in ceramics and Mrs. Arrott's skill in photography produced an excellent body of data, which was never processed. Their survey was completed for thirteen major pottery centers when, in the 1950s, it was halted by political uncertainties and Mr. Arrott's subsequent death. In 1970, the documentation was offered by Mrs.

Arrott as a gift to Ruben E. Reina provided that some use be made of it, either in teaching or in training other students interested in the technological tradition.

After reading Mr. Arrott's notes and studying Mrs. Arrott's photographs in sequence, it became evident that follow-up studies could be of value to those students of Guatemalan culture interested in continuity and change. Reina's work in the fifties among potters of Chinautla—one of the major centers—served as a basic ethnographic model of social organization in an Indian *pueblo*, showing how the technology of pottery is woven into the sociocultural system of the community.

The first step in the project was to revisit those centers studied by the Arrotts. A twenty-year interval could give us some impression of the degree of retention or abandonment of the technology as well as the number of innovations for each center. Dr. Robert Sharer, from the American Section of the University Museum, accompanied Reina in January 1973 on some of his revisits. A few days spent in visiting six of these centers—Santa Apolonia, San Raimundo, Salamá, Chiantla, San Cristóbal Totonicapán, and San Luis Jilotepeque—proved invaluable. Not only had the Arrotts done excellent work, but their descriptions from the 1940s were found to be accurate for the present. Changes appeared to be minimal.

The research moved to a second stage when Robert M. Hill, II, then an undergraduate student in anthropology, undertook a survey of regional markets in relation to pot-

tery during the summer of 1973. His objective was to document the distribution of pottery over the entire country, and he accomplished this task well. With very limited funds, provided by Reina through the University Museum, Hill visited most of the regional markets. He photographed pottery in the market, talked to potters and middlemen, and identified the production centers represented in each market. As part of his assignment, he purchased samples of the utilitarian pottery from each center, assembling a collection of pottery now at the University Museum. With careful planning, he succeeded in carrying out all the assignments and, more important, he also discovered many centers not documented by the Arrotts.

Our mutual enthusiasm for the subject increased and, in the summers of 1974 and 1975, we began a systematic visit to all new pottery centers and to the remainder of the Arrotts' centers. Our trips took us by car and on foot from the Cuchumatanes Mountains in the western part of the country to the dry country in the east, reaching *pueblo*, *aldea*, and *caserío* production centers. Nineteen additional centers were surveyed, and in each case, after meeting with the local officials in the municipality, we visited the homes of potters working at some stage of their production. After the proper introductions, the potter was asked to begin making a typical vessel, and each step was carefully photographed in black and white by Hill and in color by Reina. With a tape recorder, all conversations were recorded to give both a description and a conceptualization of the pro-

duction from the point of view of the potters, together with other pertinent information. Conversations were in Spanish with bilingual potters, and an official bilingual interpreter was used with monolingual potters. After acquiring the basic orientation into the potter's technique and a general understanding of the sociocultural setting, we proceeded to visit new centers, following a similar process. We were fortunate to have been received well in all the centers—potters were delighted to learn that someone was interested in their work.

In Philadelphia, information from the tapes was transcribed onto index cards and classified according to these major categories: manufacture, vessel form, acquisition of raw material, ecological features, population and general cultural features, potters' own judgments and explanations about their work and related subjects, central concepts guiding their behavior as potters, and changes of form. For each production center, photographs documenting all the fundamental steps of pottery making were placed in sequence. With this system, we felt that we were in control of the data and could begin our interpretation. We were easily able to compare our observations with those of the Arrotts.

The field data were used in preparing the chapters on technology and markets. Ethnographic field work carried out in previous years by Reina, particularly in the pottery center of Chinautla, gave us the background to further our understanding and interpretation of sociocultural processes in Chinautla and, by analogy, other Indian production centers.

The Arrotts' data were used, in conjunction with the authors', for the centers of Mixco, San Raimundo, Santa Apolonia, San Cristóbal Totonicapán, Chiantla, Cobán and the Alta Verapaz, Rabinal, San Luis Jilotepeque, and Casillas. Mrs. Arrott's photographs were used for the centers of Chinautla, Mixco, San Raimundo (pls. 48–54, 58–66), Santa Apolonia, Cobán and the Alta Verapaz (pls. 209–223), San Luis Jilotepeque, and Casillas. The Jocotán photographs were taken by Dr. John Fought in September 1965.

In the preparation of this work, we had in mind a mixed audience, not only Guatemalans and North Americans interested in pottery and pottery making but also anthropologists, archaeologists, and ethnographers. Therefore, the work is highly descriptive and fully illustrated to clarify the production process and to give the reader a realistic experience.

The first part of this book brings the reader into general contact with the geography, the historical roots, and the general social characteristics of Guatemala. Before entering into the technological description of pottery production, the reader will find an introduction to the specific configuration of Guatemalan Indian and Ladino social structure. The community is conceived here as the fundamental unit of social organization. The relation between the specific types of social organization and the production of pottery is the heart of this work. Emphasis throughout is on understanding the social and economic role of potters and the pottery techniques in both the "closed corporate" and "open" types of community social organization, concepts to be defined and discussed in chapter 2. We find the corporate social structure to have a positive effect on the continuity of native technology in an area. It must be stated that, for the purpose of this work, the basic structure of the society has been painted with a large brush to provide the reader with an overview of the framework within which producers, merchants, middlemen, and consumers operate and, particularly, to attempt to answer the question of *how* they feel related to each other through the production of pottery.

A significant portion of this work undertakes the technological description of pottery making, and each of the twenty-five centers is presented within its respective pottery region. The description and the photographs together should enable the reader to follow the clay from its natural form to the postfiring stage. The different procedures are then summarized and interpreted in chapter 7.

The next chapter deals with the distribution of pottery through the market system. It was found that the marketing of pottery presents us with interesting information regarding the preferences of Indians and Ladinos for certain types of vessels produced in specific centers. The Indian middlemen, actively engaged in buying and selling vessels according to the pottery region for which they are middlemen, constitute an important group in the regional market. It is interesting to see that their social and political standing, their knowledge of pottery, and their sensitivity to consumers' preferences give this group a special role in the production and trade of pottery. An important part of our work was, then, to document how far from the pottery center the different types of vessels are moved.

In order to understand production, distribution, and consumption the reader will be provided with an inside view of this process. *Costumbre* in Guatemala, discussed in chapter 9, is a concept of fundamental importance in the dynamics of continuity and change. Specific communities—where the processes of innovation and syncretism and even the death of the technological tradition have taken place—provide an opportunity to study the relationship of specific sociocultural elements to the production of pottery. The case of Chinautla, presented in depth in chapter 10, is compared to other communities where different processes have taken potters along other roads.

The concluding chapter brings our findings together and offers suggestions to ethnographers, archaeologists, and ethnohistorians. It must be kept in mind that the gener-

alizations are based on the assumption that we are dealing with a traditional type of social organization of highland Maya people, namely a closed corporate community. For other areas of Mesoamerica, because of different cultural traditions or different ecological characteristics, the generalizations may not be directly applicable.

This work, therefore, attempts to approach pottery within the unified cultural setting of Guatemala. The emphasis here is ethnographic. With this anthropological orientation and with the significant continuity of pottery technology in Guatemala, archaeologists will find an outstanding opportunity to document and test the relationships of pottery and many other aspects of culture and behavior in the past. Although the potential for archaeological interpretations was strongly present in our minds, it has been touched upon only briefly at this time. The archaeological background for one of the most persistent and fundamental sources of cultural data made by humans—pottery—together with its historical and ethnographic context—the potter in the social network—constitute ideal conditions for the study of sociocultural processes in society through time. We have attempted to answer Paul Fejos' question "What has ceramics done for man?" from the symposium "Ceramics and Man" in September 1961, as well as explain the ways ceramics have controlled thinking and social standing.

We have chosen to be selective in this work, and we hope anthropology students will find interesting areas for further research. However, what we especially hope to accomplish is to inspire Guatemalans to admire these production centers and to think highly of the many hundreds of contemporary native potters who have maintained the technological tradition which comes to them through many centuries in the past. They, as citizens of Guatemala, work quietly, frequently far away from urban centers, making a very

marginal profit and receiving little inspiration from non-Indian middlemen, whose chief interest is usually to reduce the price by downgrading the work with negative remarks about its appearance and quality.

It is difficult to separate the portions of this book by author; it slowly grew into a larger and more important volume as we continued to visit more and more centers. Hill is mainly responsible for the presentation of pottery production. A description of each center follows an introductory organization for the presentation although, as might be expected, some unevenness in quantity of information occurred as we moved from center to center. The chapter on markets was a cooperative undertaking. Most of the information about regional markets was gathered by Hill during his first field season. The design of the chapter into local, regional, and interregional markets grew from our mutual experience with studying communities and their relation to markets. Reina assumed responsibility for the chapters on Guatemalan roots, *costumbre*, and pottery innovation in the pottery-producing center of Chinautla, as well as portions of the introduction and final chapter. The concluding chapter was cooperatively conceptualized after many discussions on the implications for ethnography and archaeology. Hill, as a student in archaeology, is currently preparing a dissertation in an attempt to develop a model for ethnoarchaeological studies of pottery. In the course of this survey, language and technique became important to both of us and after we had gathered the appropriate data, Hill undertook the preparation of this material. The data have been incorporated into chapter 7 as a means to document the antiquity of each technological complex in the production of pottery.

As we advanced through the writing, the interweaving of our findings became more and more evident. Suggestions cross-related to the ma-

terial passed between us for each chapter, until we saw the final product as an ethnography of pottery for Guatemala. This is a truly cooperative undertaking from which each has greatly benefited intellectually. We feel that this work is as far as we can go on the subject until more field work is undertaken to refine the generalizations, to test new hypotheses, and to further document situations that did not receive as deep a treatment as they merit.

There are many persons to whom we would like to express our appreciation. First of all, thanks are due to the potters of each of these centers who, with much dignity (*dignidad*), agreed to share their knowledge and allowed us to photograph them in the process of pottery making because they felt that a history of their work might be of interest to others, particularly Guatemalans. Second, without the initial stimulus of Margaret Arrott and her generosity in financially sponsoring most of the field work, this work would not have been possible. In addition, other friends assisted financially in the project. To Mr. and Mrs. Alfred G. Zantzinger, Dr. Edward Buxbaum, and Mr. and Mrs. Robert Hill, our sincere thanks. The Reina-Hill Collection of vessels, now at the University Museum, was brought into the country by the American Section of the museum. It is now part of the permanent Guatemalan ethnographic collection. Very special thanks are due the Tikal Association for its substantial subsidy for the publication of this work.

In Guatemala special thanks go to Mr. and Mrs. Edwin Shook, who gave advice, moral support, and particularly friendship to Hill at the initial stages of his field work. We express our thanks to Dr. Robert Sharer, who gave Hill some of his preliminary training in the study of ceramics and who worked with Reina in the initial formulation of this project; to Dr. William Coe, who after reading the manuscript

made valuable suggestions and remains one of our important critics; to Dr. John Fought of the Linguistics Department at the University of Pennsylvania, who allowed us to use photographs of pottery from his field work among the Chorti; and to Dr. Marianne Stoller for her valuable discussions on the subject of pottery in the southwestern United States at the time this work was in progress—she made it possible for us to present our material at Colorado College in the summer of 1976, during the Southwest-Mesoamerica Institute.

Also, we wish to thank Dr. Alan Gaines of the Geology Department at the University of Pennsylvania for his analysis of several samples of clay and temper, as well as Mary R. Bullard, who reemphasized for Hill the importance of Anna Shepard's work. Our thanks go as well to Virginia Greene, from the Conservation Department of the University Museum, for her great assistance with the maps and drawings, and to the University Museum Photographic Laboratory, under the direction of William Clough, for the photographic work; our special thanks go to the Anthropology Department for funding the work of parttime research assistants.

We are deeply indebted to Virginia Lathbury for her helpful editorial work and to Jeanne Gallagher for her fine typing of several versions of the manuscript. For their dedication to their task of helping us complete the work at an earlier date than would have otherwise been possible, we are sincerely grateful.

To all the people who helped us, and particularly to our wives, Betty R. Reina and Charlotte W. Hill, who understood our interest in this research and supported us throughout the months of field work, our sincere gratitude.

Through this work a professor of cultural anthropology and a student of archaeology learned a great deal about various aspects of field work, including recording, processing, and interpreting. The authors assume equal responsibility for the material in this book.

Introduction

The Anthropological Approach

For over a century, social and cultural anthropologists have studied many societies across the world. They have lived primarily among primitive isolated groups, as well as among peasant and urban societies, in an effort to reach a systematic understanding of human social organization, thought, and behavioral patterns. Education, economics, religion, socialization, personality, political organization, social order, and the processes of change (at various cultural and social levels) are long-term social categories studied within the framework of the theoretical cultural orientation traditional in anthropology. The related activities of archaeologists, ethnohistorians, and ethnographers have confronted anthropologists with human activities from prehistoric times to the present. Unique to anthropologists, regardless of whether they are unearthing the human past or directly experiencing a style of life, is their specific concern with "man and groups, with races and people, and their happenings and doings,"[1] that is, with both the unity and the diversity of humanity.

Many anthropologists have preferred to specialize in the study of the past. Their particular study—archaeology—seeks to understand culture through material remains and has served as the basis for many generalizations about human cultural development and adjustment to a variety of environmental conditions. To attempt to go beyond mere form and to delve into function and meaning of material culture is to search for all that is uniquely human, that is, for the preservation of traditions.

Concurrently, also within the field of anthropology, other scholars—ethnographers—have concentrated on the study of contemporary groups, frequently intrigued by the problems revealed by those who studied these groups in the past. The specific social categories of "family and kinship organization and their relation to the regulation of sex and marriage"[2] have received special attention in cultural and social anthropology.

More examples can illustrate other interests of anthropologists in the areas of physical anthropology, ecology, history, and so forth.

Whether humanistically or scientifically oriented, we, as Redfield, feel that "anthropology is a group of investigations and problems concerned with biological facts on the one hand, and with cultural facts on the other, intended to write the history of men, both biological and cultural, or to test the validity of general propositions as to his animal or his cultural nature."[3] As a consequence, anthropological studies have a distinctive way of viewing and interpreting humanity.[4] Anthropologists possess a strong sensitivity toward the interrelationship of sociocultural events and, in their search among primitive, peasant, and urban societies, they have attempted to comprehend what integration is perceived.

This work on pottery is also stimulated by one of the most fascinating human creations, social organization and culture. If the general reader finds an apparent diversity of specializations within the field of anthropology, he or she must be reminded that there is a central concern which brings unity to the study of human populations. This unity is provided by the concept of *culture*, a phenomenon we ourselves have created, which lies beyond our biological nature.

There are many ways to conceptualize culture. We like to think of culture as "the accumulation of human events through *time*, directly *experienced* by members of a specific social group, from which the living members derive *assumptions* and create *principles* to guide their thinking and behavior. Culture is then an ever-moving phenomenon with a high degree of constancy that, while uninterrupted, may continue to move and to build upon its own components and dynamics."[5]

Culture has enabled people in this part of the Americas to continue with a technology begun nearly four thousand years ago, which has survived in spite of the twentieth-century modernization trends of Guatemalan society.

Culture and Pottery in Guatemala

This study of Guatemalan pottery will be carried out in the overall tradition of anthropology and within the framework of culture theory, a concept which provides the fundamental method of approaching the subjects of people, technology, and society. Pottery in Guatemala appears as one of the most enduring cultural elements. The large amounts of pottery from the many archaeological sites bespeak the importance of ceramics in the past. Today, in the midst of modernization and technological change, utilitarian pottery continues to be valued and used. The persistence of this cultural element mostly in the hands of people of Maya descent reminds other Guatemalans of a technological specialization with roots in a pre-Columbian past. Although the sixteenth-century Spanish conquest and colonization brought such new cultural elements as the potter's wheel to Guatemala, the resultant accommodation, as seen in pottery, has produced a cultural mixture in which elements from both traditions persist independently, side by side, or, in a few cases, in combination—when it has brought about new styles and forms. Contemporary pottery is produced for all levels of society, and it can be considered as forceful a social marker of the present as it has been for the past.

The importance of pottery in Guatemala today can be realized by hypothetically removing it from the scene. Such an event would bring social, technological, and economic disruption of considerable consequence to a large segment of the population. If this removal did occur, it would mean the loss of a cultural element presently needed and valued by both social groups of the population: the Indians, or Naturales, as they call themselves, and the non-Indians, the Ladinos. The demand for pottery is vast, and thousands of pieces are traded daily in local, regional, and interregional markets or are carried long distances by itinerant merchants, the *comerciantes*. For those who produce pottery, its removal would result in the loss not only of their livelihood but also of an art which has traveled a long way in both time and space. The fact that so far this has not occurred in the face of modernization indicates that human beings do not easily give up elements that are deeply valued and that have sociocultural significance. Guatemalans without pottery would be comparable to Guatemalans without maize.

The persistence of pottery and its accommodation to changing conditions, then, constitute fundamental and intriguing propositions for our study. Guatemalan women and men have not stopped producing clay utensils in demand by people who share elements of cultural value with the potters. Both producers and buyers desire traditional pottery and select it from an array that also includes metal, porcelain, and plastic utensils.

This study is anthropological from the point of view that, with an ethnographic-historic orientation, we are proposing to look into those factors related to the general dynamics of continuity, innovation, and discontinuity. One of the practical problems is to see to what extent pottery alone can be considered an indicator of social and cultural stability or change. Equally important is the question regarding the economic and social status of the potters. Beyond that is the fact that groups of people, as potters and merchants, are systematically organized for the purpose of producing and distributing vessels. From an overall viewpoint it is expected that, by studying pottery, we may better understand technology as a *cultural* phenomenon.

The concept of culture, as defined above, is particularly applicable in Guatemala, where Indians and rural Ladinos put strong emphasis on the community as a principle of social organization. Their settlements—*pueblos* alone or in conjunction with *aldeas* or *caseríos*—have community cultures of significance to the individual.

Culture has been central in the work of archaeologists, ethnographers, ethnohistorians, and physical anthropologists because it manifests itself in every human activity.[6] A simple utilitarian ceramic vessel, a complex artistic object, and a piece of highly mechanical equipment show different levels of cultural development. Primitive, peasant, or industrial peoples presumably imprint their most intimate thoughts and cultural orientation upon whatever they conceptualize, create, or manufacture.

In the world today, there are many preliterate people producing objects by means of the most rudimentary tools, and there are industrially organized nations where machines, supervised by humans, produce the material culture. Guatemala is one of those nations where both traditions—the "Little Tradition" and the "Great Tradition"—coexist. Old ways are found in the rural *pueblos*, while modern technology appears in major cities, particularly Guatemala City. This development is rather recent, and the old and new ways continue to be supported by a long-lived dual social structure, made up of Indians and Ladinos. Ladinos, primarily residents of towns and cities, constitute a sociocultural group in the mainstream of Guatemalan national culture. Their language is Spanish. Their biological descent may be Indian, mixed Indian and Spanish, or even Spanish. Those Ladinos residing in Guatemala City or in department capitals who are of colonial families or of foreign descent other than Spanish differentiate themselves by the designation "Guatemaltecos." The technology and the accompanying dual social organization—Indian/non-Indian—constitute an interesting situation for the

study of current cultural processes. Many facets of the national society are being modernized and, with this trend, how long Maya technological traditions will resist death remains a difficult question to answer. However, the fact remains that pottery in Guatemala is a technological tradition with enormous vitality, and this book will attempt to document the strength of *utilitarian* pottery when seen against the background of conquest, dictatorial governments, and present-day modernization and industrialization.

In the pottery of the Guatemala of today, the producers, merchants, and consumers have an understanding of and a respect for the natural elements found in the environment that are basic for the production of pottery. While producers can teach us a great deal about the control of those elements in the pottery-making process, Indian merchants and individual buyers manifest a quiet respect for the producers' efforts. Pottery made from the natural resources available to communities gives potters and their families a sense of security, particularly when they live at a very basic level of subsistence. This pottery fulfills their cooking and storage needs, and it also has the potentials of marketing and trading to generate an income. To know ways of forming vessels out of clay and to be able to prepare traditional food with them bring a degree of independence and individuality hard to achieve in the "Technical Order" of our industrialized world. Thus, in very subtle ways, aspects of people's personality, values, and world view are imprinted on each vessel.

There are periods of history, however, when affluent economic conditions have encouraged potters to use their time for the production of specialized and artistic vessels. Vessels created for artistic value alone, as among the Classic Maya people, were no doubt accompanied by specific religious, political, and economic complexity. It is interesting that the same clay and the same

techniques, with care, time, imagination, and motivation, resulted in the production of invaluable art objects, thus meeting the sophisticated standards of an elite group certainly active in specific socioreligious roles.

There are, then, good reasons for archaeologists working in this area to have spent an enormous amount of their research time in the analysis of millions of broken pottery pieces left behind by many generations of producers and consumers. The careful studies by these anthropologists have resulted in interesting accomplishments but, in these studies, pottery as a source of cultural data presents many limitations. Because we have learned through this study that humans weave their sociopsychological nature into their production, archaeologists, not knowing producers or consumers, face serious difficulties, particularly when the interpretation moves into the realm of values, world view, social roles—in other words, culture. We have here an aspect of life that vanishes as producers disappear, leaving a solid and silent cultural document of their past under many layers of accumulated earth.

It is rather intriguing to think for a moment of the social standing of both potters and their vessels. Pottery making has been and remains a widespread tradition in Guatemala. Many thousands of potters are currently active in their respective communities, producing as many utilitarian vessels as possible for local and other consumption. Some pieces travel many miles on the backs of traditional Maya merchants or in buses and trucks. Strangely enough, in the face of this widespread movement of vessels, pottery making as an individual skill and as a technology of society does not enjoy national prestige, nor has it taken any space in the thousands of pages of manuscripts found in archives. Neither documents of sixteenth-century Guatemala at the Archivos General de Indias in Seville nor those in the Guatemala National Archives make any reference to the

role of potters and the production of pottery with traditional techniques at the time of the conquest or afterward.[7]

It seems possible that pre-Columbian society may have taken for granted the potters' utilitarian work; perhaps people in those times had low regard for those men and women producing these vessels. It is interesting to note that the absence of recognition of these potters stands in contrast to what archival documents and codices reveal about such other crafts as jewelry making, weaving, and architecture, whose practitioners were residents of politically important centers. No doubt utilitarian pottery in those days was produced elsewhere—in the countryside away from important trade centers, as is generally the case today.

It is hoped that by looking at the contemporary potters of Guatemala, with production techniques predating the arrival of the Europeans, information about the present social setting and culture may serve eventually as a mirror for the interpretation of behavior in the past. Pottery is as basic to an understanding of Guatemalan social development as is maize—it projects fundamental aspects of culture and, furthermore, it serves as the source for reflection upon the human nature of potters and the people they serve. Potters who can successfully transform earth into utilitarian objects are very special people indeed. They provide society with the equipment needed for the transformation of produce into food.

Pottery and Cultural Processes

Pottery production may also be looked upon as an ecologically exploitative activity dependent on the presence of suitable raw materials in the natural environment.[8] In a culturally ecological sense, pottery making is an adaptive process. Among folk and peasant groups, it is an activity limited to areas where raw materials exist, making it possible for pottery to become an economic specialization as well.

Pottery may be seen as one of the many adaptive tools of human groups. In Mesoamerica, for example, it seems to make its appearance concurrently with the growth of a society developing an economy based on agricultural activities. This can occur because pottery fulfills fundamental needs, mainly cooking and storage. Hunters, food gatherers, and pastoral nomads make much less use of pottery: its size, weight, and relative fragility present them with impractical "excess baggage." One finds that pottery is part of a more intricate cultural complex[9] that includes agriculture and a high degree of sedentariness.

Pottery making, as an activity, may be studied as adaptive in a number of ways. Culturally, it is an adaptation to the demands imposed by a particular subsistence pattern —agriculture. Pottery making in a nonindustrial peasant society is usu-ally an adaptation to the local environment. We find that in Guatemala pottery making is by and large a specialization of small, rural population units—aldeas—politically and economically dependent on larger towns—pueblos. Within such an organization, pottery becomes one of several community specializations—including rope making, textiles, basketry, forest exploitation, and the raising of special vegetable crops—all dependent on the natural resources. It is unlikely that pottery production could take place without the presence of abundant amounts of suitable clay and fuels for firing, nearly all "owned" by the community.

Reinforcing the particular specialization among an agriculturally oriented people, however, is the fact that usually the environmental prerequisites are best met on land not suitable for crops. Arnold has found evidence for this both among the central Pokomam of Guatemala and in the Ayacucho Basin of Peru.[10] Thus, where agricultural land is poor, more emphasis will be placed on a specialization—in these cases the production of pottery for exchange. Institutional arrangements such as markets help support those groups fully engaged in pottery making.

Therefore, it becomes evident that pottery is an economic adaptation. Specialized settlements can survive because they interact in the economic institutions of markets. In the market, pottery producers can trade their wares with nonproducers either for cash or for agricultural produce, with the effect of mutual subsistence. The output of a few specialized pottery communities is necessary to fulfill the needs of a large population of nonproducers.

While the specific techniques employed in pottery making are sensitive to the peculiarities of the materials involved, none is so specialized that it cannot withstand changes in clay, temper, and to some extent fuel. Maintenance of a particular pottery technology is, at this level, mainly a cultural process. A high degree of conservatism is therefore prevalent, particularly in peasant societies, and its effect on pottery technology should be no more surprising than it is in the swidden technology of milpa—maize fields—or in weaving. We find that pottery technology is an extremely long-lived cultural complex and may even outlast a particular people, to be passed on to others of a totally different cultural and linguistic background, as will be discussed in chapter 7.

The Meeting of Ethnography and Archaeology

Ethnographic studies in the Maya area have been mainly concerned with the study of contemporary Indian ways of living in pueblos. Anthropologists have largely overlooked the presence of Ladinos, except to show their sociocultural separation from and political domination over Indians.

During the twentieth century, a variety of settings has been studied by ethnographers. Their works have covered groups and regions from Maya-descent people living in extreme isolation in the western highlands of the Cuchumatanes Mountains to people from the central highlands and Indians from the eastern lowlands. Comparatively the regions manifest distinctive social and cultural conditions, each at a different level of acculturation. These conditions might have resulted from the Maya social changes, the retrenchment during the early Postclassic or protohistoric period (A.D. 1000–1538), or the Spanish conquest and colonization of the sixteenth and seventeenth centuries.

North American ethnographers have been influenced by the ethnographic approach used for study of small social units—an approach known as "community studies." This in-depth investigation into the way of life of a small group, referred to by Redfield as the "Little Community,"[11] appears suitable to the fundamental unit of social organiza-

tion in Guatemala, namely the community. Thorough ethnographic descriptions of Indian towns (*pueblos*), villages (*aldeas*), and individual styles of life have been made and published. The attention of these ethnographers has centered largely, however, on the nonmaterial aspects of community culture. The analysis of technology as a cultural phenomenon and as a specialization of each community remains rather limited,

and the treatment appears superficial. This level of ethnographic information gathered by anthropologists has not satisfied the archaeologists searching, through analogies, for answers to questions and problems related to cultural processes in prehistory. By the same token, the study of technology by archaeologists has not greatly influenced ethnographers. The fact is that the areas and subjects of studies by both

Maya archaeologists and ethnographers have not been of mutual assistance. As a result, the relationship between the material and the nonmaterial culture has received only superficial attention in many cases. This is therefore an area we shall try to explore in our ethnographic survey of contemporary Guatemalan pottery-production centers—the keepers of specific Maya techniques.

Objectives

After the above remarks, it should be clear to the reader that our interpretation is concerned not only with the technology of the centers alone but also with the role of the producers in the context of the social organization, the merchants in the context of trading networks and markets, and the consumers in the context of the contemporary social system of the nation. Our study should throw light on questions regarding the social, psychological, and cultural conditions which have made possible the persistence of this activity. From an ethnographic perspective, the object is therefore not only to document a technological aspect of culture per se but also to use the results as a means of understanding *how* people comprehend and use their own products and *how*, through them, they feel socially related to others. Pottery, a human activity in this area for nearly four thousand years, will be examined in its present network of human social relations. Our specific interest is to seek patterns and some generalizations from the social organization that holds human groups together by means of a particular specialization and skill.

We need to remind ourselves that technology is viewed here as a cultural event. It is significant that pottery making in this area of the world has survived for centuries, while the descendants of the Maya have endured conquests, political revolu-

tions, and economic crises and are currently experiencing both modernization and a slow process of industrialization. The particular pottery centers studied here demonstrate some of the conditions responsible for technological continuity and change or, more specifically, for the relationship of pottery technology to society and culture.

This ethnographic study, we hope, is potentially useful to Maya archaeologists. Its fundamental strength is that our work, due to the nature of contemporary production, is concerned with simple utilitarian pottery, that is, vessels produced for domestic uses. Perhaps this is just the kind of pottery less emphasized by archaeologists, either through design, by accident, or because of the nature of their typologies. The focus of analysis has been on those sherds which are conspicuous in collections for their form and decoration. They are certainly more interesting, not only superficially but, even more, because they have been used for their temporal crossdating value. Because of their distinctive surface characteristics, they have been more easily analyzed and manipulated, without the need of specialized equipment.

One might well ask, then, what use this ethnographic study of contemporary utilitarian pottery will be to the archaeologist, particularly to Maya archaeologists. Although this subject will not be fully explored in

our ethnography of pottery, some suggestions may be advanced. The archaeologist might note the importance of the closed corporate type of community, and its culture, as a principle of organization for the contemporary Maya society and economic system. The ability to infer or prove the existence of such a form of social organization in pre-Columbian times could produce new interpretations of ceramic remains. The process of ceramic innovation in one of these communities—Chinautla—might be taken as a model for similar processes in the past (see chap. 10). It is very likely that Maya potters much like those visited for this work made a valuable contribution to the Maya civilization—a view not always recoverable archaeologically.

Our work could also be of direct historical value for students dealing with the most recent periods—protohistory—of Maya prehistory. In addition to continuity of vessel forms, archaeologists may find the techniques of production, the patterns of distribution, the potters themselves, and even the clays little changed from their period of interest. The next higher level of abstraction should deal with drawing analogies from the ethnographic present. This could be done in two ways. Archaeologists, in dealing with artifacts, assemblages of artifacts, or activity loci, may find a close similarity between the pattern

of their data and that of the living potters. On the other hand, they may be working in the same or a similar area in which a pottery center, or group of centers, occurs today. If the correspondence in terms of environment, geography, topography, and social conditions is adequate, they may profitably apply the ethnographic material for conceptualizing and interpreting a good portion of their archaeological data.

Beyond this, it is hoped that several other objectives may be reached. Foremost among these is demonstrating the value of studying *utilitarian* pottery. This will be done by viewing the process of production, distribution, and consumption, as well as the vessels themselves, in the ethnographic present. At a later date, an analytic model may be constructed to evaluate the behavior of potters and the distribution of pottery in the past, as well as to enable the detection of several sociocultural processes. Such a model could aid in the reconstruction of an economic system—the production, consumption, and distribution of pottery—as well as give a deeper understanding of the mechanisms that act for continuity or promote change.

In view of the fact that a great deal of the research work by ethnographers and archaeologists in the Maya area has been conducted independently, we feel, as do many others, that both groups of students of people and their works can still find many ways to cooperate. Together, by studying the development of the Maya people, they can effectively retrieve vast resources for further work and can create an integrated framework useful to both branches of anthropology. As a result of this research, we came to understand and experience the statement that the "ethnographer is an archaeologist who catches his archaeology alive."[12]

The Traditional
Pottery of Guatemala

1.

Guatemala
Its Roots

Where nature pulls towards disunity, men have wrought unity and diversity through human needs.
—Wolf, *The Sons of the Shaking Earth*, p. 1

The study of archaeological sites, the accounts of travelers of the last century, and present-day ethnographic reports clearly show that nature has been a constant challenge to the Maya and their descendants. Maya people, with their own technological resources and imagination, exploited their physical environment, built cities, and created complex social and economic systems as a means of balancing scarce natural resources and the never ending desires of people. The outstanding achievements of the Maya continue to baffle those scientists concerned with the rise and fall of their civilization.

Groups of people selected among diverse environmental conditions for settlement and organized themselves with specializations to use the variety of resources effectively. One-third of Guatemala consists of highlands, an upward extension of the tropical and subtropical zones of the lowland region. Here the people found valleys, protected by mountains, with favorable conditions for a sedentary existence. Their maintenance was derived primarily from cultivation of crops by the ancient swidden method of agriculture, known as *milpa* (pl. 1). The environmental differences have been a challenge to the Maya and, later on, to the Spanish commercial interests. Much of the basic native technology related to subsistence has necessarily

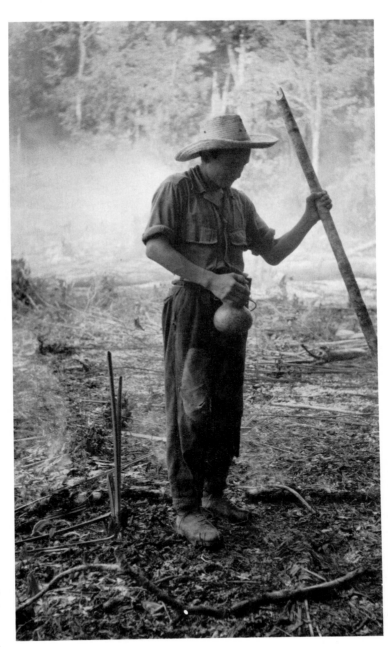

Plate 1. *Milpero* of the forest of El Petén, with digging stick and gourd

persisted even though the people have changed.

This chapter contains only a brief introduction to the geography and the general social and historical aspects of the country.[1] The study of pottery—its production, distribution, and consumption—becomes significant when placed in this overall context.

Geographical Regions and Their General Social Features

In 1964, Guatemala had an estimated population of 4,245,176—43.4 percent classified as Indians of Maya ancestry, the rest Ladinos. As one moves from the western highlands to the east, the Indian population decreases from approximately 95 percent to less than 1 percent.

Two major geographic distinctions in Guatemala affect the life style of its inhabitants: (1) the lowlands, or *tierra caliente*, which include the Pacific coast (*la costa*), the Pacific piedmont (*la boca costa*), the area beyond the northern slopes of the Verapaz, and the tropical forest of El Petén, and (2) the highlands, or *tierra fría*, which lie between the Pacific piedmont and El Petén, including the western, central, northern, and eastern highland regions.

The Lowlands

The lowlands of Guatemala lie along the Pacific coast and beyond the northern slopes of the Verapaz Mountains in northern Guatemala (pl. 2). Most of the lowland regions have potentials for economic and social development and could become the main agrarian areas of the nation. The proportion of the Indian population is below 50 percent; most are migrants from the western highlands.

The major business enterprises of the lowlands—bananas, sugar cane, coffee, and cotton—have come under the control of large, economically strong corporations. Characteristic of this development is the trend to use both human and machine energy to exploit resources. In the last decade, industrial growth and modernization have been significant. For economic and political

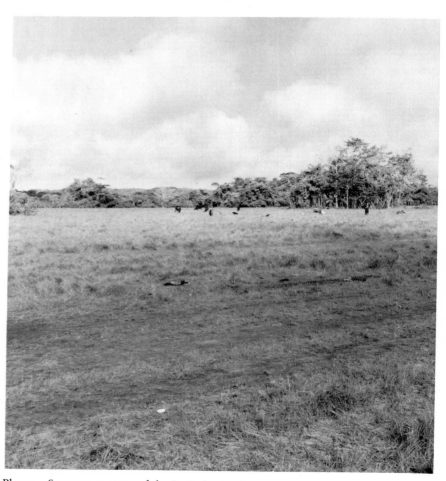

Plate 2. Savanna country of the Petén lowlands

reasons, therefore, the area is closely linked to the nation's capital.

The Pacific coast, a geographical area approximately 150 miles long and 15 miles wide, offers fertile soil in combination with inlets and lagoons formed by the higher barrier beaches. The alluvial soil has been formed by ashes and lava of recent geological periods. Mangrove swamps or dense growths of corozo palms cover large portions of the area. Here rivers flow rapidly, preventing any extensive irrigation. The coast has been a breeding ground for mosquitoes, causing serious problems with malaria.

Transportation facilities are limited in the coastal area, and the population remains sparse. Three ports—Ocós, Champerico, and San José—are terminals of the paved roads that link the coast to the highland towns and cities. Because of shallow waters, ships must remain several miles offshore, making the

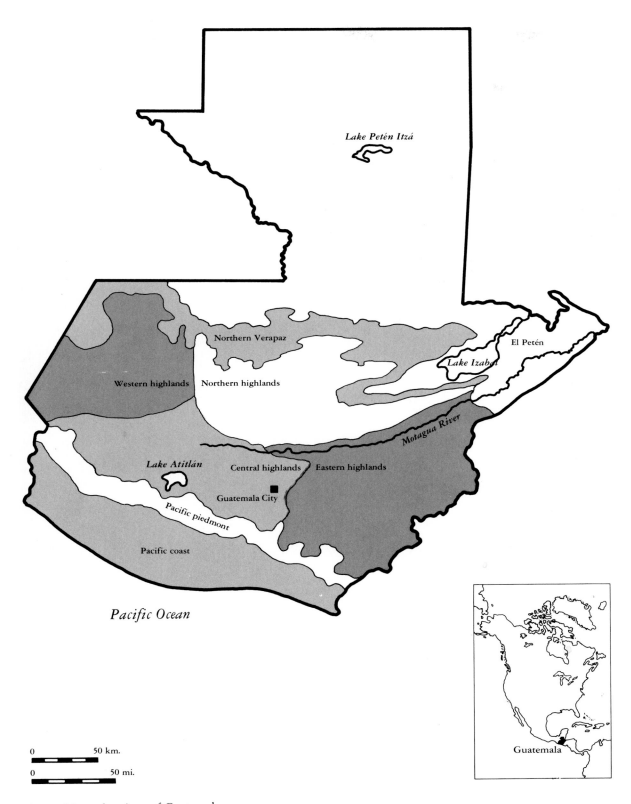

Map 1. Natural regions of Guatemala

Plate 3. *Finca* on the Pacific piedmont

loading and unloading of cargo very difficult.

Parallel to the Pacific coast lies the Pacific piedmont (pl. 3). An altitude of 650 feet marks the beginning of this region, which ascends to approximately 3,000 feet. The severely eroded soil is of recent volcanic material. Many of the swift rivers cutting the coast from north to south have their origin in the upper part of this region, among the hills and on the slopes of volcanoes. The piedmont is a natural belt of land with favorable tropical conditions and suitable rainfall and soil for the production of sugar cane, coffee, bananas, and cotton. Large tracts of land are owned by absentee landlords, who may reside in major towns or cities of the area—including Escuintla, Retalhuleu, and Mazatenango—or in the highland cities of Quezaltenango and Guatemala City.

Vegetation is lush, with large trees covered by heavy lianas and other types of roots, plants, and ferns; humidity is high, even in the summer months of the dry season. In recent years, insecticides have been heavily used to protect the cotton fields. This practice has severely affected the natural habitat of birds, fish, and reptiles.

The piedmont is a transitional zone between the coast and the highlands, attracting wage laborers to work on the large plantations. Cattle ranching, plantation production, and subsistence farming constitute, therefore, the major economic activities of the people in this area, which in turn reflect a unique type of social structure.

Ladinos and Indians come down from the highland regions to be temporary wage laborers in the banana, sugar cane, cotton, and coffee plantations or to work on livestock ranches. Some have taken permanent residence on the large landholdings—*fincas*—and they subsist on their low pay as laborers in combination with gardening, fishing in lagoons, and preparing salt from the ocean. Each year they must cope with flooding caused by the heavy rains, which begin in April and end in October.

The lowlands of the Motagua Valley, together with the Alta Verapaz and El Petén, occupy the bulk of the total land of Guatemala (pl. 4). The tropical forest of El Petén—below 1,500 feet and with less than 1 per-

cent of the population—has been, until recently, in isolation from the rest of the nation, but the area is opening rapidly and acquiring the characteristics of "new" Guatemala. Redistribution of land has resulted in a substantial increase of Kekchí Indian population and a migration of landless Ladinos from the eastern highlands. The land is controlled by the national government which, by granting temporary or long-term privileges, permits the population to exploit its resources. This situation has serious economic implications for investment and inheritance. Moreover, it is the determining factor in a life style peculiar to this area and to these people. The thin soil, overlying a limestone floor, presents great limitations for agricultural activity. Here there is lumbering for hardwoods and, in the rainy season, *zapote* trees are tapped for chicle. The dry and rainy seasons, with the short *canícula*—a few weeks of severe drought during the rainy season—constitute the major divisions of the year. The slash-and-burn agricultural method is still the basic way to cope with agriculture in the forest.[2] Lake Petén Itzá, at the center of El Petén, has been the location of the administrative center for the area since 1697, when the Itzá people were conquered.

The Highlands

The highlands are far from uniform: they present two major distinctive zones. One consists of the western highlands—formed by the Cuchumatanes Mountains—the central highlands, and the northern highlands of the Verapaz Mountains; the other zone consists of the eastern highlands—El Oriente. These regions occupy approximately 30 percent of the nation.

Along the piedmont, from the northwest to the southeast, is a series of active volcanoes separating the tropical and subtropical zones from the temperate zone. Santa María, Atitlán, Tolimán, Fuego,

Acatenango, Agua, and Pacaya are volcanoes seen clearly from west to east along the coastal region—they are a constant reminder to people of nature's potentially devastating power. Above this line of volcanoes is a region with altitudes of 3,000 to 6,000 feet, a desirable place for settlement in the tropics. From there to the border of Mexico, the habitable terrain rises dramatically to an altitude of about 9,000 feet.

In all these highland communities, the official language is Spanish, used mostly in such situations as markets, church, and official business. Spanish is, however, the language of the Ladino group. For the Indians, a Maya language (see map 7) is the mother tongue, used domestically. The degree of bilingualism varies from place to place according to the type of acculturation: bilingualism is the most recent accommodation to the modernization of the nation. It is on the rise, particularly among males; Indian women are also changing in this respect.

The Western Highlands. The Cuchumatanes Mountains have the highest altitude in Central America. The area is bounded on the north by the great lowland jungles of the Usumacinta River Valley, on the east by the Ixcán Valley, and on the west by the Mexican lowlands. The region is high, cool, fertile, and dramatically beautiful. People use the valleys and their slopes for the cultivation of subsistence crops— maize, wheat, beans, and squash (pl. 5). The land is highly fractionated into small plots (*minifundio* system), and Indian men, rather than machines, are the main source of energy in the exploitation of the environment. Cacao and rubber plants are found in deep semitropical valleys where sufficient moisture prevails year-round. In the high altitudes, the growing seasons tend to be long, and slash-and-burn preparation of fields and use of a digging stick for planting are suitable in this region. The area also offers excellent meadows for raising sheep.

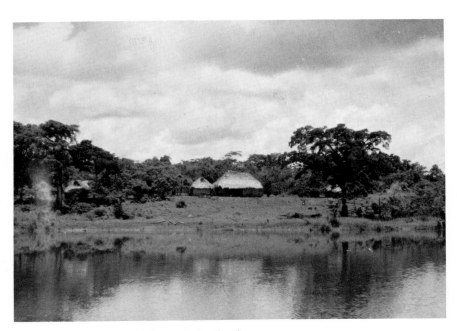

Plate 4. Typical house of the Petén lowlands

Much of the high area is frequently engulfed in clouds and mists, with an average relative humidity of 75 to 95 percent. The rainy season is caused by ascending winds and cooling air masses, bringing about 98 to 118 inches of rain annually. The area has seen rapid deforestation and, in heavily populated valleys, the land has been overtaxed. Population increase, a shortage of land available for cultivation, and the increased cost of living have forced Indians from this region to rent land in the coastal and piedmont areas or to undertake temporary work on large *fincas*.

The western highlands have the highest concentration of Indian population—deeply rooted in communities, the source of the Indians' cultural and social unity (pl. 6). The geographical features of the region separate settlements. Modern technology has slowly penetrated into the area: whereas a decade ago many towns could be reached only on foot or horseback, after many days on treacherous roadways, today they can be reached after several hours of motoring, at an average of 10 miles per hour.

The Central Highlands. Mountainous land, deep valleys, and barrancas form the central highlands, the most densely populated area of the nation (pl. 7). The ideal climate of the region is the result of its position between the lowlands and the cool upper highlands, creating a semitropical condition suitable for growing coffee and other cash crops. The seasons follow the overall pattern of the dry and rainy periods of other zones, the rainy season being ideal for planting. From valley to mountaintop, each different ecological system produces specialized products. Much of the land is worked in the traditional manner of Maya agriculture (pl. 8).

There are two major geographical points of reference: the volcanoes, which dominate the view toward the Pacific Ocean, and Lakes Atitlán and Amatitlán. Lake Atitlán, at an altitude of 5,100 feet, with volcanoes Tolimán and San Pedro in the background, is fed by the Panajachel River. Cliffs rise dramatically from the water to heights of over 1,000 feet. Near this lake, two main rivers of Guatemala find their starting point: the Chixoy, which flows

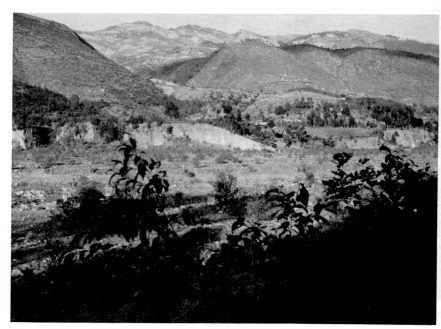

Plate 5. Western highland settlement around Chiantla, with *milpa* fields on the slopes of the mountains

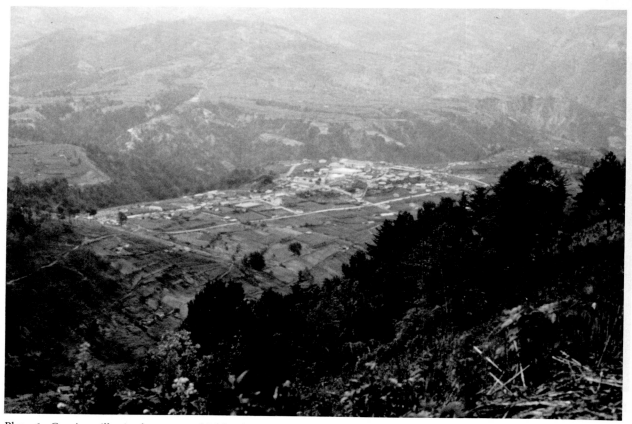

Plate 6. Comitancillo, in the western highlands

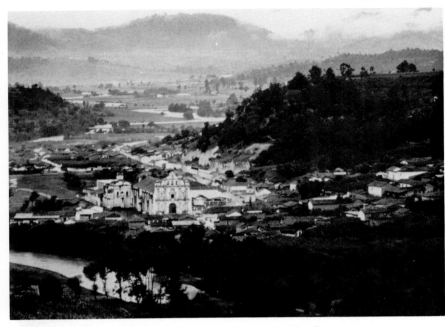

Plate 7. San Cristóbal Totonicapán, in the central highlands

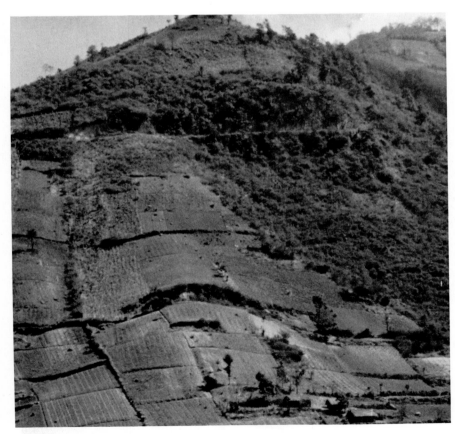

Plate 8. *Milpas* on a hillside near Quezaltenango, in the central highlands

north, and the Motagua, which flows in an east-northeasterly direction ending in the Gulf of Honduras. Smaller rivers join this drainage system, providing sources of water for settlements and some communication by small dugout canoes.

The Northern Highlands. The northern highlands (pls. 9, 10), known as the Verapaz, were formed geologically by heavily folded structures of marine limestone. Both Alta and Baja Verapaz (see map 2) have an alluvial floor, particularly around Cubulco, Rabinal, and Salamá, thus creating a rich area for the cultivation of coffee plants and vegetables. The climatic similarities with the Pacific piedmont are striking, but the soil is inferior, being heavily leached. Indians from the northern highlands have migrated in large numbers to El Petén in search of land.

The weather changes according to altitude and, whereas the north and central parts of the Alta Verapaz are characterized by a tropical climate with year-round rainfall, the southern part has a short dry season. Farming, however, is carried out in all climatic zones. The area is cut by the Chixoy River, which moves northward toward the Pasión River, an affluent of the Usumacinta. For centuries, the river system has been the means of communication and travel throughout the area. The Polochic River drains east into the large Lake Izabal, which opens to the sea. To the east of the Verapaz, and in the lower Motagua River Valley, we come again to lowlands. This latter fertile valley area, with abundant rain, is known for its large banana plantations.

The Eastern Highlands. The eastern highlands (pls. 11, 12) occupy 15 percent of the total land of the nation. The area in general—at 1,500 to 4,000 feet—is of lower elevation than the central highlands. Although the climate is subtropical, the area receives little rainfall, even in the rainy season. As in other areas of the

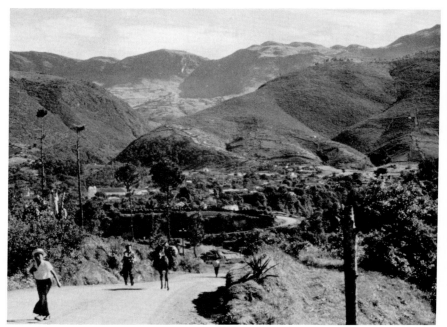

Plate 9. *Pueblo* near Sacapulas, in the northern highlands

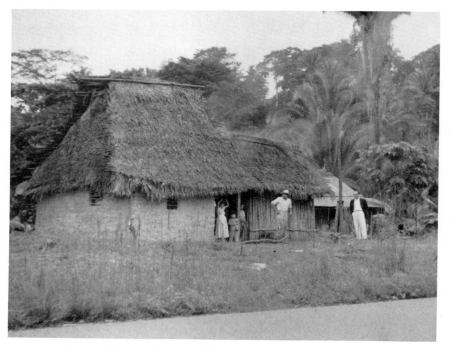

Plate 10. Kekchí Indians and a typical house in the Alta Verapaz, northern highlands

highlands, pine and cedar trees grow on the upper slopes of mountains. The northeast part of the region has been extensively weathered. Here, on the windward Caribbean side, drenching rains cause much leaching and erosion in the "high country." The waters of the Jocotán and Zacapa river system, largest in the area, flow to the Motagua River, joining it near the town of Zacapa. Here, in fields cultivated by the slash-and-burn method, the *canícula* can cause much damage. Although the *canícula* is a general climatic phenomenon in both the highlands and the lowlands, its effect in the eastern highlands is more critical than elsewhere if the drought lasts longer than is normal.

The sociocultural configuration of the eastern highland region stands in contrast to that of the western highlands. People in the eastern highlands are more deeply rooted in the nation's Spanish-derived traditions. Characteristic of the area is a lower population density, 11 percent being composed mostly of Pokomam- and Chorti-speaking Indians concentrated in a handful of settlements. Also characteristic of this area are small landholdings, but not to as great an extent as in the western regions. Adams reports that the region has a much wider selection of small, middle-sized, and large agricultural and cattle producers. Cattle ranchers control a good portion of the land, usually dwelling in comfortable houses located in the towns or, in the case of the most prosperous families, in Guatemala City. The Ladinos of the towns form a compact and powerful middle class, controlling much of the region's labor, agriculture, commerce, politics, and education.[3]

The small farmers of the eastern highlands live in *pueblos* oriented toward the larger region in which they live. They exhibit the typical superiority of urban Ladinos over Indians and over those landless Ladinos who consider themselves to be existing as Indians. Their *pueblos* are economic and political centers

without the civil-religious hierarchy of the *cofradía* system that exists in the western highland region. Their community institutions, therefore, represent a strong regional and national interest, with little local cultural identity. The oldest residents are influential at all political levels of the nation.

The Cofradía *System*

The local social organization in all these highland communities, although similar in content, exhibits many structural variations. For example, in most communities of the central highland area, the *cofradía* system is more important in the local political structure than it is in the western highlands of the Cuchumatanes. The precise organization of the civil and religious hierarchy depends upon the specific history of the acculturation process in the early colonial days, demographic configurations, and economic specializations.

Overall, the political-religious organization is central to the social structure and serves as a "broker" between the national government and the strong local community tradition. The *cofradía*'s chief function, however, is to attend to the community's holy day celebrations and help finance them. In colonial days, candles, fireworks, flowers, elaborate processions, and dances were managed by these organizations. In some Indian communities, close to one hundred religious days are observed by the *cofradías* each year (pl. 13). Cooperation is necessary and is to be understood within the framework of the *costumbre* concept, as will be discussed in chapter 9. Used as an explanation for established patterns of corporate action, thought, and behavior, *costumbre* has always been at the core of community culture. And, since the colonial days, the *cofradías* have been entrusted with the job of appeasing the saints' drives, which are very human in nature. Above all other

Plate 11. Cultivated areas in the middle Motagua River Valley of the eastern highlands

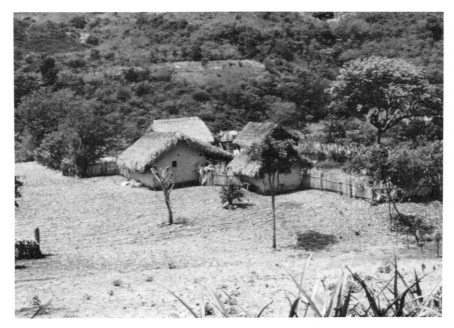

Plate 12. *Caserío* near Zapotitlán, in the eastern highlands

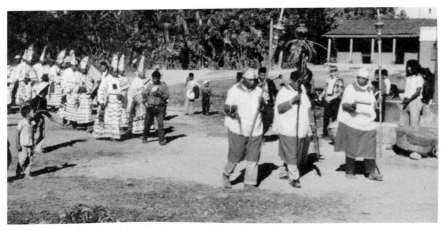

Plate 13. *Cofradía* of the apostles in Chinautla, at Easter

saints in a community is a patron saint, who may become very angry and bring disaster to the community and to the world. Through public ritual and the *fiesta titular* of the *pueblo*, people express their community identity and cohesiveness.

Summary

The immense geographic diversity of a country the size of the state of Ohio is accompanied by significant degrees of socioeconomic variations and historical events. People with a combination of community and regional traditions have organized their lives in response to ecological differences. Thus, today as in the Maya past, products of one area are exchanged through trade and marketing for products of another. Guatemala has striven to organize itself socially, economically, and politically in such a way that the strong tendencies toward localism and regional isolation are contained. The effects of this effort are beginning to show; in some places, there is still resistance to change on the part of the people, while in others there is willingness to transform the old ways of life.

In order to better understand the effect of geographical and cultural diversity, we will briefly consider the historical development of Guatemala. Contemporary Guatemala is a product of the long and unique development of Maya civilization as well as, in the last four hundred years, the addition of Spanish culture. The history of both traditions, set within the varied environment, brings modern Guatemala into perspective.

The History of Guatemalan Society

In the overall background of Maya culture, the arrival of the Spanish and, particularly, the interplay of both Maya and European traditions produced a unique and complex society. During the period between the mysterious and sudden decline of the Classic Maya in El Petén (ca. A.D. 900) and the coming of the Spaniards in the sixteenth century, there were six centuries of cultural change by conquest. This redevelopment of the Guatemalan highlands received considerable cultural stimuli and population influxes from highland Mexico that played a significant role in the transformation of highland Maya society. During this period, and in contrast to the Classic period, people built their important centers in mountainous places on easily defensible terrain. Whereas in a past peaceful society trade activities had flourished between numerous independent political units, it would appear that in the later period (Postclassic), because of population pressures, rulers of petty kingdoms were constantly at war, expanding their domains and seeking larger tributes.[4]

Pedro de Alvarado, with the aid of a large group of Mexican and Tlaxcalan mercenaries, began the conquest of Guatemala's Postclassic peoples in 1524, establishing the first Spanish capital in the Cakchiquel center of Iximché. He renamed it Santiago de los Caballeros de Goathemala. The capital was soon moved some miles east to the site known today as Ciudad Vieja, in the Panchoy Valley.

The conquest and the establishment of a society based on Spanish institutions and traditions took place in accordance with directives from the king, Charles V. Through a complex bureaucratic body managing the colonial administration, he executed the sociopolitical transformation of the Mesoamerican people. With these formal directives, and through a forceful process of acculturation, the cultural synthesis of Maya and Iberian elements had its beginning.

The Spanish *conquistadores* and the groups of colonizers, together with the native population, became subjects of the king, bound to him by the ideal concepts of obedience, honor, justice, and service to the crown. *Conquistadores, encomenderos* (trustees of the land and the people), and colonizers—from their positions of power—could readily apply these concepts to the native population to control them and to achieve economic success for the king and for themselves. The Spaniards had strong economic ambitions and constantly searched for new resources, particularly gold and silver. The *conquistadores'* greatest ambition was to achieve economic solvency and return to Spain to become part of the peninsular social structure at a higher level. But the process of social mobility and the return to Spain in possession of wealth were elusive: many remained in Guatemala, stranded for the rest of their lives.

The conquest was the cause of social disruption and personal shock for the native population. Their basic economic and cultural security was rapidly destroyed by the Spanish quest for wealth. As Alvarado and his men fought their way through Guatemala in rivalry for riches and authority, frequent Indian hostilities and rebellions drained the energies of the newly established colonial society. The problems of land distribution under the *encomienda* (trustee) system brought about serious political rifts among colonizers, officials, and the clergy. It was the native population, however, that received the full impact of the social transformation and political factionalism caused by these ambitious and discontented individuals. Political and religious officers frequently clashed with each other and with colonists over social issues regarding the treatment of the native population, and their problems could never do more than approach the threshold of solution. Only the king in Spain had the power to de-

cide, but official response took a great deal of time: fifteen months was the average amount of time necessary for answers to arrive.[5] In Guatemala some leaders, in the face of social injustice, became strong public defenders of the rights and privileges of the native Maya. Among them was the famous Dominican friar, Padre Bartolomé de las Casas. He actively opposed the abuses perpetrated by members of the colonial society, as exemplified by his stand against slavery of the native population. In his social experiment in the Alta Verapaz, he worked exclusively with the Indians and, with the king's approval, kept all the Spanish out of the area. He showed that the conquest and conversion of the natives could be done in peace.

The *conquistadores* in Guatemala became restless, for they could find no natural resources—and no gold—equal to those reported elsewhere in the Americas, particularly in Peru. As the Spaniards became disenchanted with the land of the Maya, many settlements failed, and the audiencia of Guatemala acquired the reputation of being a poor land, populated by Indians who, like children, must be guided, although with difficulty, into the Christian faith. It was not long before the colonizers realized that, as in the Maya past, the source of good living was not mining but the cultivation of the land and that traditional native technology could provide them with a secure beginning. As a result, most of the Spanish who chose to remain in Guatemala and those who could not leave modified their original ambitions and devoted more of their time and energy to promoting the organization of internal marketing and the regulation of land distribution to strengthen their economic position.

We know that, at least for the first years of the conquest, many of the Spanish were unsuccessful at farming because they attempted to use their own technology for cultiva-

tion. Some, by necessity, even planted their own fields. A document in the Archivos General de Indias indicates that the crops were ruined due to a "long drought" that was simply an error in judgment. The Spaniards misunderstood the weather cycles, particularly the seasonal progression of six months of dry weather and six months of rain. The document says: ". . . and for our sins, as we are not teachers of the quality of this land, we arrived here around All Saints' Day and seeded the fields around Christmas. This is the time of the major droughts which last until the end of April. The natives say that the land is always like that; therefore all our work was lost with the drought."[6]

Many similar failures brought about changes in the Spaniards' attitude toward the ways the Maya went about their own work. In their precarious balance with nature, the Spaniards were confronted with a new environment and had to learn the character of this new universe to subsist at all; this they could learn from the Maya. Spaniards turned to the Indians for their general subsistence technology. The ambitious Spanish administrator, the planner, joined with the Maya, the worker, who had developed appropriate techniques for production of food. Spanish colonizers became, therefore, dependents on Maya labor and consumers of Maya food. The *conquistadores* must have experienced frustration and humiliation as they turned to the Maya digging stick and swidden agriculture. A document from the cabildo of Trujillo, in neighboring Honduras, shows the quiet triumph of the Indians: "We cannot live without them in this land . . . many *hidalgos* died of hunger while others are seeding the land with their own hands, something that has never been seen."[7]

The conquest gave the service of the Indians to the victorious group, and the losers by definition had the obligation to give service. The institution of the *encomienda* assured

this to the *conquistadores*. Grants of land in trusteeship from the king gave them rights to labor and tribute from the Indians living on their *encomiendas*. When a man died, his property, or *encomienda*, reverted to the crown. During the first twenty years after the conquest, *conquistadores* had the right to service from the Indians. A man could thus attain social standing as a *caballero* (gentleman): he not only had servants for his household (some officials had as many as fifty servants), labor for his land, and Indians for trading its products, but he could also use the Indians of his *encomienda* for the pacification of other Indian groups. So Licenciado Laoisa, a judge of the audiencia, forced the Indians from Ciudad Vieja, entrusted to his son-in-law, to build his house and to give all types of service without payment, simply by his right as a *conquistador*.[8]

Abuse characterized the *conquistadores*. The Indians were constantly pressured to increase their production for the economic benefit of the *encomenderos*. Indians were assigned all the manual work, particularly construction of private houses and public buildings, opening of roads, and cultivation of fields. They also prepared the way for urban life, meeting the Spaniards' personal needs by transforming wool into blankets, cotton into colorful woven material, trees into charcoal, and clay into vessels.[9]

As a result of the drastic shocks caused by forced migrations, epidemics that killed thousands of native people,[10] abuses, and conflicts, the famous New Laws were passed in 1542. They established many limitations on *encomienda* practices and eliminated Indian slavery. Alonso López de Cerrato, as president of the audiencia from 1548 to 1555, led a generation of reformist administrators. MacLeod says that "these stricter and more honest men, with López de Cerrato again the exemplar, brought about an improvement in the position and welfare of the Indians."[11] En-

comenderos and other colonists, as might be expected, were indignant over Cerrato's reforms because they faced bankruptcy without the service of the Indians. However, Cerrato's governmental mastery hastened the incorporation of the Indians, with their own technology, skills, and knowledge of the environment, into the overall economic system of the audiencia.

The colonial society, based on specific differences of economic status and political roles, gave rise to the dual social stratification under which Guatemala has since been organized.[12] Independence from Spain in 1821 and the establishment of the republic in 1847 did not change the social and economic bases of the society at large. For Guatemala today, there is an Indian problem "in the sense that those persons who continue to speak an indigenous language as Mother tongue, follow pre-Hispanic and colonial forms of agriculture, and abide by a distinct set of more or less corporate community customs, still stand outside the national economy and society to a great extent."[13] Guatemalan Indians remain subject to the traditional political orientation within the limiting boundaries of their community.

From independence in 1821 to the dictatorship of Jorge Ubico, which ended in 1944, Guatemala had been ruled by a succession of strong governments. Approximately twenty-three years of government were more or less democratic, and some governments were more or less neutral, but fifteen years were of dictatorship and seventy years were of tyranny, during which the political officers were "nothing more than policemen with a cudgel."[14] Under the impact of such personalistic, individualistic, and forceful government, the relationship between community and nation became formal and distant. *Pueblos* had to comply with the personal directives of the dictators. Appointed regional Ladino officials acted severely, directed by the central government.

After independence, and before Ubico, Indian laborers were also subject to Ladino *patrones* (landlords). These individuals had legal rights to accuse Indians of failing to perform their duties to the *patrón*. Many arrests were made, and *patrones* had the right to request the return of the Indians to continue their manual labor in the Ladino enterprises. Therefore, after independence, the Ladino *patrones* emerged as a politically, economically, and socially strong group, supported by the national government of the period. This was a continuation of slavery, although it was slightly more benevolent than it had been in colonial days.

Ubico limited the *patrón*'s position, forcing the Indians instead to do two weeks a year of road work, and made the *jefes políticos* (political bosses) responsible for rounding up workers. He also stopped advance payment, thus eliminating indentured service.[15] With these new regulations, the *patrón* lost some control over individual Indians. The Ubico period became the "formative period during which the power of the regional *caciques*, the local upper class, and the local farmers lost its regional autonomy and became firmly dependent upon Guatemala City."[16]

In 1944, with the fall of Ubico, a constitutional era, a significant break in the political history of Guatemala, began. Indians and Ladinos were given equal rights and, ideally, equal opportunities. The purpose of the reform movement was, in part, to break down the corporate Indian community, to Ladinoize the people, and to give political decisions to the population at large. Many social reforms were implemented, including social security programs, a government agency to stimulate agricultural production, the encouragement of unionization, the development of rural education, agricultural assistance, public health services, and an attempt to promote cooperative enterprises.[17] Although the Indian

population became suspicious of government-sponsored reforms, a great deal of the public culture was changed by realigning the economic and political elements. At the same time, this was managed without serious disruption of structural continuity in the society.

The Development of Social Duality

The Indians were conceptually grouped by the Spaniards as Naturales—natives of the land. Some of them lived around Spanish towns and plantations, and eventually, as their way of life grew to be Hispanicized, they became Ladinos. The rest remained Indians, living in isolation and resisting cultural transformation. The former were at first the Indian Ladinos; later generations became simply the Ladinos. The Spaniards and the Ladinos stood in contrast to the Indians, and this strong cultural distinction has had fundamental social implications which cannot be divorced from Guatemala's history.

The Ladino population can be divided into two main social groups: the urban group, residing in department capitals and large *pueblos*, and the rural group, living in the smaller *pueblos*, most of them guests in communities "owned" by Indians. Ladinos and Indians of many communities compete for political power on the basis of historical rights. The social differentiation practiced by Ladinos is, however, supported by national principles of social order. Ladinos are socially conscious, secular, and literate and constantly safeguard their economic interests. As a group, they consider themselves socially and politically superior, oriented toward the capital of their department and, if possible, toward the capital of the nation.

The main goal of Indians—or Naturales, as they call themselves—is to possess a piece of land for *milpa*. The Indians of the central

highlands are devoutly "Catholic"—that is, their religion is a unique blend of Spanish and Maya elements—and are active in the religious and political organizations of the community. On the other hand, in some of the remote communities of the Cuchumatanes and the Verapaz, ancient Maya beliefs remain strong. Maya survivals predominate in some of these remote areas, within a formal and outwardly Catholic tradition. On the surface, the Indian appears submissive, ceremonious, and well mannered: ". . . he has rather suspiciously entered into a pact with the world around him and its people, a pact often studiously adhered to."[18]

As we briefly saw, inequality in social rights and privileges has been the basis for political and social reforms from colonial days and, even more, after independence. The dual distinctions of Ladinos and Indians have remained to this day, and current modernization trends of society are still based on the preservation of this social order. This distinction is frequently accompanied by subcultural differences, modified in part by the level of acculturation brought about by contact with the Spanish and by accommodation to urbanization and modernization. Many thousands of highland Ladinos and Indians continue to live side by side in corporate communities, each group keeping to itself. Yet the two groups have inevitably influenced each other by living in close physical proximity and sharing common community experiences. Each community, however, has developed a singular style of life, differing to a degree from all others. Nevertheless, in the pottery center of Chinautla, for instance, social interaction between the two groups is based in large part on a biological evaluation.[19] Both groups believe that they come from different *razas*, or stocks. To this day they base a number of sociological factors upon this biological hypothesis. The Indians believe that they are descended from an ancient race, that their ancestors

came from the nearby (Late Postclassic) Maya ruins, that they are different by virtue of their birth and must keep their own *costumbres*. The opposite but parallel position is taken by the Ladino group. They have no associations with the ruins but instead identify with national historical events—particularly the coming of the Spaniards, who left a genetic and cultural imprint to which they relate. Accordingly, their self-image, when comparing themselves to the Indians, is based on the concept of being "civilized." At present, Spanish-influenced communities like Chinautla have families of Indians (conservative and culturally isolated from the nation), Ladinoized Indians (with conservative ways, but less isolated), Indians who have become Ladinos, and Ladinos by birth. For the Indians the town is their property by virtue of their history. The Ladinos in this Indian corporate situation strive to maintain a peaceful coexistence, for antagonizing the Indians can bring social awkwardness and economic disadvantages. Since interaction between groups is limited to services—business or godparenthood—enterprising Ladinos conceal their negative feelings for utilitarian reasons.

Thus, the quality of the relationship between Indians and Ladinos can have local flavor. While discrimination may exist within the social structure, the people are not at war. In general, although people are differentiated by virtue of their cultural affiliation, the need for local socioeconomic expediency bridges a national social distance far too great to be maintained in the context of a *pueblo*. The Indians and the Ladinos seem to play roles in a satisfying social game, each finding individual reward in a distinct style of life. Because the game is workable, the two groups seem to have made a choice to continue living in this tradition.[20]

Adams recognizes that the position of the Guatemalan Indians with respect to the developing national society and centers of authority has

been changing.[21] The Indians, long accustomed to the domination of the Ladinos, are becoming more sure of themselves as individuals with constitutional rights, but they still have reservations about what Ladinos might do next. Although culture changes, the fundamental social structure remains essentially the same.[22]

Becoming One Tradition

As noted before, Europeans in the land of the Maya were unable to make their way alone. Acceptance of a sociocultural synthesis became necessary, and many present-day Guatemalan culture traits are the result of reciprocal borrowing and innovation.

It might be intellectually exciting to discern the origin of the component elements of Guatemalan culture. However, the separation into Maya or Spanish elements is of little concern to most Guatemalans today. In the lowlands of El Petén, the people of the *pueblo* San José Petén, descendants from the Itzá group, continue to keep their three human skulls on the main altar of the community Catholic church.[23] There, a unique ritual pattern has been placed in a Catholic setting. In 1960, San Joseños resisted attempts of new Spanish Catholic missionaries to remove the skulls from the church altar. The skulls are at the center of the community culture-security system (pls. 410–413). How the skulls came to be in the church, what portions of the elaborate ritual are Spanish or Maya in origin, is of no concern to the San Joseños. For them, it is all one thing, a *costumbre* of the *pueblo*. The result of the cultural synthesis continues to find its best expression in the structures of the community.

In sum, the Ladinos have ideally followed in the footsteps of their Spanish ancestors while the Indians, as in the colonial days, have continued to labor for the nation. Ladinos and Indians, however, exist today not only in their own community but also in the framework of a complex society, among a network of relations linking the various levels of the social structure. Guatemala is becoming modernized, but the process is contributing to the alienation of people from nature and from each other as paved highways cover the countryside, cities develop shopping centers, and modern hotels rise above colonial buildings. Still, close to cities as well as in remote mountains, we find potters who, with the ancient and stable technology of their Maya ancestors, are producing ceramic vessels for themselves, for other Indians, and for rural and urban Ladinos.

2.

Pottery Production
An Introduction

For all practical purposes, pottery production in Guatemala today occurs within the highland zone of the country (see map 2).[1] Much of this production is in the hands of potters utilizing ancient Maya methods and techniques, with little if any western influences. In some areas, elements of Spanish pottery technology have merged with the native methods. Three productions centers—Totonicapán, Jalapa, and Antigua—make pottery by traditional Spanish methods, vestiges of a once prosperous industry imported by the *conquistadores* over four hundred years ago, but these centers do not directly concern us.

Detailed descriptions of the production in twenty-five centers will be presented in the next four chapters. For each center, the information includes location, history, linguistic affiliation, ecological and sociological background, technology of manufacture and firing, marketing of the product, and the center's relative importance as a producer (see also chap. 7, tables 2 and 3). The centers themselves are organized by geographical pottery regions (map 8). This is not simply a heuristic device but reflects the pattern of pottery distribution between production centers and regional markets. A pottery region may be defined as a network composed of a production center or group of centers supplying a regional market or group of markets. Organization of the data in this way will permit their correlation with the data on marketing in chapter 8. Other methods of organizing the material could have been used. The centers might have been presented on the basis of the country's political divisions, the departments. However, no correlation has been found between these political entities and the distribution of pottery-production centers. Another means of presenting the cases might have been along ethnic—Ladino vs. Indian—lines. This would not have proved advantageous either, as most non-wheel-using Ladino potters appear to have derived their technology from the Indians and would merely reflect the local Indian group.

Production Centers: People, Settlements, and Social Organization

The location of traditional pottery production in Guatemala is conditioned, in part, by the availability of the basic raw materials: suitable clay, water, and fuel. All centers are located close to the basic raw materials, while certain special materials (tempering or slipping substances) may at times be imported from distant sources. In fact, the original determinant of pottery production as a specialization in a given community may have been the availability of suitable clay deposits. The desirable characteristics of "their clay" for plasticity, color, hardness, and durability are known to the potters in each production center.

Fuel, usually pine wood and cones supplemented by dried dung, dried grass, and other combustibles, is a critical resource. Production of pottery is threatened in several centers at present simply because the local forests have been exhausted. It is probable that fuel depletion has, in fact, forced individual potters and, in other cases, entire centers out of production in recent years. Because of the marginal profits realized from pottery manufacture, most potters can no longer afford to stay in production if they must pay for long-distance transport of fuel or for other natural resources such as materials for slip or decoration.

The population of Guatemala, as stated earlier, is divided into two sociocultural groups: the Indians and the Ladinos. The 1950 census lists 46.5 percent of the total population as Ladino and 53.5 percent as Indian. These percentages have been changing during the last two decades, as many thousands of Indians have adopted Ladino culture traits. Because of this process of Ladinoization, a large percentage now falls in between the two main groups. Members of this middle group are abandoning their place of birth and changing their appearance as the social situation demands.

All three groups—the Indians, the Ladinos, and the middle group—reside in settlements designated politically as cities, *pueblos*, *aldeas*, *caseríos*, and *núcleos poblados*. The last four settlements are grouped to form a *municipio*, or township, usually with a *pueblo* as its political head (*cabecera municipal*) and a number of dependent *aldeas*, *caseríos*, and *núcleos poblados*. By governmental decree and at different periods in Guatemala's history, these classifica-

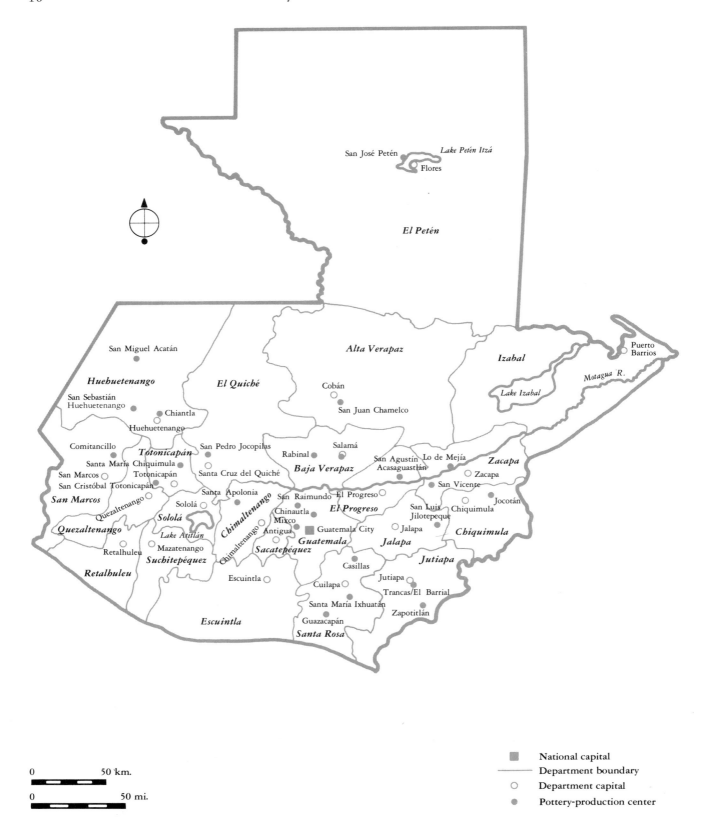

Map 2. Republic of Guatemala

tions have been assigned to Indian and Ladino settlements as they met national criteria. It is not unusual to find that some settlements, as they progressed or declined, have changed their political status while, in others, redefinition by the national government has not kept pace with changing populations and economics.

For our study of pottery centers, the *pueblos*, *aldeas*, and *caseríos* are of particular interest because pottery production using traditional Maya technology is generally found here, rather than in cities or on *fincas*. The governmental designation of *pueblos* indicates certain demographic levels, public services, and other urban standards. For instance, all heads of *municipios*—municipalities—are in the category of *pueblo*. The remainder of the population resides in small rural settlements designated as *aldeas* or *caseríos* or in other settlements of lesser political standing. Thus, the sociocultural classification of Indian or Ladino, in combination with the political classification of *pueblo*, *aldea*, or *caserío*, results in the first major social classification of settlements: Indian *pueblo*, Indian *aldea*, Indian *caserío* or Ladino *pueblo*, Ladino *aldea*, and Ladino *caserío*. As might be expected where two major sociocultural types are in opposition, there will also be settlements that fall in between and are therefore difficult to classify. Guatemalans refer to these settlements as "half Indian" or "half Ladino."

The Indian *pueblo* and the Ladino *pueblo* each possess a distinctive social structure. The closed corporate structure is found primarily among Indian *pueblos* of the highlands, while the open noncorporate community is found primarily among Ladino and Ladinoized Indian *pueblos* of the humid lowlands, the humid low highlands, and the dry low highlands.

The closed corporate organization can be briefly characterized as a structured system in which each individual is expected—or even forced through institutionalized social pressure (envy, witchery, gossip)— to embody in behavior and thoughts all those cultural elements contained within the boundaries of the community. Here individual freedom is limited. "Adherence to the culture validates membership in an existing society and acts as a passport to participation in the life of the community." [2]

In the case of closed corporate communities, all members are equally socialized into the special technology viewed as part of the total community tradition. *Oficio* is the term used by the people of a closed community to describe their economic specialization. By so doing, each member becomes an active guardian of the unique community heritage. For example, in the closed corporate Indian *pueblo* of Chinautla—an important pottery-production center—according to the community definition, all women ideally are potters, charged to produce the traditional vessels, while all men are charcoal makers (*carboneros*) and maize farmers (*milperos*).[3] In other closed communities, the technological specialty may be weaving, basket making, rope making, and so forth. The crucial fact is that, no matter which specialty is established, all able members are expected to practice the same community-defined specialization. Making the traditional pottery of the community not only defines a person as a potter but also serves as the mark of membership in the corporate body.

It is very possible that this type of community social organization is a survival from preconquest times; as Wolf states, the "persistence of the 'Indian' cultures" after the conquest seems "to have depended primarily on maintenance of this structure." [4] In sum, the social system encourages the formation of a community culture with distinctive linguistic and social elements. "The Indian maintains a feeling of personal security so long as he stays within the framework of his culture and is enabled to follow without deviation the pathways which it lays down for him." [5]

In contrast to the closed corporate organization, the open community structure lacks the formalized corporate structure. "It neither limits its membership nor insists on a defensive boundary. Quite the contrary, it permits free permeation by outside influences." [6] Individuals of the open system tie their "fortunes to outside demands"; [7] these individuals are free to choose their own livelihood through which to seek personal development.

Members of open community systems, found in Ladino or Ladinoized settlements, undertake a diverse range of craft activities, referred to as *artesanías*. In contrast to the closed systems, each specialization may be practiced by only a few families in a *pueblo*. Residents of these communities view their technological specialization as their family's livelihood and heritage in the context of a wider society, instead of as part of a local tradition. One example of an open *pueblo* is Jalapa, with its Spanish-Ladino heritage, where pottery production today is in the hands of men within a number of independent single-family units. Other specialties include being merchants, shopkeepers, laundresses, seamstresses, tailors, traders, carpenters, and so forth. Thus, the diversity of individual economic pursuits in the open system stands in direct contrast to the uniformity in the closed system.

As a hypothesis, it can be stated that closed corporate *pueblos*, in contrast to open noncorporate *pueblos*, possess the strength to enforce continuity of technological traditions by keeping their unique products at the center of the community culture (see chaps. 9 and 10). The community product has an importance beyond its immediate economic or utilitarian function, and it is closely integrated into the overall ideological system of the community.

As a corollary, the degree of stability or change in pottery technol-

ogy relates to the corporate intensity fostered by the closed social system at a particular stage of its development. When the corporateness begins to break down, the control of pottery technology is no longer as dependent upon the community structure and varies according to the degree of individual freedom permitted by the community social system. One of the first signs of this process of change is the appearance of individual innovations within the technological tradition.

The pottery-production centers of Chinautla, Santa Apolonia, San Raimundo, San Cristóbal Totonicapán, Santa María Chiquimula, Comitancillo, and San Luis Jilotepeque are excellent examples of Indian *pueblos* with a closed corporate structure. Because of their unique social structure, these *pueblos* can support an independent style of life—a community culture—administered by a political-religious organization. The religious organization (*cofradía*), the organization of elders (*principales*), together with the municipal political administration, forms a very strong corporation regulating much of the behavior of all people born in the town.

Indian *aldeas* are small social entities under the political administration of a *pueblo*. Examples include the *aldeas* around Santa María Chiquimula, San Miguel Acatán, and San Sebastián Huehuetenango. For most public services, *aldeanos* depend on the *pueblo*. The sociopolitical arrangement between a *pueblo* and its incorporated *aldeas* affects the fundamental aspects of *aldea* life. *Aldeas* do not usually have *cofradías* and a full political organization. Indian *aldea* people do not appear as socially restricted as Indian *pueblo* people, where the religious-political organizations mesh.

Indian *aldeanos*, however, in contrast to Ladino *aldeanos*, feel strong identification with the Indian community culture of which they are a part. Frequently, the *aldea* people

participate in the *pueblo*'s *cofradía* ceremonies, thus making themselves part of the *pueblo* community culture. An *aldea*, in a sense, is a settlement awaiting development, whose people hope that someday their political status will change to that of a *pueblo*.

The pottery-production centers of Santa María Ixhuatán, Zapotitlán, Casillas, and present-day Mixco are typical Ladino *pueblos* with an open noncorporate structure. Without the formalized structure of the corporate *pueblos*, people in these centers are left to their own initiatives, and they have freedom to borrow from the outside culture for their personal improvement.

Wolf clearly presents the situation in the following paragraph:

In contrast to the corporate peasant community where the community retains the right to review and revise individual decisions, the open community lends itself to rapid shifts in production because it is possible to mobilize the peasant and to orient him rapidly toward the expanding market. Land is usually owned privately. Decisions for change can be made by individual families. Property can be mortgaged, or pawned in return for capital. The community qua *community cannot interfere in such change.*[8]

The Ladino *aldea* people live in a Ladino *pueblo* style, although in a modest rural environment—*más humilde*. Examples here include Lo de Mejía, Trancas, and El Barrial. Characteristic of both Ladino *pueblos* and Ladino *aldeas* is the fact that they take their cues from national culture rather than from local history. Under these conditions, settlements with open social structures do not generate a community culture as do Indian corporate *pueblos* and *aldeas*.

There are a number of pottery-producing centers, primarily in the eastern region of the nation, in which a few Ladino or Ladinoized

potter families reside as squatters (*gente posando*) in the most marginal land along *finca* roads. The oldest squatter settlements appear to be organized around a store (*tiendita*) and a humble chapel. These settlements—such as El Llano, Zapote Abajo, and Zapote Arriba—aspire to become *aldeas*. In the meantime, they are recognized under municipal political jurisdiction as *caseríos* or *núcleos poblados*. Their important sociological distinctiveness is their relation to the land. The people of these settlements, in contrast to Ladino *aldeanos*, do not have title to lands or houses, nor do they have any other local economic or political control. The lack of land, water sources, and easy access to local markets prevents them from establishing home gardens and *milpas*. They subsist on their labor and depend upon the *patrón* for employment. The potters—all women—alternate their work with employment at harvest time, picking vegetables and fruits, while the men work on the nearby *fincas*. Their cultural orientation is restricted, compared to that of Ladino *aldeanos*, and is profoundly affected by a life based on deep economic uncertainties. Their possessions are limited to a few personal items, and social and economic advancement is hardly possible under such conditions. Their pessimism and deterministic outlook are reflected in conversations although, interestingly enough, the Ladino *caserío* potters manifest a sense of freedom and security less apparent among those women of the same settlement without the pottery skill. In general, their spatial and temporal orientation in life can be characterized as very limited and closely bound to their immediate surroundings.

A significant difference in the social concept of pottery emerges among the potters of Indian *pueblos* (corporate social system) and the potters of Ladino *pueblos* (open social system). Indian *pueblo* and *aldea* potters see their work as an

economic activity specifically defined by their community culture. The profits are to be invested primarily in community ceremonies and also in private family ceremonies. Those articles manufactured for ceremonial purposes (candle holders, censers, etc.) are therefore the products of community culture. Ladino *pueblo* potters, on the other hand, see their vessels as a commodity to be converted into cash for the sole purpose of the family's support. Those articles made for artistic displays and urban consumption are the products of their own open *pueblo* tradition.

The Ladino potters of *aldeas* and *caseríos* think primarily of making utilitarian vessels required for economic subsistence; they rarely have sufficient energy or time to experiment in the making of elaborate or ceremonial pieces. Artistic displays are outside these potters' cognitive orientations.

In summary, an attempt has been made here to distinguish among several types of pottery-production centers. The sociopolitical structure and some aspects of the culture have been the bases for the distinctions. Indian and Ladino potters produce their vessels in these socioeconomic contexts, and the persistence of pottery production with a traditional native technology seems to have depended primarily on the maintenance of these types of sociocultural systems.

The Potters

In settlements where pottery is still made using traditional Maya techniques, pottery production in general is in the hands of women. This is true even in those areas where western technology has affected the ancient methods. Three exceptions are Rabinal, Santa María Chiquimula, and San Cristóbal Totonicapán, where both men and women share in the manufacturing process. Men are exclusively potters only in the three centers—Antigua, Jalapa, and Totonicapán—where pottery is made by the Spanish method, utilizing the wheel. In some centers, men do assist women (their mothers, wives, or daughters, as the case may be) in procuring clay, water, and fuel. However, it is safe to say that the majority of the work involved in making pottery is done by women. There can be little doubt that pottery manufacture by women in Guatemala is an ancient pattern and that the bulk of prehistoric Maya utilitarian pottery was also made by women.

In Indian *pueblos* and *aldeas*, the basic unit of pottery production is invariably the individual household. Children assist in gathering fuel and tending the firing process. Small girls learn various aspects of the production process from the senior potter of the household (their mother, aunt, or grandmother). In each household,

often only one woman actually forms the vessels. The others are either learning or are put to such nonskilled tasks as grinding clay, slipping, or polishing finished vessels. Even though various vessel forms may be produced in a center, the individual potter often specializes in one particular form. As mentioned, the communities of Rabinal, Santa María Chiquimula, and San Cristóbal Totonicapán are exceptions to this pattern. In the first two communities, pottery is made in an almost assembly-line manner. Members of the family often specialize in different tasks, so that each vessel may pass through several individuals' hands before it is completed; however, the senior potter of the household still oversees all activity.

Ladino and Indian potters, in all cases, seem to be very special people. Potters appear calm, patient, and secure. They are formal and most elegant in their interactions with outsiders, particularly with those interested in their skill and production. Potters from important centers, in particular, are also very curious about vessels from other centers. When they have a chance to examine a foreign or prehistoric vessel, their inspection is cautious and their evaluation technical. If a potter experiences embarrassment (*vergüenza*), the state of mind and general nervousness produced can affect her work and cause failure. The potter must, therefore, patiently and securely cooperate with those earthly elements provided by nature to her own place of birth for her use as a potter. One senses her quiet but strong social dominance. The potter commands respect from husband and children, and they quietly cooperate by assisting with small tasks. The potter, however, is in control of the full administration of the production.

After visiting approximately one hundred Ladino and Indian potters, there is no doubt that, socially and psychologically, they are unique and very stable human beings. Some of them have the makings of artists, even though they are producing utilitarian vessels. This reputation is usually enjoyed locally, and potters are classified as bad or good. Community public opinion, particularly within corporate *pueblos*, is important to a potter, and some of the best potters enjoy a very high social standing in the religious system of the *cofradías*. A good potter is highly respected; her individuality and sense of responsibility, combined with her skill, make her locally recognized as a good person who produces beautiful things. It is inspiring to observe potters' fascination with the process of pottery

making, and frequently one finds them in a contemplative mood. They project and inspire respect for the clay they are able to transform into vessels. Thus, in this aspect of making a living, Indian potters in particular feel they are working in harmony with nature.

Basic Pottery-Making Techniques

In analyzing the technology of the pottery centers studied, a division has become apparent which allows the techniques of pottery making to be grouped as either basic or supplementary. This division corresponds, to some extent, to the potters' own cognitive orientations. Basic techniques serve to organize the potter's work and to produce an initial, rough, and incomplete vessel. These techniques are, by analogy to painting, similar to the initial sketching of the artist's subject. The potter, as the painter, has at this stage a definite conception of the finished piece. Through the use of various supplementary techniques the potter then develops and refines the rough form into a complete vessel. There are, then, six categories of basic pottery-making techniques practiced in Guatemala today. They are here called the full mold technique, the concave basal mold technique, the convex basal mold technique, the flat mold technique, the orbiting technique, and the scooping technique.

The Spanish word *molde* is exactly equivalent to the English word "mold." Both connote the control of shape and imply a degree of standardization and specialized production, while lacking specificity as to the manner in which shape is controlled. This is especially true in an area of preindustrial ceramic technology, such as Guatemala, where this concept is used by native potters to describe vastly different production techniques. This is a potential cause of confusion, particularly in regard to making technological correlations between community cultures.

In the full mold technique, clay is placed in a mold which is, in effect, a complete vessel itself. The clay is then pressed against the interior of the mold to form another complete vessel. Once the vessel is dry and removed from the mold, a small number of supplementary techniques are employed to bring it to a finished state. Even as vessel shape is determined entirely by the full mold, and thus a high degree of standardization is achieved by the individual potter, the range of vessel shapes produced is also extremely limited. The full mold technique occurs in Guatemala along the middle Motagua Valley from the Zacapa area to Rincón Grande in the department of Guatemala.

Potters utilizing the concave basal mold technique begin by patting out a large disc of clay between their hands in a manner similar to that used in making tortillas. This disc is then pressed inside a concave form to shape the lower one-fourth to one-half of the vessel. This might seem to be merely a variation of the full mold technique but, although concave molds usually produce specialized vessels, they leave most of the shaping process to the individual potter. Frequently she will rotate the mold a bit to work more comfortably on a particular section of the vessel under construction. Some observers see this as a precursor to the potter's wheel. It should be noted, however, that full revolutions are rarely made; in any event, the speed is insufficient to produce a centrifugal effect. A significant exception is found in the pottery-producing center of San Cristóbal Totonicapán, where smaller vessels are formed using rapid rotation approaching the effect of the potter's wheel. In all cases, the concave basal mold allows the potter to proceed directly to the construction of vessel walls without waiting for the base to dry, as with the convex basal mold. The concave basal mold technique is the most widely utilized of all those found in Guatemala today. It predominates in the northwestern section of the western highlands, in the northern highlands, and on portions of the south coast.

In another variant of this technique, the concave form is simply a shallow depression made in hard earth by the potter. Vessels made in this earth mold are unmistakable, because impressions of the earth and actual particles of dirt occur on the lower part of the vessel exteriors. Although not found in Guatemala today, this variant is known archaeologically from the Valley of Guatemala and the middle Motagua Valley and was reported still in use in El Salvador[9] and Mixco[10] during the 1940s.

The convex basal mold technique refers to a method of production in which a clay disc, similar to those made initially in the concave mold technique, is pressed against the exterior of a convex form to give some shape. The convex form itself is often an old vessel inverted so that the potter, in effect, places the clay against the exterior of the vessel bottom. This process can control from approximately the lower one-fourth to two-thirds of the vessel body. Once a vessel has been given its initial shape in this fashion, it is usually set aside to dry until it can be removed from the mold without collapsing under its own weight. In different centers, a number of supplementary techniques are then used to complete the vessels. This technique is used today in three widely separated geographic centers, two of which are located in the eastern highlands.

In flat mold pottery making, pot-

ters begin by forming a clay disc as do concave and convex basal mold potters. This disc is then placed on a flat surface—a low stool or an inverted flat-bottomed pot—which limits the maximum diameter of the vessel base and thus the size of the whole vessel. Instead of working the clay down over the sides of the work surface as in the convex mold technique, flat mold potters build their vessels *upward* from this base, using several supplementary techniques. This flat mold technique is known today from the extreme eastern portion of the department of Chiquimula, as well as from San José Petén in the northern region.

In utilizing the orbiting technique, the potter generally starts with a large mass of clay placed on the ground. Through a variety of methods, the potter forms a concavity in the center of this mass and proceeds to raise the walls by lifting the clay between two hands. The potter usually shuffles backward or sidesteps around the work to maintain symmetry. Either the bottom or the top part of the vessel may be produced first, depending on the particular center. When dried, this portion is inverted, and the rest of the vessel is formed by raising excess clay left purposely, by adding coils of clay, or both. This basic technique requires a great deal of skill and muscular control, and the results are uncanny.

Orbiting is widely used in the central highlands and in one center in the southern part of the northern highlands.

The scooping technique, like orbiting, is a basically free-form method of pottery making. Beginning with a solid mass of clay, the potters dig or scoop clay out of the middle of the mass with their fingertips, leaving a crude, hollow form. A great deal of further manipulation, much of it with the fingers alone, is then required to finish the vessel. This simple but very effective technique is limited in distribution to the extreme southeast corner of the eastern highlands.

Supplementary Techniques

In addition to the basic technological processes discussed, there are a number of supplementary techniques which, while not sufficient to produce vessels alone, are essential to the construction process as a whole. These supplementary techniques may be divided into those which are auxiliary to the basic construction, carried out on wet, pliable clay, and those which figure in the finishing of dry vessels.

Coiling is the most frequently used auxiliary construction technique. Although coiling in its strict sense implies the continuous application of a single roll of clay upon itself in an upward spiraling motion, the term's general use has been to designate the application of any rolled piece of clay. It is this latter meaning we have in mind when using the term. In Guatemala, individual coils (reaching once around the vessel) or coil segments (reaching some part of the way around the vessel) are usually added as part of the building process. In addition, coils and coil segments also serve as the basis for fashioning vessel necks and handles.

Surface rolling is another interesting process well suited to nonwheel pottery making. In it one of the few tools of the Guatemalan potters—the corncob, or wooden spool—is used. This technique involves skillful coordination as the potter rolls the corncob or wooden spool upward over the exterior clay surface beneath the palm of one hand, while the other hand parallels this movement from inside. Although seemingly inefficient, vessel walls, built through one of the basic techniques or through coiling, are raised almost miraculously after a few minutes' work.

An allied technique, often used alternately with surface rolling, is surface scraping. As opposed to vessel scraping, the idea here is not to remove the excess clay but to draw it upward to heighten and thin the vessel walls. Tools used in this process include corncobs, pieces of wood and cane, gourd fragments, and stiff pieces of rubber. Often these tools have special shapes to conform better to a particular section of the vessel.

Smoothing is the last auxiliary construction technique. In the communities where it is used, it is also the last construction operation performed on a vessel while it is still wet. In some centers, this process may be carried out repeatedly during construction. It is accomplished by drawing a smooth instrument, such as a wet cloth or the potter's own wet hand, over the surface of the vessel.

Of the finishing techniques, scraping of a vessel may be undertaken at various times during its construction. It is usually done, however, once the particular part of the vessel to be scraped has achieved some initial hardness through drying. Usually a section of gourd is used to scrape away at the vessel interior, though sections of tin cans are also common today. Vessel scraping serves to smooth the interior but, most important, it thins the walls uniformly, thus producing a lighter, well-balanced vessel.

In many pottery centers, vessels are slipped once they have dried further. Slips consist of suspensions of clay and water, varying in density. These are usually applied to the exterior surface using either the fingers, a crude brush, or a cloth. Some centers further embellish their vessels by the addition of another color, usually a heavy suspension of clay called a paint, in the form of

designs. The white-on-red decorated pottery of several communities is representative of this. Another type of slip is a suspension of powdered talc. Applied to cooking vessels, it imparts nonsticking qualities similar to the Teflon used in industrially produced utensils.

While not all centers slip their vessels, most do burnish them. This process consists of rubbing a smooth, hard object over the semi-dry clay surface. The objects usually employed are smooth, river-worn pebbles of quartz, ax-shaped stones from archaeological sites, pieces of obsidian, or hard nuts. This process makes the vessel less porous and gives it a smoother, more attractive surface.

True lead glazes are applied in only two centers: San Cristóbal Totonicapán and Chiantla. This technique was undoubtedly copied from Spanish potters, such as those who set up production during colonial times at Totonicapán. The greenish glaze used in both native and European-derived centers is essentially the same, the raw material for all of them being mined in the Cuchumatanes Mountains of Huehuetenango.

Firing

This final step of vessel production is still carried out using the traditional open firing method. Only European-derived centers utilize high-temperature closed kilns. The Arrotts made a detailed study of the firing process in Chinautla to determine the range and duration of temperature. Although similar studies are lacking for the other Guatemalan pottery centers, these results (table 1) should be considered typical. Temperature readings were made with a Wheelco Instrument Company thermocouple and pyrometer. The end of the thermocouple was placed in the fire's center, about eight inches above the bed, and its position was not changed during the firing. Other readings were taken with the same fuel but with the end of the thermocouple in different positions. With it placed just above the coals of the bed, a maximum temperature of 1320° Fahrenheit was recorded. An equal temperature was recorded when the end of the thermocouple was placed just below the level of the burning bunchgrass. While in the latter position, it was noted that a gust of wind, with its cooling blast of air, would cause a

TABLE 1. *Temperature Range during Firing in Chinautla*

Elapsed time in seconds	Approximate temperature		External action
	Centigrade	Fahrenheit	
00	-0-	-0-	Live coals added
07	149	300	
08	202	400	
09	260	500	
10	426	800	
11	536	1000	
15	592	1100	
16	—	—	Bunchgrass added
17	649	1200	
18	592	1100	Gusty wind
19	649	1200	
20	592	1100	Bunchgrass added
24	620	1150	Wind continues
25	637	1180	Bunchgrass added
29	649	1200	Wind drops
36	599	1280	
39	715	1320	
43	715	1320	
47	699	1300	
53	671	1240	
58	626	1160	

drop in temperature of up to 500° Fahrenheit in a matter of seconds. The lost heat was recovered almost as rapidly after the gust had passed. There is a fair degree of local variation among the traditional Maya pottery centers as to specifics of open firing, especially with regard to fuels and their utilization.

Contemporary Pottery Forms

The traditional pottery forms of contemporary Guatemala can be divided into five major groups according to function:[11] carrying vessels, storage vessels, cooking vessels, serving vessels, and ceremonial vessels. Carrying vessels are used for the transportation of solid or liquid materials, usually water and foodstuffs. Storage vessels are used for the gross storage of water and foodstuffs; these are usually the largest

vessels. Cooking vessels are used directly in food preparation, while serving vessels are used for meal presentation. Ceremonial vessels are used in private and public religious rituals. There is a degree of obvious overlap between the first four functional groups. A *tinaja* may be used both to carry and to store water. An *olla* may be used to store, cook, and serve food. But, although some forms are almost general-purpose vessels, the majority fit into only one of the above groups.

The vessels which make up these five functional groups can be subdivided into some seventeen major form categories, along with several rather rare, special forms. Each major form category is designated by a discrete term, although in some cases there are regional differences in usage, and each pottery-producing center has its own variants of these forms. We have selected the most widespread and commonly used terms, and each is defined below. We have indicated the idio-

matic, more localized terms in parentheses where appropriate. Many of these terms have functional connotations, so that very similar forms may be given different names, depending upon their use. The meaning of these terms varies somewhat from area to area, but our definitions are based upon the full inventory of pottery forms produced in Guatemala today. The descriptions of these forms are illustrated with typical vessels from the contemporary pottery-producing centers.

I. CARRYING VESSELS

Figure 1. *Tinaja (cántaro)*
A globular jar with a rather small flattened base and a standing neck that usually has a flaring rim. Most *tinajas* have two loop handles low on the sides, although some may have three handles placed higher on the shoulder. *Tinajas* are used throughout most of Guatemala for carrying water.

Figure 2. *Porrón (pichinga)*
An intricately designed water bottle with a globular body, two necks (one narrow and tubular for pouring, the other wider and flaring for filling), and a single centrally placed loop handle.

Figure 3. *Tecomate*
Essentially a canteen modeled in clay after the hourglass-shaped *tecomate* gourd. Usually suspended by a cord looped around the vessel between its upper and lower lobes, it is highly favored by *milperos* in the Oriente, who want an easily transportable supply of cool water.

II. STORAGE VESSELS

Figure 4. *Tinajera (cántaro)*
A very large version of the *tinaja*, although the neck may be lower and wider. Used for storing water in the house, *tinajeras* are made to allow some sweating in order to keep the water cool via evaporation.

Figure 5. *Apaste grande*
A very large version of an *apaste*, conforming to the European concept of a basin. These vessels are usually employed to store kernel corn and beans. Potters sometimes use such vessels for storing large quantities of clay in water.

III. COOKING VESSELS

Figure 6. *Apaste (lebrillo)*
A basinlike bowl with a flat base, flaring or rounded walls, and a mouth that is usually open (an out-flaring rim). *Apastes* usually have two loop handles placed below the rim. This form is used as a rather general-purpose cooking vessel and is especially popular for cooking beans.

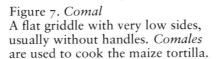

Figure 7. *Comal*
A flat griddle with very low sides, usually without handles. *Comales* are used to cook the maize tortilla.

Figure 8. *Olla*
A caldronlike vessel with a small flat base, rounded sides, and usually a slightly restricted mouth. *Ollas* usually have two loop handles, often below the rim on the vessel body. *Ollas* are a very common, general-purpose cooking pot.

Figure 9. *Pichacha*
An *olla* with multiple perforations throughout the base and lower body walls. *Pichachas* are a specialized form used as a colander in the processing of maize for consumption.

Figure 10. *Sartén*
A pan with a flattened base and rather low vertical or slightly flaring walls. *Sartenes* usually have a pair of horizontal loop handles and are used for cooking or frying a variety of foods.

Figure 11. *Tamalero*
A rather specialized vessel with a very restricted mouth, usually with four loop handles placed low on the sides. As the name indicates, *tamaleros* are used to cook or steam tamales.

IV. SERVING VESSELS V. CEREMONIAL VESSELS

Figure 12. *Tapadera*
A lid, often with a single large handle in the center. *Tapaderas* are produced in many sizes and are used to cover *ollas*, *apastes*, and *tamaleros*.

Figure 13. *Batidor*
A small cuplike bowl with a flat base, rounded walls, and usually a slightly restricted mouth. Often a single handle joins the rim to the vessel body, but the *batidor* may have two handles. It may be used as a drinking cup or a container for pouring liquids.

Figure 16. *Brasero (incensario)*
Often a small cuplike vessel, resembling a *batidor*, with a pedestal base. The *brasero* holds burning embers and is usually used as an incense burner.

VI. SPECIAL FORMS

Figure 14. *Cajete*
A simple, open bowl, often with a slightly out-flaring rim, no handles, and usually a pedestal base. It is frequently used to serve both liquid and solid foods.

Figure 17. Figurine
Modeled pottery effigies, usually of human or animal figures. Although technically not pottery vessels, contemporary production of figurines in Guatemala is directly associated with two major pottery centers—Chinautla and Santa Apolonia—and involves the local traditions of pottery decoration.

Figure 15. *Jarro*
A pitcher with a globular body, a rather tall standing neck, and an open spout. A single loop handle joins the neck to the shoulder of the vessel. The *jarro* is used to hold and pour liquids.

Far from being recent innovations, the majority of the basic vessel forms are solutions to functional needs of great antiquity. The basic utilitarian assemblage was in existence at least as early as the Middle Preclassic and has continued, with some slight modifications, to the present time. For the purpose of illustrating this continuity, figures 18 and 19 show a sample of preconquest vessels from different areas and periods of the Maya highlands and the south coast.

Figure 18. Preconquest vessel forms. (a) after Kidder, Jennings, and Shook
1946: fig. 187; (b–d) after Woodbury and Trik 1953: 413

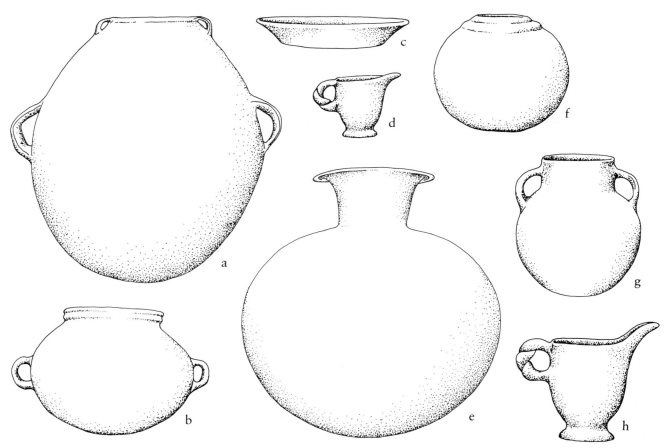

Figure 19. Preconquest vessel forms. (a, b, g) after Woodbury and Trik 1953:
413, 416; (c, f) after Coe and Flannery 1967: 29, 38; (d, e, h) after Kidder, Jennings,
and Shook 1946: figs. 166, 188

3.

Pottery Production
The Central Region

This region of the Guatemalan central highlands has the largest number of pottery centers in the country (map 3). It was the most densely populated area before the Spanish conquest, and the concentration of native population continues to be high. Distinctive of the region is the influence exerted by the nation's two largest cities: Guatemala City on the east and Quezaltenango on the west. Consequently, a great deal of the national economic and political administrative activities pass through and concentrate at these two points. By the same token, national modernization is best represented in these cities and their immediate surrounding areas. The intermediate points, such as Lake Atitlán, attract tourists because of the natural beauty; others, such as Antigua, Iximché, and Mixco Viejo, are attractive because of their historic or prehistoric remains.

As might be expected, an extensive system of ancient trails and modern roads links numerous *pueblos* and *aldeas*. The people continue to live in relative cultural isolation following the specification of their community culture. Interaction between communities is largely based on economic transactions and takes place at the many local and regional markets which serve now, as in the past, to distribute pottery from the various pottery centers throughout the central region.

Represented in the population of these pottery centers are four major linguistic groups: Pokomam (Chinautla and Mixco), Cakchiquel (San Raimundo and Santa Apolonia), Quiché (San Pedro Jocopilas, Santa María Chiquimula, and San Cristóbal Totonicapán), and Mam (Comitancillo). Some pottery is evidently made in San Miguel Ixtahuacán, also a Mam-speaking community, which is very similar to that of Comitancillo. However, the former center was not visited.

Chinautla

The pottery-producing *pueblo* of Chinautla is located within a section of steep hills and ravines seven and one-half miles north of Guatemala City. The Chinautlecos may represent cultural continuity from the inhabitants of the Late Postclassic archaeological site known as Chinautla Viejo.[1] When Guatemala's archbishop, Pedro Cortés y Larraz, visited Chinautla in 1769, he found a Pokomam population of 279 families and 1,149 individuals.[2] The population of the *municipio* of Chinautla remains predominantly Maya—3,195 out of 4,498 inhabitants in 1950. These people reside in the municipal center, in seven *aldeas*, and in nine *caseríos*. The pueblo itself is Pokomam-speaking with, according to the census of 1950, a population of 1,273 Indians and 142 Ladinos. Of the seven *aldeas*, three—El Durazno, Sacojito, and Tres Sabanas—have a close cultural identification with the *pueblo*. This is seen from the high incidence of intermarriage between these people and those of the *pueblo*.

The houses in Chinautla, built at the mercy of the topography, are strung out along major and minor pathways. Chinautlecos prefer to live in the town rather than on the isolated country land they own and cultivate. Because they live in town, they must walk long distances to reach their maize fields—*milpas*—and to gather clay and fuel for the production of pottery. To live in town is considered, furthermore, a *costumbre*, or custom, passed on to them by their ancestors. This settlement pattern permits Chinautlecos to maintain a corporate community with clear-cut boundaries in relation to both members and nonmembers. Their identity as Chinautlecos is related largely to the *oficio* of women as potters and men as *milperos* and *carboneros*. Over one hundred days of community religious activities are celebrated each year by the members of the political-religious organizations known as *cofradías* (see pl. 13). Cooperation among individuals exists within the framework of the *costumbre* concept, which implies a repetitive action that has the sanction of tradition. The phrase "the law of the saints" is used to refer to the overall tradition of the community. This is *costumbre*, and it is at the core of the Chinautla community culture.

The Chinautlecos' way of life and that of the Guatemalan urban society meet through economic and political interaction and, over time, the contact has favored the continuation of Chinautla's community style of life.[3] So far, the internal cohesiveness remains greater than the pressures for change exercised by the external national culture. Yet, despite the strength of its traditions, this corporate community is undergoing profound economic and social accommodation, stimulated by pressures from Guatemala City. An

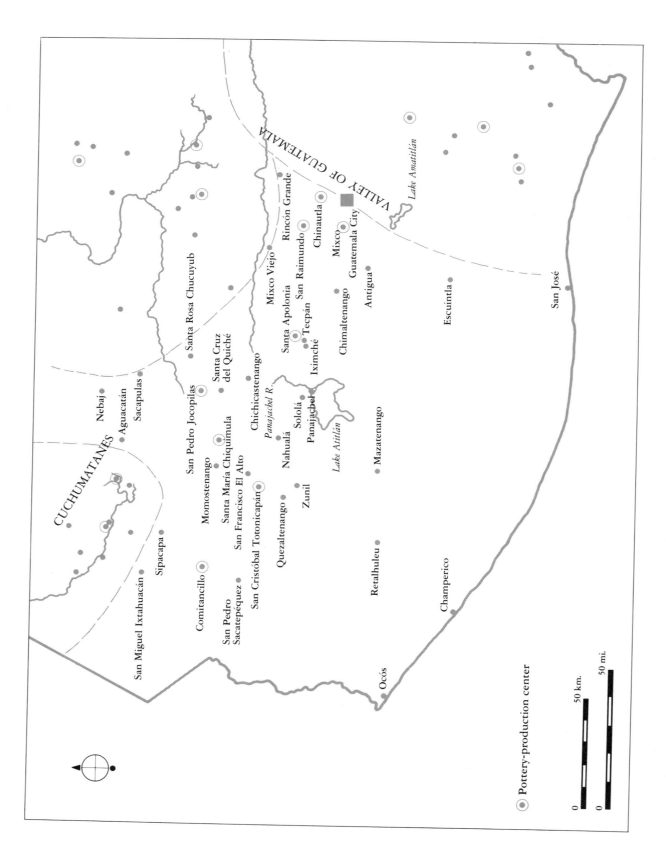

VALLEY OF GUATEMALA

Lake Amatitlán

San José

Rincón Grande

Mixco Viejo

Chinautla

San Raimundo

Mixco

Guatemala City

Antigua

Santa Apolonia

Tecpán

Iximché

Chimaltenango

Escuintla

Santa Rosa Chucuyub

Santa Cruz
del Quiché

Chichicastenango

Panajachel R.

Sololá

Nahualá

Panajachel

Lake Atitlán

Mazatenango

Nebaj

Aguacatán

Sacapulas

San Pedro Jocopilas

Momostenango

Santa María Chiquimula

San Francisco El Alto

Quezaltenango

Zunil

CUCHUMATANES

Sipacapa

Comitancillo

San Pedro
Sacatepéquez

San Cristóbal Totonicapán

San Miguel Ixtahuacán

Retalhuleu

Champerico

Ocós

◉ **Pottery-production center**

0 50 km.

0 50 mi.

Map 3. Central region

analysis of these trends and their effect upon the pottery tradition of Chinautla will be considered in some detail in chapter 10.

In the *municipio*, pottery is made in the *aldea* of El Durazno as well as in the *pueblo* of Chinautla. While there is some variation in clays, forms, and decorative motifs, the basic technique of pottery manufacture is the same for potters of both *aldea* and *pueblo*.

Various vessel forms are produced in Chinautla, including the *apaste*, *batidor*, *brasero*, *jarro*, *tinaja*, *olla*, *porrón*, and *tinajera*, plus a number of figurines and other recent innovations referred to in this work as urban ware (figs. 20, 21). The grace-

ful Chinautla *tinaja* remains one of the most characteristic, famous, and widely used hand-formed vessels made in Guatemala. These vessels are made with two kinds of neck: those with a wide flaring neck are commonly used for water storage at home, while those with a narrow neck are for fetching water from the central fountain. The locally made *tinajera* is similar in shape to the wide-mouthed *tinaja* but is many times larger and often has fluted decoration on the neck and body. Chinautla *jarros* have small, *tinaja*-like bodies but have a modeled spout on the rim and a single handle opposite the spout, running from directly below the rim to the shoulder. The

local *apastes* are straight-walled vessels, flaring out slightly to the rim, which is often crenelated. Two plain strap handles are placed vertically at opposite points relatively low on the body. *Batidores* in Chinautla have somewhat globular bodies, slightly restricted necks, and flaring rims, sometimes with a modeled spout. On spouted vessels, a simple strap handle is attached opposite the spout at the rim and just above the waist; otherwise, two strap handles are attached under the flaring rim and at the shoulder. *Braseros* have *olla*-like bodies and three rounded, cylindrical feet. Chinautla *ollas* have bodies similar to *batidores* in form but are larger and have a low direct

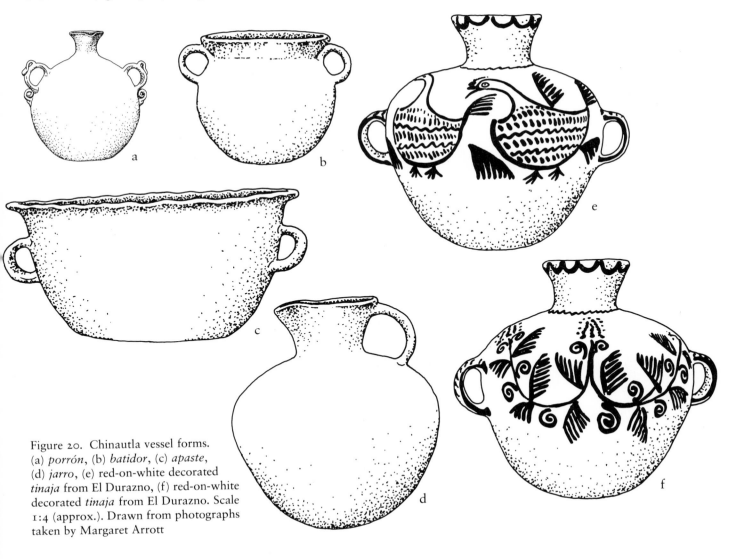

Figure 20. Chinautla vessel forms. (a) *porrón*, (b) *batidor*, (c) *apaste*, (d) *jarro*, (e) red-on-white decorated *tinaja* from El Durazno, (f) red-on-white decorated *tinaja* from El Durazno. Scale 1:4 (approx.). Drawn from photographs taken by Margaret Arrott

Figure 21. Chinautla vessel forms. (a) *tinajera*, (b) red-on-white *tinaja*, (c) white-on-red urban ware. Scale 1:4. From the University of Pennsylvania Museum, Philadelphia, Reina-Hill Collection, 1973

rim. Two large strap handles are attached high on the body, below the rim. The local *porrón* is a flattened canteen-shaped vessel with a high, constricted neck, often modeled into a spout, on one of its flat sides. Its two high-placed strap handles are embellished with small modeled scrolls of clay.

In Chinautla, as in most Guatemalan pottery-production centers, pottery is exclusively a women's specialization, although all members of the household assist in transporting the raw clay home from the mines. This is especially true in the months of March and early April, for it is imperative to get a store of clay under shelter to last through the approaching "winter," when heavy rains make working the clay pits both difficult and dangerous. Even so, pottery production is severely curtailed during the months of May to November. Torrential rains and a pervasive dampness descend on the Guatemalan highlands, fuel becomes wet, winds are gusty, and sudden downpours may ruin a firing lot.

The three clays used in Chinautla are all fine-grained with inclusions of mica and moderate amounts of extremely fine sand. All are highly plastic and remarkably free of extraneous materials. In their natural state they are commonly referred to as white clay, red clay, and black clay. On being fired, however, all three take on similar buffs, reddish browns, and yellowish reds. The colors from the fired black clay are duskier and duller, whereas those from the white clay tend more to a brilliant yellow cream or reddish cream in contrast to the deeper orange tones obtained from the red.

These clays are in privately owned deposits, so potters must purchase from the owners, who hire laborers to mine the clays. This is a hazardous occupation, especially in the white clay mine, where excavations reach a depth of forty-eight feet and cave-ins have caused several deaths. Because the clay beds in this mountainous region are accessible only by

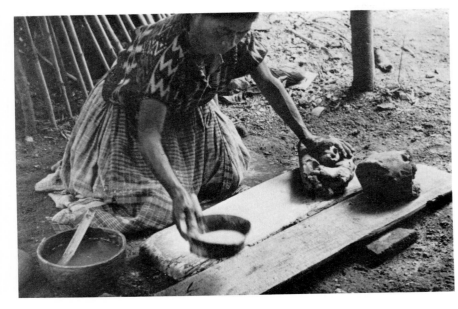

Plate 14

rugged footpaths, the clay must be taken home in baskets or in nets supported by tumplines. Thus, a great amount of time and energy is expended obtaining clay. For one of the larger *cargas*—loads—of white clay, close to one hundred pounds, Chinautlecos paid as much as $4.00 as of 1955. Red and black clay cost less.

The lumps of raw clay are stored on the hard-packed earth floor within the dark interior of the potter's house. During the dry season, fifteen to twenty-five pounds are brought outdoors each morning for the following day's work. Without being aged, the clay lumps are broken down with a wooden mallet and left to dry through the day. Toward evening, the clay is gathered in an old *tinajera* and covered with water. By sunrise the next day, it has become a heavy workable mass.

Every potter wedges her own clay. This is a strenuous task, requiring a strong back, wrists, and fingers to manipulate the heavy clay until a proper uniform consistency is attained. The potter begins by taking several handfuls of the wet, sticky clay from the *tinajera*; she then places the clay on a broad, heavy, smooth board lodged on the ground against her knee. The surface of this board has been well coated with an extremely fine pumice—volcanic dust—dug from nearby cliffs (pl. 14); this prevents the wet clay from sticking to the board. If the clay is still too wet to work, dry powdered clay is added to hasten drying without sacrificing the clay's plasticity. Pumice, because it decreases the clay's plasticity, is used as temper, though some potters in the *aldea* of El Durazno do not add any temper to red clay when making *ollas*.

The weight of the clay mass to be worked varies, depending upon the vessel to be built. In general, however, eight to twelve pounds are wedged at a time. The amount of pumice temper worked into the clay seldom exceeds 10 percent of the clay's weight. During the wedging, foreign matter—such as bits of wood, rootlets, pebbles, or vegetable material—is carefully searched out and removed. As successive amounts of clay are prepared, each is set out of the drying rays of the sun and covered with banana leaves, until a supply of wedged clay sufficient for the day's work has been accumulated.

All Chinautla pottery is made by the convex basal mold method, supplemented by coiling. For a *tinaja*, the clay is fashioned freehand on the wedging board into a round disc approximately ten inches in diameter and one inch thick. This is pressed down over the hemispherical base of an inverted vessel, the convex mold. The potter then carefully draws the clay disc out and down over the mold with the rounded side of a section of split cane. She stops when a thick, shallow bowl form is reached, then leaves the clay to dry until it is sufficiently firm to be removed from the mold without danger of distortion or breakage. She then places it in the shade, mouth downward, to dry until leather-hard.

When the vessel has hardened, the base is scraped to the desired thinness with a piece of gourd and placed rim up in a slight depression on the wedging board. This depression serves only to steady the round-bottomed form, not to shape it. A heavy coil of wedged clay about five inches thick and up to fifteen inches long is now rolled out on the board (pl. 15), and the rim is lightly wetted with slip (pl. 16). The coil is taken in the right hand between the thumb and the last three fingers and is allowed to lie in the palm of the left hand (pl. 17). The right hand feeds the coil onto the rim; the fingers and thumb pinch and join the

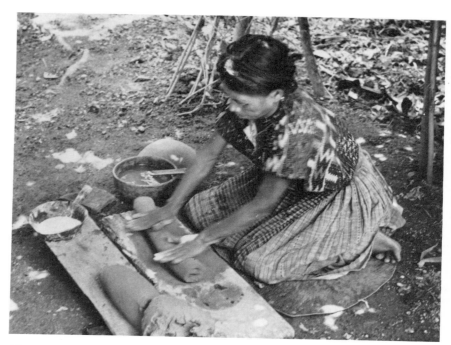

Plate 15

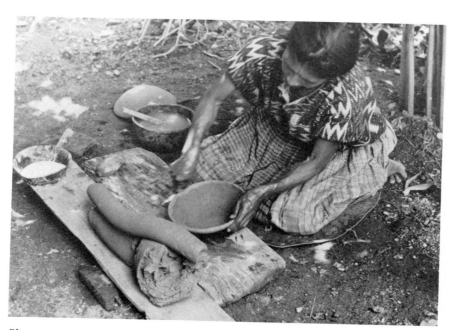

Plate 16

clay of the coil firmly into place. This coiling operation proceeds rapidly but may come to an abrupt stop if the potter's sensitive fingers encounter any particles of foreign matter. These are quickly plucked out, and the resultant hole is filled with fresh clay.

By the time the coil has been completely applied, it has been pressed and flattened into an extremely heavy collar on top of the prepared base (pl. 18). The next step is to thin and raise this collar and thus begin forming the vessel walls. This is accomplished through the use of the side of the right index finger, as the tip of the thumb applies pressure through the vessel wall. While the left hand molds itself to the vessel wall in support, the right index finger and thumb apply pressure and draw up the clay of the collar in short, diagonal strokes (pl. 19). The potter alternates working on the interior and the exterior with her right hand, her left hand always taking a position opposite in support. In this way, the vessel walls are quickly raised to a height of about six inches. At this point, another, smaller coil is added similarly to the first, but it is applied to the interior of the first coil (pl. 20). The potter then proceeds as before to raise the walls still further, adding coils until the desired height is reached (pls. 21–24).

Before forming the shoulders of the vessel, the potter turns her attention once more to the seam formed where the walls join the base. This area is carefully reinforced with daubs of clay, or sometimes a small coil, if judged necessary, is applied to the exterior. With her fingers, the potter then smooths the additional clay into the surface.

Additional coils of clay are now added and worked as before, as the potter carefully begins to draw the clay in over the opening to form the shoulders (pl. 25). When an opening of proper diameter is achieved—one just large enough to accommodate the potter's arm—she begins to use the round surface of a section of

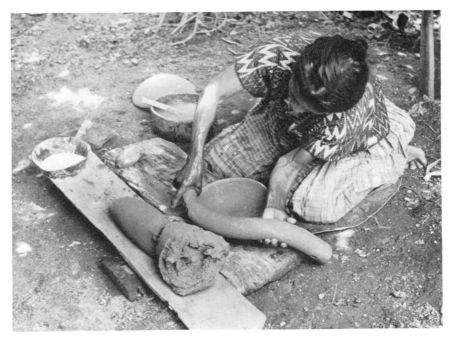

Plate 17

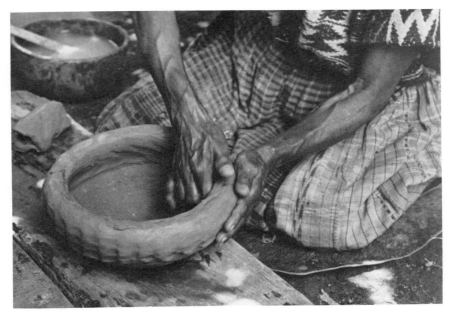

Plate 18

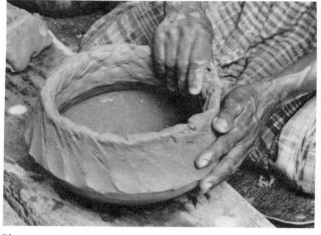

Plate 19

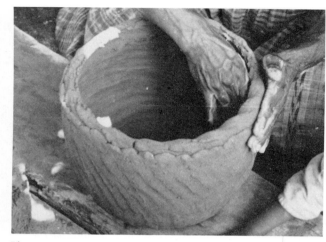

Plate 22

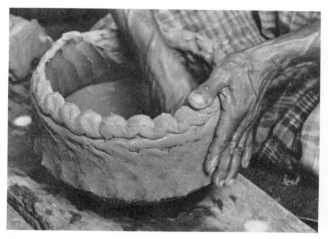

Plate 20

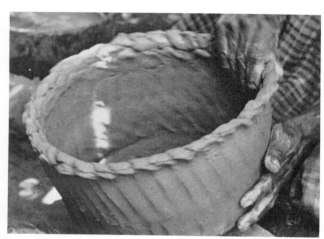

Plate 23

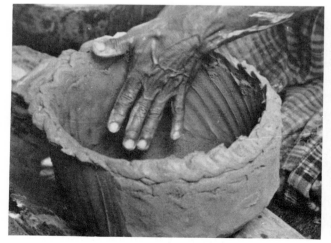

Plate 21

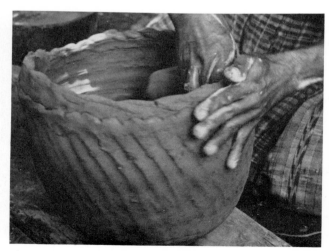

Plate 24

split cane. This she holds in her right hand and draws over the exterior of the vessel, while her left hand, inserted through the opening at the top, parallels the strokes in support (pl. 26). The potter, who has been sitting back on her knees, must rise up and bend forward to get her left arm far enough into the opening to support the pressure from her right hand. This position places great strain on the potter's legs and is very tiring. By the time she has finished this process, the vessel has attained its final shape, and the exterior is well smoothed. The vessel is now set aside to dry for about twenty-four hours so that the new section will become leather-hard (pl. 27).

As the potter always has many vessels at various stages, she moves over to work with another, already dry vessel. The next step is to scrape away the excess clay from the vessel interior. For this the potter again uses the piece of gourd and shaves off slivers of clay, achieving a uniform thickness. *Tinaja* wall thickness varies only between five-sixteenths and three-eighths of an inch. Despite this thinness, the unfired vessel may be safely handled by an experienced potter.

Construction of the vessel neck follows the same method used for the walls. A heavy coil is wedged, then flattened and applied to the small opening on top of the vessel (pls. 28, 29). It is then pinched up and flared slightly between the thumb and the last three fingers of the potter's right hand (pl. 30). Depending on the size of the neck being built, another, smaller coil may be applied to the interior of the rim (pl. 31). The neck is then further raised and flared with the piece of split cane (pl. 32).

The potter next flares the neck even more and gives the rim some definition, using a wetted green leaf. This she folds and holds in the crotch between the thumb and forefinger of her right hand. The rim is then grasped between them, while the left hand slowly turns the vessel on its rounded base in the depres-

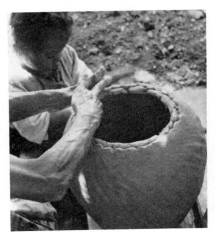

Plate 25

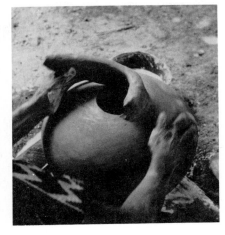

Plate 28

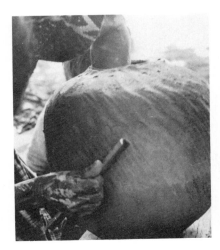

Plate 26

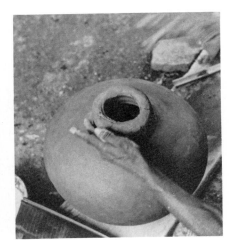

Plate 29

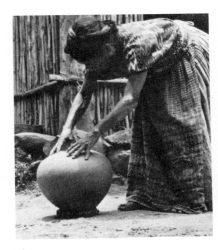

Plate 27

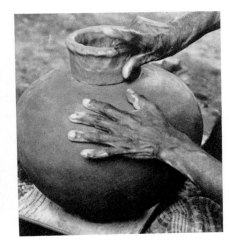

Plate 30

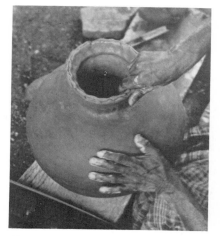

Plate 31

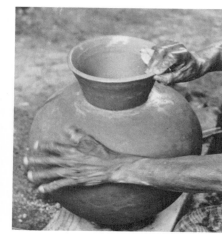

Plate 34

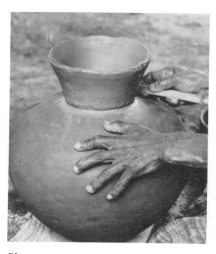

Plate 32

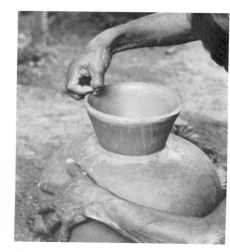

Plate 35

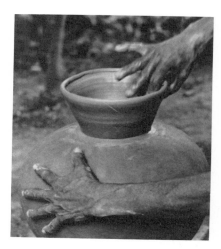

Plate 33

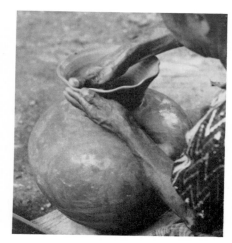

Plate 36

sion on her workboard (pl. 33). When the desired flare is reached, the potter turns her attention to the rim. She first squares it off by applying pressure through her thumb on the exterior, her index finger on top, and her middle finger on the interior of the rim, all pressed close together. Her left hand, meanwhile, continues to rotate the vessel (pl. 34). Next she turns her index finger slightly, to apply pressure through the nail while still maintaining the same basic position. This serves to round off the rim (pl. 35).

Wide-mouthed *tinajas* often have crenelated or wavy rims. The potter achieves this by pressing gently with the thumb of her right hand on the interior of the neck at regular intervals, while her left hand supports each spot from the exterior (pl. 36).

To form the characteristic broad and flat Chinautla handles, the potter holds a roll of clay in her left hand and pulls it several times between the thumb and fingers of her right hand (pl. 37). She further models it upon her workboard, cuts two equal lengths, and daubs slip on the points of the body where the handles will be affixed. She attaches a handle to the upper point first (pl. 38), presses it firmly into place, gives it a slight curve downward, and attaches the lower end (pl. 39). She works additional pieces of clay into the joints to insure a firm bond (pl. 40), then adds an effigy or a triangular element to the upper portion of each handle to help give a firm grip for lifting the vessel to the head.

After a few hours' additional drying, the vessel is ready for finishing. Only a small percentage of the vessels produced in Chinautla are slipped, as potters feel this treatment is excessive, especially on the white and red clays. The exteriors of both slipped and unslipped vessels are thoroughly burnished after drying and before painting, however. Potters may use a smooth, river-worn pebble or, preferably, one of the ancient, small, ax-shaped stones found in the local preconquest ruins. Both red and white slips are used, but

these are usually reserved for vessels made from the dull-firing black clay. Clay for the red slip is imported at high cost and is much prized by the potters. White slip made from a form of talc, rather than from clay, is also imported and is expensive. The slips are applied with a cloth dipped in the thick suspension, then drawn over the entire surface, including the handles, while the vessel is still drying. These slips are also used for painting birds and floral Ladino-style designs. White clay vessels receive this decoration in red, and red clay vessels are decorated in white. Potters in the *aldea* of El Durazno go one step further by applying red decoration to white-slipped vessels (pl. 41). These styles of decoration may indicate continuity with both the red-on-white and the white-on-red ceramics from the Late Postclassic period.

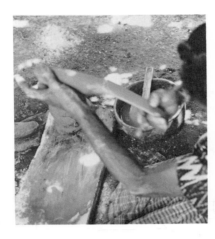

Plate 37

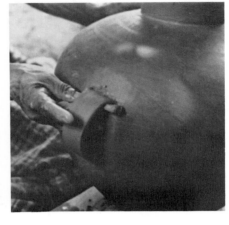

Plate 40

While the same basic procedure is followed in constructing all the forms produced in Chinautla, there are some minor variations. *Olla* walls have a slight curve inward, and those of *apastes* flare out somewhat. These two vessel forms are burnished inside as well as out to keep food from sticking. For the larger *tinajera*, the potter must kneel while building the lower portion; she then stands and walks around the vessel as she completes the upper portion. The shoulders of these vessels are often fluted. Because of the uncomfortable working positions, the amount of clay required, and the skill necessary to succeed, only a very few potters specialize in this form.

Pottery firing usually takes place on either Wednesday or Friday. Not all vessels are fired the week they are made, since it may take many days for the larger ones to dry. Until firing, all are stored indoors, away from moisture. When a sufficient number of vessels are ready, they are brought out in the early morning for an all-day exposure to the drying sunlight.

An even distribution of heat is essential to proper firing. To insure

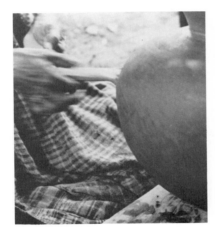

Plate 38

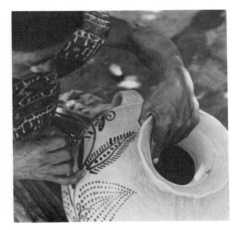

Plate 41

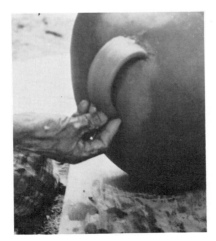

Plate 39

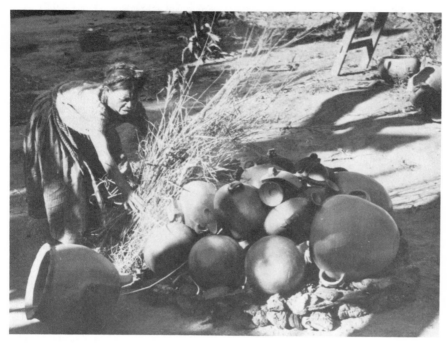

Plate 42

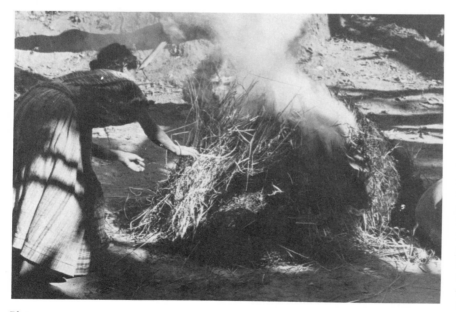

Plate 43

this, chunks of well-rotted pine, pine cones, pine bark, and dried cow dung are placed in repetitive order in a circle six feet in diameter. Bundles of dried straw are untied and piled nearby for easy access. Large broken sherds are gathered and piled to one side, ready to reflect the heat or prop up unsteady vessels.

The vessels are carefully stacked on the firebed, the larger ones forming a lower layer and the smaller ones interspaced on top (pl. 42). A slight error in placement could result in a shift during firing, and many vessels would be broken.

Once the vessels are stacked securely, live coals are scattered between them to ignite the fuel below. For a quarter of an hour the fuel is allowed to burn freely, until flames are leaping above the firing lot. Now the entire lot is swiftly covered, top and sides, with the highly flammable straw. Great clouds of smoke rise upward immediately, as the grass catches and the fire burns intensely. The potter skillfully rushes in and out, adding or shifting straw to secure the greatest possible uniformity of heat (pl. 43).

When the fire begins to fail for lack of fuel, the potter separates the glowing ashes of the straw with a long wooden pole and peers into the fire to determine the color of the vessels. If one of them appears to be under-fired or has become blackened, coals are shifted over it to oxidize the soot and bring up the color. This maneuver must be swift, for the fire dies rapidly. Great fluctuations in temperature cause drastic contraction, followed by equal expansion in the heated clay, creating strains that are often beyond the endurance of the vessel. Losses from exploding vessels amount to about 10 percent. However, potters are well aware of this danger and do their firing in the late afternoon, when the chances of wind are lowest. Fireclouds often appear upon the sides of the vessels. This feature is not deliberate; rather, it is an accident of firing, the result of exposing the clay surface to a reducing

atmosphere. When exposed to a fire—where the supply of oxygen is minimal—oxides of iron, the pigment in the clay, turn black. This occurs on those portions of vessels close to smoldering fuel and hot ashes. The stain appears, but its form cannot be predicted. In fact, the potters of Chinautla do all they can to prevent such fireclouds, being embarrassed when they do appear—for buyers consider them imperfections and such vessels bring a lower price.

When the fire has died (table 1), the potter disassembles the firing lot in one of two ways, depending on the clay from which the vessels are made (pl. 44). Those made of black or red clay are removed from the embers and left in the open to cool rapidly. This supposedly strengthens the vessels' walls. Vessels of white clay, however, are left in the ashes to cool slowly. This is done because of the belief that vessels of white clay are more sensitive to sudden changes in temperature and will break if cooled rapidly.

The number of vessels a potter produces per week is highly variable. Each potter can make about twenty medium-sized vessels per week, while only three or four very large *tinajeras* can be made per week.

In the past, most Chinautla potters marketed their own vessels at the Mercado Colón in Guatemala City after a tiring journey on foot. From there, itinerant merchants would carry this pottery in special frames—*cacastes*—on their backs, selling it over a large part of western Guatemala. Today, most Chinautla potters ride a bus to the interregional market—Mercado La Terminal— or wait at home for buyers to come to them. Economic pressures and close proximity to the national capital have added new forms to the inventory produced by Chinautla potters. All these accommodations and alterations, combined with the new roles of Guatemala City's markets, have created a unique situation for potters in Chinautla.

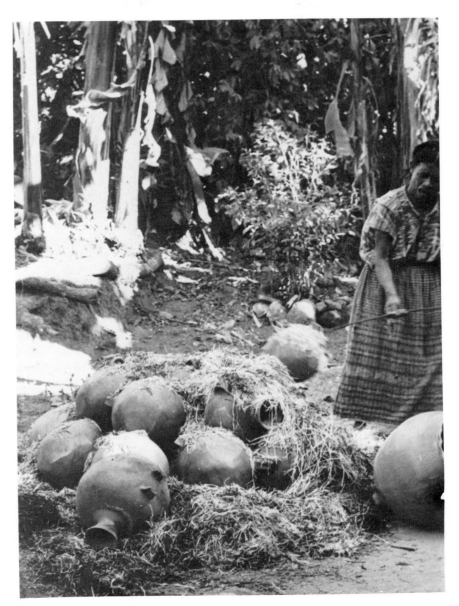

Plate 44

Mixco

The *pueblo* of Mixco, still largely Pokomam, is located six miles west of Guatemala City on the Pan-American Highway. The town was built in 1525, when the Spanish forced the resettlement of a Pokomam group after Pedro de Alvarado destroyed one of their important political-religious centers. In 1648, in one of the earliest references to this pottery center, Thomas Gage reported a population of three hundred families. The English Dominican friar noted that "in the town itself there is no other commodity, except it be a kind of earth, whereof are made rare and excellent pots for water [*tinajas*], pans [*sartenes*], pipkins [*apastes*], platters [*comales*], dishes (bowls), chafing-dishes [*apastes*], warming pans [*sartenes*]. In these those Indians show much wit, and paint them with red, white, and several mingled colors, and sell them to Guatemala, and the towns about."[4]

Archbishop Cortés y Larraz, during his visit to Mixco in 1770, found three hundred families, numbering 1,440 people. He too found a vigorous tradition of pottery making: "All this work is done by women. They prepare the clay, form pieces without the [potter's] wheel, paint, and fire them without a kiln, and they turn out beautiful, decorated, and well-fired vessels. The men have no other participation [in pottery making] than to take the vessels to sell, and with this they meet all the household expenses."[5]

Cortés y Larraz also found that households had a unique organization centering on this pottery specialization: "The head of each household has all his children and their families in the same residence [*jacal*], but each one has a kitchen and a separation for animals—pigs and chickens. Each one works on a different task and no one participates in the work of another. In fact, one daughter works on plates [*comales*], another works on serving pieces [*apastes*], another on water vessels [*tinajas*], etc. Asking for the reason behind this arrangement, I was told that it was done in order not to interfere with each others' sales."[6]

From these accounts there can be little doubt that Mixco pottery was directly descended from the common red and black on cream pottery traditional of the Late Postclassic highlands—Chinautla polychrome, made by the Pokomam. That at least some Chinautla polychrome pottery was made by the Pokomam is further attested to by a sixteenth-century report submitted to Philip II by the Licenciado Palacios.[7] In it, he describes a very similar type of pottery made at the town of Ahuachapán, one of the few remaining Pokomam enclaves in western El Salvador.

In 1950, the population of the *municipio* of Mixco stood at 11,784, with about one-third of the people living in the *pueblo* itself (4,131), the rest living in twelve *aldeas*, two *caseríos*, and three *colonias urbanas*—urban developments near Guatemala City. The *municipio* population was classified as 8,445 Indians (Cakchiquel and Pokomam) and 3,339 Ladinos. Once a closed corporate community, Mixco has become an open modern community. Effecting this change have been the encroachment of Guatemala City, the Pan-American Highway, and the separation of the religious-political power structure by the transformation of the *cofradías* into Ladino-type *hermandades* (brotherhoods).

Although a hundred or more women continued to produce pottery at Mixco earlier in this century, pottery making had all but disappeared by the time the Arrotts documented the technology in the 1950s—only a few old women in the *pueblo* still made *comales*. The Arrotts were aware that the craft was dying there and gave us an account of the potters' attitude. They noted that, unlike Chinautla potters, the potters of Mixco seemed indifferent to the quality of their product.

The source of the clay used in Mixco lies some three-eighths of a mile west, over the hill from the *pueblo*. The land is privately owned, and the dark brown clay cost about 40¢ a hundredweight in the 1950s. The female potters usually make small purchases of twelve to fifteen pounds at a time, which they carry home in baskets balanced upon their heads. The clay is fine-grained, containing iron oxides and small percentages of sand and mica; it becomes moderately plastic when wet.

If brought to the house during the rainy season, the clay is stored inside for protection. During the dry season, it is deposited outdoors, and the potter makes no effort to protect it from the dust and light trash that blow about. Since most of the *comales* are made during the dry season, the clay used is contaminated, a fact that seems not to concern the potter, although the finished product will be weaker because of these impurities. The potter makes no effort to steep the clay in water to soften it; she merely dashes water on a portion of the clay she will use immediately and takes it to her wedging board.

A more serious deficiency in the potter's preparation lies in her failure to add sand temper to the raw clay, which has a low sand content. It is difficult to believe that the women of Mixco are unacquainted with this advantage. In reality they do know but, when pressed, they offered this explanation: "It is not our custom." Given the fine reputation of its *comales* in the past, it seems unlikely that this has always been the custom in Mixco. It may be that with the encroaching city and with competition from other centers these potters have lost pride in their work, so they are willing to settle for a lower quality requiring less effort.

The *comales* produced in Mixco vary in size from six to seventeen inches in diameter. They are made directly on the earth mold—usually the size of the largest *comal* produced. The mold itself is made of a mixture of lime, sand, coarse earth,

and water known as *mezcla*; the mixture, a heavy paste, is troweled into a previously prepared shallow, rounded pit made in a convenient spot on the bare earth of the patio. It is then modeled into the form of a *comal* and allowed to harden and dry.

When about to begin work, the potter lightly dusts the surface of the mold with sand or dry powdered clay, to prevent the wet clay from sticking. Kneeling on the ground, at the edge of the mold, she first flattens a ball of half-wedged clay to form a heavy disc. Her right hand rotates the disc clockwise while, with the heel of her left hand, she presses the clay down and outward from the center (pl. 45). The action is swift, continuous, and firm. After three revolutions of the disc, the potter has pressed the clay out to the curled edge of the mold to form an exceedingly thin, uniform *comal* (pl. 46). After smoothing it with her hands, she rotates the *comal* with her left hand while, with her right, she grasps the edge with a small folded piece of wet leather held between thumb and fingers (pl. 47). This action bevels, smooths, and curls up the edge to form a finished rim.

To remove the newly formed *comal* from the mold, the potter gets to her feet, stoops, places her thumbs side by side under the near edge of the wet disc, puts her outstretched fingers upon the upper surface, and gently pulls the sheet of clay up and toward her. As she straightens, the disc hangs limply downward, reaching from above her knees nearly to her feet. Seemingly unconcerned, she carries it slowly into the deep shade or into the dark interior of the house and carefully lays it down upon the bare earth.

The *comal* is not finished: it has lost much of its concavity, the rim has sagged, and the whole vessel has an amorphous appearance. The potter allows it to dry in the shade, while she may make and set aside three or more additional vessels. She now returns to the first and, by the

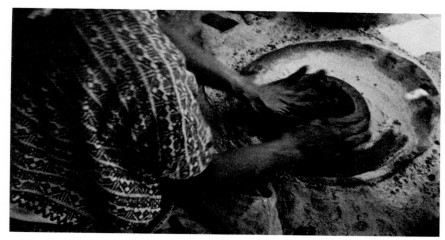

Plate 45

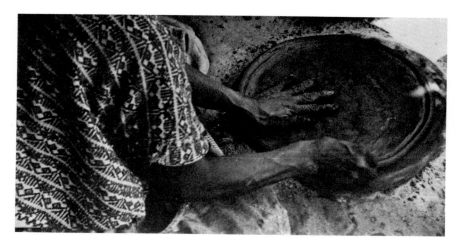

Plate 46

Plate 47

same method used to extract it, she replaces it in the mold. Wetting the surface lightly, she deftly restores its form by pressing gently with the palms of her hands; she also reshapes the rim.

While the vessel is still in the mold, the potter dips a smooth round pebble about the size of a hen's egg into a bowl of talc suspension and rubs it into the vessel surface. The process, called giving a "complexion" to the *comal*, requires care and patience. In the marketplace the result will be carefully scrutinized, for buyers are quick to notice any inadequately covered areas or any places where the coating has chipped away.

During the course of a day, a Mixco potter works for several hours at a stretch. She may make six, eight, or a dozen vessels. In a week's time she will have thirty to thirty-six seventeen-inch *comales* ready for firing. Dried in shade and sunlight, these will be able to withstand the sudden heat of a free-burning open fire.

Fuel is scarce in the immediate vicinity of Mixco: deforestation and the growing city have severely reduced this resource. Potters must put in long hours on the mountainsides to the north and west in order to gather enough bundles of small pine branches and twigs for the firing.

The firebed is several inches thick, three feet long, and three or more feet wide—depending on whether one or two rows of *comales* will be stacked upon it. The *comales* are stacked on end, separated by twigs and an air space. When the row or rows have been arranged, the potter scatters live coals from above to ignite the wood below. As it bursts into flame, twigs and an assortment of dry vegetable trash are distributed evenly over the surface of the firebed. This trash is not the best fuel for this purpose, as these women know, but the hot-burning straw is no longer available in the area.

In less than fifteen minutes the fire reaches its highest temperature, and this level of heat is maintained while the fire continues to burn furiously for about another fifteen minutes. Thereafter, it is allowed to die. The duration of glowing heat is roughly forty minutes. By this time the wood and trash have turned to gray ashes and the temperature falls to a point where the *comales* can be handled.

Casualties during firing average about 10 percent. The major portion of such losses can be directly attributed to the failure to add sand temper and to thoroughly wedge the clay.

In the 1950s, these potters still continued to produce *comales*, which were shipped to the capital, to towns in the nearby northern highlands, and toward the coastal regions of the southwest. However, the return for each of these women was low compared with that secured by potters in other centers and, according to a *regatona* in a Guatemala City market, compared with the wages paid in the nearby city. The Arrotts said that the trend in Mixco, therefore, was away from *comal* making. The younger women have turned their backs upon this traditional craft, and young girls are no longer willing to apprentice themselves to pottery makers. In 1973, not a single potter was found in the area—an instance of technological death (see chap. 10).

San Raimundo

San Raimundo lies on a plateau in the foothills northwest of Guatemala City. In the sixteenth century, this area was part of the *encomienda* of the historian of the Spanish conquest, Bernal Díaz del Castillo. In 1636 San Raimundo Las Casillas, an undeveloped parcel of land, was purchased by an Indian named Baltasar Pérez Tocay from a Captain Pedro de Aguilar.[8] The population in 1950 was 6,922, 4,903 of whom were Cakchiquel-speaking Indians, the remainder classified as Ladinos. Less than two thousand people lived in the closed corporate *pueblo* of San Raimundo, head of the *municipio*; the rest lived in the seven *aldeas* and ten *caseríos* scattered throughout the 144 square miles of the *municipio*.

Pottery making is a household activity among the Indian families in the municipality, particularly in the *aldea* of La Ciénega. These individual households, as in other communities, are often extended-family units organized around a central courtyard. The potters—all women—of San Raimundo are known for their large, well-shaped *comales*, even though these have only a limited distribution within the central highlands and the south coast. A crude *apaste* is also produced as well as, rarely, small *tinajas* and *jarros*, but these forms are solely for local use.

During the past quarter century, several changes in pottery technology have occurred in San Raimundo. The impact of diminishing fuel resources has forced modifications in the method of firing observed by the Arrotts almost thirty years ago. Moreover, the Arrotts reported at length on the great care with which the San Raimundo potters applied the talc slip to their *comales*, whereas today less time and effort seem to be expended on this procedure. These first signs of change—an indication of a weakening in the San Raimundo pottery tradition—appear to be the beginning of the same process of disruption that ultimately led to the abandonment of pottery making in Mixco.

The locally obtained clay is well suited for the massive vessels produced; it fires to a rust red. It is high in sand content and proportionately low in plasticity. After spreading out the clay in small lumps on the ground to dry for a few hours, the potter dashes it with water, transfers a suitable amount to her wedging board, and gives it a thorough kneading, adding either powdered clay to reduce the moisture content or talc as a temper, if needed (pl. 48). After wedging it until smooth,

uniform, and readily workable, the potter forms a rough cylinder of about six pounds of clay—the amount required to make a small, slightly oval *apaste* with a maximum width of eight and one-half inches by a height of seven inches.

The potter transfers the clay cylinder to a clean, smooth, and level spot on the hard-packed ground of the courtyard. Stooping over, she plunges her clenched fist downward into the pliable mass at a point just off-center. Moving clockwise, she repeatedly plunges her fist into the clay as she quickly makes one orbit around her work. The result is a crudely formed, low, oval bowl with extremely heavy walls and a conical protuberance at the center of the base, caused by the off-center plunging of her fist—later she will redistribute the clay to flatten the base.

With this first circuit completed, the potter continues her orbiting without loss of momentum, pulling the clay of the inside wall upward with the tips of the fingers of her right hand (pl. 49). With the crotch of her left hand, formed between the thumb on the inside and the four fingers on the outside of the vessel, she checks the wall for uniform height as her right hand pulls the clay upward and, at the same time, shapes a heavy and uniformly thick collar around the perimeter. Three orbits, with her hands constantly at work, and the vessel has attained its full height.

At this point, the potter reverses her direction. Moving counterclockwise, she continues to draw the clay upward, but now her right-hand fingertips operate on the exterior (pl. 50), while the outstretched fingers of her left hand act as a support and, simultaneously, gently shape the wall (pl. 51). In two or three more orbits, the potter makes the walls uniformly thick and forms a light collar around the perimeter.

Next, exerting pressure with the crotch of her left hand, the potter flattens this collar, here and there plucking off or adding bits of clay to

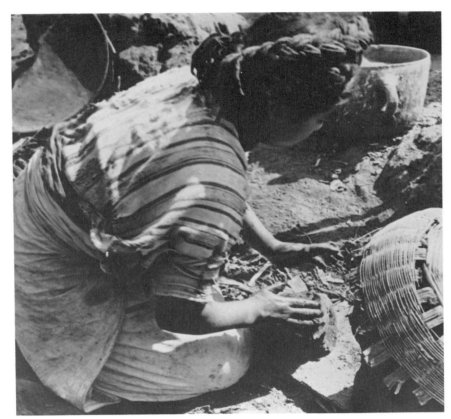

Plate 48

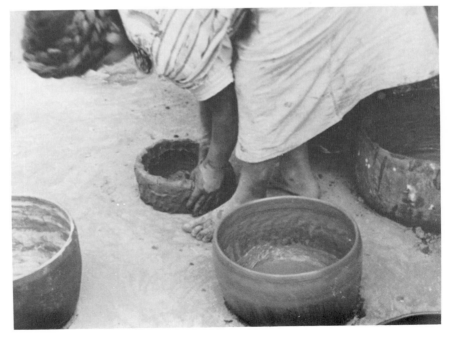

Plate 49

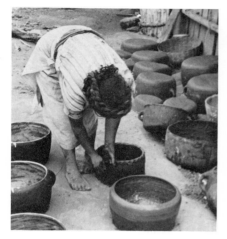

Plate 50

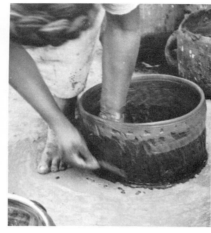

Plate 53

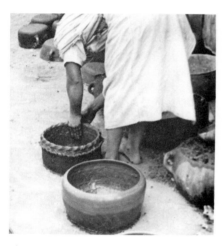

Plate 51

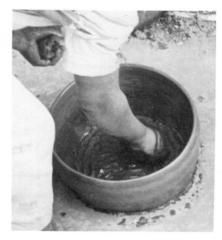

Plate 54

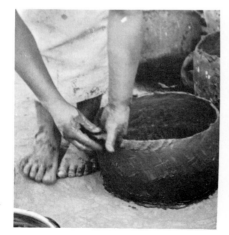

Plate 52

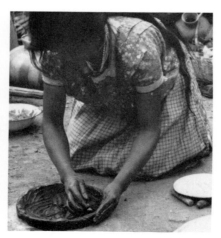

Plate 55

equalize the rim (pl. 52). The interior and exterior surfaces of the vessel walls are ready for smoothing. She does this by holding, first, a section of split cane in her right hand and drawing it upward (pl. 53), using next a rounded stick and finally a folded wet cloth. While her right hand smooths, her left hand exerts a light pressure to bow the wall outward, giving it a gently curved exterior. With this completed, she transfers the cloth to the rim. After a few circuits of continued counterclockwise movement, with the wet cloth folded between thumb and fingers over the rim, she deftly models a smooth glistening lip. Continuing to move around the vessel, the potter next applies the wet cloth to the interior and exterior walls to achieve the same smoothness. Then, flattening the central cone with her fingertips until the base is uniform, she gives that a final smoothing with the cloth (pl. 54).

The *comal* is made in a similar fashion, and many women of San Raimundo devote themselves exclusively to producing this form. The potter sets a column of clay weighing five to twelve pounds, depending on the size of the *comal* to be produced, on the bare ground at a smooth spot. She presses it down to form a large disc eight to twelve inches in diameter. Kneeling, the potter thrusts the heel of her right hand into the wet clay at a point just off-center and pushes outward, away from her body, as her left hand slowly rotates the disc on the ground (pl. 55). As in the *apaste*, the outward thrusts leave a truncated cone in the center. After three revolutions, she has forced the clay out to its limit.

To form the low rim, the potter lifts the *comal* edge slightly with her left hand, while she folds a wet cloth, held between thumb and fingers of her right hand, over it. She then rises slightly and moves clockwise, smoothing with the cloth until the rim has a slightly upturned and evenly beveled lip (pl. 56). The woman moves around the *comal*

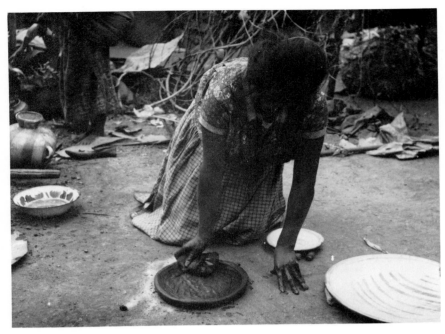

Plate 56

with unhesitating sureness, and the vessel becomes remarkably circular (pl. 57). The clay, however, is still very damp and limp, so that the rim sinks toward the ground as it is released. To save the concavity she has worked for, the potter supports the rim with corncobs thrust underneath it at suitable intervals (see pl. 59). The *comal* remains in place for an hour to dry in the sunny, cool atmosphere.

When the *comal* and the *apaste* are leather-hard, the potter can carefully handle them without danger of breakage or distortion. In this next step, she scrapes the exterior bases of both forms. A tubular section of tin sheeting makes an excellent tool for this purpose. Seated and holding the vessel in her lap or between her legs, the potter systematically shaves clay from the bottom until its smoothness and thickness satisfy her (pl. 58). A large *comal* may be a full half inch thick, making it extremely heavy and rugged yet still subject to easy breakage if not handled carefully when lifted.

Following the scraping, the potter gives the interiors of both vessels a "complexion" by rubbing them with a slip of talc and water to prevent food from sticking. She applies this coating to the *apaste* with a cloth saturated with the mixture. On the *comal* it is customary to use a rounded pebble—the size of a hen's egg or larger—to spread the talc paste and to work it into the surface (pl. 59). Talc does not readily adhere to clay; consequently the potter must take great care to work on only a small section at a time and to leave no areas uncovered. The women of San Raimundo are meticulous in this matter and take pride in the beautifully finished surfaces of their *comales*. As mentioned previously, however, they appear to take fewer pains with their work than they did at the time the Arrotts made their observations. With the affixing of the small loop handles to the *apaste*, both forms undergo several days of drying in the shade or, preferably, within the dark interior of the house.

The firing of *apastes* at San Raimundo follows a pattern similar to that of other pottery centers of Guatemala. A bed of brushwood several inches deep is laid (pl. 60), upon which the vessels are stacked. Live coals are then scattered between the crevices of the stack, igniting the brush underneath. As the flames leap to above the level of the pots, the stack is covered with straw or vegetable trash. The heat mounts rapidly to reach a high level, and it is maintained for about half an hour.

Comales at San Raimundo, unlike those at most centers, are seldom fired along with *apastes*. Nearly thirty years ago the Arrotts reported the careful procedure used for firing *comales*, only two at a time, over an intensely hot bed of oak-wood coals. By that method the first *comal* was placed face down over this bed, supported three or four inches above it on three large, previously fired *apastes* (pl. 61). After ten minutes, the potter, using sticks, dragged live coals from the fire, put them on the already heated *comal* (pl. 62), placed the second *comal* on top (pl. 63), and surrounded the stack with chips and twigs of oak (pl. 64). The second *comal* was then covered, also with chips and twigs of oak (pl. 65). Such a fire attained a greater heat than the fire in which the other vessels were baked, with the result that *comales* emerged from their firing substantially stronger (pl. 66).

In the interval since these observations were made, shortages of fuel, especially oak, have forced the potters here—as in many pottery centers—to use a variety of avail-

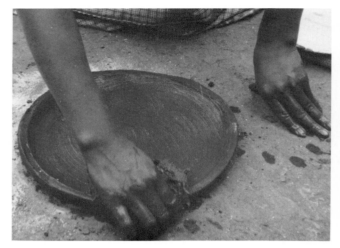

Plate 57

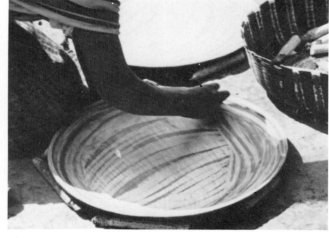

Plate 59

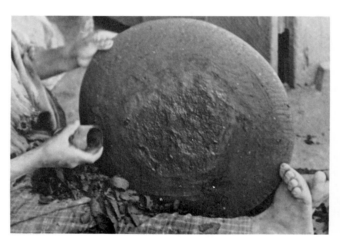

Plate 58

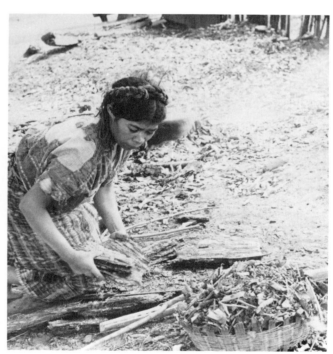

Plate 60

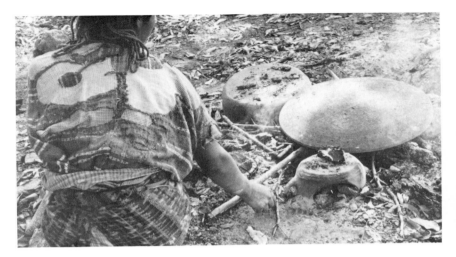

Plate 61

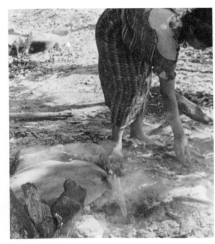

Plate 64

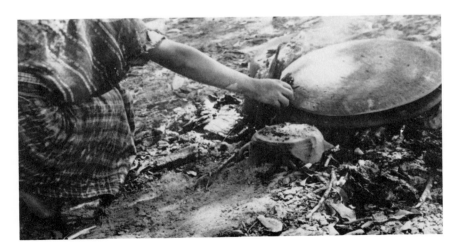

Plate 62

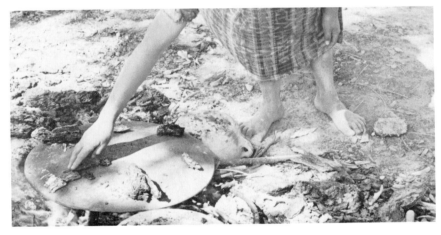

Plate 63

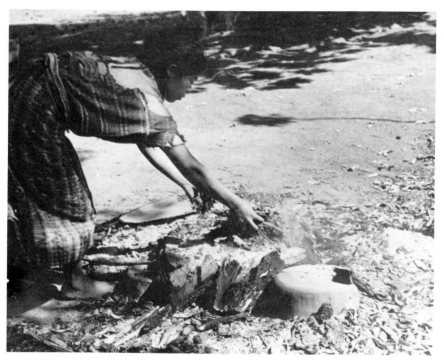

Plate 65

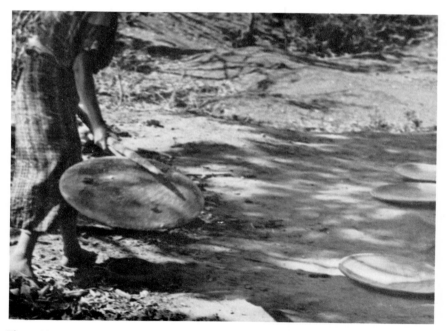

Plate 66

able combustibles: pine cones, trash, dried dung, and the like. These materials do not furnish the coals or the level of heat formerly provided by the oak. Consequently, a different method of firing has been adopted— one that does not require large coals for support and that can accommodate more vessels and thus be more economical. Today's method consists of stacking as many as twelve *comales* on edge, one behind the other, each separated by twigs and other burnables, directly upon a bed of fuel (pl. 67). Old *comales* and adobe blocks placed around the stack insulate the fire from outside winds and retain heat. Once ignited, the entire stack is covered by all manner of combustibles, including dried grass if available (pl. 68).

As previously stated, San Raimundo pottery does not enjoy a wide distribution. Although these *comales* are unexcelled in Guatemala, the large percentage of sand in the clay that guarantees they will emerge from firing intact also renders them unusually heavy. This, coupled with their large size and their fragility, makes them poor risks for *comerciantes*, who would have to carry them on their backs to distant markets. With the advent of truck transport, however, carefully packed crates of three vessels each are taken to the markets of Guatemala City and to towns of the central highlands and the south coast.

Santa Apolonia

Santa Apolonia, in the department of Chimaltenango, lies on the high plateau of Tecpán near Iximché, the ancient capital of the Cakchiquel kingdom, conquered by the Spanish in 1524. The present *pueblo* dates from the colonial era. At the time of Archbishop Cortés y Larraz' visit in the eighteenth century, Santa Apolonia had a population of some one hundred families, or five hundred persons.[9] In connection with pottery making, the archbishop

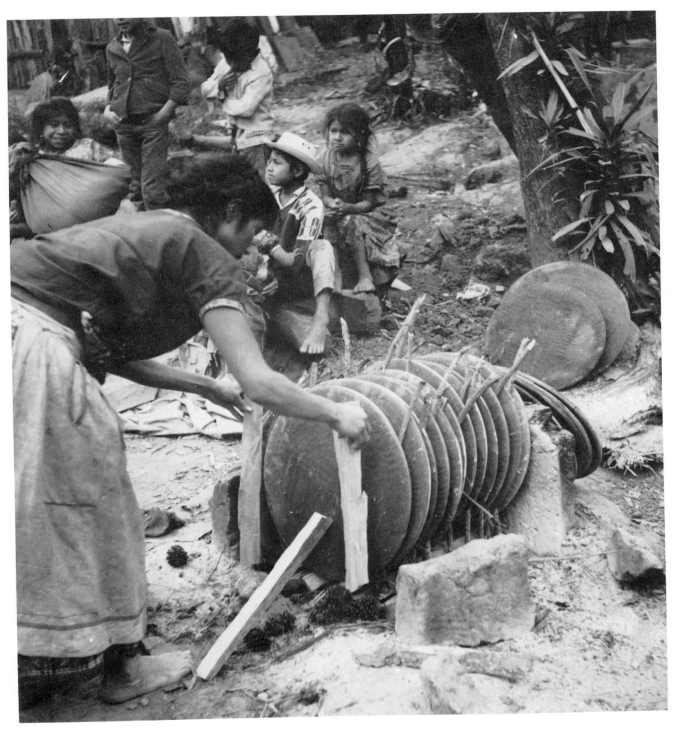

Plate 67

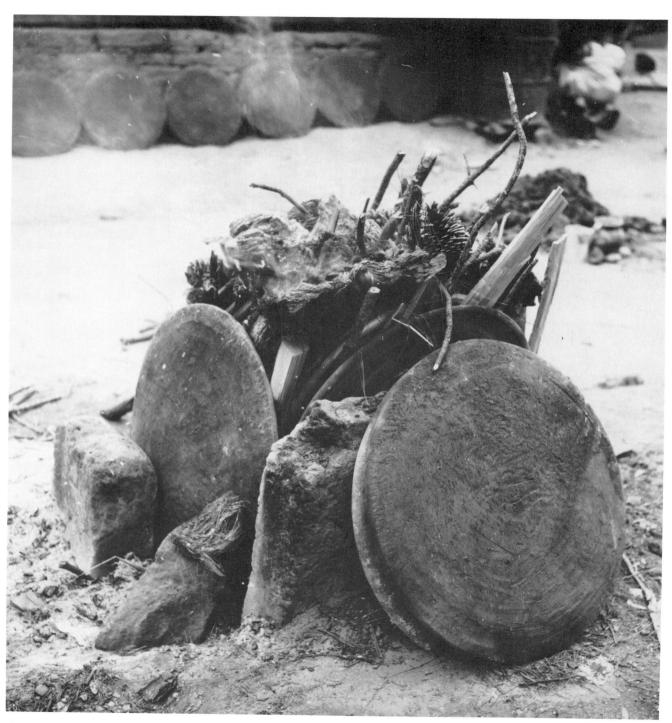

Plate 68

noted that "in the *pueblo* of Santa Apolonia they make much pottery, primarily *cántaros* [*tinajeras*] and *tinajas*; the men do nothing more in this activity than bring the clay to the houses, and everything else is done by the women. With this work they support their families fully with food and clothing . . . for this they have the reputation of being very rich Indians with a great deal of money."[10]

In 1950, 2,809 people lived within the municipality. A large majority are of Maya descent and speak Cakchiquel. Only 406, including nearly all the 322 Ladinos in the *municipio*, lived in the *pueblo* itself. Most of the inhabitants dwell in the surrounding countryside, in twelve *aldeas* and twenty-one *caseríos*.[11]

The community of Santa Apolonia remains traditional in its outlook and culturally isolated from the outside world. As of 1973, the *pueblo* was still without electricity. The traditional Indian political and religious organizations continue to be pivotal to the structure of the community. There are six *cofradías*, each with five *mayordomos* (officers) and a *principal* (leader). Three of these have parallel women's organizations. These religious organizations operate in cooperation with the formal political structure of the *municipio*, headed by an Indian mayor. The men's chief occupations continue to be tending *milpas* and making charcoal and lime. As can be seen, the Indian group of the population maintains a corporate social structure analogous to that of other *pueblos* in the highland region.

Several dozen pottery-making families live in the *pueblo*, and others live in the *aldeas* of Chuantonio, Chiquex, and Parajbey as well as in the *caserío* of Choatacaj. Clay is gathered locally, usually by the men, from deposits on municipally owned land. The men pay a tax of $1.25 for gathering clay for the entire dry season, and they also carry the finished vessels to market. Women perform all other tasks associated with making pottery. The

common forms produced are the *tinaja, tinajera, olla, jarro, tamalero, apaste, brasero,* and *batidor* (figs. 22–24). The orbiting technique is used to produce all vessel forms.

The Santa Apolonia *tinaja* is a tall vessel with a globular body and broad shoulders. It has a high, narrow, flaring neck and two plain, slightly downturned strap handles

attached opposite at the shoulders and waist. Women carry it on their heads. The locally made *tinajera* is a much larger vessel, intended for storing water at home. Its body tends to be spherical, with a low neck and a direct or exteriorly thickened rim. Its two handles are comparable to those on the *tinaja*, although some examples at the time of the Arrotts' visit had small appen-

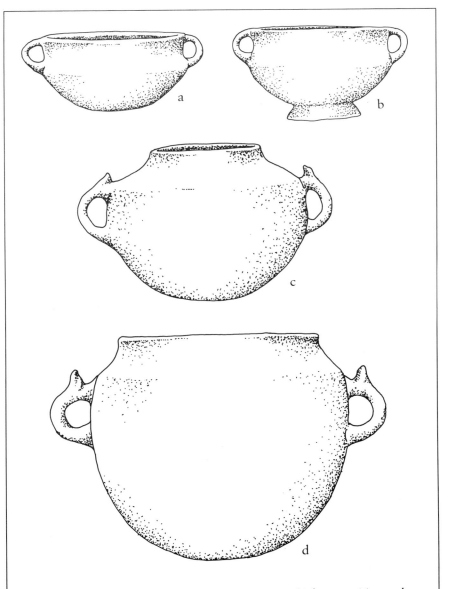

Figure 22. Santa Apolonia vessel forms. (a) *apaste*, (b) *brasero*, (c) *tamalero*, (d) *olla*. Scale 1:4 (approx.). Drawn from photographs taken by Margaret Arrott

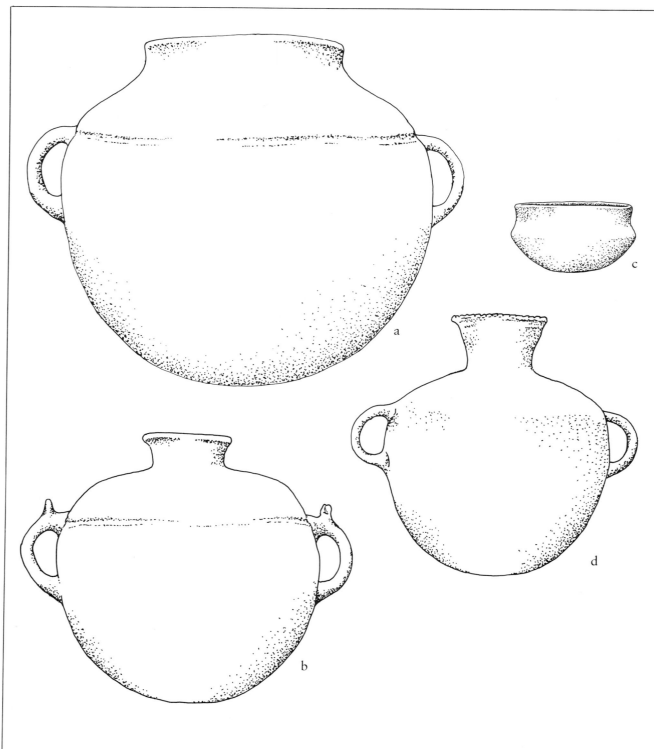

Figure 23. Santa Apolonia vessel forms. (a) *olla*, (b) *tinaja de las montañas*, (c) *batidor*, (d) *tinaja*. Scale 1:4 (approx.). Drawn from photographs taken by Margaret Arrott

dages attached to the top, similar to the wing handles at Rabinal. A third vessel in this class is the *tinaja de las montañas*. It has a large spherical body with a narrow neck of medium height, a flaring mouth, and two handles attached as on regular *tinajas*. Presumably these vessels are especially useful in steep terrain, where they would be carried with a tumpline.

Santa Apolonia *ollas* are large vessels with a hemispherical base and tall, slightly curved walls. These walls recurve inward to form narrow shoulders, from which rises a low neck with a direct rim. Two handles with small appendages are attached at points just below the shoulders and at the waist. The *tamalero* produced here is similar, although smaller and more squat.

The local *apaste* is shallow, bowl-like in shape, with a gentle upward-flaring curve which reaches its point of greatest diameter just below the lip, where it reverses. The plain strap handles are attached at lip and shoulder. The *brasero* has the same characteristics, with the addition of a low pedestal base, modeled from a ring of clay placed on the bottom of an inverted vessel at the end of the construction sequence. The Santa Apolonia *batidor* is another variation of the *apaste*, this one without handles.

All vessels are made from a clay that fires to a bright red. Farther up the valley, the women of the *aldeas* turn out a *tinaja* of a pale, buff-firing clay. An imported clay, firing to a pinkish gray, is expensive, costing 25¢ per ten pounds in the 1960s—it is used to slip vessels completely and to paint attractive white-on-red decorations. Thus, Santa Apolonia pottery may represent ceramic continuity from the white-on-red pottery of the Late Postclassic period. Common motifs include alternating wavy or straight lines with dots, as well as interesting sunburst patterns. Most vessels are burnished and slipped on the exterior, and cooking vessels receive a coating of talc on the interior.

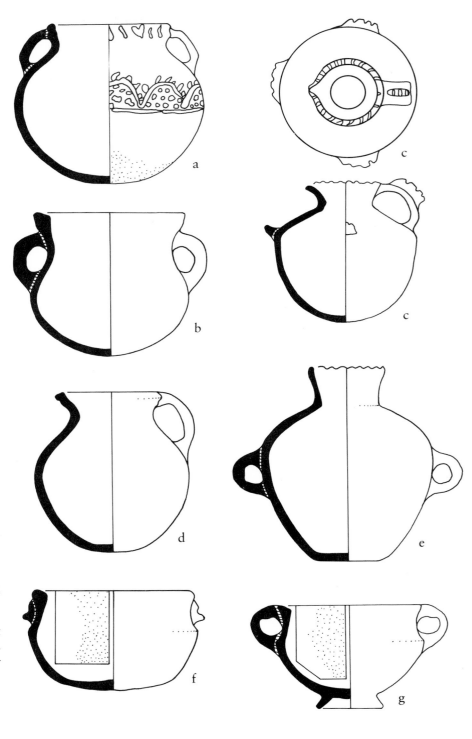

Figure 24. Santa Apolonia vessel forms. (a) white-on-red *olla*, (b) *olla*, (c) *jarro*, (d) *jarro*, (e) *tinaja*, (f) *batidor*, (g) *brasero*. Scale 1:4. From the University of Pennsylvania Museum, Philadelphia, Reina-Hill Collection, 1973.

Plate 69

Plate 71

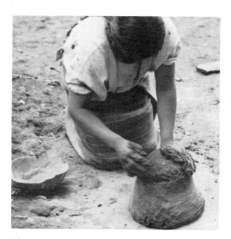

Plate 70

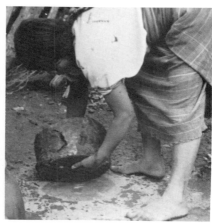

Plate 72

Within the past few years, the seeds of pottery innovation have been sown within a single household located in the *pueblo* (see chap. 10). The inspiration for these changes came from Ladino teachers from the capital and from the local priest, an American, who persuaded a family of progressive Indians to try several new pottery forms. At present, these potters, while continuing to make handsome traditional vessels, will attempt to produce the new ones to order. The daughters are beginning to experiment with some of the new forms that have found acceptance in the urban market. These include a *brasero* that resembles the traditional form, except that it stands on a very tall stemmed base; *floreros*— tall flower vases with scalloped rims and ring bases; *masetas*—flower pots, squat vessels with two auxiliary containers attached to opposite sides; and small *jarros*. The potters of this innovative household report, although with some hesitation, that to date other Santa Apolonia residents have shown no prejudice or resistance to their experiments.

Santa Apolonia clay comes from local mines in lumps of varying sizes. The potters do not increase its plasticity by weathering. They sun dry it for a day, then break it down into uniformly small nuggets, which they place in a *tinajera* and cover with water. By the following day, the clay is ready for working.

The potter takes twelve to fourteen pounds of clay—enough for an *olla* thirteen inches high by twelve inches in diameter—and places it on the hard, bare earth, which she has swept clean and sprinkled heavily with dry, powdered clay. The laborious task of wedging follows (pl. 69). The potter works until the clay is uniform and has absorbed enough of the dry powder to be ready for working. The moisture content is extremely high: the clay is hardly firmer than well-kneaded bread dough.

Forming a rounded clay column six to eight inches high by ten inches in diameter (pl. 70), the potter

plunges her left hand into its center
(pl. 71) and, getting to her feet,
models the clay into a cumbersome
ring (pls. 72, 73). Moving this ring
to another, similarly prepared spot,
she straightens the walls and adjusts
the ring to a uniform diameter by
rotary pressure from within (pl. 74).
Now, still upon her feet and stoop-
ing over, she begins to move slowly
backward in a clockwise motion,
orbiting around the clay ring; she
supports the outer wall with her
right hand, while the four fingers of
her left hand work in the soft clay of
the inner wall (pl. 75). Her right-
hand fingers now proceed gently,
but with great firmness and speed, to
drag the soft clay of the interior up-
ward to form a steadily rising wall
(pl. 76). Enough clay remains undis-
turbed in the bottom of the ring for
the potter to complete the base after
she has finished this upper portion.
After circling backward two or three
times around the work, dragging the
clay upward as she goes, the potter
begins to shape and refine the walls.
In this operation, her right hand
works while the left supports the
wall from inside (pl. 77).

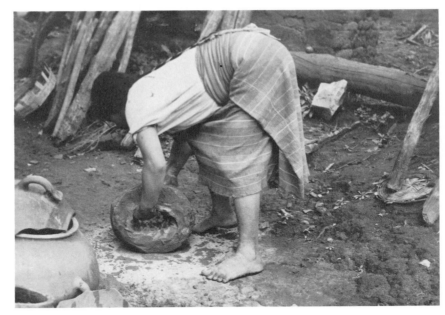

Plate 73

The upper portion of the vessel
continues to grow as the potter uses
the edge of her right palm to drag
the clay diagonally upward to form
a ruffled collar about the opening. In
the meantime, her left hand has been
at work on the inside. While follow-
ing and supporting as the right hand
pulls the wall diagonally upward,
this hand does the shaping (pl. 78).
At first the shape is scarcely percep-
tible; only as the potter completes
her third or fourth orbit does a
symmetrical shape appear (pl. 79).

Work on the surface of the top
half of the vessel now proceeds
rapidly with the aid of a corncob (pl.
80). While continuing to move
backward, the potter rolls the cob
with gentle diagonal pressure up-
ward from the heel of her right hand
to her fingertips, leaving the imprint
of its rough, pocked texture upon
the clay, while with her left hand
she locates and smooths over in-
equalities of thickness in the interior

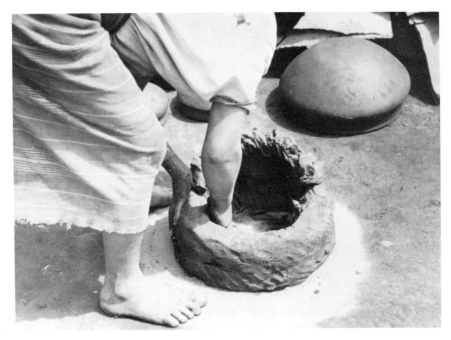

Plate 74

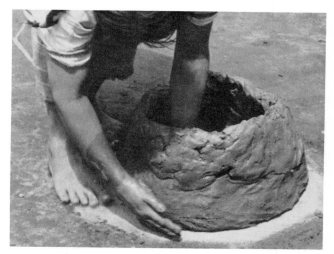

Plate 75

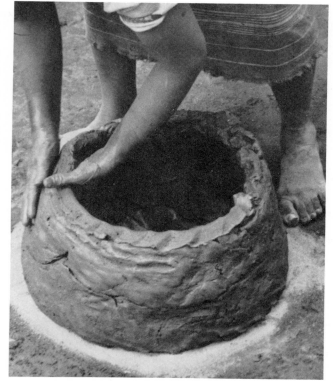

Plate 77

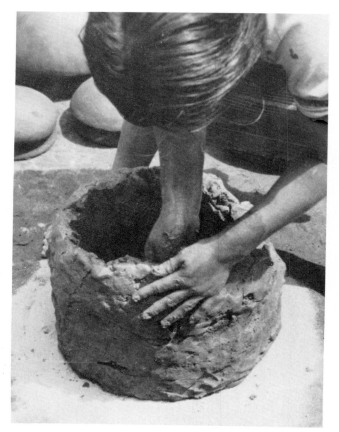

Plate 76

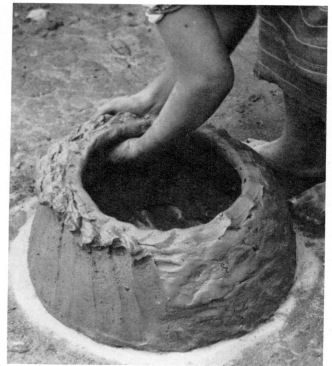

Plate 78

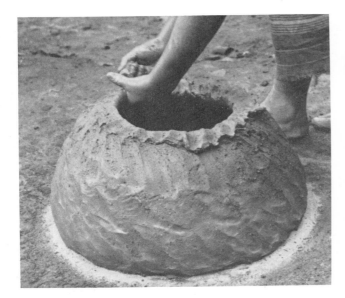

Plate 79

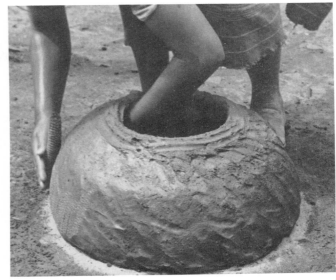

Plate 80

walls. This done, she rolls a smooth, short, rounded stick about an inch and a quarter in diameter over the surface (pl. 81). The pockmarks disappear and the surface becomes more uniform. Finally, the potter goes over the entire vessel with her wet hands, then smooths it with a folded wet cloth held in the palm of her right hand—this gives the surface a glistening evenness (pl. 82).

The formation of the vessel rim closely approximates the method of the modern potter using the wheel, except that again the pot remains stationary while the woman orbits around it. Holding the soft clay at the opening within the fold of a wet cloth or leaf held between thumb and forefinger of her right hand (pl. 83), she moves around the vessel rapidly to form the upturned rim (pl. 84). The Santa Apolonia potter strives for perfection and spends several minutes checking, smoothing, adding, or scraping before she is satisfied.

At this stage, with the first part of her task accomplished, the potter leaves the half-completed vessel to dry in the sun for an hour or longer. While it is drying, she goes on to complete the upper portions of two or three more vessels. As she works, she takes time to test the clay of the

growing number of pots. If her sensitive fingers tell her that any one of them has reached the desired firmness before she is ready to continue work on its lower half, she will cover that vessel with green leaves or a damp cloth to keep the clay workable. After forming the additional vessels, she will turn over one of the semidry upper halves and place it carefully on its rim upon the ground. This manipulation is difficult, for the vessel can still be easily distorted.

When she has inverted the vessel, the clay deliberately left within the ring when she began work becomes visible. The clay is flat and creased from resting on the earth and has a six-inch-wide hole in the center, but it is still wet and pliable. Putting her left hand through the aperture to support the heavy clay from within, the potter shapes the curving walls of the bottom toward the diminishing space around her supporting hand (see pls. 89, 91–94). To extract her hand and complete the base, she uses a corncob to draw the clay toward the center, exerting pressure through the cob, slowly removing first her whole hand, then her fingers. Rolling and pressing the clay toward the center, the potter reduces the opening to a point where only one fingertip remains within

the vessel. She withdraws this finger, raising a heavy flap of clay around the small opening that remains. This she rolls flat, incorporating it with the rest of the bottom, and the base is completed.

The method changes for a larger vessel such as the *tinajera*. For this, or for a very large *olla*, although the potter leaves the reserve of clay in the bottom, she removes it before completing the upper half. This is necessary because the weight of the clay needed to make these larger forms (amounting to about forty pounds for the *tinajera*) would be too great for the still damp vessel's walls to support.

After removing this extra clay, the potter inverts the *tinajera* and wedges two large coils—each six to eight inches in diameter and one-half the vessel's circumference in length—into the walls of the upper half, which now rests on its rim (pl. 85). The potter has no trouble with the great weight just added to the fragile vessel, and from this point on the manner of working the clay coils upward to form walls and to close the bottom is identical to that used in modeling this portion of smaller vessels (pls. 86–94).

After completing the bottom half, the potter leaves the vessel to dry to

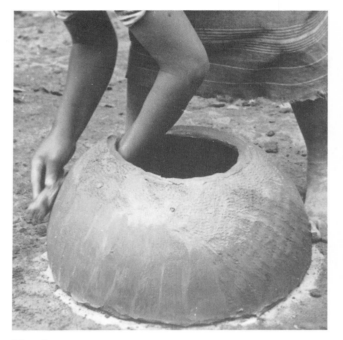

Plate 81

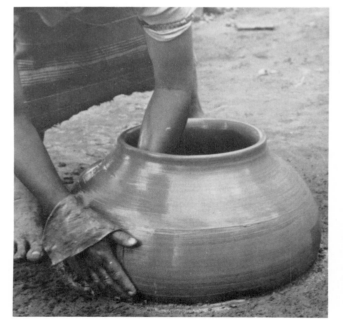

Plate 82

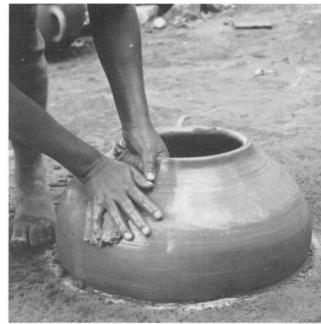

Plate 83

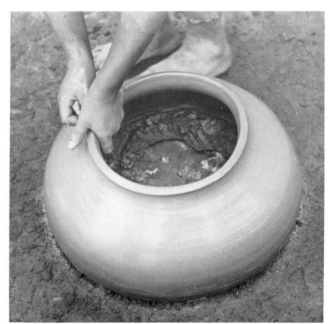

Plate 84

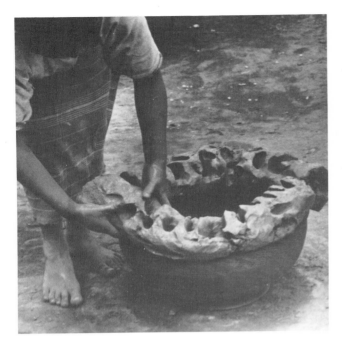

Plate 85

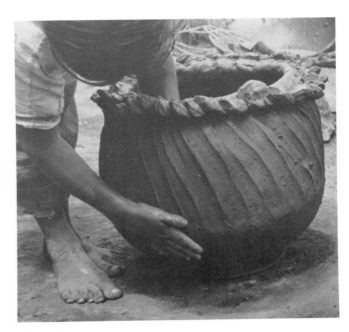

Plate 87

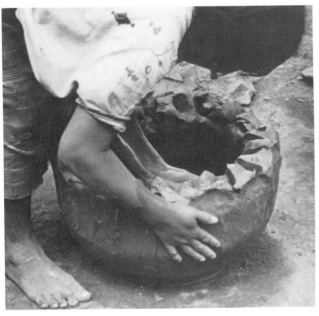

Plate 86

Plate 88

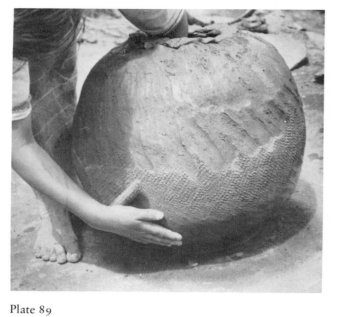

Plate 89

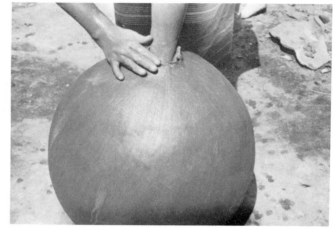

Plate 92

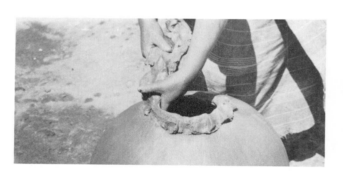

Plate 90

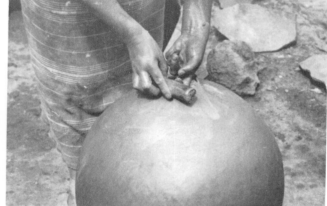

Plate 93

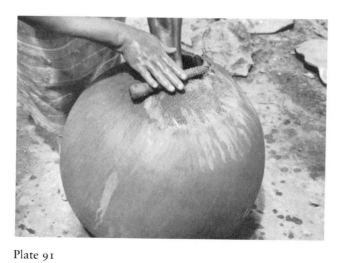

Plate 91

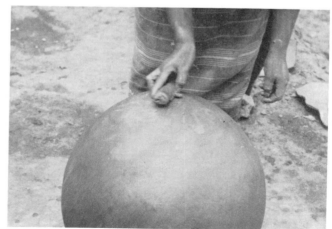

Plate 94

a stage where it can be handled without danger of distortion. Two hours in the sun are usually enough. She again inverts the vessel and places it mouth upward upon a cradle of straw or cloth; kneeling before it, she proceeds to scrape the interior with a section of sheet-tin tubing three or four inches in diameter by one and a half inches in length. Steadying the vessel with her left hand, she uses the edge of the tin section to shave off the hardening clay in thin slices, a tedious and exacting job, until the proper thickness is achieved. Then, with the same instrument, she carefully smooths the surface to remove any irregularities where dirt or foreign matter might later accumulate.

At this time the vessel handles are attached. Handles in Santa Apolonia are simple rounded loops that the potter forms with her wet hands by pulling part of a roll of clay into a short thick rope. She presses and wedges the upper end of this rope to the vessel body at a spot where slip has been applied as glue. With the upper end joined, the lower end, hanging vertically downward, is similarly fastened to the body. She carefully reinforces both joints with clay, smooths them, and adjusts the handle to its proper curve. With the addition of the second handle, this job is done.

If the vessel is intended for cooking, the potter coats its interior with a thin paste made from finely ground talc. As noted before, this is referred to as giving the vessel a complexion. This should prevent food from sticking and, if correctly applied, it serves the purpose well. The potter must do a thorough job of spreading and pressing the paste into the surface, however, because talc does not readily adhere to clay and may flake off as the clay dries if it has been carelessly rubbed on.

In the next operation—the application of a slip—the potter coats the vessel surface by hand with a thickish suspension of clay and water. When this has thoroughly dried,

she burnishes the surface with a rounded pebble.

During firing, the rapid rise in heat is a severe trial to any clay vessel and, if it is not entirely free of moisture, its chances of survival are poor. Well aware of this danger, the potters of Santa Apolonia, as elsewhere in Guatemala, take the precaution of drying their vessels slowly and thoroughly before firing. Drying begins in the interior of the homes, then continues for at least a full day in the sunlight. In most pottery centers this is considered sufficient; but the Santa Apolonia potters have an ingenious method of preheating their vessels for up to twelve hours prior to firing. The potter places the vessels on a wooden rack suspended from crossbeams within the house—the rack is positioned four to five feet above a broad fire of slow-burning logs, which in time disintegrate, leaving a thick bed of live coals. Next she removes the vessels from the rack, places them first on the coals at the outer edge of the bed, and then moves them gradually to its center. This removes the last vestiges of water from the clay, reducing firing losses from moisture to a minimum. These potters have, however, one final difficulty to overcome.

With outside firing, wind is always of serious concern. Santa Apolonia, at an elevation of 7,500 feet, is subject to strong currents of air and sudden gusts of wind. Pottery firing must take place in the calmest periods of the day: the hours of dawn or evening. But even this scheduling gives no real assurance that unpredictable winds will not disturb the fire, lift the burning straw, and expose the hot vessels for an instant to cold air. Once the fire is lit, the next hour is one of constant vigilance, for the potter may need to act quickly to prevent damage from a sudden gust of wind.

The potter builds the fire of oak branches a finger in thickness, broken into more or less uniform lengths, laid to form a bed six to

eight inches deep. The vessels are stacked upon this bed, usually in two tiers, the top vessels resting directly upon those below. When the vessels are arranged, the potter scatters live coals through the crevices between them to ignite the oak sticks below. From a slow beginning, the fire quickly mounts upward. As the flames rise above the top vessels, the potter covers the stack with quantities of straw, distributed to give a deep and even covering. In a few moments the fire bursts through the grass and the stack becomes a mass of flames. During the first half hour of burning, the hot-firing straw must be replenished repeatedly; thereafter, it is allowed to burn to a deep, nearly weightless blanket of glowing ashes. This is the time that a gust of wind is most feared. The potter keeps the heat at a fairly steady level, with less frequent additions of straw, for another half hour. At the end of this time the fire is allowed to die. Before the pots have fully cooled, the potter lifts them from the ashes, one by one, using a long wooden pole.

After removing them from the fire, the potter dusts the slipped pots thoroughly to rid the surface of clinging particles of ashes. Following this, she gives them a coating of *agua de masa*, a thin liquid drained from the mixture of lime and ground corn used to prepare tortilla dough. The water quickly evaporates and the residue, rubbed to a high polish, enhances the appearance of the vessels. Unslipped vessels, on the other hand, immediately receive a fine spraying of water, flicked onto the surface with a small whisk. This spray causes small rings to form from the carbon that was invisible on the vessel after firing—each ring radiates from a point where the drop of water struck. The potters of Santa Apolonia find this mottled pattern attractive, as do the buyers in the regional market at Tecpán.

The number of vessels a potter produces each day in Santa Apolonia, as elsewhere in Guatemala, is

highly variable, depending upon the individual's circumstances. She may be married to a woodcutter or to a worker in the lime industry close by and may have few dependents, in which case her contribution to the family income is less important. On the other hand, she may be a widow or an unmarried mother, with children to feed. Some potters are content to produce three or four pots a day; others may have reason to turn out five or six of average size as well as two *tinajeras*. The weekly profit is more important than the number of vessels the potter makes. Thus, on a given day, one individual may decide to make only small *apastes* and a few *braseros*, while another may concentrate on medium to large *ollas* or *tinajeras*. Of these last forms, the output in the area is light, for the work involved in preparing and handling such heavy masses of clay taxes most of these women, although the higher prices of the larger sizes compensate for the lower output.

No potter works on Sundays. Thursdays are market days in Tecpán, and it takes at least one full day a week to gather fuel and fetch clay from the beds. Thus, a potter dependent upon her own labor for her livelihood will have an average weekly firing of twenty to twenty-five vessels of various forms and sizes during the dry season. Most Santa Apolonia potters are adept at creating a wide number of traditional forms and prefer to vary their work. The Tecpán market may handle as many as six to eight hundred vessels of Santa Apolonia pottery. Itinerant merchants carry them off in great numbers toward the south coast and western Guatemala and in lesser numbers to the national capital, Antigua, Chimaltenango, and the many smaller towns and villages nearby.

San Pedro Jocopilas

The *pueblo* of San Pedro Jocopilas is located in the department of El Quiché, in the western part of the central highlands. About six miles north of the department capital—Santa Cruz del Quiché—and twenty-five miles south of Sacapulas, San Pedro Jocopilas is situated on a rolling fertile plateau, surrounded by hills and mountain ranges. An unexplored archaeological site nearby indicates a long history of occupation in the immediate area. The *pueblo*, formed by the Spanish colonial resettlement policy between 1546 and 1548, incorporated several distinct Quiché groups. The *municipio* population—5,453 Indians and 734 Ladinos in 1950—remains predominantly Quiché Maya. Today all but the several hundred inhabitants of the *pueblo* (214 Ladinos and 117 Indians) live in dispersed hamlets (one *aldea* and ten *caseríos*) and on isolated farmsteads throughout an area of some 358 square miles.[12]

Except for the Tuesday and Friday market days and Sundays, the *pueblo* of San Pedro Jocopilas is almost deserted. The *pueblo* serves as the center of traditional Indian religious and political organizations; there are seven *cofradías*, each having its own house for a combination of shrine and organization headquarters. Many traditional aspects of Maya religious ritual and belief systems remain strongly embedded in the local community culture.

Pottery production, rare near the town, is largely confined to the isolated *aldea* and *caseríos* of this municipality. In these settlements, the more traditional self-sufficient households remain, and the pressures of the modern world are less than those in Chinautla or even in Santa Apolonia. Informants stated that, in the past, pottery production was centered in the *pueblo* itself. The influx of Ladinos and the pressure to modernize caused the general abandonment of the craft in the *pueblo*.

The forms (figs. 25, 26) made in this area include *tinajas*, *ollas*, *pichachas*, *braseros*, and *comales*. Also, *jarros* and *apastes* were noted by the Arrotts. Both the forms and their method of production are remarkably similar to those from another Quiché center, Santa María Chiquimula to the southwest. The *tinaja* made here is essentially a large sphere with a short neck of relatively small diameter, modeled to pick up and reverse the curve of the body proper, thus ending in a slight flare. Two opposite wide strap handles are attached just above and below the body's widest diameter and, midway up the body, halfway between the two handles, an inch-long tab juts horizontally outward. This tab is serviceable rather than decorative, for the vessel is too round and too heavy when full to be carried on the head. Instead, a tumpline passed through the two handles and under the tab supports the vessel as it is carried on the back. In this connection, it must be noted that, in contrast to most other communities, the men are the principal drawers and carriers of water.

Two basic kinds of *ollas* are produced. One has the spherical body of a *tinaja*, with a wide mouth and a low, flaring rim. The other has a much larger, rather egg-shaped body; the rim may vary from erect to everted. The San Pedro Jocopilas *pichacha* may be fashioned from either of the two *olla* forms, the only modification being holes bored through the lower body before the vessel dries. Handle placement on the *olla* and the *pichacha* is the same as for *tinajas*.

A range of body forms is produced in the *brasero* category. One variation is an almost exact replica of the *brasero* made at Santa Apolonia, while others have larger, more *olla*-like bodies. *Comales* here have a pleasing dishlike curve and receive no treatment to impart a nonstick surface. All vessels are carefully burnished until smooth. A few potters further embellish their work with simple designs painted

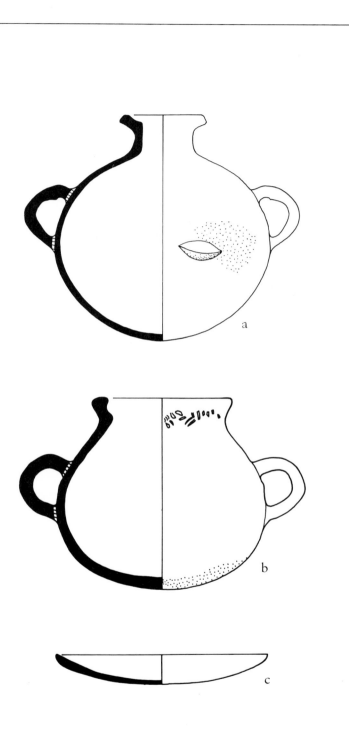

Figure 25. San Pedro Jocopilas vessel forms. (a) *tinaja*, (b) *olla*, (c) *comal*. Scale 1:4. From the University of Pennsylvania Museum, Philadelphia, Reina-Hill Collection, 1973

with a white slip which, as in other centers already described, may represent continuity from the white-on-red pottery of the Late Postclassic.

The potters—all women—of San Pedro Jocopilas seldom specialize; most have the ability to make all the forms in the community inventory. The only exception to this pattern is the *comal*. Only a few specialists in the hills to the north "beyond the cemetery" make these vessels. The orbiting method is used for all forms.

Men gather clay for their wives, and widows gather clay themselves. Once collected, the local clay is dried in the sun, then ground with a river cobble on a flat slab of rock (pl. 95), and then stored with water in an old *tinaja* until used. No temper is added. After properly wedging the clay, the potter forms a heavy ring of clay on the ground in her yard for the first step in producing an *olla* or a *tinaja*. Sidestepping around her work in the typical orbiting fashion, the potter extends the ring upward a few inches with diagonal strokes of her right hand, palm up. Her left hand bunches the clay together at the top of the growing walls, forming a collar (pl. 96). She repeats the procedure twice, each time drawing the walls higher, curving them in slightly, and forming successively smaller collars of clay on top (pl. 97).

When she has built a somewhat pointed dome of clay, the potter begins using a wet corncob to further shape the walls (pl. 98). She has left an aperture wide enough to admit her left hand, which supports the exterior movements of the corncob in her right hand. She uses the corncob in a dragging-rolling motion under her right palm and fingers. To give the final contours to this part of the vessel, she draws the cob up along the exterior. After this, she forms the low neck of an *olla* or, for a *tinaja*, she builds up the shoulders only to an aperture, upon which she will later build the neck (pl. 99).

With the walls still thick and with

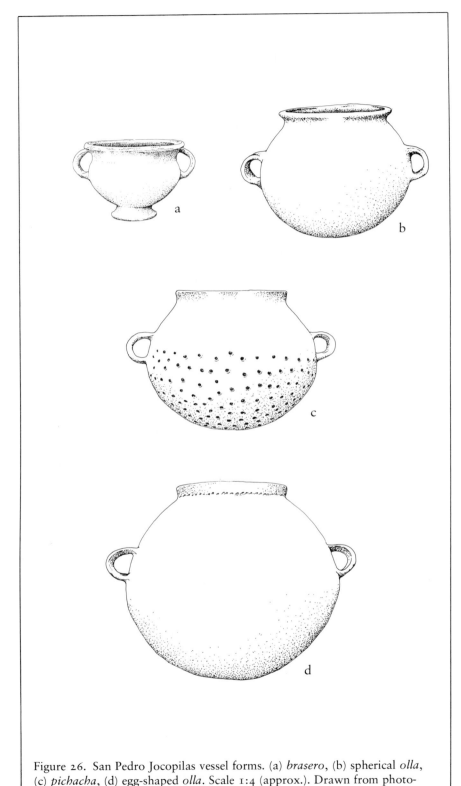

Figure 26. San Pedro Jocopilas vessel forms. (a) *brasero*, (b) spherical *olla*, (c) *pichacha*, (d) egg-shaped *olla*. Scale 1:4 (approx.). Drawn from photographs taken by Margaret Arrott

a large amount of clay still at the base, the potter leaves the half-built vessel in the sun until it can be inverted without collapsing. When this stage is reached, she carefully lifts the vessel from the ground, turns it over, and sets it on a base made of two straw collars placed one on top of the other. The potter then resumes work, drawing up the mass of clay from around the base by rolling and dragging again with the corncob (pl. 100). Once these walls have reached their proper height, she begins to close off the bottom in a manner similar to the methods employed in Santa Apolonia and Santa María Chiquimula, drawing clay around an ever-shrinking aperture with her right hand until only one finger remains inside the vessel for support. One seemingly casual but carefully timed sweep of the corncob makes the final closure, and the vessel is formed. The potter smooths the entire vessel with the corncob that has itself become smooth from repeated use. Now she may add the wide strap handles, fashioned from flattened coils of clay. She attaches the handle at the higher point first, bends it carefully into a tight curve, then attaches it at the lower point. Although the construction of a *tinaja* neck was not observed, construction marks on finished vessels indicate that a small coil of clay was added to the orifice at the shoulders and drawn up with the corncob. The potter would have formed the rim by running her wet fingers around the top of the vessel neck. Once dry, the vessels are burnished with smooth, river-worn quartz pebbles (pl. 101).

One pottery-making household, located slightly north of town, illustrates the cooperation and individual specialization typical in pottery making. In this household, an aged widow and her two daughters produce both *tinajas* and *ollas*. Labor is divided according to talent and circumstances. The mother is now too old to prepare the clay or form the pottery on the ground, but

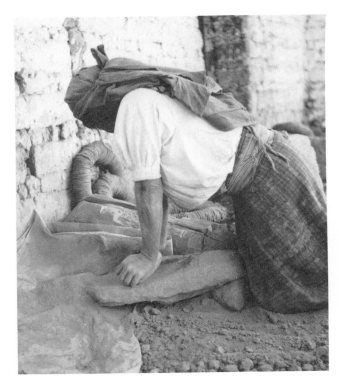

Plate 95

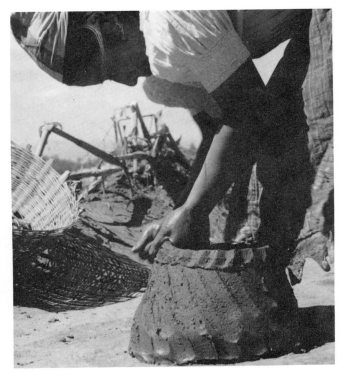

Plate 97

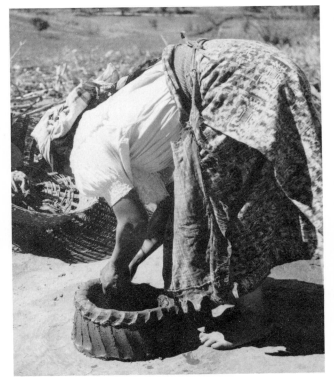

Plate 96

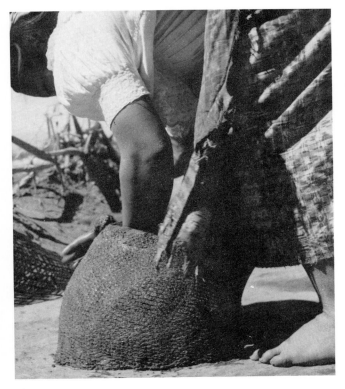

Plate 98

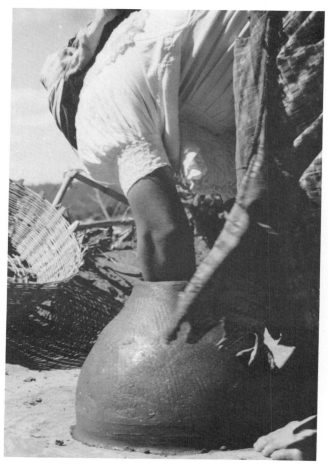

Plate 99

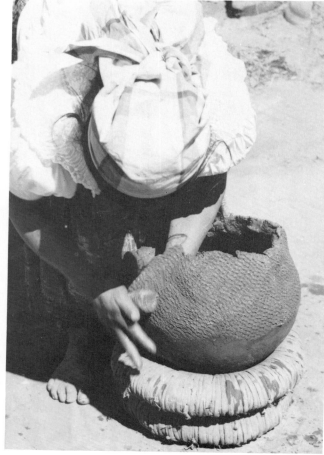

Plate 100

she has carefully trained her second daughter, who has the necessary skills, to make pottery. This daughter now produces six to ten vessels each week. The oldest daughter, who lacks this natural ability, does much of the unskilled work of grinding the clay, preparing the fire, and so on. The youngest daughter is "still learning" but can make three to six vessels each week. The mother continues to assist by carefully polishing each completed vessel with a smooth river cobble. This family unit's weekly production of nine to sixteen vessels is probably about average for this center. With estimates of the number of potters here exceeding a hundred, one quickly appreciates the great importance of this center for the entire northern Quiché region.

The potters of San Pedro Jocopilas have a significant technological variation in the firing of their vessels. They use wood, dried dung, and straw but, whereas the potters at Santa Apolonia place their vessels directly on the firebed, and Santa María Chiquimula potters use only broken handles and necks as a base for vessels, it is the custom here to place twelve to sixteen previously fired *ollas* mouth downward on the earth, separated from each other by a space of about twelve inches. With the firebed laid among these, the new vessels are set upon the upturned bottoms of the old. This permits unlimited access to oxygen and allows the fire to burn freely around each vessel. It also precludes the black fireclouds that disfigure the vessel surfaces.

Another distinctive feature of San Pedro Jocopilas is the degree of *costumbre*, or religious ritual and belief, directly associated with pottery production. This specialized belief system focuses on rituals performed to prevent breakage during firing. The rituals take place at three separate localities: a shrine in the mountains, the shrine of San Pablo in the *pueblo*, and a shrine in the church. Potters perform rituals that include the burning of candles and incense at one or more of these localities early in the morning on Monday and Thursday, the days of firing— the most critical time in the pottery-making process. Potters say that "the pottery does not explode if you make *costumbre*." Additionally, the *costumbre* will assure that the "money flows out of the buyers'

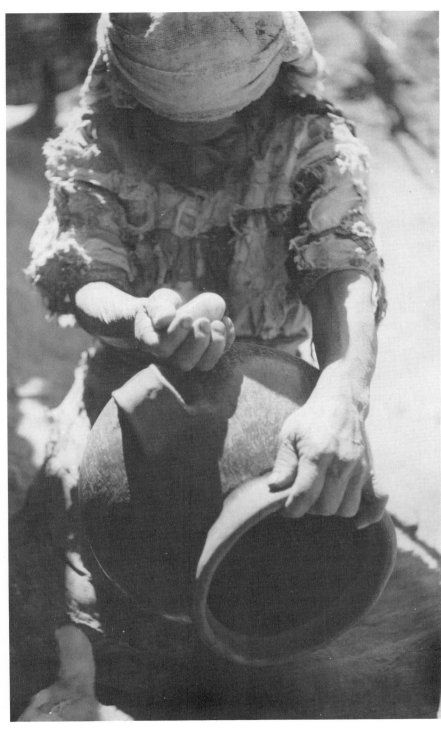

Plate 101

pockets" at the market (see chap. 9).

After the rituals are completed, on the eve of a market day, the dark, low-lying hills surrounding San Pedro Jocopilas come to life with many tiny spots of leaping orange red flames. Many more firings will already have taken place during the afternoon; some will follow in the darkness of the early morning. By seven o'clock the next morning, another work cycle will have been completed; vendors and merchants carrying hundreds of brightly colored, scarcely cool pots will travel along well-used trails on their way to the markets in Chichicastenango and Santa Cruz del Quiché. It is significant to note that, because of the timing of pottery manufacture, firing, and marketing, as well as the religious beliefs that reinforce the entire pottery-making and marketing system, potters do not participate in the formal Catholic religion of the town. Potters, preparing for firing the next day, cannot leave their work for Sunday mass.

Most pottery is marketed by two methods. With the first, the potters themselves or members of their families take their wares directly to market and become vendors for the day. The two regional markets of Santa Cruz del Quiché and Chichicastenango absorb most of this activity. By the other method, merchants come directly to potters with whom they have long-standing business relationships and buy pottery for resale in remote regions. Formerly, all the pottery marketed in this way was carried on the merchants' backs, and probably this method still accounts for a great deal of the pottery sold, but motorized transport has gained in importance along the few roads of the region.

The greatest flow of San Pedro Jocopilas pottery is southward, to and through Santa Cruz del Quiché. From there some goes eastward to markets in *pueblos* and *aldeas* along the road to Joyabaj. More continues on south to Chichicastenango, Sololá, and even Panajachel. Very little moves from there to the west, for it

encounters competition from the glazed ware made in San Cristóbal Totonicapán and the excellent pottery of Santa María Chiquimula. About 20 percent moves northward, through Sacapulas up into the mountains between Nebaj and Uspantán, as well as northwestward as far as Aguacatán. In the mountainous north, it is of interest to note that this pottery meets and surmounts a light competition offered by pottery made in the vicinity of Chiul, an *aldea* of Santa Rosa Chucuyub. This pottery is similar in form to that of San Pedro Jocopilas, but it is very inferior and, fired without a prepared platform, heavily fireclouded.

Santa María Chiquimula

This picturesque production center, in the department of Totonicapán, is relatively isolated at an altitude of 8,200 feet. In 1950 the *municipio* had ten thousand inhabitants, of which only fifteen were classified as Ladinos, the rest as Quiché-speaking Indians. The *pueblo* of Santa María Chiquimula proper had a population of 1,406 and, as head of the *municipio*, ten *aldeas* and seven *caseríos* were under its jurisdiction.

From a distance the town has the appearance of a southern Spanish *pueblo*, particularly because of the red tile roofs and the whitewashed house walls. The massive colonial church and the town hall (*alcaldía*) are located around the plaza, site of the weekly market. These public buildings remind visitors of a strong religious acculturation and of the present political integration into the national political structure.

Characteristic of the people now, however, are a high degree of monolingualism and a resistance to further cultural modification. As in many other pottery centers, the social structure is characterized by a religious-political organization in which *cofradías*, eight in number here, and a group of political officers of the Indian municipality together maintain the community culture and translate national policies.

As in many other centers, the pottery identified as having been produced in Santa María Chiquimula is actually a product of three *aldeas* that surround, and are politically and culturally dependent on, the *pueblo*. The *aldeas* themselves are dispersed, as opposed to nucleated, settlements, and the potters appear to be scattered throughout. To our knowledge, this is one of only three centers in Guatemala with a non-wheel technology where both women and men are the potters. Although one lone elderly woman was observed actively engaged in pottery production, the majority of the potters are young men, often with families. The head of the household is generally the actual potter, and the entire family takes part in pottery production. Mothers help fire their sons' pots, boys and girls may add handles and burnish their fathers' vessels, and wives assist in all these ways if not more. Thus, while pottery making, along with *milpa*, is man's work, it involves his whole family to at least some extent and may be thought of as a family specialization.

The inventory of forms produced in this area consists of *tamaleros*, *ollas*, *pichachas*, *tapaderas*, *comales*, *jarros*, and *tinajas*, as well as roofing tiles (fig. 27). The local *tamaleros*, neckless jars, are tall and have two vertically placed strap handles; most seem to be made of reddish orange clay. Also of the same clay are *ollas* and *pichachas*; both vessels have two vertical strap handles. Santa María Chiquimula *tapaderas* are made, for the most part, of the red orange clay and have a strap handle on top. *Comales*, also red orange, are made on a round board, are well finished, and have one horizontally placed handle on the rim. The local *jarros* are generally white; they have globular bodies with medium-sized necks shaped into spouts and long strap handles reaching from the neck just below the rim to the shoulder. Most *tinajas* are also white, although a very few red orange ones were seen. Two distinct types are produced. One is broad as well as tall, with a proportionately short neck and two vertical strap handles on the sides. This the men use, carrying it by means of a tumpline passed behind the vessel, under a low protruding clay tab, and through the two handles (pl. 102). The other *tinaja* is much smaller, but by no means a miniature or a toy. It is more squat, with a medium to high neck and two vertical strap handles placed below the shoulders. The women carry these *tinajas* on their heads, and the greatest effort in decoration is lavished upon these vessels.

The women's *tinajas* are generally decorated with designs painted on with a red slip. Occasionally one will find a white *tamalero* or *olla* decorated in red, but these are rare. Decoration is almost always floral—either naturalistic or repeated stylized motifs are used. The decoration is confined to the upper half of the vessel, particularly the shoulder area and, to a lesser degree, around the handles and on the neck. Although the designs are very different, this pottery may represent continuity with the red-on-white pottery from the Late Postclassic period.

The potters around Santa María Chiquimula use three types of clay for vessel construction. One normally fires to a clean white color, another to a smooth reddish orange, the last to a yellowish color. The white clay is obtained without charge at a deposit some five and a half miles from the *aldea* of El Rancho, where we observed the pottery-making process. The red paint clay, bought in the town of Momostenango, cost 20¢ per pound in 1974.

After gathering white clay and taking it home, the potter first dries and grinds it, then runs it through a sifter. This sifter, of local manufacture, consists of a piece of rawhide punched with holes in a regular pattern and strapped to a small circular wooden frame. Then, without aging it, the potter stores the clay in a

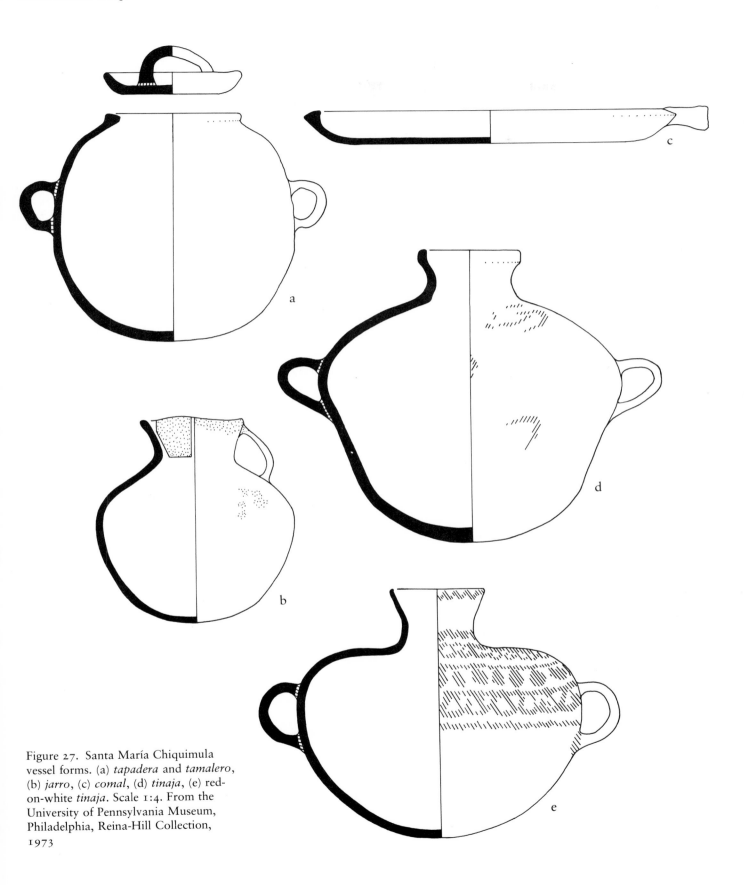

Figure 27. Santa María Chiquimula vessel forms. (a) *tapadera* and *tamalero*, (b) *jarro*, (c) *comal*, (d) *tinaja*, (e) red-on-white *tinaja*. Scale 1:4. From the University of Pennsylvania Museum, Philadelphia, Reina-Hill Collection, 1973

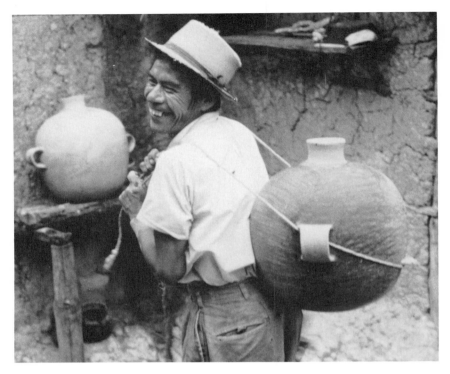

Plate 102

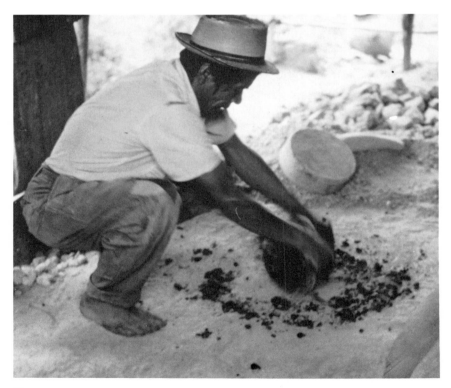

Plate 103

shed. He keeps only a small amount of clay stored in water, and when ready to work he will add dry clay, without any temper.

Working on the ground in the courtyard of his house, the potter begins by wedging wet and dry clay together. He squats down and turns the clay over and over with great force, continuing to add dry clay until the mass satisfies him (pl. 103). At this time he brings out a workboard, places the clay upon it, and continues wedging until the plasticity suits him. After this, he forms a heavy cylinder from the clay, stands up, and bending over lifts it and throws it down on end, then strikes it heavily with the palms of his hands to flatten it (pl. 104).

Using the orbiting technique, the potter begins actual construction as he inserts his right hand (this potter was left-handed), fingers extended, into the low, squat cylinder and pushes the clay from the middle toward the sides, forming a large heavy ring or collar (pl. 105—for better photography, the potter placed his workboard on a *pichacha*). Still bending at the waist, he begins to move around the work, drawing the walls up between his hands (pl. 106). It is important to note that he is building the vessel in an upside-down position. That is, the rim of the vessel is resting on the board, and he is building upward to what will be the rounded bottom. The potter pulls up the clay by drawing the edge of the little finger and the palm of his left hand vertically along the exterior of the work, while the tips of his right-hand fingers parallel this motion on the interior wall (pl. 107). The pressure exerted by his little finger and the edge of his palm leaves deep wide grooves on the exterior and forms a small collar of clay on the top. The potter draws this collar higher, in stages, as he continues to raise the walls.

The potter next shifts his attention to the interior of the vessel, where his left hand does the work of pulling up the clay while his right hand, in support, parallels the verti-

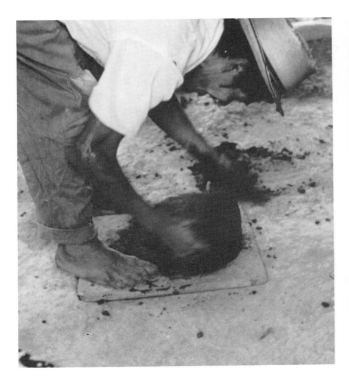

Plate 104

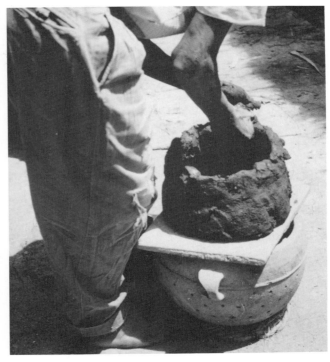

Plate 106

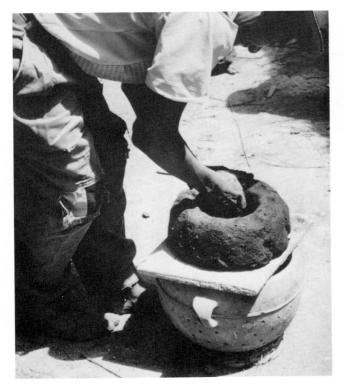

Plate 105

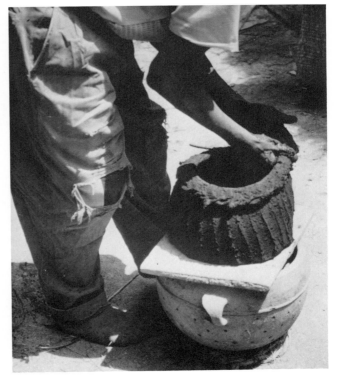

Plate 107

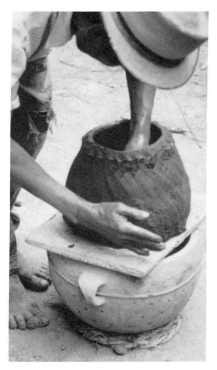

Plate 108

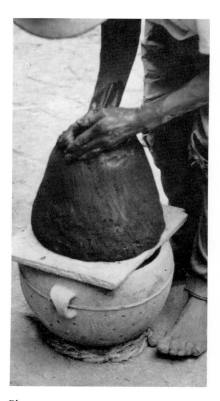

Plate 109

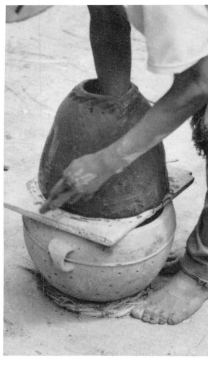

Plate 110

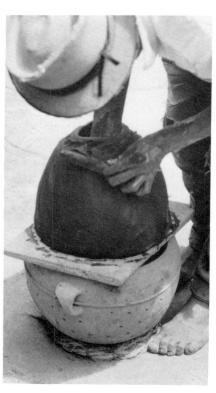

Plate 111

cal strokes on the exterior (pl. 108). This motion of the right hand also smooths the exterior surface to a moderate degree. The collar at the top of the work is now much reduced in size, and the potter is ready to begin closing over the bottom.

In this stage of production, the potter draws the palms of his hands up along the exterior toward each other at the top. He repeats this motion around the vessel, which takes on the appearance of a smooth, truncated cone (pl. 109). With the opening at the top further reduced, the collar of clay is almost indiscernible. Once again the potter's attention shifts to drawing up clay from low on the interior of the work, applying pressure to the clay between his hands as he raises them, and further smoothing the walls as he goes. His right hand is still on the exterior, the left in the interior.

Next, taking a wet corncob in his left hand, the potter draws it in short strokes around the lower part of the work (pl. 110). This motion shapes the rim to its maximum diameter. He then uses the corncob to draw the clay straight up from the lower part toward the opening, which is now so narrow that there is just enough room inside for the potter's right hand to parallel the movement of the corncob in support (pl. 111). The vessel begins to lose its cone shape and becomes a somewhat pointed dome. The potter continues to use the wet corncob and to bend over at the waist as he works, but his strokes have become shorter and are directed latitudinally around the ever-shrinking orifice. Each short smooth stroke brings a bit more clay closer around and over the opening, and the potter slowly removes his right hand until only the four fingers are left inside. He stops a moment to give the bottom of the vessel its final shape from inside, as this will be his last opportunity before closing over the bottom. Resuming work with the corncob, the potter draws up clay around the opening into a small collar that he will use to close over the bottom of the vessel. He con-

tinues using the corncob with short strokes and removes his fingers, one at a time, from the opening as it shrinks. This is a crucial moment, for the walls need continued support around the opening, and the potter must close the bottom over while the clay is soft. Only the last joint of his right forefinger remains inserted in the opening (pl. 112), when suddenly the potter withdraws his finger and closes the opening in what is almost an act of magic. With the bottom closed, the potter now soaks the corncob in water and with short strokes smooths over the area just completed, so that the marks left are similar to those on the rest of the vessel (pl. 113). Finally, he cleans and moistens his hands and smooths over the entire exterior with the palm and fingers of his left hand while walking, still stooped over, around the vessel (pl. 114). Then, leaving it on the workboard, he sets the vessel aside to dry.

After the vessels are dry enough to support their own weight, the potter—who has been working on several vessels in various stages of construction—places those that are to become *tinajas* in collars of rushes and cloth to support their rounded bases. He fashions the shoulders by adding coils to the rim and working inward, then allows each vessel to dry further before adding handles and the neck. The handles are rolled lengths of clay, flattened in the potter's hands and attached at one end to the shoulder of the vessel. The potter draws each handle out, smooths it with a moist corncob, and attaches the lower end to the side of the vessel. He forms the neck from a simple coil of clay that he pinches on at the opening left when he completed the shoulders (pl. 115); he raises this coil in a manner similar to that employed in making the vessel walls—pulling up the clay between the fingers of his two hands, one on the interior, the other on the exterior (pls. 116, 117).

When the vessels have reached the leather-hard stage of drying, the potter burnishes them by rubbing obsid-

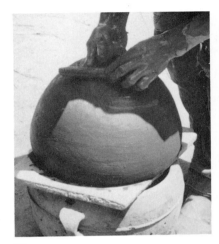

Plate 112

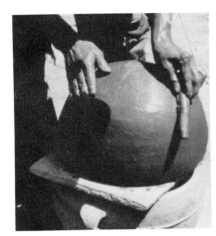

Plate 113

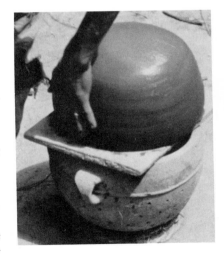

Plate 114

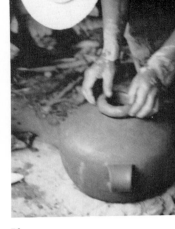

Plate 115

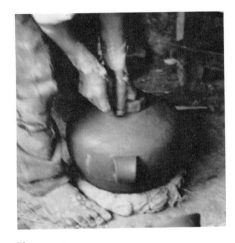

Plate 116

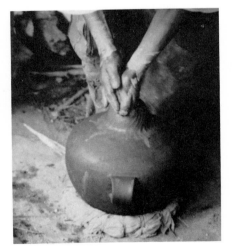

Plate 117

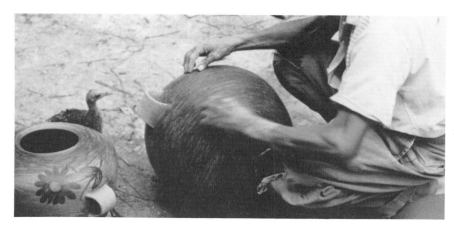

Plate 118

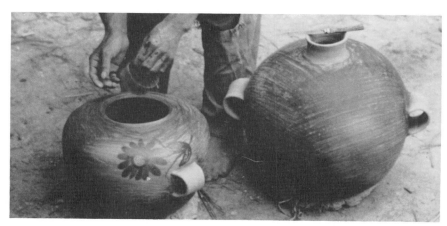

Plate 119

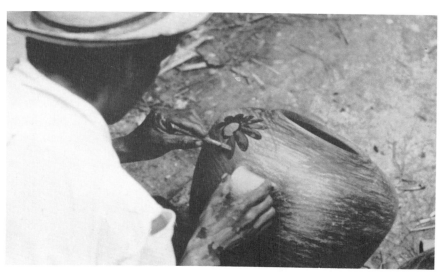

Plate 120

ian nodules—apparently archaeological specimens—back and forth across their exteriors (pl. 118). He smooths and evens out the interiors by scraping them with a section of tin can and a knife (pl. 119). *Tinajas* to be decorated are now ready for painting.

The red clay used for painting decorations on white vessels is bought dry. The potter breaks it up and leaves it in water; before painting, he strains the mix through an old blanket. With the resulting liquid he paints designs on the *tinajas*, using either a twig or a feather (pl. 120).

Although we observed no complete firing sequence, enough information could be gleaned from the several firings seen at different stages to describe the process in general terms. The potter builds a fire of dry pine needles, to draw moisture from the earth. In the ashes she places necks and handles broken from discarded vessels to support the vessels to be fired. This raises them off the ground, allowing for better air circulation and more complete oxidation. The potter then stacks the vessels, mouth up, to form one layer, upon which a second layer of pots, placed on their side, fills in the spaces between those below. Covering over the entire firing lot with a thick layer of pine needles (pl. 121), she lights the fire, adding more pine needles when necessary. Great columns of white smoke, easy to spot along the valley, billow up from such fires. When the potter feels the pots are ready, she pokes a hole in the ashes with a long branch to inspect the vessels. If they are ready, she brushes away the ashes and allows the pots to cool until they may be handled and moved indoors for storage.

The Santa María Chiquimula potters produce between one and three dozen regular undecorated *tinajas* per person or family each week, usually approaching the lower figure in the rainy season, the higher in the dry season. At the *aldea* most extensively studied, an estimated seventy-five to one hundred people

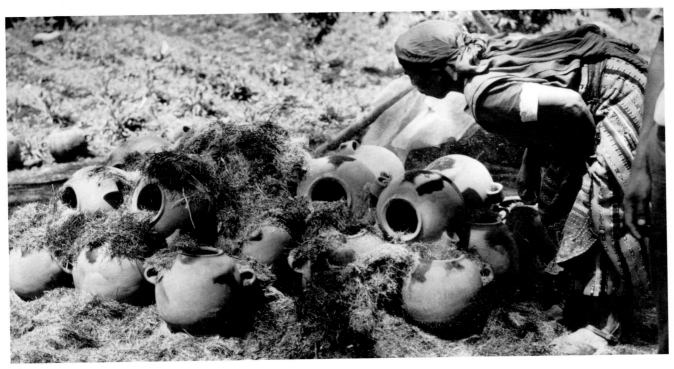

Plate 121

were engaged in pottery making. Only four or five, however, were commonly acknowledged to be interested in decorating. Potters keep the best and most attractive vessels for their own household, selling the common undecorated vessels. This is similar to the practice of San Luis Jilotepeque potters but contrary to the practice in Chinautla.

Although people in the Santa María Chiquimula area use a sizable amount of the pottery produced, vendors sell only a small quantity, primarily *ollas, tamaleros, tapaderas,* and *pichachas,* in the local *pueblo* market. Even the regional market at San Francisco El Alto accounts for a comparatively small amount of the pottery sold. In Santa María, most of the people selling pottery appear to be merchants from the immediate area who buy pottery from the producer and transport it to market themselves. Most of this pottery is then shipped by truck to the pottery-poor Pacific coast agricultural region. This is particularly

true in the Retalhuleu area, where large quantities of Santa María Chiquimula pottery are always available in the markets.

San Cristóbal Totonicapán

San Cristóbal Totonicapán is located in the fertile valley of the Samalá River, about eight and a half miles west of the department capital of Totonicapán. In addition to pottery, San Cristóbal Totonicapán is well known for its large Sunday open market. According to Fuentes y Guzmán, the town was founded in the sixteenth century and was originally called San Cristóbal Puxilá, preserving part of its pre-Columbian name. Although the area was strongly influenced by the Spanish, the *municipio* remains predominantly Maya in character. Its religious-political organization supports the closed corporate structure of the community. Most people in the *municipio* speak Quiché; in

1950, 10,212 of its 11,099 inhabitants were classified as Indian, only 887 as Ladino. San Cristóbal proper has a population of 2,979 Indians and 841 Ladinos. Around the *pueblo* are six *aldeas* and seven *caseríos,* scattered throughout the valley and nearby hills.[13]

The *municipio* is one of the few where both men and women are potters. Most live in the *aldeas* of Xecanchavox, Xesuc, and Pacanac, where clay and fuel sources are abundant. Of the variety of forms produced, men specialize in making some of the largest vessels in Guatemala—massive *tinajeras* and *apastes* (fig. 28). Even considering the size of these vessels, an unusual amount of clay goes into their making, up to 25 percent more than is average for similar vessels in other areas. The walls are a full half inch thick, with lip and handles correspondingly heavy. The largest *tinajera*—a water jar nearly thirty inches high and twenty inches in diameter—requires sixty pounds of

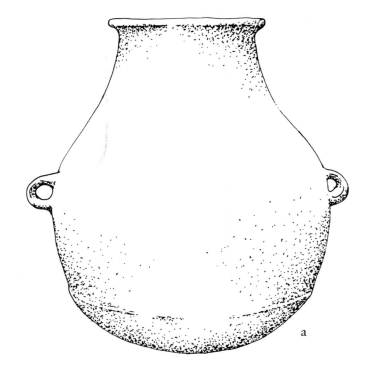

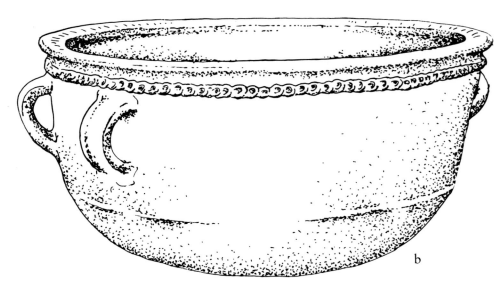

Figure 28. San Cristóbal Totonicapán vessel forms. (a) *tinajera*, (b) large *apaste*. Scale 1:4 (approx.). Drawn from photographs taken by Margaret Arrott

wet clay. Even after firing, it weighs up to forty-two pounds. Few men were carrying on this tradition even during the Arrotts' visit; women made most of the pottery.

The smaller forms made in San Cristóbal Totonicapán include *apastes, ollas, batidores, tamaleros, sartenes,* and *pichachas,* often with only subtle differences between them, as well as *jarros* and *comales* (figs. 29, 30). The cooking vessels have lids with a loop handle. The local *ollas* and *pichachas* are globular in shape, with low raised necks, direct rims, and two opposite strap handles placed high on the vessel's shoulders. An *olla para tamales* is produced with a more squat body with pronounced shoulders. This vessel has a very low raised rim with two horizontal strap handles placed high on the body opposite each other.

The locally made *tamaleros* vary from low, wide, and squat to tall, almost bell-shaped vessels. Most of the larger vessels in this class have four strap handles attached vertically midway up the body; they may be spaced evenly or grouped in pairs. The smaller vessels may have only two handles. The only constants that distinguish this group are the shoulders, which curve far over to leave a small mouth, and an extremely low rim or ridge about this opening.

Small *apastes* and *sartenes* are similar; both are wide, shallow, and platterlike, with two strap handles attached vertically just below the rim. *Apastes* here have straight walls which flare out slightly from the edge of the concave mold; *sartenes'* walls curve out from the same point and then reverse to form the rim.

The local *jarros* have a great variety of spout shapes—even the same potter makes several kinds. Of the four general types distinguished, one *jarro* had a long spout that ran almost at a right angle upward from the rim. Another type of long spout had a much flatter angle. On a narrow-spouted vessel, the potter need only pinch the neck between

thumb and forefinger to form a small "V." A wide-spouted version requires careful modeling to effect a square design.

Most *comales* here have a single loop handle placed horizontally at the rim, from which the fragile vessel can hang on a wall, away from careless children and stray domestic animals.

Although San Cristóbal Totonicapán vessel shapes have been discussed, sizes have been only suggested. The fact is that the variation in size is so great within vessels of the same form that an attempt to enumerate them would serve no end. Vessel size here depends on the size of the concave basal mold, and the size of the mold in turn differs from potter to potter.

All vessels are made from a clay that fires to a reddish brown. Almost all vessels are coated with a glaze that fires to a greenish or yellowish tint, depending on the amount and purity of the lead used and the evenness of application. Lead for the glaze is purchased locally by the potters; it is imported from the Cuchumatanes by middlemen. However, a range of unglazed *comales* and *tamaleros* is produced in San Cristóbal Totonicapán and, apparently, by a few Indian women in the city of Totonicapán itself. On unglazed *comales*, a wash of lime mixed with water prevents tortillas from sticking. Characteristically, vessels are glazed thoroughly on the interior but only roughly on the upper portion of the exterior. Additional surface treatment consists of incised or press-molded decorations. Such decorations are usually limited to the area below the rims and on the shoulders.

The pottery is formed on a fired-clay concave basal mold. However, it is the way the potters use this mold that makes San Cristóbal work distinctive. The bottom of the mold is fitted with a protruding pivot so potters can rotate it upon a wooden or stone platform. Thus, they form their pottery on a spinning mold that closely approaches the potter's

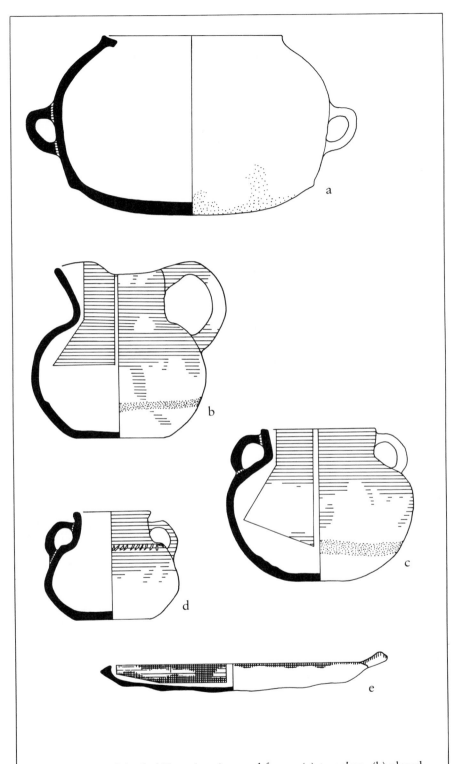

Figure 29. San Cristóbal Totonicapán vessel forms. (a) *tamalero*, (b) glazed *jarro*, (c) glazed *olla*, (d) glazed *olla*, (e) glazed *comal*. Scale 1:4. From the University of Pennsylvania Museum, Philadelphia, Reina-Hill Collection, 1973

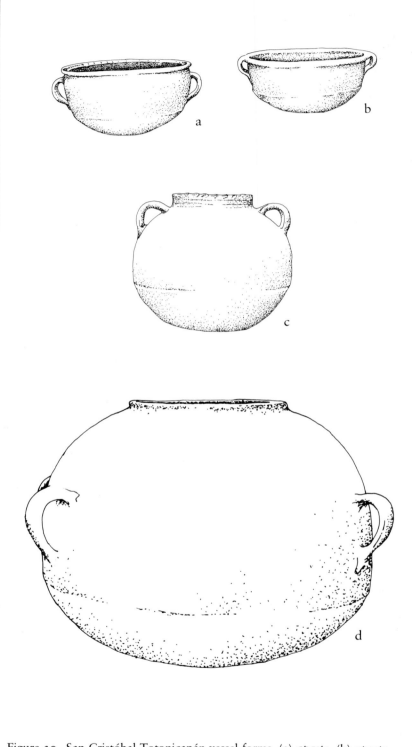

Figure 30. San Cristóbal Totonicapán vessel forms. (a) *apaste*, (b) *apaste*, (c) *olla*, (d) *tamalero*. Scale 1:4 (approx.). Drawn from photographs taken by Margaret Arrott

wheel, except that with this they have neither the same speed nor the control, since the rotating axis is free to move about on the platform. However, the dynamics of forming and the resulting striations on the finished product closely resemble those on wheel-made pottery. This does not hold for large vessels, which are rotated slowly.

Pottery here is usually produced inside the house. The clay must be purchased locally at 10¢ to 15¢ per hundred-pound load. It is ground on a stone metate different from that used to grind the lead glaze. Once pulverized to a flourlike consistency, the clay is mixed with water in the center of the dirt floor. Ironically, when this operation was recently observed, the water was poured from a plastic *tinaja* of a type that has become popular in some areas of Guatemala.

To construct a *tinajera* or one of the large *apastes*, the male potter begins by placing eight to ten pounds of prepared clay upon his wedging board which he has coated with sand to prevent the clay from sticking (pl. 122). With a large mano, or stone roller (pl. 123), he flattens the clay into a disc five-eighths to three-quarters of an inch thick, with a diameter slightly larger than that of the mold (pl. 124). A board is then slipped under one edge of the wet disc (pl. 125), the mold is slipped under the board (pl. 126), and the potter drags the board and the clay to a point where the board may be withdrawn and the clay disc allowed to settle downward into the open concavity of the mold (pl. 127). With the palm of his hand, the tips of his fingers, and a section of firm yet flexible leather, the potter adjusts the clay to fit snugly, rotating the mold as needed and turning up the edges of the disc to give initial form to the vessel walls (pl. 128).

The potter builds the walls upward by adding successive sections of clay coils. These he rolls out to a comfortable length between his hands (pl. 129) and applies, first with his right hand, by pressing one

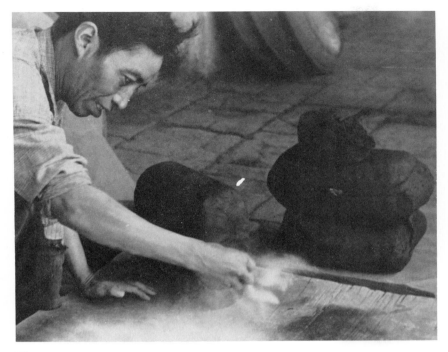

Plate 122

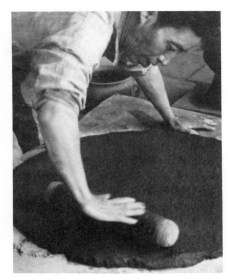

Plate 124

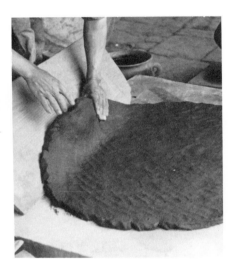

Plate 125

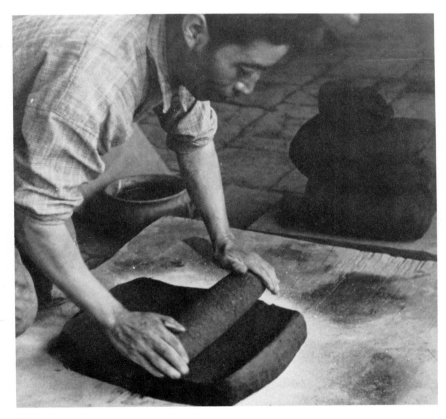

Plate 123

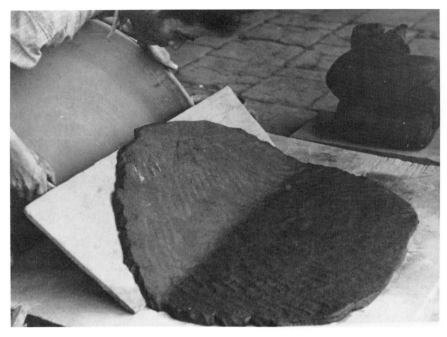

Plate 126

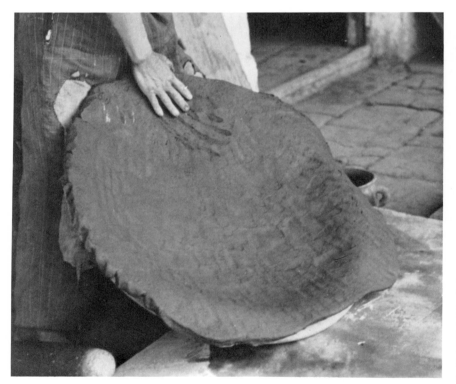

Plate 127

end into place and drawing the coil out along the rim, pinching it every inch or so with his thumb and forefinger (pl. 130). His left hand, cupped along the exterior, guides and supports as he works. Because these *tinajeras* and *apastes* are so large, one coil long enough to circle the perimeter completely would be unduly cumbersome; for this reason, the potter rolls out short lengths reaching only from one-quarter to one-sixth of the way around.

At a point a few inches above the rim of the mold, the potter stops working on the walls in order to complete the interior of the base. With his right forefinger, he pushes shallow depressions into the base—these help him determine the final thickness (pl. 131). Then he scrapes and moves the clay with a strip of leather held in his right hand, while turning the mold with his left hand (pl. 132).

Returning to the walls, the potter adds more coils, alternately pressing them carefully into place and working them up with a wet corncob rolled and drawn over the exterior with his right hand, while his left, now inside the vessel, parallels and supports the movement of the corncob (pl. 133). The potter keeps track of the growing walls with a marked length of wood (pl. 134). At the highest mark, he transfers the vessel, still in its mold, from the platform to a heavy collar of straw and allows it to dry for an hour (pl. 135).

The walls have now reached a height of eighteen to twenty inches, too high to handle comfortably sitting down. When he starts work again, the potter remains standing and moves around the vessel, adding coils as he goes, up to the rim, where extra care is needed (pls. 136–138). Here he applies a single coil reaching the entire distance around the top. Pinching it into place as he did the others, he places his right forefinger on the upper surface of the coil and runs it back and forth around the rim to give the typical everted profile (pl. 139). He keeps his left hand backed against the vessel neck, with

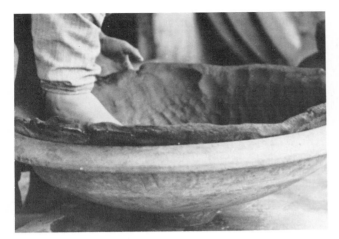

Plate 128

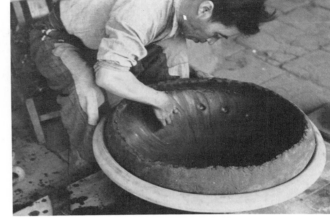

Plate 131

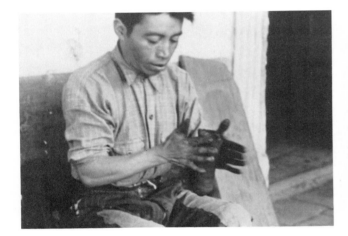

Plate 129

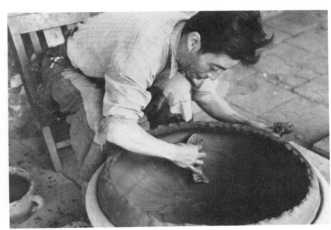

Plate 132

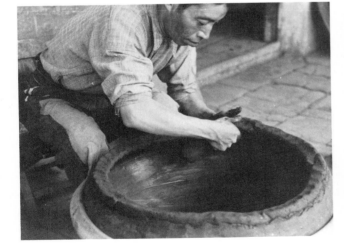

Plate 130

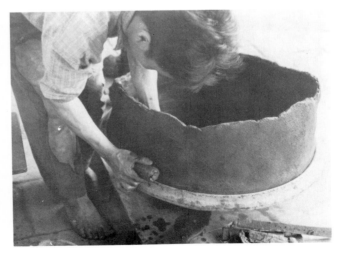

Plate 133

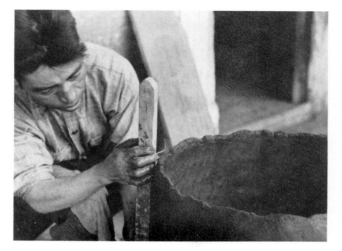

Plate 134

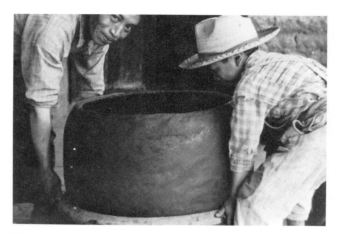

Plate 135

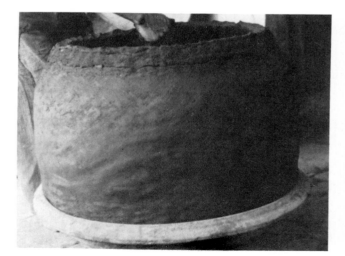

Plate 136

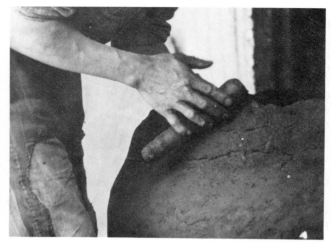

Plate 137

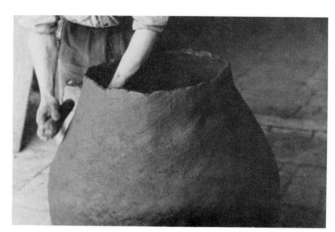

Plate 138

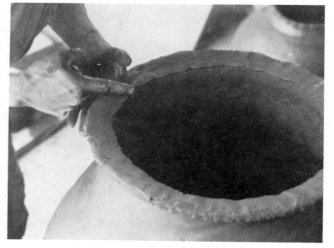

Plate 139

his raised forefinger acting as a guide and support for his right hand. Draping a piece of wet leather over the rim, he draws it around to give the final shape and smoothing. Characteristically, *tinajeras* receive decorations of shallow finger punctations just below the rim and, sometimes, press-molded designs (pl. 140).

Handles are short coils shaped between the fingers into a rough strap. The potter attaches the upper end, drawing and pushing the clay into place to strengthen the bond (pl. 141). He thins and lengthens the strap between the fore- and middle fingers of his right hand, bends it over carefully, and attaches it at the lower point (pl. 142). After working pieces of clay into the handle joints to strengthen them (pl. 143), he gives the handles a final shaping and smoothing with his fingers, and the vessel stands completed (pl. 144).

The female potters of San Cristóbal use the same general procedure for the smaller vessels they make. Except when attaching handles or molding spouts, however, they carry out the entire operation while spinning the mold upon the work platform. The speed of rotation is faster with small vessels, so the result more closely resembles work with the wheel.

Unlike potters in many other centers, potters here do not wait until their vessels are complete to scrape away excess clay from the interior. As work progresses, they must draw the clay about and even it, inside and out, to attain a proper uniform thickness; following that they must smooth all surfaces. This calls for great care—mechanical aids for achieving the desired end are at a minimum. The potters of this center are expert in meeting this problem with a corncob, wooden roller, shaped piece of thick, firm, but flexible leather, skilled fingers, and the palm of the hand.

Upon completing the vessel, the potter removes it from the mold and carries it into the sun to dry. After a first firing, it receives a coating of

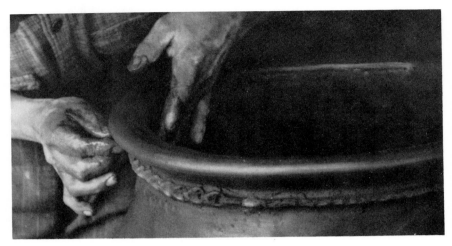

Plate 140

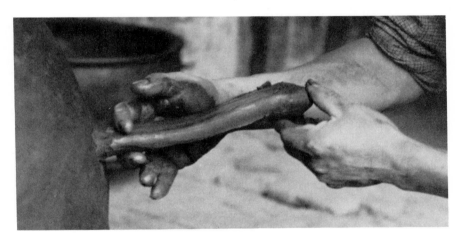

Plate 141

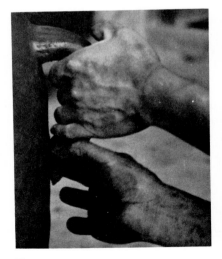

Plate 142

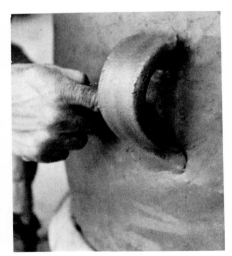

Plate 143

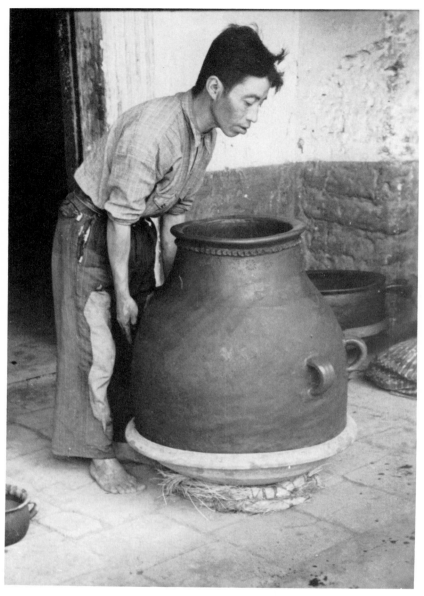

Plate 144

glaze. The glaze is prepared from locally purchased lead. It is melted, sulphur (*tizate*) is added, and the mixture is allowed to cool. It is ground again with more sulphur, water is added, and the resulting glaze is poured into the vessel and swirled about to coat the interior. On the upper part of the exterior the glaze is carelessly applied with a palm leaf or a cornhusk, leaving the lower part unglazed. All vessels from this center retain the distinct impression of the concave basal mold.

The traditional open firing method is still used for both preliminary and final firings. Broken vessels provide a platform for kindling, the vessels are stacked in a rough pyramid, and more wood and a thick layer of pine needles are placed over the pile. Once fired, the glaze takes on a variable yellowish green cast. Because of careless application of glaze and low firing temperature, the surface often fails to fuse completely, and vessels remain porous. Our overall impression is that the technique of glazing remains alien to these potters. In fact, glaze appears to be a fairly recent addition to their technology, learned perhaps only a few generations ago from the European-derived pottery factories at Totonicapán. Though they show little interest or skill, these potters continue to use glaze, for their vessels command a premium over pottery from other centers.

San Cristóbal pottery achieves the greatest distribution of any hand-modeled ware in the country, with the possible exception of *tinajas* from Chinautla. Although informants can recall men from San Cristóbal Totonicapán carrying pottery to Guatemala City in *cacastes* during the 1930s and 1940s, this pattern has changed. Today merchants from both inside and outside the community handle most of the pottery; people who have capital to either own a vehicle or rent space on one can thus transport pottery in bulk to regional markets around the western part of the country and to

markets in Guatemala City. These merchants generally buy, not from the potters themselves, but from middlemen in San Cristóbal who build up large stockpiles of vessels purchased from the potters. Merchants may have one or more stalls in one or several regional markets and may also sell pottery to middlemen in these markets. This pattern is now dominant, particularly in trade to the Pacific coast, yet one may still see numerous small-volume merchants packing loads of pottery on *cacastes* into the more remote areas of both the highlands and the coast.

Figure 31. Comitancillo *olla*. Scale 1:4. From the University of Pennsylvania Museum, Philadelphia, Reina-Hill Collection, 1973

Comitancillo

The municipality of Comitancillo is located in the department of San Marcos, about twenty-two miles by road from the department capital. In addition to the town proper, there are eight *aldeas* and eighteen *caseríos* within the *municipio*. In 1950, of the 10,944 inhabitants, only 131 were classed as Ladinos, and all of these were town residents, bringing the population of the *pueblo* to 336. The principal language is Mam, and Spanish as a second language is almost nonexistent.[14] Here, too, an archaeological site, unexplored but probably dating to the Postclassic period, suggests a continuity of native settlement.

The Comitancillo potters—all women—like the majority of the population of this *municipio*, live in the scattered *aldeas* and *caseríos* rather than in the town proper. The *aldea* of Sabalique and its *caserío* of Ixmoco are especially noted for their pottery production, as is the *aldea* of Chicajlaj. The *aldeas* specialize in particular forms.

Shapes are limited to the *olla* (fig. 31), *tinaja*, *comal*, *jarro*, and *pichacha*. Comitancillo *ollas* have a globular shape, with a low-raised neck; two strap handles are placed opposite each other on the waist of the vessel. *Pichachas* are similar, except for their wider mouths and the

holes bored in their walls. The local *tinajas* are larger, with a more pronounced egg shape, much more restricted necks and mouths, and two strap handles. If the potter wants a watertight *tinaja*, she applies pine sap to the exterior just after firing, while the vessel is still hot enough to melt the sap as it is rubbed on. Contrary to *comales* elsewhere, Comitancillo *comales* receive no treatment of talc or lime slip.

Vessels here are crudely executed in general, for the potters strive to produce as great a number as possible. All are unslipped and unburnished; often the marks of the corncob used in construction are still visible. The clay has a high sand content so is friable, and this, in combination with the thin vessel walls, gives an impression of extreme fragility. Vessels fire to a color ranging from cream to light orange. Innovations are neither expected nor likely to be forthcoming, as production is geared to a market that demands utilitarian vessels and is unaffected by the more recent influences of urban centers and tourism.

Most potters own their clay sources and use a mixture of at least two kinds of clay for their work. After mining the clays and taking them home, the potter allows them to dry before grinding and mixing them, which she does in an area of her courtyard set aside for this pur-

pose and kept scrupulously free of foreign matter that might contaminate them. A stone slab serves as a metate, and a large cobble serves as a mano (pl. 145). The potter shovels the ground clay off the metate by hand into a shallow depression lined with stone slabs (pl. 146). Here she mixes the two clays and adds water, then wedges the clay in this depression until it has a satisfactory consistency.

Moving to another part of the yard, the potter sets a flat, wide stone slab on top of a narrow but thicker slab to form a platform on which to work, using the orbiting technique. She places a low wide cylinder of clay on the slab.

To begin actual construction on either an *olla* or a *tinaja*, the potter slides her right hand into the clay mass and pulls up the clay to the outside to begin forming the walls. She now sidesteps around her work, dragging up clay from the bottom of the vessel with her right hand, and pinching it onto the top of the walls with her left (pl. 147). On the next orbit around, the potter keeps her right-hand fingertips low inside to push the clay against the base of the vessel walls (pl. 148).

To draw the walls higher, the potter shifts her right hand to the vessel exterior, applying pressure with her little finger as she draws the clay up, while the fingers of her left hand fol-

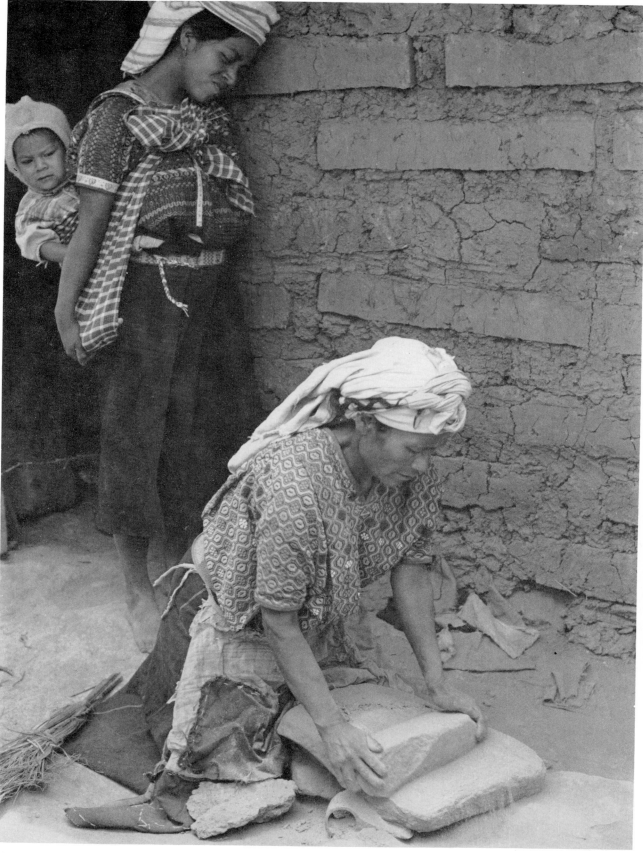

Plate 145

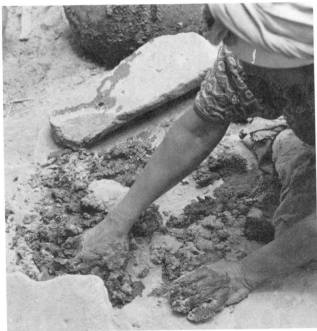

Plate 146

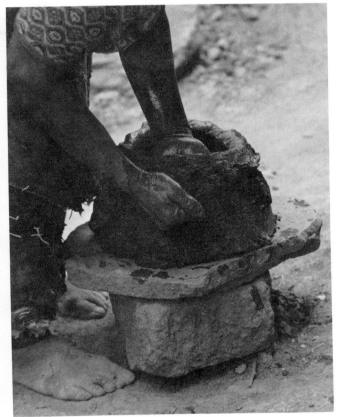

Plate 148

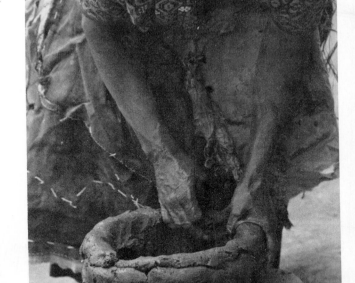

Plate 147

Plate 149

low the movements on the interior for support (pl. 149). After two or three orbits around the vessel in this manner, a collar of clay has grown around the top. The potter smooths this collar by drawing it up with the fingertips of her right hand. The thumb of her left hand, hooked over the rim, guides and supports her right hand (pl. 150). The drawing-up process begins again, raising the walls further and forming another collar (pl. 151).

For the next step, the potter employs a moist corncob as a shaping tool. This she rolls back and forth over the exterior with the palm of her right hand, beginning at the bottom and working up, with her left hand supporting the vessel from the inside (pl. 152). When she reaches the top of the vessel, the potter begins to draw the clay around instead of rolling it. By drawing the clay up from below and pushing carefully with her left hand from inside, she forms the shoulders and gives definition to the opening where the low neck will be built (pl. 153).

Still using the corncob, the potter builds up the neck, drawing clay from the shoulder and pulling it up between the corncob and her left palm, still held within the opening.

At this time she smooths the half-built vessel with a wet piece of cloth pressed and dragged around the exterior, with her left hand mirroring the movements inside the vessel, still for support (pl. 154). If the vessel loses some of its shape during this process, the potter can restore it by using the corncob to draw the clay around again (pl. 155). After a final smoothing with the wet cloth (pl. 156), she sets the vessel aside to dry.

After leaving the vessel in direct sunlight for about an hour, the potter can begin the next step. While waiting, she may begin or finish other vessels or perform some prefir-

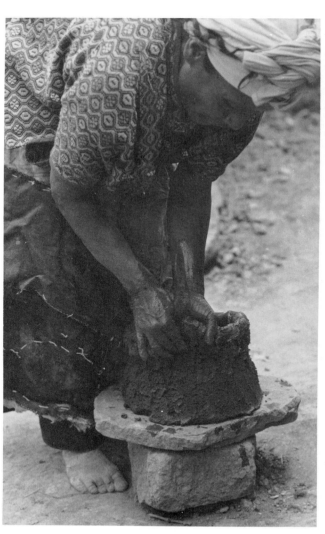

Plate 150

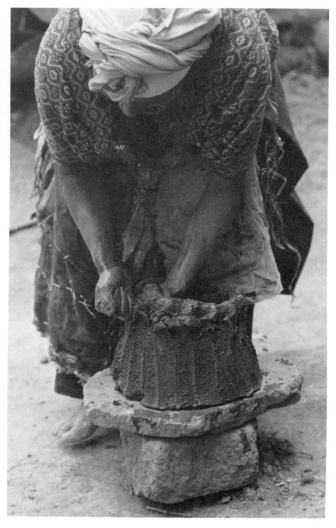

Plate 151

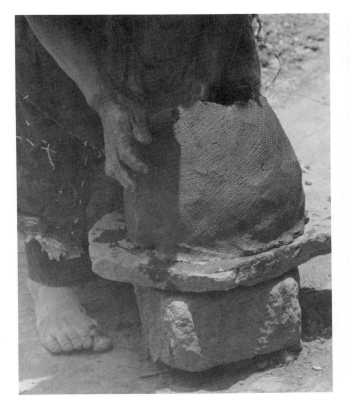

Plate 152

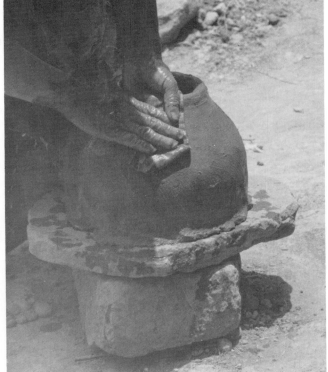

Plate 154

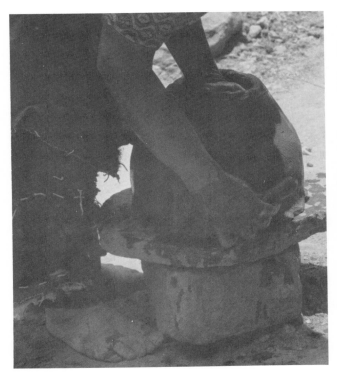

Plate 153

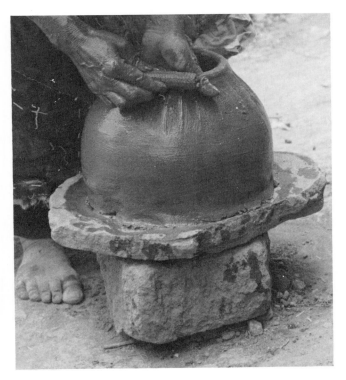

Plate 155

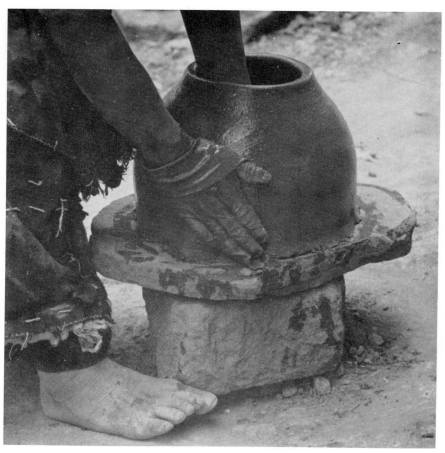

Plate 156

ready, the potter begins preparations for firing, which is usually attempted at dusk. First a circular bed of pine twigs is laid down, upon which she places the pots upside-down in two layers. Branches are added to the pile, and the whole is then covered with pine needles and set afire. The fire usually burns about an hour; when it dies, it is left undisturbed for approximately half an hour to allow the vessels to cool slowly. Potters report losing vessels only infrequently. This gives the impression that, even though their work lacks decoration, these potters are in complete control of the medium and its technology.

Potters spend four days a week actually making vessels. Of the other three, they spend one day gathering materials, one firing vessels, and the other marketing them. Potters produce between twelve and twenty-four vessels each week.

Marketing of Comitancillo pottery may be on both the local and the regional levels, with different mechanisms of transport and disposal. Women bring their work to town on Sundays, when local people from *aldeas* purchase some pottery. Merchants buy most of the production, however, for transport to and sale in other areas. In years past, the majority of merchants packed the vessels out on their backs to as far as the south coast. This commerce is still actively pursued by many of the *aldea* men, but the bulk of the exported pottery, especially that sent to San Pedro Sacatepéquez, Quezaltenango, and the coast, is shipped by truck. Throughout the southwest highlands, this pottery competes with the half-glazed pottery from San Cristóbal Totonicapán. The latter is preferred for cooking fried or stewed foods, while the Comitancillo pottery is used mainly for boiled foods, such as tamales and *ixtamal* (corn gruel).

ing repairs on vessels whose handles need securing.

When she judges the vessel to be ready, the potter turns it over (pl. 157) and immediately removes the excess clay from what was the bottom, then uses a corncob to draw up the clay now at the waist of the vessel (pl. 158). After the vessel has reached the desired height, thickness, and curve, the potter rolls out a thick coil and applies it with her right hand, while her left pinches it into place (pl. 159). If the coil is not long enough, she shapes and adds another piece. She resumes rolling the corncob, until an opening just large enough for the three middle fingers of her left hand remains (pl. 160).

Again the potter uses the corncob to draw up the clay. The walls will have no later thinning, so she must be sure they are just as she wants them. To this end, she spends much time moving clay around until she is finally satisfied. Then, drawing the clay up a bit at a time, she slowly closes the opening until only one finger of her left hand remains inside. One more sweep with the corncob, the finger is removed, and the hole is closed (pl. 161). Then, smoothing the exterior with the wet palms of her hands (pl. 162), the potter leaves the vessel to dry. When the vessel reaches the leather-hard stage, the potter can move it from the slab and add handles. These are simple lengths of flattened clay that she applies to the vessel with some wet clay as an adhesive, then secures with extra clay at the joints.

When about twelve vessels are

Plate 157

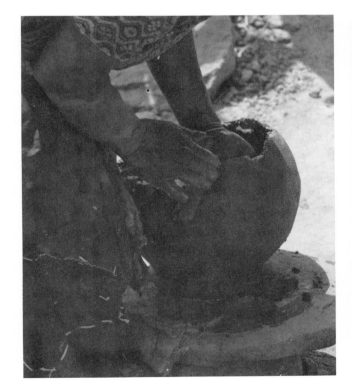

Plate 158

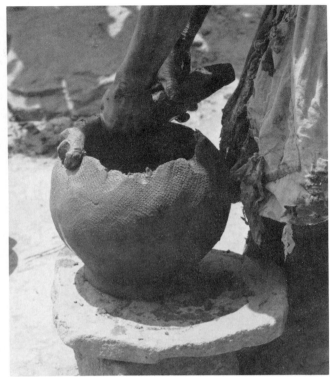

Plate 159

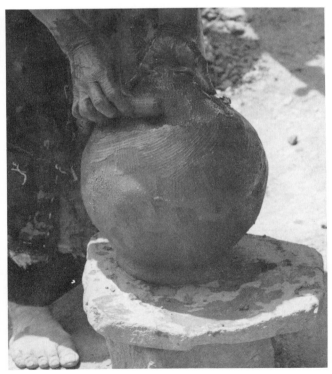

Plate 160

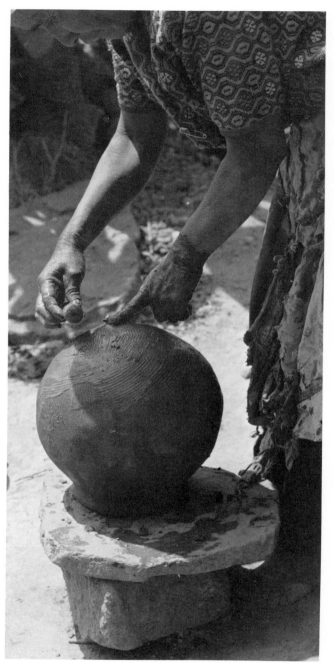

Plate 161

Plate 162

4.

Pottery Production
The Northwestern Region

Three important pottery-producing centers lie within this region (map 4). San Sebastián Huehuetenango and Chiantla are near the department capital and regional market of Huehuetenango. San Miguel Acatán, on the other hand, sits in a remote mountain valley, serving the people of the high country. A small amount of pottery is also produced in Santa Bárbara, but this center was not visited. In the recent past other communities in the high Cuchumatanes Mountains, such as Santa Eulalia, Jacaltenango, and San Sebastián Coatán, also made pottery. Oliver La Farge reported for Santa Eulalia that "as late as 1927 pottery was baked here. In 1932 both these crafts [pottery making and weaving] had been abandoned."[1] The same author reported pottery making in the other two communities, but his descriptions are not complete enough for us to relate them to techniques of the centers still producing.[2] According to La Farge, San Miguel Acatán was already an important pottery-production center, exporting to Santa Eulalia.[3] He attributed the decline in pottery making to the *finca* system, developing around the turn of the century, with its need for Indian laborers, "with the result that in this village [Santa Eulalia, though true generally in the region], having a surplus of cash, the women abandoned the arts of weaving and pottery-making."[4]

In the course of the present survey, no community aside from San Miguel Acatán and some of its *aldeas* produced pottery for the northern region. The towns in the north, particularly Santa Eulalia, Soloma, and San Mateo Ixtatán, are depen-

dent on San Miguel Acatán for pottery, which they use for both domestic and commercial purposes—salt making in San Mateo Ixtatán, liquor distilling everywhere. More southern towns such as Todos Santos bring in their pottery from San Sebastián.

Cortés y Larraz, after visiting several of these remote places, made a classic statement which reveals the reality of travel in those days.[5] He said: "*Es camino tan triste que parece se hace palpable la tristeza*" (The road is so sad as to make sadness palpable). Although today motorized transportation has changed the means of reaching the isolated *pueblos*, the road remains *triste*.

San Sebastián Huehuetenango

The *pueblo* of San Sebastián, located some fifteen and a half miles northwest of Huehuetenango, is mentioned as early as 1690 by Fuentes y Guzmán, who praised the local climate and natural beauty.[6] Nearby are the pre-Columbian ruins of Toj Joj, indicating the long occupation by indigenous Mam-speaking peoples in this valley between the Santa Bárbara Mountains to the south and the Cuchumatanes to the north. The colonial town was destroyed in the nineteenth century by a massive flood of the Selegua River, and little remains now of this former *pueblo*.

Today, the majority of the population lives in settlements scattered along the flanks of the mountains. There are eight *aldeas* and twenty-six *caseríos* within the municipality. The municipal center had only 158

inhabitants in 1950. The population in the *municipio* is mostly Indian— 4,554 Indians and only 245 Ladinos were reported in the 1950 census. The dominant language is Mam.

Pottery production is carried on in *aldeas* and *caseríos*, including Chichicana, Chemiche, Palajuchu, Xil, and Mapa. Women make the pottery, but men make roofing tiles from the same clay and sand, so they help in mining and transporting the raw materials. Active potters are often in their middle years and have daughters who assist with the more menial jobs of grinding clay, applying slip, and burnishing. Potters obtain rights to the privately owned clay source—about $10.00 per year in 1975—for all the clay they can use. Some families own sand deposits of river-washed pumice that occur at the Selegua River. A brilliant red-firing slip comes from clay brought in from outside the community and sold to the potters.

The fairly wide range of shapes produced in San Sebastián Huehuetenango seems to have remained stable since the Arrotts' visit in the late 1940s: *tinajas, ollas, pichachas,* and *jarros* are made (figs. 32, 33). Potters make two kinds of *tinaja,* one for women, the other for men. The women's *tinaja* is a tall, globular vessel with a raised neck of medium height. It has a flared rim and appears wide-mouthed for a *tinaja*. Two opposite strap handles reach from the shoulder to below the vessel waist. Women carry it on their heads, despite the high profile, and steady it with a free hand (pl. 163). The *tinaja para cargar* has a larger, more spherical body with a low neck and a small mouth. Men

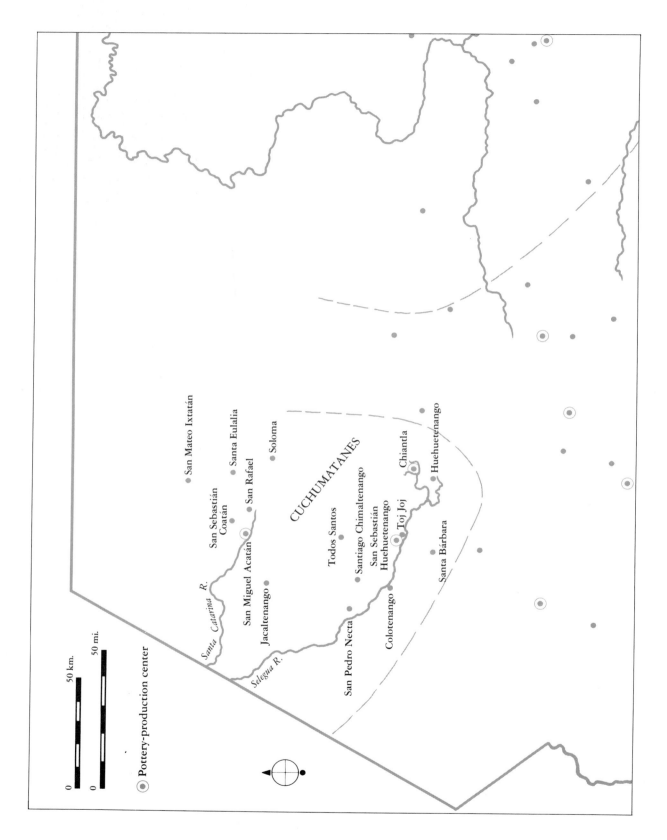

Map 4. Northwestern region

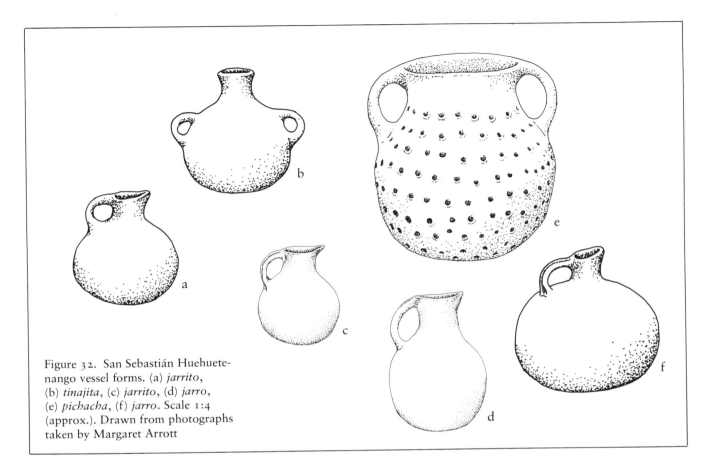

Figure 32. San Sebastián Huehuete-
nango vessel forms. (a) *jarrito*,
(b) *tinajita*, (c) *jarrito*, (d) *jarro*,
(e) *pichacha*, (f) *jarro*. Scale 1:4
(approx.). Drawn from photographs
taken by Margaret Arrott

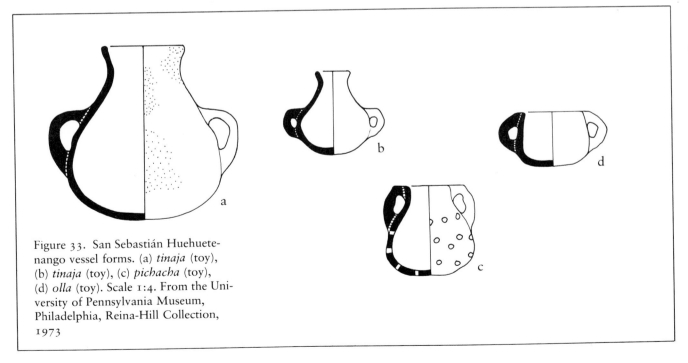

Figure 33. San Sebastián Huehuete-
nango vessel forms. (a) *tinaja* (toy),
(b) *tinaja* (toy), (c) *pichacha* (toy),
(d) *olla* (toy). Scale 1:4. From the Uni-
versity of Pennsylvania Museum,
Philadelphia, Reina-Hill Collection,
1973

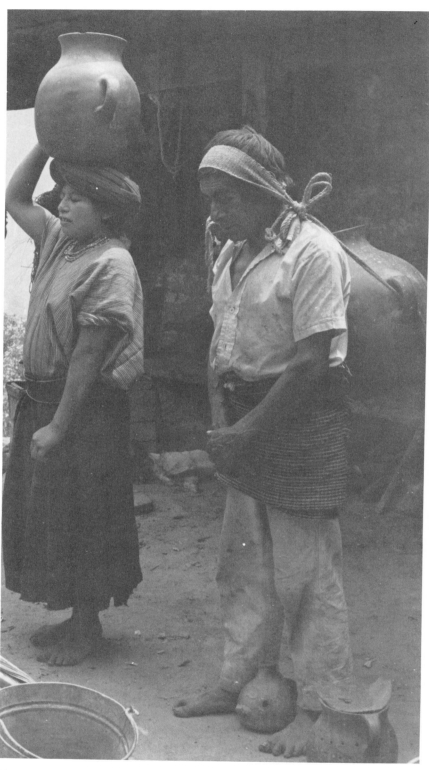

Plate 163

carry it with a tumpline passed through the two strap handles and under the broad base (pl. 163). The local *pichacha* is similar in shape to the women's *tinaja*, except that its two strap handles are attached opposite at the rim and the shoulder, above the holes in the lower body. The *olla* is more globular than the women's *tinaja* and has a low neck with a direct rim.

San Sebastián *jarros* or *jarritos* make up another classification that may be separated into two groups. Vessels in the first group would be called *jarros*, or pitchers in English. They have an almost teardrop shape, except for a flattish base and a modeled spout, with one strap handle attached at the rim and shoulder. Vessels in the other group have much higher and narrower necks placed on more nearly spherical bodies. A *tinajita*, a special variant, has a small spherical body and a high neck, but two strap handles are attached at the shoulder and waist. One is tempted to call this vessel a canteen. All the above forms, with the exception of *ollas* and *pichachas*, receive a red slip and a careful burnishing.

After the clay has been mined, it is taken to the potter's house and laid out in the yard to dry. The woman interviewed—an extremely prolific potter—had built a special shelter under which to work. This not only afforded a relatively cool, dry place to work but also shielded finished and partially completed vessels from direct sun and provided an area for grinding clay. Equipment for this consisted of two cobble manos and two slab metates, with a shallow depression in the earth beside them for the freshly ground clay (pl. 164). The potter, or in this case her daughter, adds some volcanic sand to this clay, piles up the mixture, and forms a depression in the center of the mound; she then adds water from a nearby *olla* (pl. 165) and begins kneading the clay mass (pl. 166). Although the feel of the mass is the primary criterion of how much sand

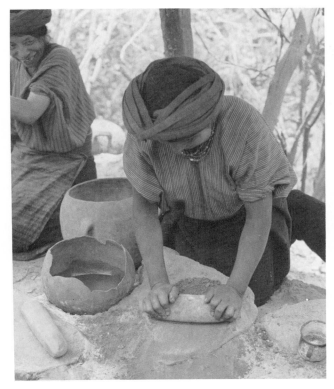

Plate 164

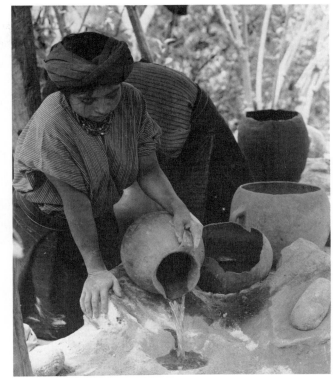

Plate 165

to add, the potters did volunteer a clay/sand mixture of 2:1.

After kneading, the potter takes a large piece of the clay between her hands and pats it out into a large disc with slightly raised walls (pl. 167). She places this in a shallow concave basal mold already dusted with volcanic sand to prevent sticking (pl. 168). The potter sits on her knees with her work in front of her. With the clay disc properly seated in the mold, she begins to scrape clay up from the inside with her fingers, especially the forefinger of her right hand, while cupping her left hand around the exterior as support (pl. 169). Turning the mold from time to time during this process, she brings new sections into a convenient angle for work. After raising the walls four or five inches, the potter rolls out a coil of clay (pl. 170) and presses it to the rim, using her right hand on the inside, her left on the outside (pl. 171); she works this clay up as she did the disc walls. She next employs a piece of split cane to smooth and shape the work, drawing the cane upward from the bottom of the exterior with her right hand, while her left parallels each stroke on the interior, still turning the mold as needed (pl. 172). Using the same method, she begins the shoulders—first rolling out another coil, then applying it with her left hand while her right pinches it into place. On a small vessel, the potter may continue almost without pause, but larger ones require a drying period before the shoulders can be formed. For this reason, the potter can keep several vessels underway (in this case four), each in a different stage of construction.

After forming the shoulders, the potter adds another, smaller coil around the opening to make the neck (pl. 173); she draws this coil up with the piece of cane and her hands to finish with a rim (pl. 174). Even though she turns the mold much more frequently and rapidly during this process, it does not approach the speed of even a slow-moving potter's wheel. She is still doing the shaping with the piece of cane, and a more rapid turning of the mold simply brings another portion of the vessel into position for work.

After this preliminary shaping, the potter pays a great deal of attention to perfecting the neck and rim. She turns the mold slowly with her left hand, keeping the middle three fingers of her right hand in the vessel mouth to smooth the neck joint and give added shape to the shoulders. Alternately, the mold lies motionless while the potter models the same parts on the outside with the piece of cane or her fingers (pl. 175). The flare of the mouth is added last, when the potter places the four fingers of her right hand over the rim and applies pressure gently toward herself, at the same time turning the

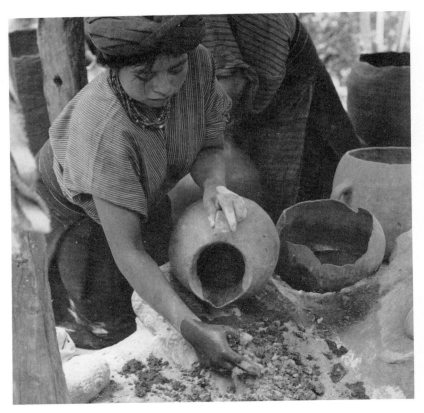

Plate 166

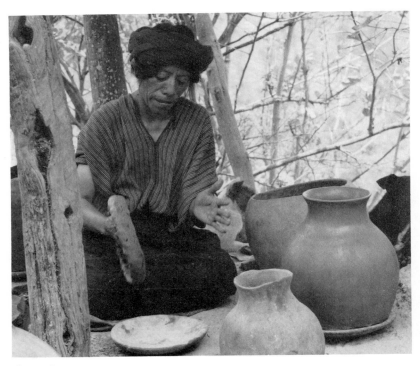

Plate 167

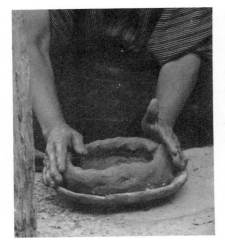

Plate 168

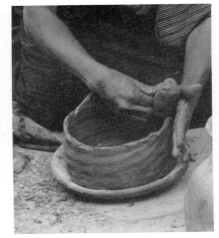

Plate 171

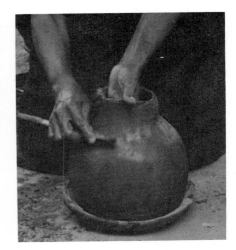

Plate 174

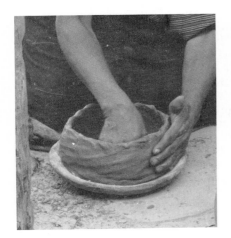

Plate 169

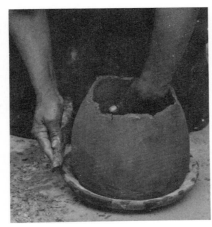

Plate 172

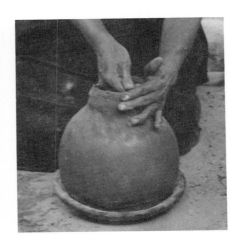

Plate 175

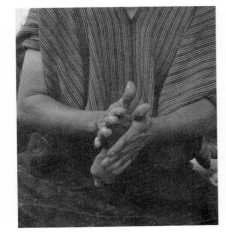

Plate 170

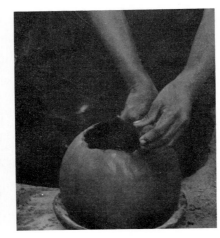

Plate 173

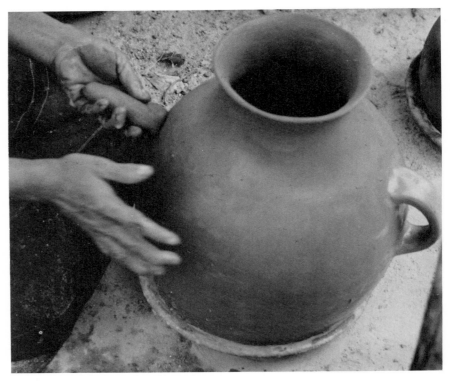

Plate 176

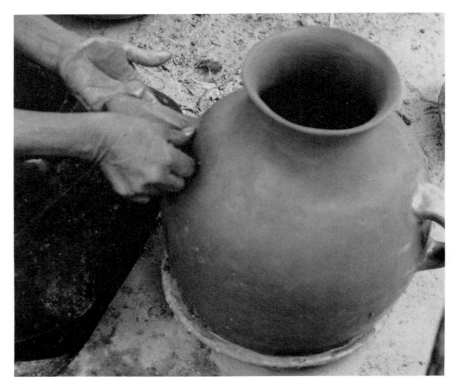

Plate 177

mold very slowly with her left hand.

A large vessel might be left to dry at this point; on a small vessel, the handles may be applied almost immediately. These are sections of clay coil (pl. 176) that the potter flattens with her thumb and forefinger drawn above and below. She fastens the top of one section to the vessel by pressing it into place and smoothing clay off the handle into the joint with the thumb of her right hand (pl. 177). She then takes the handle in her left hand and bends it over the first two fingers of her right hand to determine curve and length (pl. 178), then presses the lower end into place, securing it as she did the upper end, and construction is essentially complete.

After the vessel has dried completely in the shade of the potter's shelter, it is ready to be slipped. As the first step, the potter, or her daughter, adds a small amount of water to a bowl full of the brilliant red-firing slip clay. She squeezes the two together with the fingers of her right hand until she is satisfied with the consistency. The potter then simply wets her hand in the slip and spreads it over the vessel surface in long longitudinal strokes (pl. 179). Before the slip has dried completely, she burnishes the vessel well with a smooth river-worn pebble (pl. 180).

Although a firing was not observed, the method can be reconstructed after seeing the location and interviewing potters. The firing procedure in the San Sebastián area appears to be of the common open type, with vessels placed right-side-up on a bed of ashes and split wood, more fuel being interspersed between the vessels, and the whole being covered with straw. The only peculiarities of this method are the greater amount of split wood used than in most other centers and the lesser amount of straw, which is scarce in this area.

As always, production varies from potter to potter. The woman interviewed was heavily engaged in pottery making and had a daughter to undertake all subordinate tasks, as

well as a husband who occasionally
made tiles and was thus amenable to
helping assemble the raw materials.
Therefore, a figure of eighteen to
twenty vessels per week may not be
too high for this family but is per-
haps too high for the *pueblo* as a
whole. It might be noted, moreover,
that potters here specialize in pro-
ducing certain forms. While the pot-
ter interviewed was adept at making
both men's and women's *tinajas*, she
made only one type each week and
produced no *jarros* at all, but
bought them from other potters in
the area.

Potters and their families take
their own vessels to market. A Sun-
day market in the *pueblo* of San Se-
bastián itself serves to distribute pot-
tery locally, but potters also go to
such places as Colotenango, San
Pedro Necta, San Rafael, Santiago
Chimaltenango, and Huehuete-
nango every week or two. At these
markets merchants, both Ladino
and Indian, buy large quantities of
pottery for redistribution through-
out the southern Cuchumatanes
area. At these markets the potters
themselves buy *comales* from
Chiantla, as this form has all but
died out in the San Sebastián area, as
well as some pottery from San
Miguel Ixtahuacán, particularly *jar-
ros* and *ollas*.

Chiantla

The *municipio* of Chiantla—almost
four miles north of the department
capital of Huehuetenango—is lo-
cated at the foot of the Cuchuma-
tanes Mountains, the highest range
in Guatemala. The immediate vi-
cinity is characterized by a treeless
plateau heavily dissected by deep
gullies. Of the thirty-three *aldeas*
and twenty-two *caseríos*, the more
distant are isolated by poor roads
and very steep terrain. The area is
drained by the Selegua River and its
tributaries.

The inhabitants of the town and
the nearby *aldeas*, while often of
Mam-Maya heritage, reveal a pre-

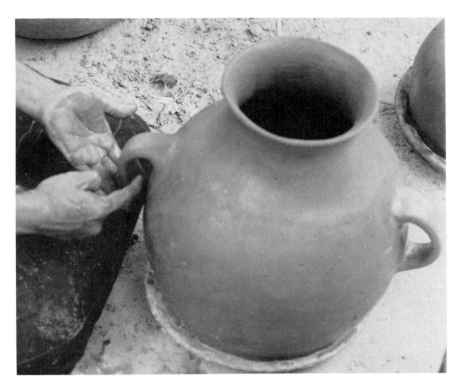

Plate 178

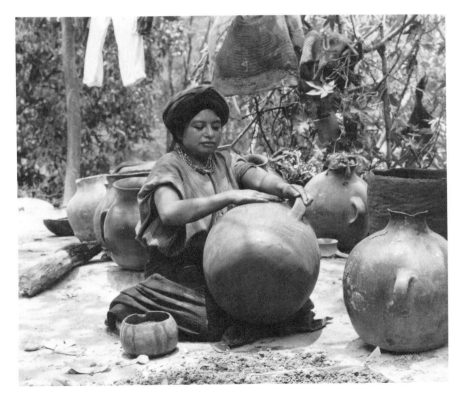

Plate 179

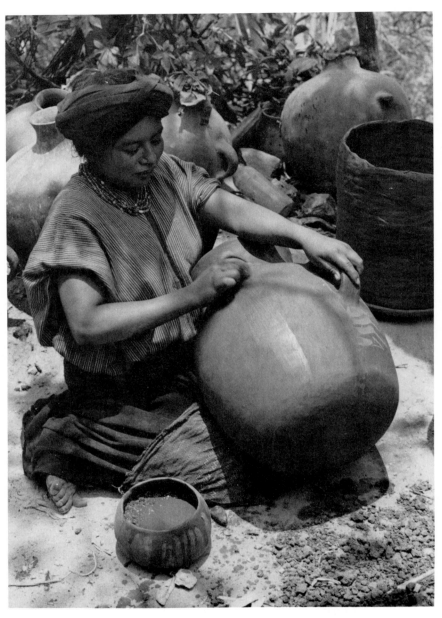

Plate 180

dominantly Ladino character indicated by their dress, speech (Spanish), and world view. In 1950, over half the population was Ladino—8,234 out of a total of 14,327. The remaining 6,093 persons were Indian. The Mam-speaking people are most frequently encountered in the isolated *aldeas*.

Most of the Chiantla pottery is made west of the *pueblo* in settlements along the Selegua River, mostly *caseríos* composed of dispersed houses occupied by members of the same family. The men of these residential groups cooperate in agricultural activities, as well as such other specialized pursuits as making tiles, bricks, and lime. The women of the *aldeas* of Los Regadíos (especially its *caserío* of Las Tejas), El Carpintero, and Torlón produce a series of sturdy vessels, including *apastes*, *batidores*, *comales*, *jarros*, *ollas*, and *tinajas* (figs. 34, 35).

All vessels, except perhaps *batidores*, are produced in a wide variety of sizes. A particularly large *apaste* is locally considered a distinct vessel called a *lebrillo*. Chiantla pottery is identified by a thin greenish glaze on the smoothed interiors and upper exteriors of all vessels except *comales*. The glaze is carelessly applied and never covers the entire exterior; it is made from a suspension of water and pulverized lead sulphide ore, mined by local men in the Cuchumatanes Mountains to the north. One might easily mistake Chiantla pottery for that of San Cristóbal Totonicapán farther south, except for the vessel shapes, which at this northern center have a more rustic appearance.

Chiantla *apastes* have shallow, rounded bases and high, straight, then flaring walls. Two to four strap handles, spaced evenly, may be attached to the rim and upper body. The locally made *batidores* are small vessels with curved walls ending in slightly restricted orifices or, sometimes, in low direct rims. A single strap handle is often added at the rim and lower body. *Ollas* here have shallow rounded bases, like *apastes*,

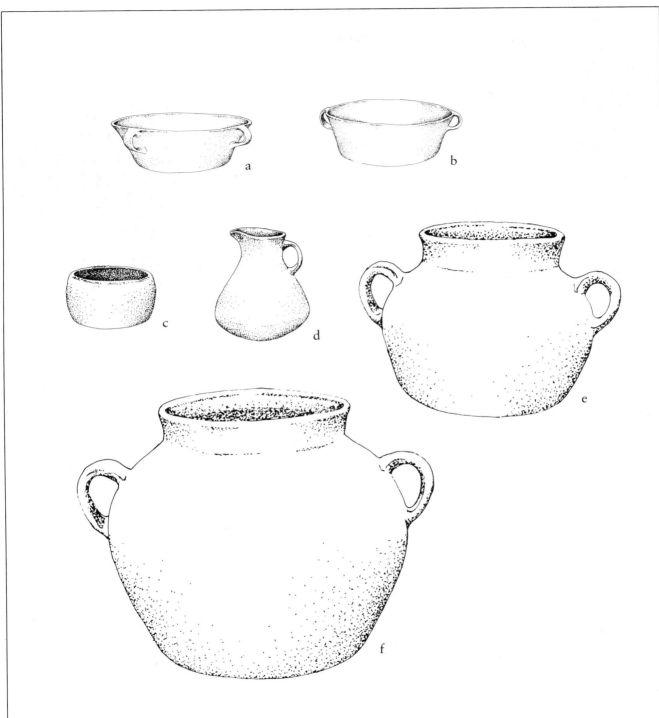

Figure 34. Chiantla vessel forms.
(a) *apaste*, (b) *apaste*, (c) *batidor*
(without handle), (d) *jarro*, (e) *olla*,
(f) *tinaja*. Scale 1:4 (approx.). Drawn
from photographs taken by Margaret
Arrott

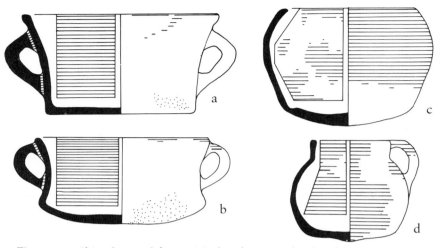

Figure 35. Chiantla vessel forms. (a) glazed *apaste*, (b) glazed *apaste*, (c) glazed *olla*, (d) glazed *batidor*. Scale 1:4. From the University of Pennsylvania Museum, Philadelphia, Reina-Hill Collection, 1973

betraying their manufacture upon concave molds. The curving walls reach their greatest diameter about two-thirds of the way up and thereafter close over to form shoulders around a constricted mouth, surmounted by a low neck with a direct rim. Two strap handles are placed high on the vessel, attached at the shoulder and the point of greatest diameter. Chiantla *tinajas* are very like *ollas* and could easily be mistaken for them. The main differences are the greater size of the *tinajas*, their much broader, more sloping shoulders, and their tendency to have slightly flaring rims. The *jarros* are pitcher-shaped vessels with rounded bases, S-curved bodies, modeled spouts, and a single strap handle reaching from directly beneath the rim to just below the point of maximum diameter, opposite the spout. *Comales* are made in full molds.

Clay is mined locally from several deposits along the Selegua River and fires to a light brown. Individual potters may specialize in one or more vessel forms; for example, women who make *comales* seldom make any other form. This is apparently due to the different technological skills (in both forming and finishing) required for *comales* compared to other vessels. The potter makes the *comal* completely upon the full

mold, spreading and wiping the clay until she has produced a duplicate vessel (pl. 181). For other vessels, made upon a small concave basal mold, the potter turns the mold slowly, making a pot in a manner similar to that used in San Cristóbal Totonicapán. After the vessel is partially dry, she removes it from the mold. *Comales* receive no further treatment except firing. A potter can produce six to seven *ollas* and twenty *comales* each week.

In the past, all vessels were fired in the open (pl. 182). The vessels were stacked upon a base of wood kindling (*comales* were also separated by wood) and covered with more kindling and pine needles. Large sherds were placed around the fire to conserve heat and keep gusts of wind from disturbing the fire. In recent times, however, a significant change in firing practices has taken place. Although this change was probably beginning about the time the Arrotts visited, thirty years ago, they do not mention it in their accounts. In response to increasing scarcities of kindling, experimental attempts were made to use the large lime kilns for firing pottery. Reportedly these could use any size of wood and were more economical in consuming fuel. These large kilns, however, produced temperatures too high for firing, but further experi-

ments with a smaller version of the kiln were successful. This kiln, measuring about a yard on each side for firing *comales*, retains the virtue of fuel economy and maintains the proper temperature (pl. 183). Furthermore, it can fire thirty-five to forty-five *comales* at a time, compared to the six to eight that could be fired with the traditional open method. Slightly larger versions of the new kilns are currently used to fire *ollas* and other vessels.

The potters of Chiantla deny the existence of elaborate Maya ritual *costumbres* associated with success in pottery making. Even so, they burn a candle in front of the kiln at the beginning of firing, because when they do this, explained the husband of a potter, "God helps" the pottery to fire better.

San Miguel Acatán

The *pueblo* of San Miguel Acatán lies in a high, extremely beautiful mountain valley formed by the Santa Catarina River. The principal language is Kanjobal, and there, too, an archaeological site near the town suggests a long period of indigenous habitation. San Miguel is about fifty miles northwest of the department capital of Huehuetenango, a five-hour drive in a four-wheel-drive vehicle. The region has been exploited since colonial times for its rich deposits of silver and lead. Mining appears to have declined in the area, but several lead mines are still in operation, with trucks making the long and extremely difficult journey every few months. Most of the land, however, is given over to agriculture—men farm the steep slopes and narrow valley floors in the traditional manner, with corn and wheat being the principal crops. Although San Miguel Acatán is at an elevation of 6,890 feet, the east winds coming up the river valley from Mexico keep the climate temperate.[7] In 1950, the municipality had a population of 10,446; only 167 were Ladinos, living in the

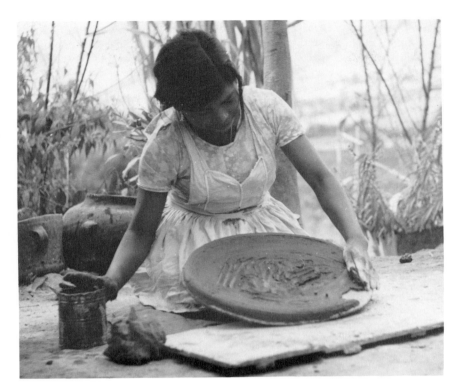

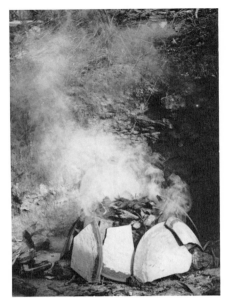

Plate 182

Plate 181

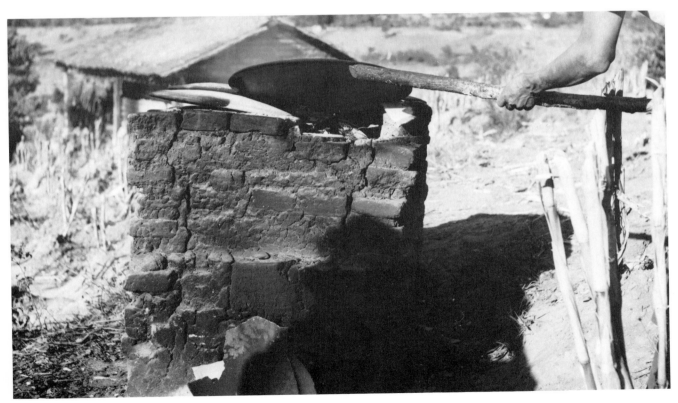

Plate 183

pueblo that itself boasted a population of only 1,244. The majority of the people live in the nine *aldeas* and sixty-one *caseríos* of the outlying area.

Most of the ethnographic work in this area was done in the first part of this century and expresses the traditional viewpoint of early ethnographers in American anthropology. It seems clear that the settlements referred to then as villages are the present *aldeas* and *caseríos*, having technological specialization and exchanging their products through the market system or through itinerant merchants.

The elaborate traditional trading system existing within the *pueblos* and *aldeas* of the area is overseen by a body of officers—not a *cofradía* of the central highlands, yet a group with the same functions—in charge of regulating *costumbre*, which reinforces technological continuity. The officers are known as the prayermakers. They are chosen annually by the *principales*, individuals at the top of the power structure who have formerly been prayermakers. At the head of the organization is the *principal del pueblo*, usually a prosperous individual with both civil and religious power. Through these officers all members of the community are active participants in community affairs, and their adherence to the culture, frequently represented by a technological specialization in addition to specific religious rituals, validates their community membership and promotes a sense of corporateness and social closeness.[8]

Although some potters can still be found in the *pueblo* of San Miguel Acatán, they are older women who do not produce pottery regularly, and it is probable that in a few years no potters will be left there. Most potters live in *aldeas* and *caseríos* located in small valleys adjacent to the *pueblo*. Most often mentioned are the *aldea* of Coyá and its *caserío* of Taquiná, the *aldea* of Poza and its *caserío* of Petanchim, the *aldea* of

Paiconob, and the *aldea* of Chimban. Women produce all the pottery, and women with families are usually the most active potters.

The potters interviewed were residents of the *aldea* of Coyá which, although only in an adjacent valley, was about two hours away from the *pueblo* by jeep trail and more than three hours away by foot. One of the still functioning lead mines lies at the foot of the ravine where the settlement is located, and many local men find employment there, although for low wages—$1.00 per day in 1975. The *aldea* is spread over the steep side of the ravine and the mountain, and farming is difficult at best with the rocky soil and such steep terrain.

The dispersed settlement pattern and the extremely rugged terrain made it next to impossible to count potters or to verify figures given. However, seven women were named as pottery makers in the lower part of Coyá, while "many more" lived farther up the mountain. Besides *tinajas*, Coyá potters produce *ollas*, *pichachas*, and *comales*. The same inventory has been reported for the *aldea* of Paiconob, in the eastern part of the *municipio*, but only *comales* and *ollas* have been reported for the Poza area. Forms may be specific to these *aldeas*, but we have no conclusive proof.

The pottery of the San Miguel Acatán area has been described by Siegel as one of the "old, rather crude crafts."[9] We take strong exception to Siegel's comment—pottery from this area is among the most aesthetically pleasing and technologically sound of all pottery produced today in Guatemala (fig. 36). This applies particularly to the *tinaja* produced here. It has a unique diamond-shaped body, with a deep conical bottom, a very wide waist, steep conical shoulders, and a narrow flaring mouth. The opposing thick strap handles are near the waist, attached just above and below. This vessel is an excellent example of a pottery form adapted

to a particular environment. Here, in the steep and rugged Cuchumatanes, one must climb almost doubled over from the water sources in the valley. This makes carrying a *tinaja* on the head impractical, if not impossible. With a tumpline passed through the two handles and under the vessel's waist, however, the carrier (almost always a woman) can walk bent over up the hill, with both hands free and with the *tinaja* upright, its conical body resting against the carrier's back. This is a good reason why San Miguel *tinajas* are not traded out of these steeply mountainous regions, for they can be carried only in the manner described.

The local *ollas*, made in all sizes, have attractive S-curved bodies with flat bottoms. The larger ones have two strap handles placed opposite and attached at the rim and shoulder; the *pichacha* here is similar but has holes. Smaller *ollas* have two lug handles placed opposite, just above the shoulder. *Jarros*, not produced in Coyá, are made elsewhere in the area, although their source was not found. They have globular bodies with high necks rising to a flaring rim. A long spout is placed at the rim or just below, and a single strap handle opposite the spout is attached below the rim and at the shoulder. *Comales*, made in molds, have no particular distinctions. All vessels fire to a pleasing deep red and are so well burnished they appear to have been slipped. The firing is extremely efficient and leaves the vessels hard without being brittle; they are resonant when knocked with a knuckle in the universal method of testing pottery vessels. Such a well-adapted pottery tradition offers little innovation incentive and, without the pressures of the urban Ladino and tourist markets, none is likely to be forthcoming.

Clay and sand sources occur nearby. The most intensively studied potter was the widow of a man who had owned a clay source with his brother. It is assumed from this that

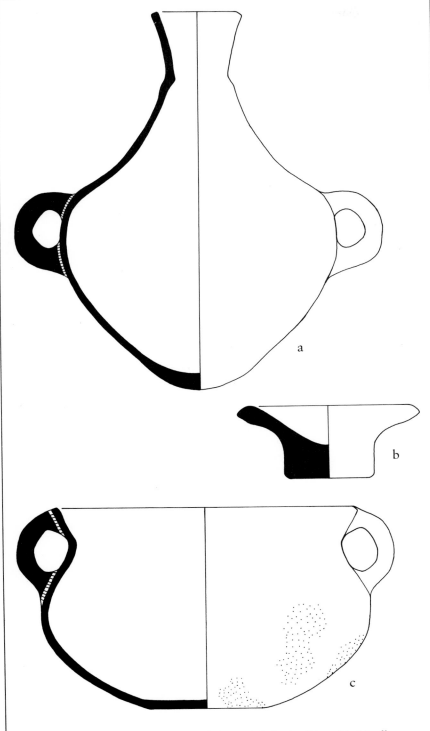

Figure 36. San Miguel Acatán vessel forms. (a) *tinaja*, (b) mold, (c) *olla*. Scale 1:4. From the University of Pennsylvania Museum, Philadelphia, Reina-Hill Collection, 1973

most clay sources are privately owned, even if the owner or his family is not engaged in pottery making.

After clay and pumice sand have been gathered and dried, they are passed separately through a nylon net bag to sift out larger particles and impurities (pl. 184). When asked, the potter said she uses equal measures of sand and clay, but this seems to be too high a sand content for superior pottery. In whatever proportion, sand and clay are mixed together, water is added, and the potter begins to wedge the mass, adding sand and clay as needed to obtain the proper "feel" (pl. 185).

The technique of *tinaja* construction utilizes the concave basal mold, with coils added and drawn up with pieces of rubber as well as the fingers. The potter sits in a very low chair, just off the ground. A low wooden box serves as a work platform, and she places the mold upon this. This mold, called a *xok mok*, or bottom of the *tinaja*, is as distinct as the vessel produced from it. Aside from having a conical instead of a shallow spherical interior, it has a pedestal base one to four inches high. This pedestal appears to make the mold more stable as the potter works on a raised surface, such as the box; accounting for the differences in pedestal heights is more difficult. A possible explanation is that larger vessels are built on molds with lower pedestals and that these lower pedestals may be more stable. Only two *tinajas* were observed while being constructed, however, and no final conclusion can be drawn.

The potter dusts the mold with pumice sand to prevent sticking, then pats out a disc of clay between her hands (pl. 186), presses it into the mold, and adjusts it until she is satisfied with the fit (pl. 187). She rolls out a clay coil between her hands (pl. 188) and applies it with her left hand, while her right hand pinches it into place (pl. 189). The potter then works the walls up a

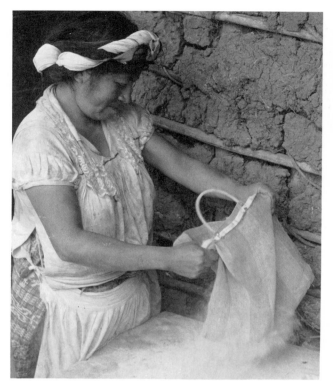

Plate 184

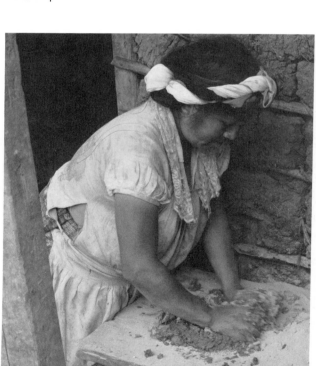

Plate 185

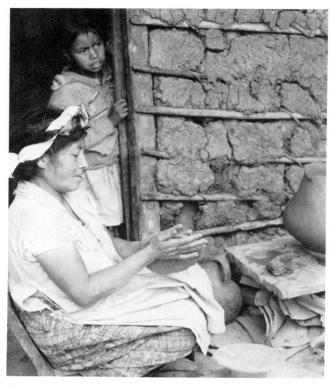

Plate 186

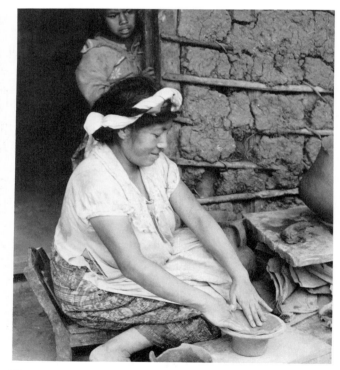

Plate 187

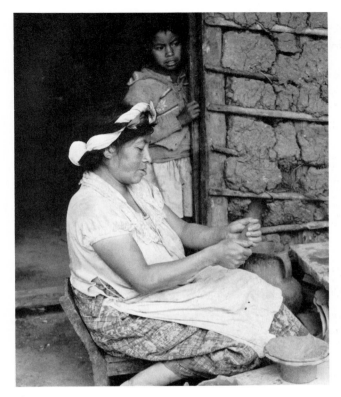

Plate 188

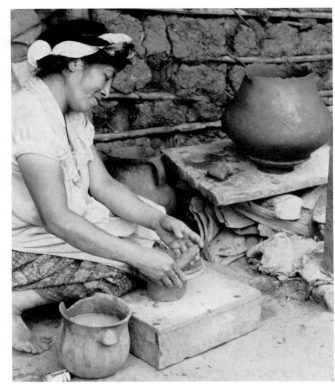

Plate 189

short way, from the inside, using her right thumb primarily while her left hand cups the exterior in support (pl. 190).

Switching to the vessel exterior, the potter begins to use one of the pieces of rubber she has salvaged from an old truck tire. She has several of these in different sizes, with various sizes of crescent cutouts at the edge of each. She keeps them next to her in a small *olla* full of water, to be used as needed according to their shape and the specific modeling she has to do (i.e., waist, neck, rim). At this point, the potter employs a flat-edged piece of rubber in her right hand to smooth, thin, and draw up the vessel walls, while her left-hand fingers provide support from inside (pl. 191). Through all phases of shaping she strokes in steep diagonals from the bottom up toward herself, varying only the length of the stroke. At first, her strokes cover the length of the vessel. Shifting again, the potter works

with a piece of rubber on the interior (pl. 192), then leaves the vessel to dry.

Although the next step of construction was not witnessed, informants explained that the potter would add another coil and work the walls out and up with her rubber tool until she had achieved the desired diameter and wall thickness. She then rolls out another coil, applies it to form the upper part of the shoulders (pl. 193 — the potter is now working on a vessel which had been partially constructed before our arrival), and works it up as before, except that she bends the walls inward (pl. 194). Then, a final coil added and worked up forms the neck (pls. 195, 196).

The amount of time expended on forming the mouth and rim demonstrates how important this section is to the potter. She first forms the flaring neck and the indentations that mark it off by employing one of her rubber tools. With intense concen-

tration and care, she chooses the point at which she wants the neck to begin and, using the cutout side of her tool in her right hand, presses it in slightly and then draws it up, her left hand providing support from inside the vessel (pl. 197). After one or two strokes in the same place, the potter turns the mold enough to bring another section into working position. She continues the process until she is satisfied that the height and flare are correct.

With her fingers, the potter carefully trims off any excess clay at the rim area (pl. 198). After completing this step, she shapes the rim by making a fist of her right hand, gently placing it in the vessel mouth, and, extending her thumb out to the rim, rotating her hand slightly, thus smoothing the surface (pl. 199). At the same time, she supports the neck from the outside with her cupped left hand. Turning the mold several more times, each time bringing a new section of the rim into position,

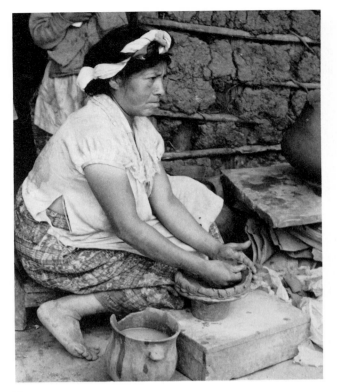

Plate 190

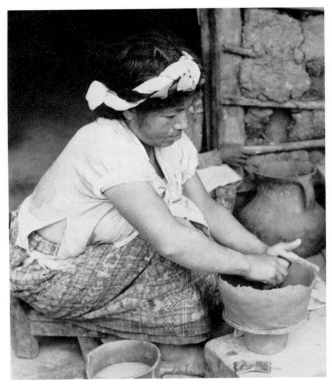

Plate 192

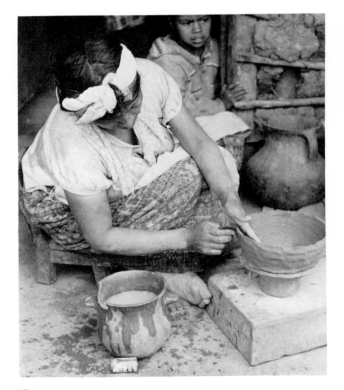

Plate 191

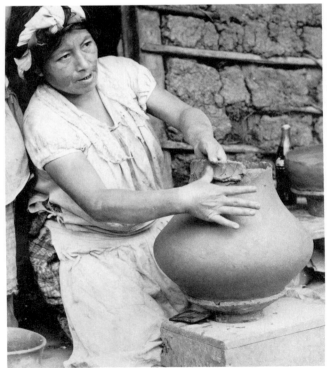

Plate 193

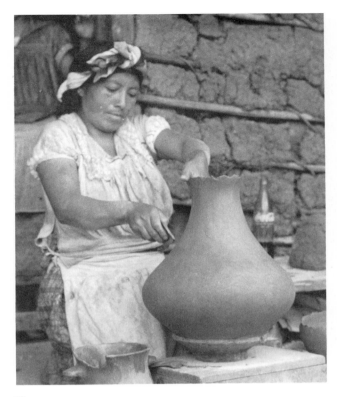

Plate 194

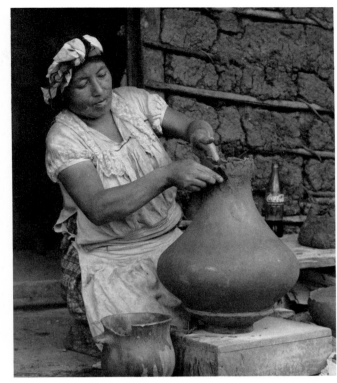

Plate 196

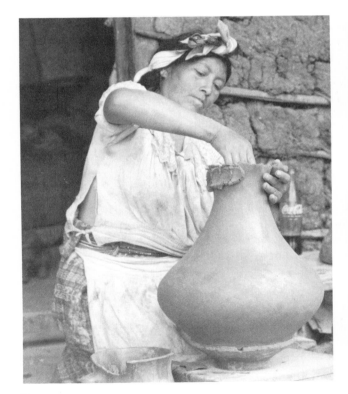

Plate 195

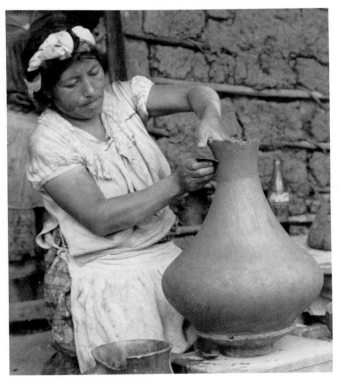

Plate 197

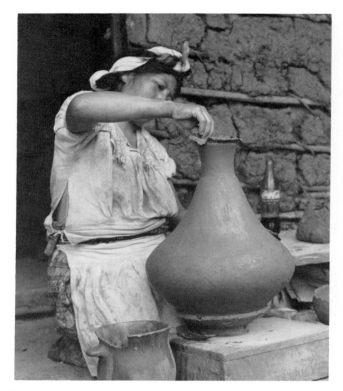

Plate 198

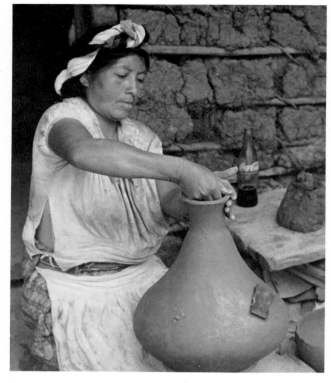

Plate 199

the potter gives a final interior and exterior shaping to the mouth and rim with a rubber tool. Last of all, she gives the whole vessel a final shaping with yet another tool (pl. 200).

Handles are two short lengths of coil flattened between the palms. The potter, drawing the side of her right thumb over the surface while holding a strap in her left palm, widens the ends to give them an "I" shape. She curves the handle gently over and presses it down lightly onto the vessel surface, using her right thumb to press down the clay from the top end first, then the lower end (pl. 201). She works small bits of clay into the joints both inside and outside the handle loop in order to strengthen them (pl. 202). After measuring the vessel with her out-stretched hands (pl. 203), the potter places the second handle directly opposite the first and applies it in the same manner as the first. She gives both a final smoothing with a rubber tool, then sets the vessel aside to dry.

When the vessel is leather-hard, the potter, or in this case her daughter, removes it from the mold and burnishes the entire vessel above the mold scar with a river-worn pebble (pl. 204); then, scraping off the mold scar itself with a trowel or an old knife blade (pl. 205), the potter burnishes the remaining bottom area.

Aside from the care exercised in vessel construction, it is the method of firing that is most responsible for the quality and durability of San Miguel Acatán pottery. The two most distinguishing features of this process are the individual firing of vessels and the exclusive use of split wood as fuel. Since vessels are fired with such great care, firing losses are very rare.

A low fire is built and allowed to burn down to coals. Vessels to be fired are placed at the edge of this bed of coals for preheating to prevent later breakage in actual firing (pl. 206). When a potter judges a vessel to be ready for firing, she places it mouth up in the coals

and builds a cone of newly split wood and pieces of partly consumed wood from previous firings around it (pl. 207). The potter tries to keep the spaces between pieces of wood as small as possible and sometimes overcompensates by adding extra wood. After packing small pieces of kindling inside the cone at its base, the potter fans vigorously with a woven reed fan to ignite the whole lot (pl. 208). Usually a potter's husband cuts the wood but, as the potter interviewed was widowed, she had to purchase wood in the *aldea* at 25¢ per load in 1975. Each load contains enough wood to fire four *tinajas*. The absence of straw for covering the fire means a great heat loss, but split wood offsets this by giving a high and sustained temperature for a long period of firing. The firing of one *tinaja* was timed at twenty minutes. During this time, the potter places other vessels around the fire to preheat. While waiting for vessels to preheat or to fire, she usually busies herself with

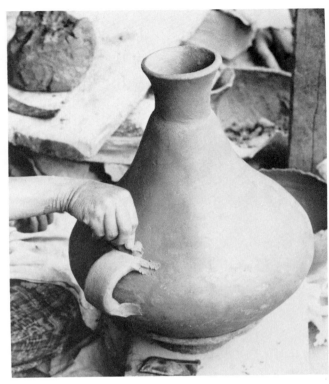

Plate 200

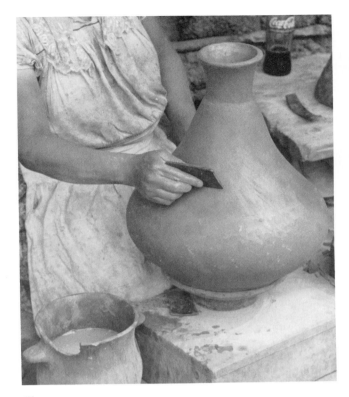

Plate 202

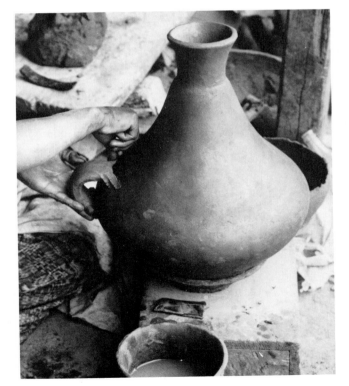

Plate 201

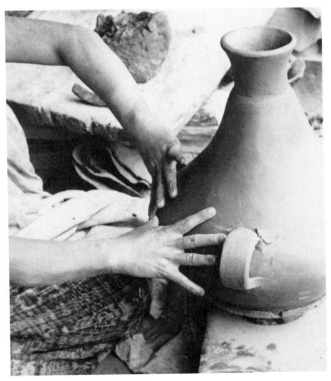

Plate 203

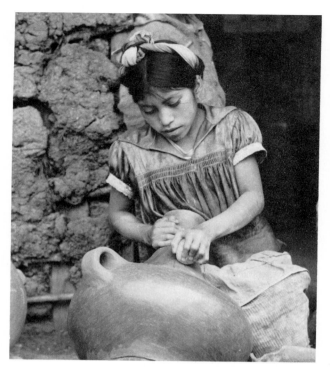

Plate 204

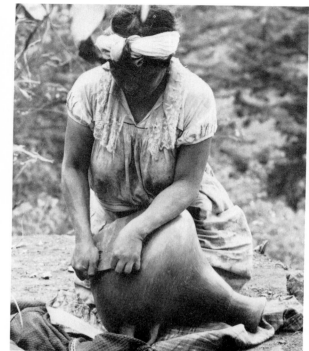

Plate 205

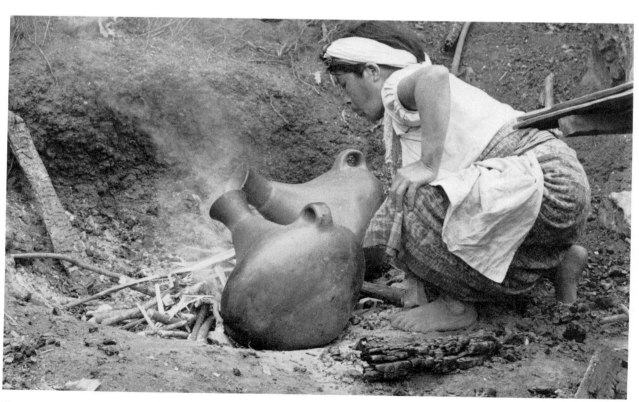

Plate 206

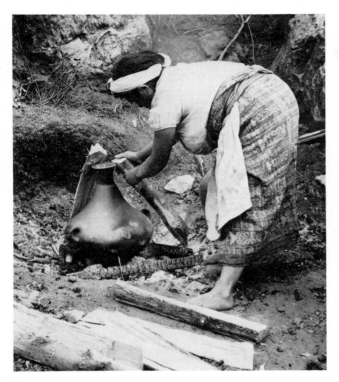

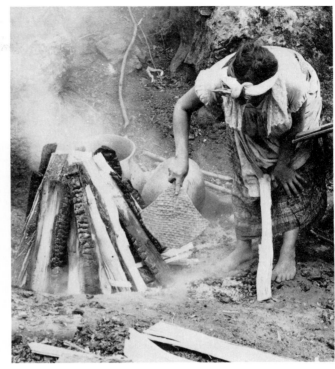

Plate 207

Plate 208

such jobs as burnishing and scar removing, as well as chopping wood.

The potter periodically checks the amount of fuel consumed and the condition of the vessel being fired. When the lengths of wood are between half and three-quarters consumed, she begins to remove them one by one, using two green sticks as tongs. The partially consumed wood is tossed a good distance away to keep the area close to the fire, where the potter walks barefooted, as cool as possible. With the vessel once again fully exposed, the potter places a sturdy stick through one of its handles and carries it to a group of three previously arranged stones, where she sets the vessel to cool.

The potter most carefully studied worked four days each week on *tinajas* and made one vessel per day. Even though she was the sole support for her family and therefore relied completely on her pottery for subsistence, the same production figures probably held true generally, the reason being that *tinajas* sold locally for a high price—around

80¢ in 1975. It will be remembered that the only wage work was in the lead mine and that this paid only $1.00 per day. Thus, each *tinaja* sale represented a sizable contribution to the family income, especially for those potters whose husbands gathered wood for firing.

Marketing patterns in this area of the Cuchumatanes are distinctive. Because of the rugged terrain, *aldea* markets often handle distribution of local products in the manner typical of a local *pueblo* market. For example, residents of nearby non-pottery-producing *aldeas* may come to the weekly Coyá market to purchase *comales* or the *tinajas* which are specialties of the Coyá *caseríos*. The same people might travel to Paiconob or Poza for an assortment of *ollas*. Itinerant merchants also attend the market days at Coyá. Some buy pottery to sell in the *pueblo* itself, while others take vessels back to their own *aldeas*. Among merchants arriving at the market area, carrying goods by tumpline is still common but, contrary to the practice in other

pottery regions, there appears to be a marked preference for packing vessels on mules.

Traditionally, *fiestas* are times for heavy exchange. For example, during the February *fiesta* at Pet, one of the *aldeas* of Santa Eulalia, Indians come from all over the area with their special products. Large *cargas* of *ollas* and *tinajas* are taken to Pet from the San Miguel Acatán area, to be exchanged for salt and other products. It is a *fiesta de costumbre*, stated a San Miguel bilingual Ladino.

The municipal center of San Miguel Acatán, instead of having the local *pueblo* market one would normally expect, displays most of the typological characteristics of an urban local market. These characteristics result from geographical extremes in the region. San Miguel Acatán, the administrative *pueblo*, receives surplus products, including pottery, from the *aldeas*. These surpluses are sold to the *pueblo* population only; *aldea* people frequent the nearer and more easily

reached *aldea* markets. The *pueblo* market fails to meet one criterion of an urban, interregional market in microcosm in that it does not serve as a transshipment point. This is due to two factors. First, the town is literally at the end of the road—the jeep trail ends there. Second, Paiconob, the *aldea* that produces the most pottery for export, is nearer to the regional market of Soloma than to the *pueblo* of San Miguel, making shipment through the municipal center redundant. Thus, geography and settlement patterns serve to isolate the town from the outlying areas and make it dependent on surpluses from these areas for its own support.

As already mentioned, Soloma acts as a regional market. Several factors combine to make this so. Soloma is centrally located and is connected by dirt roads to the other major population centers and pottery-production centers in the region. Jacalteca, Chuj, and Kanjobal are spoken in the center, so merchants and producers coming from the San Miguel Acatán area (Kanjobal) can sell to Solomans or to merchants from San Mateo Ixtatán (Chuj), and Soloman merchants can act as middlemen for merchants from Santa Eulalia (Kanjobal). Although Spanish could become the lingua franca for the area, most Indians still prefer their own tongue, and most know enough of other closely related languages in this region to transact business. Regardless of language, however, Soloma would still be the important regional market center because of its favorable location with regard to production centers, populations, and transportation. Although travel by bus is becoming more common in this region, foot and mule travel are still the most important means of moving people and goods.

5.

Pottery Production
The Northern Region

Cobán and the Alta Verapaz

The people of the Verapaz were pacified and acculturated into Christianity through a program conceived by the famous Padre Bartolomé de las Casas. His position, and that of his Dominican order, was that they could bring Indians to the "true religion" through patience, persuasion, and kindness. By discouraging Spanish settlers for a long time after the conquest, the Dominicans kept the people of the Alta Verapaz in social isolation. Under these conditions, the cultural pattern acquired distinctive qualities that contrast with other parts of Guatemala, including the Baja Verapaz. Even when Cortés y Larraz visited the area in 1769, Cobán—the present department capital—had only 6 Ladino families living among 10,895 Kekchí speakers.[1]

Cobán is today the most important city in the department of Alta Verapaz. In 1950, the population of the whole department was 188,758: 176,231 Indians and 12,527 Ladinos. Cobán itself had 25,587 Indian inhabitants out of a total population of 29,613.

Beyond the administrative urban center of Cobán, Indians reside in scattered settlements, as they did in pre-Columbian times. In spite of direct efforts, Europeans have had little success in changing this pattern. Perhaps because of this separation, a strong trade network developed. It has been reported that in early colonial days traders efficiently covered a wide area, exchanging agricultural and craft products, including ceramic vessels. Contacts among people were, therefore, through individuals

rather than through formal groups. This high degree of insularity conditioned events of the nineteenth century, when the area was opened to European immigrants, particularly Germans. King suggests that, in the Alta Verapaz, "the Indians more nearly adjusted to the Spaniards and to the European culture patterns than did other native Mesoamericans."[2] It follows that the relationship of social structure and culture typical of other pottery centers in the highlands does not appear here. The distinctions in the Alta Verapaz are the lack of town organization, the dispersed settlement pattern, the social freedom of women, the retention of Kekchí monolingualism (and Ladino bilingualism), the lack of Ladino domination over the Indians,[3] and the absence of the religious-political organization of the cofradía.

Because—with its widely scattered settlements and its diffuse community organization—this area lacks discrete pottery-production centers, we prefer to treat the pottery of the Alta Verapaz as the output of a single production area. In the Alta Verapaz, therefore, the pottery-making households, separated by limestone outcrops, lie scattered throughout this rugged and beautiful area of highland rain forest. Indian potters live between the aldea of Chiché to the south, through the environs of San Juan Chamelco, north to San Pedro Carchá, and beyond. Pottery making is not a skill practiced by all women, as it is in Chinautla. The female potters are scattered among the rest of the population, making an accurate estimation of their numbers impossible.

Without the closed corporate communities found elsewhere in the Guatemalan highlands, the female potters have much freedom to act, specialize, and think, guided by a body of personalized beliefs. In 1975, the failure of a potter to successfully transform clay into a vessel while being observed by strangers had its explanation in the life qualities of the clay, which were fighting against the efforts of the potter. The clay was alive and had feeling, and the potter found it difficult to dominate it because she was nervous in the presence of strangers. In the world view of these Alta Verapaz potters, those elements of nature to be transformed by humans are still conceptualized through assumptions that may have been typical of beliefs in pre-Columbian times. Pottery remains an individualistic enterprise and has persisted virtually unchanged for hundreds of years, despite the efforts of missionary programs designed to alter the life style of the people.

Two unsubstantiated pieces of information were obtained concerning production. First, a very few men are engaged in the production of tinajas that are reportedly five times as large as those produced by the women. Second, an intermediate-sized tinaja is made for men to carry using a tumpline. Neither male potters nor the other two vessel types were observed during our stay in the Alta Verapaz. It should be noted, however, that our investigations centered on both producers and markets where quantities of pottery are concentrated. That we still saw neither of the above-described vessels, therefore, may not be due to

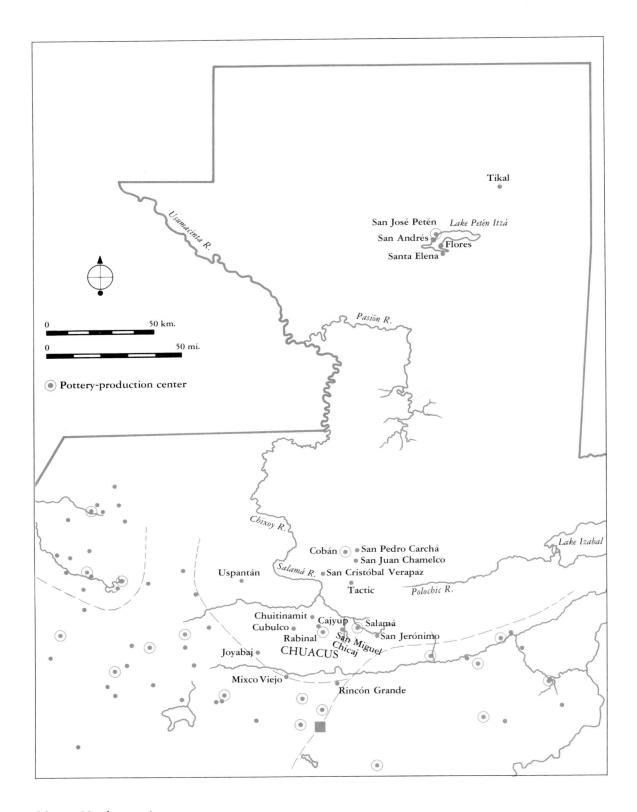

Map 5. Northern region

casual oversight but, rather, to the scarcity of these vessels and producers.

The quality of pottery from this area varies greatly—such variation is a reflection of the infrequent contact among potters and the relative weakness of community pottery standards. Some pottery, such as the graceful *tinaja*, is well made and attractive. Other examples are more crude. Nevertheless, there is uniformity both of forms and of techniques throughout the area.

Forms appear to have remained stable since the Arrotts visited the area in 1950, except for the development of some crude, tourist-oriented figurines. The variation in quality tempts an observer to posit a large array of forms, but the most we can justify are eight basic ones under five categories: *tinajas, ollas, ollitas, cajetes,* and *incensarios* (figs. 37, 38).

The *tinaja* remains the most distinctive form produced in the area. The lower half of its body ranges in shape from globular in inferior vessels to semiconical in fine ones. At the shoulder the curve reverses sharply from convex to concave. Neck and mouth sizes vary greatly, but all flare to some extent. Two strap handles are placed opposite each other, below the recurve. The bottoms of the vessels are concave, somewhat in the manner of modern wine bottles, and women carry these vessels on their heads. Large *ollas* here have the same lower bodies as *tinajas*, as well as similar placement of handles. Instead of continuing the graceful recurve of the *tinaja*, however, a low flaring rim is shaped, giving these vessels wide mouths. These large *ollas* are used for storage, not for cooking, whereas those from Rabinal and Salamá in the Baja Verapaz serve the opposite purpose. Small *ollitas* have globular to hemispherical bodies with low flaring rims and one or two strap handles attached at the rim and shoulder. *Cajetes* are produced with hemispherical bodies and direct rims with

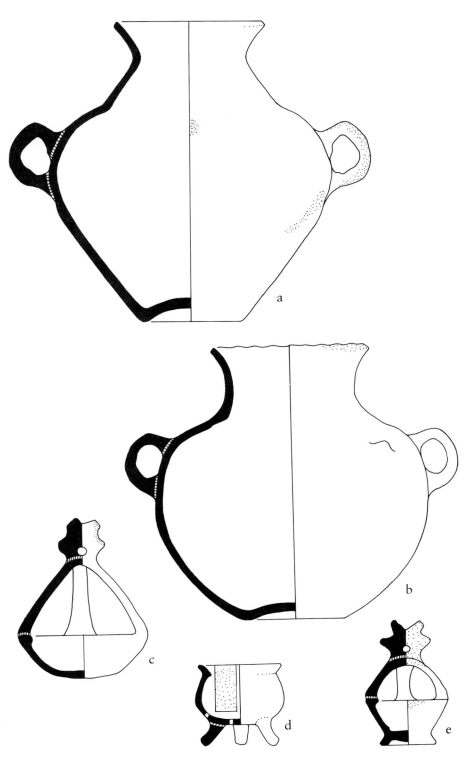

Figure 37. Cobán and the Alta Verapaz vessel forms. (a) *tinaja*, (b) *tinaja*, (c) *incensario*, (d) *incensario*, (e) *incensario*. Scale 1:4. From the University of Pennsylvania Museum, Philadelphia, Reina-Hill Collection, 1973

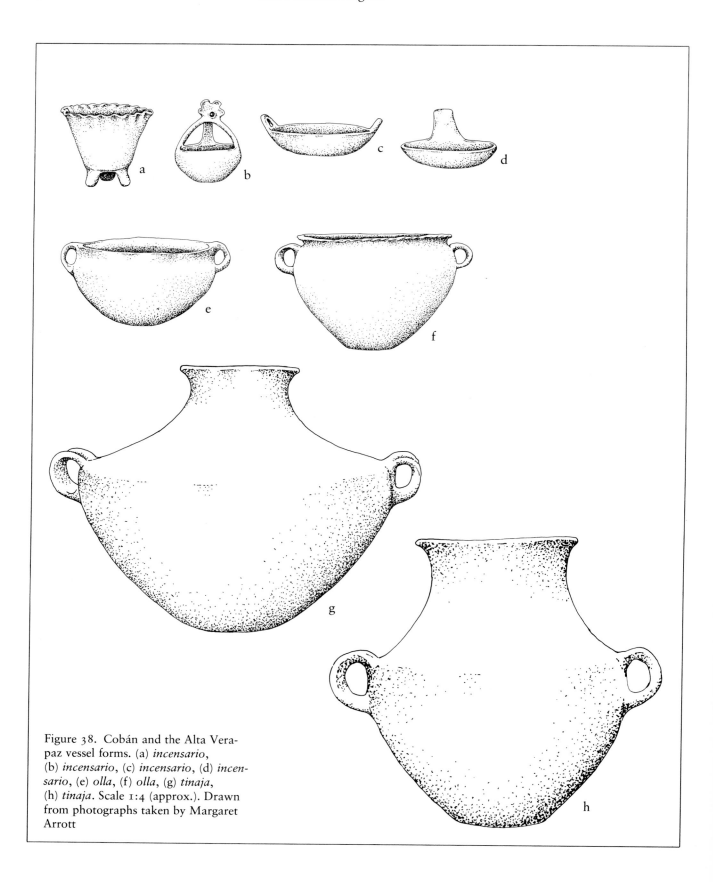

Figure 38. Cobán and the Alta Vera-
paz vessel forms. (a) *incensario*,
(b) *incensario*, (c) *incensario*, (d) *incen-
sario*, (e) *olla*, (f) *olla*, (g) *tinaja*,
(h) *tinaja*. Scale 1:4 (approx.). Drawn
from photographs taken by Margaret
Arrott

two or more tab handles spaced evenly below the rim.

A variety of *braseros*, here called *incensarios*, is produced in quantity for ritual use in this area. Among them, the most unusual is shaped like a small frying pan with a long flat handle, reminiscent of the "ladle censers" of the Late Postclassic period, and there may indeed be continuity here. Another type has a low hemispherical body with two horizontal loop handles placed opposite each other on the direct rim. Another form has three straps, spaced 90° apart at the rim, running up to join in a partial dome where a crudely modeled tab with a hole punched through it allows the vessel to be hung. The final censer form has a slab-footed tripod base, flaring walls, and a modeled rim. Most vessels are slipped and well burnished and fired to a deep red. This is often marred, however, by patches of black fireclouding, to which the potters are generally indifferent.

The one innovation since the Arrotts' visit appears to be the introduction of very crudely modeled human figurines. These are sold mainly in the market at Cobán and probably represent a response to opportunities offered by the growing numbers of both Guatemalan and foreign tourists visiting the area.

Actual pottery making was observed by both the Arrotts—at an unknown location—and ourselves—at San José la Colonia just outside of Cobán. After clay is mined, it is packed back to the female potter's house, where it is stored inside, wrapped in plastic or banana leaves, until needed. The potter adds sand to the clay as temper, and the mass is wedged for about ten minutes, then rolled into a thick cylinder.

Although she carries out all work on pottery in the house (the potter is working outside here for photographic purposes), the potter maintains as little contact as possible with other people, including her family, while construction and finishing are underway. Any interruption or variation in her procedure, such as changing her work area or being watched by others, may have serious effects on her ability to produce a serviceable vessel.

To build a *tinaja* or a large *olla*, the potter begins by shaping a thick disc of clay about eight inches wide between her hands (pl. 209). She presses this into a shallow concave basal mold previously dusted with sand to prevent the wet clay from sticking. She then forms the walls by pinching up the clay around the edge of the disc, her thumbs in the interior and the tips of her fingers on the exterior (pl. 210). With this rough base to work on, the potter next rolls out a coil of clay between her hands and applies it to her work with her left hand, while pinching it into place inside the rim with the thumb and fingers of her right hand (pl. 211). Interestingly, she often uses both hands to pinch the coil into place, whereas in other areas potters usually use their left hand to turn the mold (pl. 212). She draws up and thins the walls by pulling her cupped right hand diagonally up across the interior, applying pressure through her forefinger against her left hand, which is pressed against the exterior for support (pl. 213). She adds another coil, pinches it on, and draws up the clay as before. Next, taking a section of gourd in her right hand, the potter uses this to draw up clay on the exterior, while her left-hand fingers provide support from inside, thus thinning and raising the walls further (pl. 214). She then applies a thinner coil and works it up as she did the others.

By now the walls are the desired height and the potter concentrates on a more refined thinning of the walls. The vessel is still in a crude state but, by scraping with her right-hand fingertips, the potter thins the interior before starting the vessel neck (pl. 215). Then she adds a thin coil of clay around the opening and draws it up with her cupped right hand as before (pl. 216). Next, she uses the piece of gourd to pull the clay in toward the opening (pl. 217). She scrapes excess clay from the rim with her fingertips (pl. 218) and smooths the inside of the vessel neck by passing the gourd around it (pl. 219), then using the palm and fingers of her right hand (pl. 220). The potter accentuates the flare of the neck by drawing a gourd fragment from shoulder to rim, pressing in halfway through her stroke for the shape she wants (pl. 221). With the gourd fragment, she now smooths the rim interior in the same manner (pl. 222). Still using the piece of gourd, she goes over the whole vessel for a final smoothing and shaping; then she may embellish the rim by pinching indentations with her fingers at intervals or by making small nicks with a thumbnail (pl. 223).

To form the handles, the potter first rolls out a clay coil and folds it in thirds to give her three short lengths of clay lying side by side. These she smooths into handles, which she attaches first at the lower point, then bends upward to the higher point. To space the handles, she measures with her hand from outstretched thumb to little finger. This again is different from other pottery regions of Guatemala, where handles are applied at the top first, the other end being allowed to fall gently into place a comfortable distance down the side of the vessel. The potter works the ends of the handles into the vessel walls to strengthen the joints, then puts the vessel aside to dry until it can be removed from the mold. After the mold is detached, the potter gives the vessel base its concave shape by pressing it down gently over a hemispherical section of gourd. After this is done, she applies slip with a piece of cloth that she wipes across the exterior. Next she burnishes the vessel with a stone, using long latitudinal strokes.

The technique of firing in this area is interesting: it involves construction, with green poles and saplings, of what is essentially a temporary kiln (pl. 224). The process begins

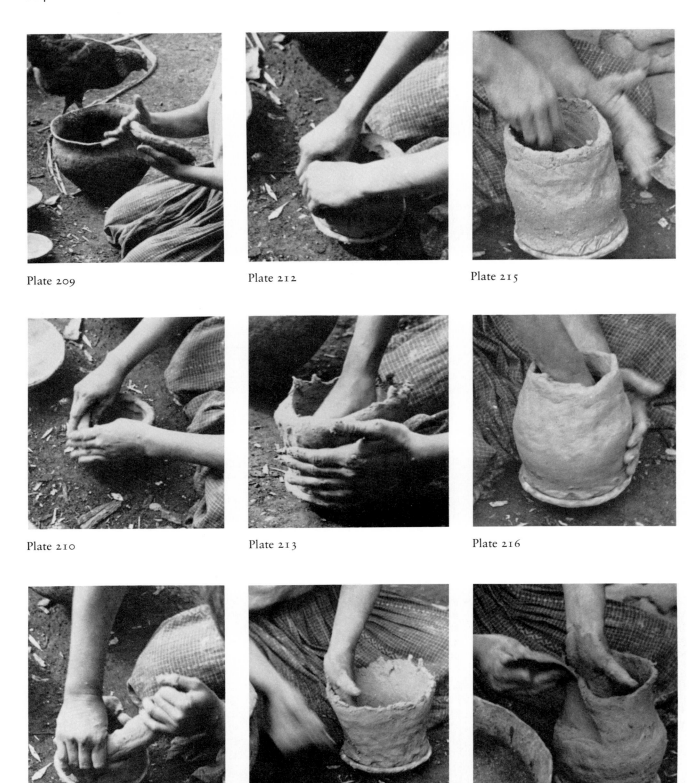

Plate 209

Plate 212

Plate 215

Plate 210

Plate 213

Plate 216

Plate 211

Plate 214

Plate 217

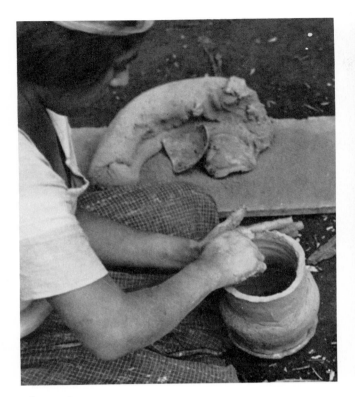

Plate 218

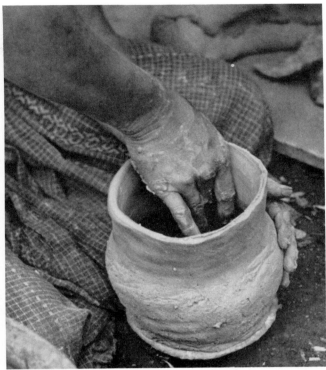

Plate 220

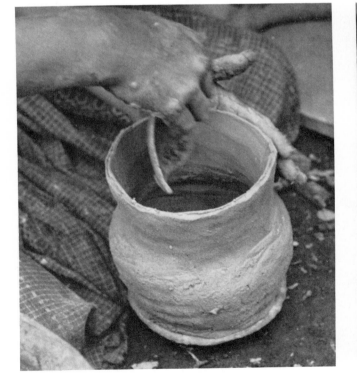

Plate 219

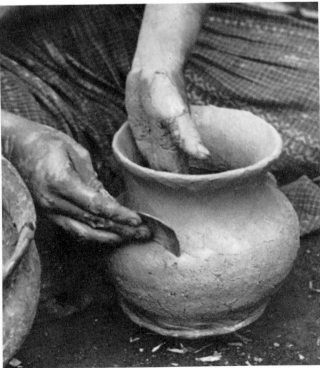

Plate 221

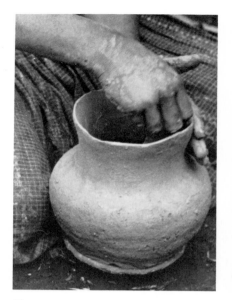

Plate 222

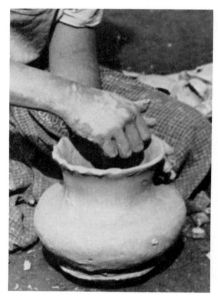

Plate 223

Plate 224

with the preparation of a bed of ashes, upon which dry branches are placed. The amount of fuel varies with the number of vessels to be fired, but informants stated that two loads of dry wood were needed to fire one dozen *tinajas*. Vessels are placed mouth down in one layer in the center. Around this a low structure of green logs is built up log-cabin style until the walls are higher than the vessels inside. Large amounts of green saplings and branches are needed to cover the vessels—four loads for each dozen *tinajas*. This procedure is followed, in the words of informants, "so that air does not enter." Actually, the flow of air is not being prevented, only controlled. After the fire is lit, air enters freely from the sides to promote efficient oxidation and high temperature. The green-wood cover not only retains heat during firing but also prevents the vessels from cooling too rapidly after the fire has died down. When partly cooled, the vessels are picked from the ashes with a pole and stored inside the potter's house.

With this technique of pottery construction, the potter most extensively studied could produce five to six vessels per day, but she worked only two days per week on actual construction, thus limiting her production to about a dozen vessels each week. While this daily production figure seems acceptable, many more potters probably spend three or four days building vessels.

The marketing of pottery in the Alta Verapaz is distinct from the pattern in the rest of Guatemala and reflects to a great degree the peculiarities of the dispersed settlement pattern. Women take their vessels to several markets, including Cobán, San Pedro Carchá, Tactic, and San Cristóbal Verapaz. Most of the vessels are purchased there by the local people, others coming in from the surrounding *fincas*, and pottery merchants. Much trading between vendors and merchants and among merchants takes place in San Pedro Carchá, after which vessels

move north in quantity to the more remote *fincas* and settlements. A good deal never reaches the market, however. People living near potters tend to go directly to them to purchase vessels. This, combined with the geographical separation of potters in the area, means that much pottery is distributed locally without ever entering the market system.

Salamá

The *pueblo* of Salamá is the department capital of the Baja Verapaz, located nearly eighty-seven miles by road north of Guatemala City at the north slopes of the Chuacús Mountains. Salamá, founded in 1562, was settled by Spanish colonists and squatters. The Dominican fathers, anxious to succeed with their social experiment in the Verapaz, attempted to keep the native population isolated but could not stop the continued influx into the fertile Salamá Valley. As a result, although approximately one-quarter

of the inhabitants still speak Kekchí, Salamá is predominantly Ladino in character, and its social structure is open. In 1950, the *pueblo* itself had a population of 2,760, with nearly 10,000 people living throughout the surrounding hills and the valley in thirty-eight *aldeas* and thirty-one *caseríos*.[4] Pottery production is centered in the *aldea* of El Rincón Grande, east of the town, although pottery is also made in other *aldeas*.

The pottery of the Salamá *aldeas* falls within the traditional Maya techniques, although it is made in Ladino fashion by women who no longer dress in the native manner, who speak Spanish, and who work standing at an elevated platform or table within the house, except when making *comales*. The predominant forms are the *olla* and the *comal* (fig. 39). Other forms, including the *apaste, tinaja, jarro,* and *sartén,* are still made but are far less common. The *tinaja* is now rare, as most of the *tinajas* used locally are imported from nearby Rabinal. The *sartén* is made only for local *fiestas,* having

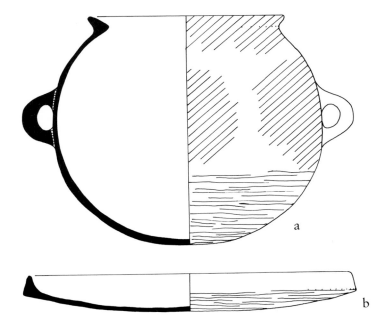

Figure 39. Salamá vessel forms. (a) orange-washed *olla*, (b) *comal*. Scale 1:4. From the University of Pennsylvania Museum, Philadelphia, Reina-Hill Collection, 1973

been replaced by modern metal pans in most households. It has a rounded base, low vertical walls, and two triangular nubbin handles on the rim. The *olla* is produced with a flat base and a rounded lower body up to the edge of the mold. From there the walls are straight but angle slightly upward, stopping at a small everted rim. Two opposite strap handles, roughly vertical, are placed on the upper body. In general, vessels are poorly executed, with little attention paid to the details of symmetry, slipping, and affixing handles.

The female potters collect the light clay, which fires to a reddish brown; in the vicinity, they also secure a special clay for the thin orange red slip they put on *tinajas*, *ollas*, *sartenes*, *jarros*, and *apastes*. The only imported item is the talc they grind and rub into the *comales* to form a nonstick surface. The potters wedge the clay thoroughly and add a temper of sand, sifted wood ashes, or a combination of both in variable quantities, depending upon the consistency of the raw clay.

To construct an *olla*, the potter works at a wooden table inside the door of her house. She places the prepared clay in a fired-clay concave basal mold and presses and smooths it into this mold to form the vessel base. As soon as it can be safely lifted, she removes this wet form from the mold and sets it aside to dry. When it is leather-hard, the potter returns the partially formed vessel to the work table. She shapes an extremely large and heavy coil of clay between her hands (pl. 225), applies this to the inner edge of the rim with her left hand, and pinches it well into place with the thumb and fingers of her right hand (pl. 226). Despite its great size, the coil is only long enough to reach halfway around, so she rotates the work on its base and places a similar coil on the other side.

Next, without any tools other than her wet hands, the potter raises the two coils to form the upper walls of the vessel (pl. 227). With her left

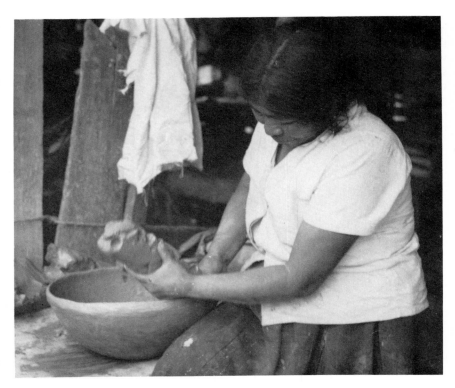

Plate 225

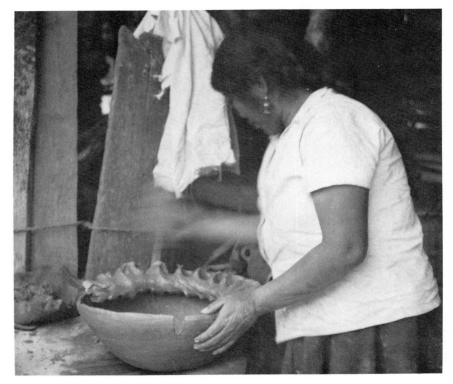

Plate 226

hand in the interior and her right on the exterior, she draws the clay upward in short, then longer, diagonal strokes, applying pressure through her fingertips and turning the mold as necessary to reach new sections of the work. She removes excess clay by scraping along the rim with the fingertips of her right hand, while slowly turning the vessel with her left hand. She then shapes, thins, and scrapes the interior, working with the palm and fingers of her left hand in latitudinal sweeps, while her right hand parallels the strokes on the exterior (pl. 228).

To form the rim, the potter uses a small piece of leather. This she soaks in water and drapes over a section of the rim area, then presses the clay through the leather with her right hand, between her thumb on the inside and her last three fingers on the outside. Her left hand rotates the vessel slowly in a counterclockwise direction (pl. 229). After several turns, she bends the lip outward to its everted position. Then, holding the strip of leather—rolled into a small cylinder—in her right hand, the potter makes a final sweep around the vessel to finish the rim by applying pressure between the leather on top and the first two fingers of her left hand on the outside edge (pl. 230). She smooths the vessel all over with her wet palms and puts it aside on the floor to dry.

Handles, quickly and crudely shaped between the fingers from short lengths of clay, are applied carelessly and unevenly. No burnishing is done, but some vessels do receive a weak orange red slip in careless patterns of bands and loops.

Women who make *comales* specialize in this form; they use techniques different from those used for the other Salamá vessels. A potter shapes the *comal* upon a fired-clay mold placed on the ground. She spreads the clay and smooths it over this mold with skillful fingers and hands, then rotates the newly made *comal* between the fingers of her right hand to form a rim. Once the *comal* becomes partially dry, she

Plate 227

Plate 228

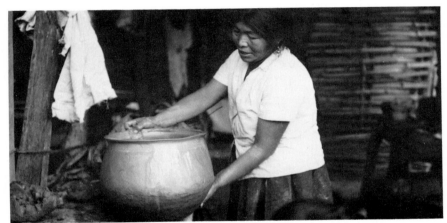

Plate 229

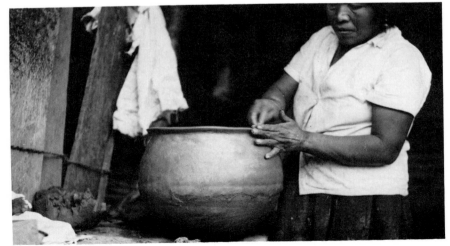

Plate 230

removes it from the mold and rubs a suspension of ground talc thoroughly into its inner surface. The talc coating is smooth, without the swirled pattern characteristic of the *comales* made in San Raimundo.

Salamá pottery is stacked and fired in the open, in a manner similar in all respects to the method generally used in the Guatemalan highlands, except for the *comales*. These are stacked on edge against an adobe wall and fired, a procedure much like that followed in San Raimundo. The percentage of breakage seems high, to judge from the piles of discarded, damaged vessels in the yards.

Most of the *olla* production is used in the nearby area, either in the potters' own households or, sold through the markets of Salamá, San Miguel Chicaj, and San Jerónimo, in others. The only form with a wide distribution is the *comal*. These are carried by tumpline on the backs of merchants traveling to Cobán and other markets of the Alta Verapaz. The profit from this grueling two-day journey is so low that until recently merchants could not afford to use motorized transport and stay in business. The Salamá area is definitely a minor center of production. Pottery making appears to be on the decline, but any scarcity of pottery from Salamá is more than amply filled by vessels from Rabinal.

Rabinal

The *pueblo* of Rabinal is in the Baja Verapaz, within the fertile Urrán Valley to the north of the main ridges of the Chuacús Mountains. This valley is rich in pre-Columbian tradition, and the Rabinal area itself has a legacy of occupation by Maya peoples since long before the Spanish conquest.

Archaeological sites abound in the vicinity. Chipochec is ten and a half miles west of Rabinal, Tiquerán lies eleven miles northwest, and Tuculacán is thirteen and a half miles to the east. The splendid ruins of the Late Postclassic citadel of Cajyup (Cacyiú) overlook the town almost two miles to the north, and the even larger site of Chuitinamit (Nima Tinamit or Tzoc Pocoma) is on another high hill six miles across the valley.

According to local legend, these sites were built by the Pokomam, who were forced to abandon their fortresses to the armies of the expanding Quiché nation shortly before the Spanish conquest. The men of Rabinal who relate the accounts point to the pass over the Chuacús to the south, leading to the Valley of Guatemala and Mixco Viejo, as the route taken by the retreating Pokomam refugees.

Rabinal is mentioned in several pre-Columbian Maya chronicles. The *Título Real de don Francisco Izquín Nehaib* records the tribute from Rabinal to the Quiché king: "The bearers from Rabinal entered at midday to pay their tribute of cacao, their tribute of salt and *jícaras*."[5]

In 1537 the famous Dominican friars, Bartolomé de las Casas and Pedro de Angulo, met with the *caciques* of the Quiché provinces in the Urrán Valley region. According to tradition, these *caciques* were led by one named Rabinaleb. As a result of this famous meeting, twelve *caciques* accepted de las Casas' offer of peaceful conversion to Christianity, and the way was opened for the conquest of the "valleys of eternal peace" (*los verapazes*) without a shot being fired. Soon thereafter, de las Casas founded the town of Rabinal, building a church and one hundred houses for its inhabitants.[6]

Archbishop Cortés y Larraz visited Rabinal between 1768 and 1770. He wrote of Rabinal's "beautiful location" and estimated the population at nearly 3,000 Indians and 283 Ladinos.[7] In the nineteenth century Rabinal was the home of Brasseur de Bourbourg, the famous Maya linguist and scholar. As of 1950, the *municipio* had a population of 11,858: 9,065 Indians (speaking Rabinal Achi, a dialect of Quiché) and 2,793 Ladinos. The *pueblo*, an important administrative center, had 2,743 inhabitants, approximately 900 of whom were Ladinos, and the remaining people lived in twelve *aldeas* and fifty-five *caseríos* distributed over an area of 313 square miles.

Most potters live in the *pueblo*, in the *barrio* of San Sebastián, while people with other specializations—among them painting the gourds typical of this town, raising fruits, and working in general agricultural activities—reside in the *barrios* of Santo Domingo, Apóstol, and Mártir respectively. The Ladinos of the *pueblo*, residing near the plaza, have a socially open community. However, the *barrios* appear as closed corporate social units, each practicing a specialization and linked to each other by sixteen organized *cofradías*. Unlike potters in other pottery centers, the male potters of San Sebastián have their own *cofradía*, La Cofradía de los Alfareros, which is in charge of the May third celebration—the Day of the Crosses. In addition to their religious obligations, male potters are expected to produce their best vessels for all the other *cofradías* as well as for their own at celebration times. These vessels are needed in the chapel to present each *cofradía* with twelve *tinajas* full of a ritual drink. The best male potters have reached the highest *cofradía* rank and themselves produce or supervise the production of vessels for ceremonial occasions. Other potters, most of them women, live in *aldeas*. They produce the vessels sold in large quantities to itinerant merchants for resale in regional markets.

About twenty years ago, a factory was established in Rabinal as a commercial venture to mass-produce wheel-made but unglazed pottery, primarily for the urban and tourist trade. This pottery, recognizable by the shallow relief versions of so-called ancient Maya motifs

painted in garish, postfired colors (red, green, and black), is not to be confused with the indigenous pottery traditional of Rabinal.

In colonial times, the potters of Rabinal manufactured hundred-gallon jars to store the wine and olive oil produced by the great Dominican hacienda of San Jerónimo in the nearby Salamá Valley. Although the vineyards and olive groves have long since disappeared, this legacy has had a profound effect on the traditional pottery of Rabinal. It appears that, in order to manufacture these storage jars, the Spanish recruited men and trained them to become potters. Even though these large vessels are no longer made, the heritage of this colonial industry lives on. One male potter expressed this loss: "In the days of my grandfather, we were true potters."

Today, in contrast to the prevailing pattern in Guatemala, pottery making in Rabinal is a cooperative family undertaking that involves the full participation of males and females of all ages. Father and son engage in the tasks of supplying and preparing the clay, as well as actually forming the vessels, assisted by the women of the family. Even more unusual, perhaps, is the fact that seldom does one member of the household make an entire vessel. Rather, one of them—the father, for instance—may shape the amorphous clay to a point where it becomes a semifinished vessel, whereupon he abandons it and turns to making a second, a third, and possibly up to ten vessels, bringing each to the same stage. Meanwhile his wife and children have been working in a similar manner, but any one of them, depending upon his or her ability, may leave their self-imposed task and complete the vessels begun by the father. In due time this family member—the daughter, for instance—may return to the vessels which she began, if these have not already been finished by her brother, mother, or even father. And so it goes, through the many separate

steps involved in making a vessel. Not one person but three, four, or possibly more may add their touches to a single vessel. The result, in households where there are several family members of near equal abilities, is a patio of very active potters. This pattern seems the more amazing as one notes that all is being accomplished in silence, without strong direction from any one person.

Rabinal potters produce two types of traditional pottery, each with a particular inventory of forms and each aimed at satisfying a different market. The first type, characterized by heavy walls, red orange color, and incised decoration, is acknowledged by older potters to be the most traditional pottery. The other has much thinner walls and is lighter, less finely finished on the surface, and decorated with white paint. This second type is produced expressly for export, particularly to the Alta Verapaz. Its light weight allows merchants to carry more vessels. The lack of attention to finishing details allows larger quantities to be made and keeps the price low enough to be more than competitive with pottery produced in other areas.

The first type of heavy, traditional pottery includes *tinajas*, *cántaros*, *ollas*, *apastes*, and *braseros* (fig. 40). The *tinaja* is a large globular vessel with a low neck, a wide mouth, and a slightly flaring rim. Two distinctive strap handles—shaped like wings due to the addition of a small clay cone to the upper exterior surface of each handle—are placed opposite each other, attached at the shoulder and waist. The local *tinajera*—here called a *cántaro*—is similar, though larger and more spherical, with three wing handles spaced evenly and a much smaller mouth. This vessel is intended for use by men, who carry it by a tumpline through the three handles. Although the Arrotts make no specific mention of *cántaros*, we feel this must have been an oversight, because

cántaros are not a new form. The *tinaja*, on the other hand, is for women to carry on their heads.

Rabinal *ollas* have bodies similar to *tinajas*, the main difference being wide mouths and low flaring rims. Handle shape and placement are the same as on the *tinaja*. Local *apastes* are more nearly hemispherical and have a less pronounced break between body and rim. The rim itself is flaring, and two plain strap handles are attached opposite at the rim and high on the body. *Braseros* are similar vessels, though smaller, and have low pedestal bases. The Arrotts do not report the *brasero* for the 1950s, and again we feel this was an oversight. This ritual vessel is made especially for the various *cofradías* in Rabinal and thus would not normally be produced or seen.

All vessels of this first traditional type are made from a clay that fires to a deep, brilliant red orange. Incised decoration is always applied to *tinajas* and *cántaros* and is frequently applied to *ollas*. *Apastes* apparently receive such treatment only on special request, such as an order placed by a *cofradía*. *Braseros* also receive incising but are made infrequently, as noted above. Decoration usually consists of a geometric pattern of dots and alternating straight or undulating lines. More elaborately decorated vessels have representations of birds and flowers. On a very large Rabinal *olla* found in Cobán, dating from the 1930s, a two-headed eagle was the central figure on one side, and a deer was the main figure on the other. These patterns are made with the blunted point of a wood, bone, or metal instrument. Although burnishing with a stone was reported by the Arrotts, our informants specifically denied the practice.

Of the pottery intended especially for export, only two forms are produced: *batidores* and *jarros*. The *batidor* appears to be a composite of an *olla*-shaped body with *apaste*-like handles and handle placement. The *jarros* have globular bodies,

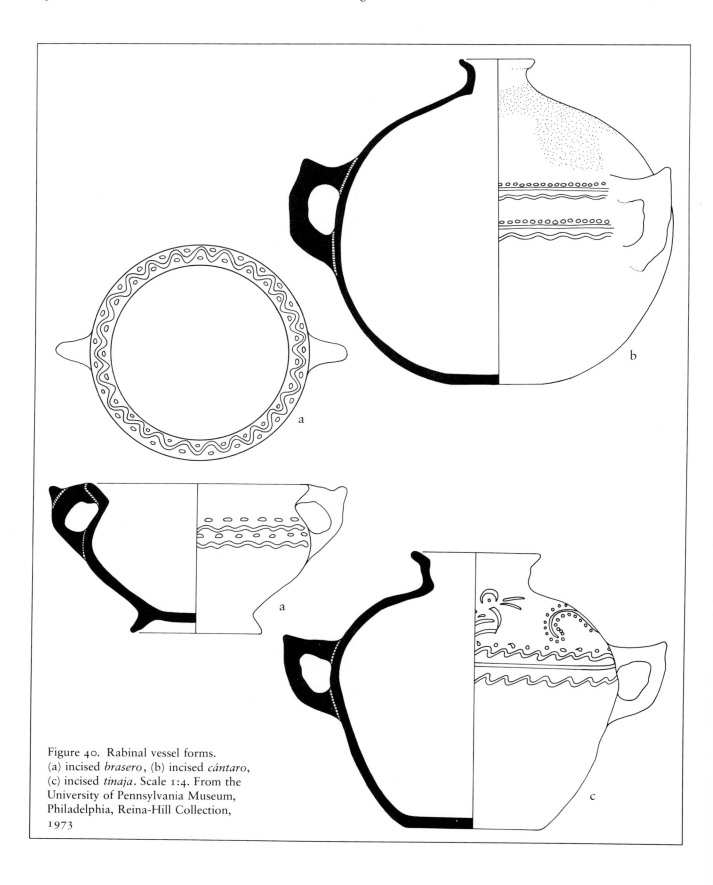

Figure 40. Rabinal vessel forms.
(a) incised *brasero*, (b) incised *cántaro*,
(c) incised *tinaja*. Scale 1:4. From the
University of Pennsylvania Museum,
Philadelphia, Reina-Hill Collection,
1973

high flaring necks, and modeled
spouts. One plain strap handle is at-
tached at rim and shoulder. As
noted above, these vessels receive no
special surface treatment, only a
cursory painting of dots between
white lines that may be straight,
wavy, or a combination of both.
This pigment is made from a blue
black talc, ground and mixed with
water. Although this type of pottery
may be an innovation to meet the
demands of a growing market in the
Alta Verapaz, the date of its intro-
duction was not obtained, and thus
proof remains lacking.

Potters go once a week to a mine
over a mile from town for clay. It is
dried in the sun at home, then put in
ollas with water to steep overnight.
Sand for temper is sifted through a
basket before being mixed with the
clay.

In Rabinal, potters work within
the courtyard of individual houses,
employing the orbiting technique.
To make an *olla*, a *tinaja*, or a *cán-
taro*, the potter begins by placing a
crudely shaped mound of wedged
clay eight to twelve pounds in
weight on a sanded bit of level
ground (pl. 231). He plunges the ex-
tended fingertips of his right hand
into this mass to a point less than an
inch above the ground (pl. 232). Al-
though this first operation is similar
to that performed in San Raimundo,
the Rabinal technique of plunging
only fingers, rather than the whole
fist, into the clay causes far less
disruption of the clay body and
preserves the integrity of its shape to
the greatest limit possible. When he
has reached the desired point—just
short of the bottom of the clay
core—the potter does not withdraw
his hand. Instead, he moves back-
ward, counterclockwise, around the
mound and thrusts the clay gently
outward, while the tips of his fingers
pull the clay in a slow, circular, and
upward-spiraling movement to form
the vessel walls (pl. 233). When the
walls have reached a height of about
ten inches, the potter rolls more clay
rapidly between his hands to form a
thick coil and places this firmly

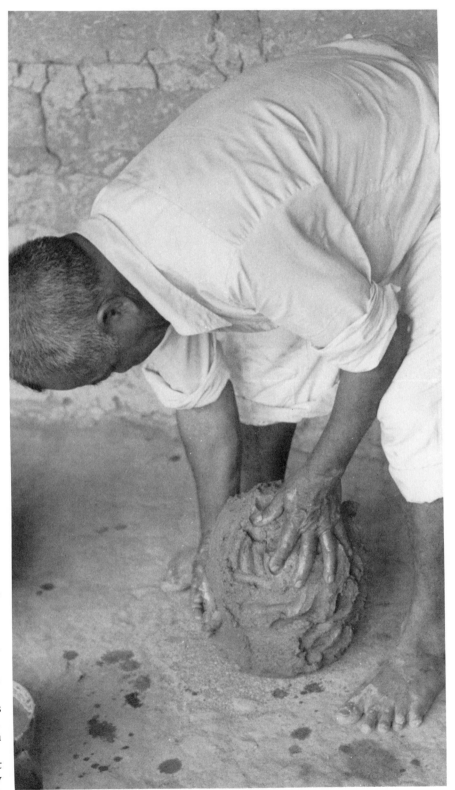

Plate 231

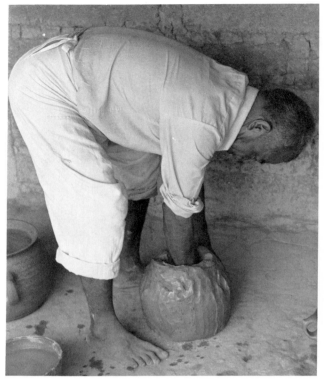

Plate 232

Plate 234

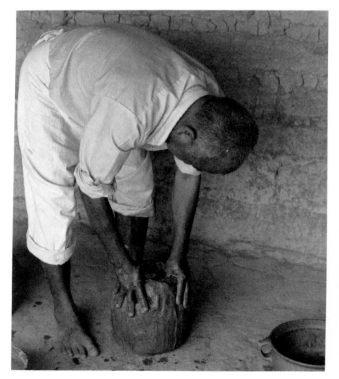

Plate 233

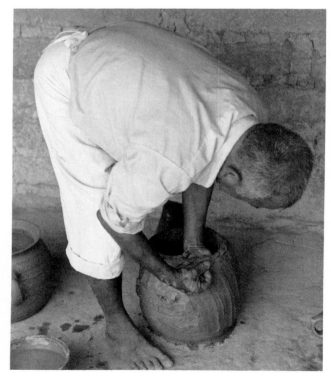

Plate 235

around the top of the work (pl. 234). This method of manipulating clay increases its strength.

From this point, the potter proceeds in a manner similar to that followed in other pottery centers that use this orbiting technique. When the interior has been formed, the potter shifts his left hand to the interior to support the walls while, reversing his circular movement to a clockwise direction, he uses the heel of his right hand to pull the excess clay of the outer surface upward (pl. 235). This is a diagonal motion that both thins and smooths. Supported inside by his left hand, which parallels the movement of his right, the vessel walls take on the desired form. Most excess clay is gathered from the exterior in his right-hand palm, though some accumulates at the top of the work and forms a small collar (pl. 236). With his left hand, the potter adds this excess clay to that on top, pinches it into place with his right hand (pl. 237), then draws it up in the same way, except that his hand works inside the vessel near the top. This action further joins and thins the walls. From this operation yet another mass of clay collects in his right hand, and again the potter adds it to the top. Excess clay from these coiling operations is stored in the bottom of the vessel under construction, where it remains moist and workable.

With coiling now completed, the potter begins to employ one of a number of fist-sized, slightly hour-glass-shaped wooden spools, called a 'koibaj (pl. 238). With one of these spools in his right hand, he starts at the exterior base of his work and draws the tool upward over the clay (pl. 239). The fingers of his left hand parallel this movement inside for support. After a few orbits around the vessel, the potter reaches the rim, where he uses shorter, lighter strokes.

For an *olla* the next step is formation of the vessel rim, for which the potter uses no tool other than a wet piece of cloth. Initially, the potter

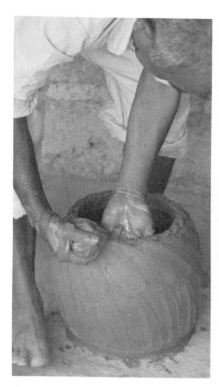

Plate 236

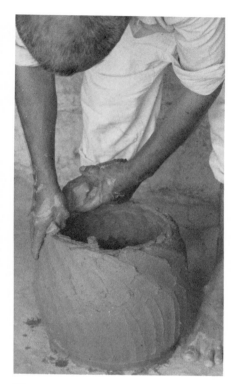

Plate 237

Plate 238

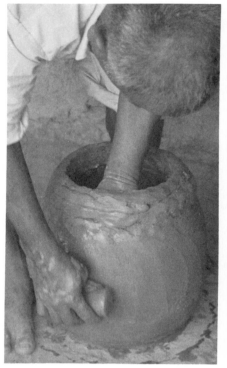

Plate 239

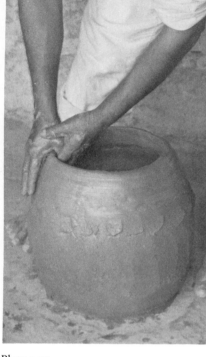

Plate 241

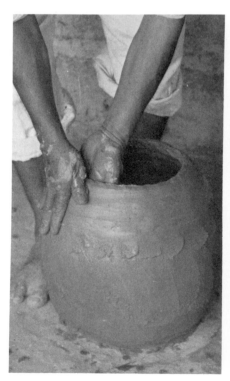

Plate 240

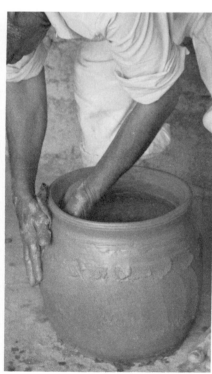

Plate 242

runs the crotch of his right hand around the edge, exerting moderate pressure to make it even. He then sweeps his left and right hands around the vessel—the latter still on the exterior, the former in the interior—to form a slight shoulder, so he can judge where to place the rim (pl. 240). He drapes the wet cloth over the edge and over it places the crotch of his right hand. Steadying his right hand with his left, he begins to bend the edge outward as he side-steps around his work (pl. 241). This soon gives a close approximation of the finished rim, and the potter switches his attention back to the shoulder area, which he smooths and shapes as before, this time with the wet cloth under his right palm (pl. 242); he then works his way down the sides of the vessel, smoothing and shaping with his hands and the cloth. A *tinaja* or a *cántaro* is built similarly, except the vessel walls arch over inward to form the shoulders, instead of flaring outward to form the *olla* rim. Whatever the form, the potter leaves the vessel at this stage to dry for one to one and a half hours.

The potter may now begin another vessel in the manner described above or, if he has enough ready, he may work on others at different stages of completion. Affixing handles, incising decoration, scraping, and other processes are all possibilities. These are jobs that any member of the family can perform as groups of vessels become ready.

To affix handles, in this case on a *tinajera*, the potter rolls out a suitable length of clay between his hands, then pokes two holes (one for an *apaste* or a *batidor*) through the vessel body with his right forefinger (pl. 243). He passes one end of the coil through the upper hole (or attaches it at the rim for an *apaste* or a *batidor*), then gently bends the coil and inserts the other end into the lower hole. Small bits of clay are added and worked into the area of the joints (pl. 244). To give the handle its characteristic wing shape, the potter adds a small cone of clay to

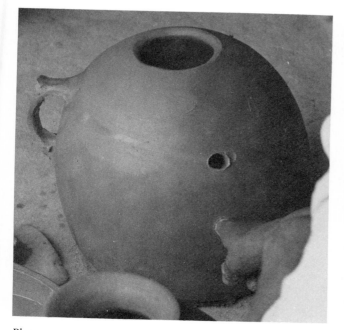

Plate 243

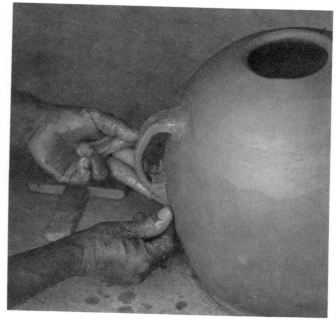

Plate 244

the top, then works it on and shapes it with his fingers (pl. 245). To measure for symmetrical placement, he uses the span of both hands as guides. Incised decoration is then applied, in this case by the potter's son to another vessel (pl. 246).

The potter may now thin the vessel interior. In the past, gourds were used to scrape the walls; now, however, sections of tin cans may be used as well. The vessel remains on the ground while the potter works bent over it. Holding the scraper in his right hand, he uses long powerful strokes around the interior to remove the clay, cupping his left hand around the exterior as support (pl. 247). He deposits excess clay in a nearby basket for reuse. The observer is acutely aware by now that, compared to potters in other centers, the Rabinal potter has used many times more clay than needed to build a vessel. More than *costumbre* must be at work here—factors of plasticity and the yield point of the clay are assuredly involved. With scraping finished, the vessel receives a final smoothing with a wooden spool and the hands, after which the potter leaves it to dry for

several hours before he forms the base.

When it is considered dry enough, the potter sits down and takes the vessel in his lap. He holds it on its side at an angle, mouth downward, and, using a scraper, does some initial thinning on the lower exterior and the base (pl. 248). Then, with his right hand clenched, he punches at the vessel bottom from the inside outward, while supporting the base from the outside with his left hand (pl. 249). Reversing the vessel position, the potter is able to support it from the inside with his left hand while, with the fingers of his right, he smooths the rough spots on the lower exterior and the base (pl. 250). He then resumes scraping to remove the scar left from where the vessel sat on the ground or where clay accumulated near the base (pl. 251). After smoothing the base with his moistened palms, the potter completes the vessel by going over it with a wooden spool (pl. 252); he then places it mouth down on the ground in the sun to dry.

The body of a *tinaja* or a *cántaro* is left to dry for two days before the neck is built up. For the neck, the

potter first adds a small coil of clay to the opening where the shoulder ends (pl. 253). He draws this upward on the exterior, holding a wooden spool in his right hand and keeping the fingers of his left hand in the interior (pl. 254). When the neck is the desired height, the potter gives it a final shape and flair by drawing a wet cloth around the rim of the vessel, in the same way he completed the rim of the *olla* (pls. 255, 256).

The technique of firing in Rabinal is distinctive. The number of vessels fired at a time varies between one and three dozen. Inside a hollow square or rectangle built of broken vessels, straw is burned to create an ash bed. Vessels to be fired are then set, mouth up, in the ashes in one layer only. The whole is then covered with an apparently random combination of fuels, including dried animal dung, brush, and straw (pl. 257). It appears that animal dung is preferred—one family studied sent the youngest boys out to the pasturelands with tumpline packs to gather it. As an actual firing was not observed, no data on length of firing are available. At least three-quarters of the vessels are ex-

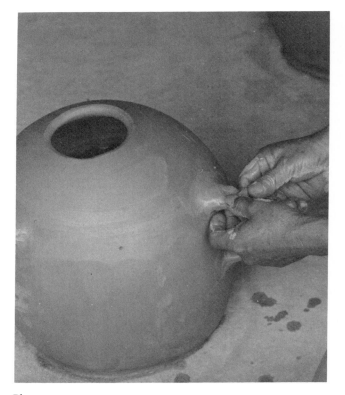

Plate 245

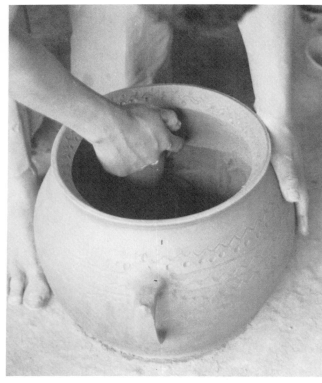

Plate 247

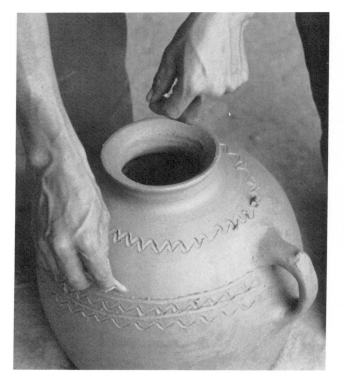

Plate 246

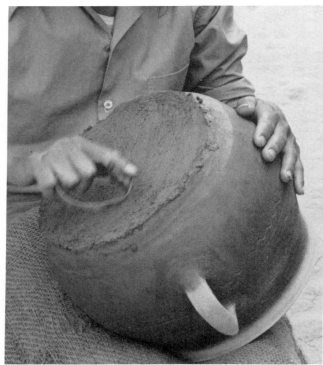

Plate 248

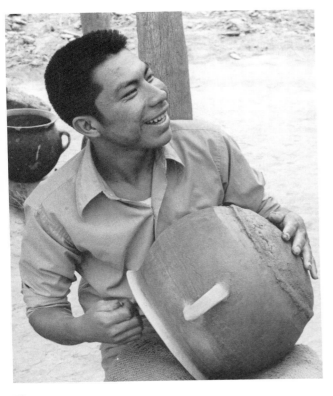

Plate 249

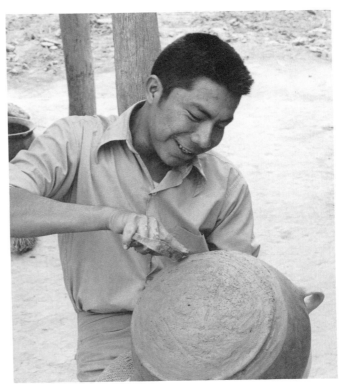

Plate 251

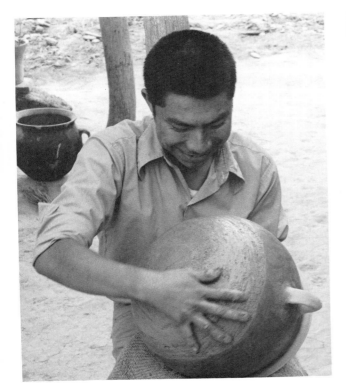

Plate 250

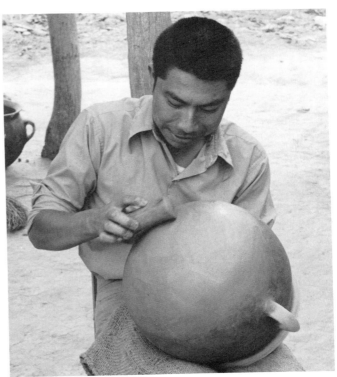

Plate 252

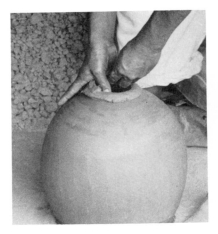

Plate 253

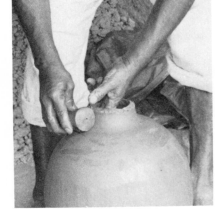

Plate 254

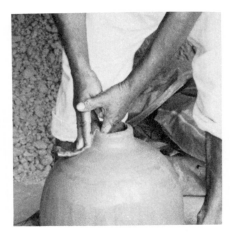

Plate 255

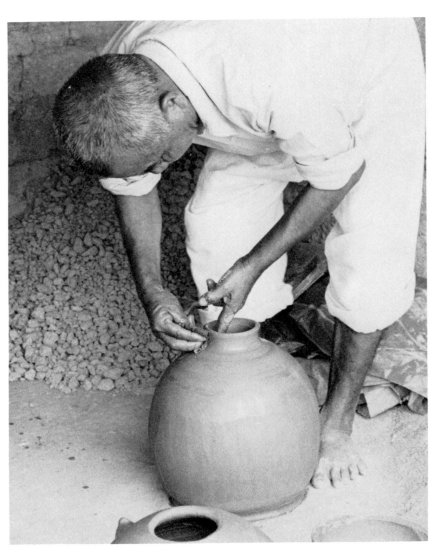

Plate 256

pected to survive firing. A common accident is the separation of the base from the upper vessel, but the cause of this is unknown.

As is often the case, productivity is extremely difficult to estimate. About two dozen vessels were under construction at the home of the family most intensively studied, requiring a ten-hour workday from 6:00 A.M. to 6:00 P.M., with a two-hour siesta. This was clearly hard work for the potters but, because these particular vessels had been ordered by a *cofradía*, they had to be finished. A figure of one dozen vessels per day seems closer to the average and—considering one day a week to gather materials, one to fire, and Sunday to rest—a weekly production of four dozen vessels seems reasonable. This is certainly within the capabilities of those potters who produce the lighter export-type ware, since less clay means less tiring work and shorter drying time for vessels. Pottery making is carried out to this extent only during the dry season, as the male potters tend their fields during the rainy season. Pottery production stops completely during the first two weeks of the rainy season so the fields can be prepared and planted.

Different mechanisms exist for marketing the two types of Rabinal pottery. Much of the heavy pottery is consumed in that part of the Baja Verapaz, and the *pueblo* of Rabinal

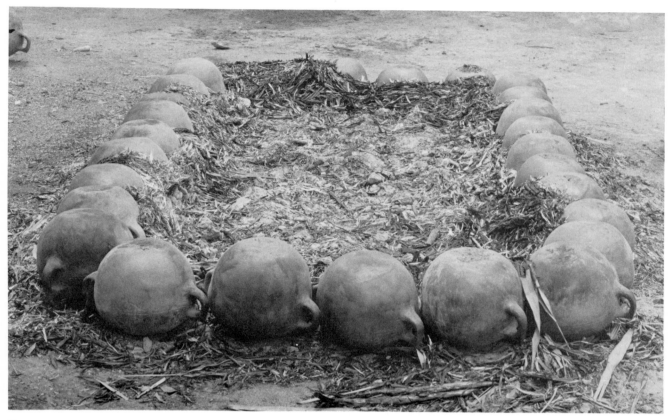

Plate 257

is extremely important as a distribution center. Here vendors sell to merchants who then redistribute the pottery to the various towns and settlements. Export-type pottery, however, is a different matter. The potters have regular buyers—itinerant merchants who come every few weeks to pick up several dozen *batidores*. As of 1975, the potters received $1.20 per dozen *batidores*. The pottery is then taken by truck to such markets in the Alta Verapaz as Cobán, Tactic, San Cristóbal Verapaz, San Juan Chamelco, or San Pedro Carchá. Here it finds a ready market, along with a few traditional Rabinal *tinajas* and *cántaros*, despite potential competition from local pottery-production centers around Cobán.

San José Petén

The *pueblo* of San José Petén is situated along the northwestern shore of Lake Petén Itzá in the midst of the lowland rain forest of northern Guatemala. San José is located approximately twenty-five miles southwest of the ruins of the majestic Classic Maya center of Tikal. The inhabitants of the *municipio*—less than 935 in 1950—particularly the 465 inhabitants of the *pueblo* itself, are descendants of the last independent kingdom of native Americans: that of the Itzá, conquered by the Spanish in 1697.

The Itzá began to lose their foothold in Yucatán in the latter part of the twelfth century. *The Book of Chilam Balam of Chumayel* makes reference to this event: "Then later in the Twelfth Century, Hunac Ceel, the ruler of Mayapán, organized a conspiracy against Chichén Itzá. . . .

The consequences were far reaching. . . . Not only was there a permanent readjustment of the political forces of northern Yucatán . . . it resulted in a migration of a considerable portion of the Itzá to the distant region of Lake Petén in what is now the Republic of Guatemala."[8] Later on, during the "great Maya revolt" of 1546 to 1547, large numbers of Indians again left their homes, and "some undoubtedly went to the distant and still free Petén Itzá."[9]

This description of San José Petén pottery making was included only because the area lies within the political boundaries of Guatemala. The technology is of interest in the lowlands, however, as it is similar to the one Thompson described for the Maya communities of the Toledo district, Belize.[10] We are hesitant to credit this technique to the Maya of the Classic period, since the Maya of San José derive ultimately from

Yucatán, and the origins of the Maya in the Toledo district are obscure.

Thus the linguistic, general technological, and other aspects of the San Joseños' cultural heritage are derived from the Maya of Yucatán rather than from those in the Maya highlands to the south. The Peteñeros have faced many natural, economic, and political hardships on their frontier and have forged a distinctive Peteñero cultural and social identity. The ways of the Maya have provided San Joseños with their technology (*milpa*, a livelihood derived from the forest, pottery, etc.) and with a knowledge of safety when they are in the forest. In the department capital—Flores—San Joseños are practical and well oriented to the national culture.

These Maya- and Spanish-descent Peteñeros have remained in isolation in this frontier area throughout nearly three centuries of postconquest history. Under such conditions each town of El Petén strove to remain a corporate community; however, in an isolated jungle area and in the absence of private landownership, there was a need to become involved with each other. Thus, there is both a community and a multicommunity level of social organization in central El Petén.[11]

The social integration of San José, different from pottery centers of the highland communities, is "based not on connective social institutions, but rather on shared standards of behavior and belief and on a commitment to a way of life explicitly defined as distinctive, or, at least, contrasting with the way of life found elsewhere in Petén. . . . San Joseños are conscious of existing in an historical context and perpetuating a valued collective past."[12]

San José is the only known pottery-producing center in the lowlands of El Petén. There is a dual orientation of production, however, as women make pottery both in the *pueblo* and on scattered *ranchos* of the forest next to *milpas*, but for very different purposes. While *rancho* pottery production is oriented toward domestic consumption or kitchen use, *pueblo* pottery is produced only once a year, in October, just prior to the home ritual with human skulls in November (pls. 410–413). In the absence of the *cofradía* organization typical of the highland area, San Joseños are guided by an older man known as the *prioste*. Only *ollas* are made for the ceremony; the ritual food consumed during the celebration is prepared in these vessels. After this initial ceremonial use, the vessels may continue to be used during the year, until they are replaced by new vessels before the next ritual.[13] Old and broken vessels are also used as containers in a variety of household tasks, including the production of pottery.

The shapes of the vessels made in and around San José Petén bear a close resemblance to forms produced in Late Postclassic Yucatán and El Petén, as well as modern Yucatán. Forms include *tinajas* (three different types), *ollas*, *tamaleros*, *cajetes*, *comales*, *batidores*, and *tapaderas* (fig. 41). Of these, the most interesting are the *tinajas*. Two types, locally called *cántaros*, are used to store water. They are produced in both narrow- and wide-mouthed versions, the former designed for pouring water, the latter designed for being filled with water poured from a gourd. The small-mouthed *cántaro* has a subspherical body, a high neck, and two horizontal strap handles placed opposite on the vessel shoulders. The wide-mouthed version has an S-curved body with a proportionately higher neck. Handle type and placement are the same as on the small-mouthed vessel. The third *tinaja*, the only one so called by the San Joseños, has a shape much more typical of *tinajas* of highland Guatemala. Its globular body is smaller than that of either of the other two, and its high flaring neck is intermediate in size. The greatest difference is that the two strap handles are placed vertically, attached at shoulder and waist.

Ollas are produced in a variety of sizes, but all have the same basic shape: globular bodies, with wide mouths and flaring rims. The *tecomate*, a bowl with a restricted mouth, has an almost hemispherical body, but the shoulders are built toward the center to restrict the opening. Two upturned horizontal strap handles are placed opposite a short way below the rim. *Cajetes* here are small hemispherical vessels with direct rims and no appendages. *Comales* are large—eighteen to twenty-four inches in diameter—and uncommonly deep. The *tapaderas*, used to cover the large *ollas* during cooking, are really *comales* with a large loop handle attached at the apex of the vessel's convex surface. The *batidores* are small vessels with subspherical bodies, high necks, and everted rims. A single, heavy loop handle is attached to the rim and waist of the vessel.

In 1960 to 1962, clay for the San José pottery was obtained without charge in Santa Elena, about two and one-half hours away by dugout canoe. This clay is preferred because of its prefered lead color. A mineral temper, called *hi*, is added before the vessels are formed. The *hi* is prepared from rocks, gathered in and around San José, containing feldspar and quartz. These are heated and ground on a metate and added to the wet clay. Occasionally *hi* is found already pulverized, as sand, at San Andrés, a *pueblo* about a half hour by canoe or on foot from San José.

After preparing the clay, the San José potter builds the vessel upon a small stone slab, which serves as a flat mold, placed in front of her. The potter, sitting on a low wooden stool inside her house, works the clay into coils to make the walls of an *olla*. She makes the first coil on the slab and, as she shapes the walls, leaves the base open. With the second finger of her right hand, she

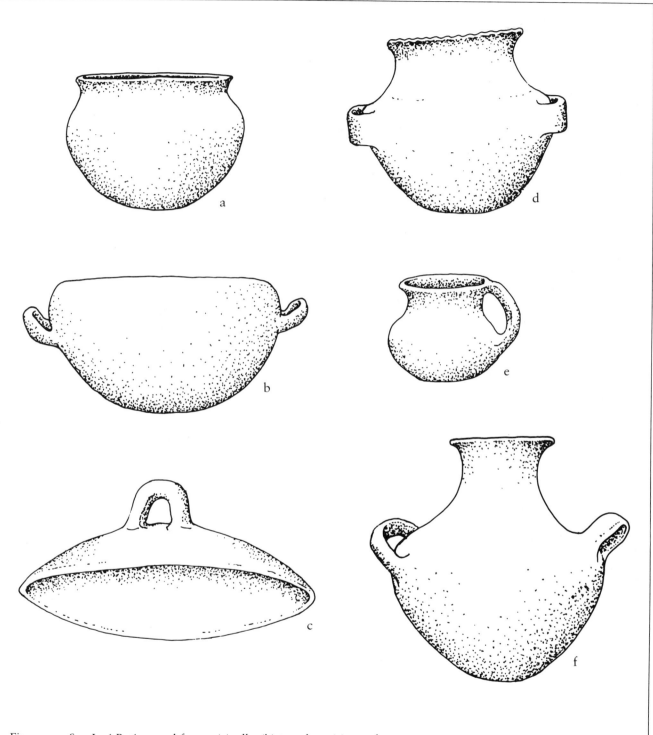

Figure 41. San José Petén vessel forms. (a) *olla*, (b) *tamalero*, (c) *tapadera*, (d) *cántaro*, (e) *batidor*, (f) *cántaro*. Scale 1:4 (approx.). Drawn from photographs taken by Margaret Arrott

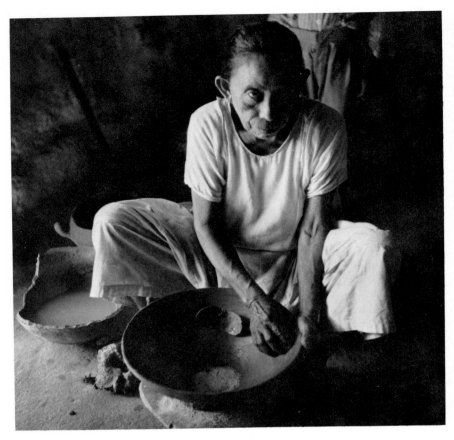

Plate 258

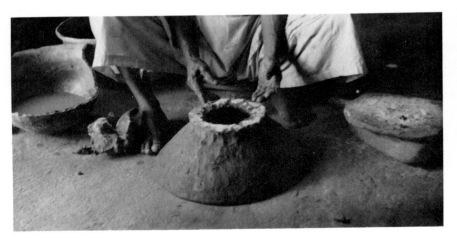

Plate 259

presses and smooths the coils, while her left hand supports the vessel walls (pl. 258). She leaves the half-finished *olla* to dry overnight, then removes it from the slab the next day and inverts it (pl. 259). To form the base, she adds clay to the opening left from the original coil and closes it over. After this has partially dried, she turns the vessel over and finishes the rim to form an out-turned lip. After scraping the vessel walls with a gourd to give them uniform thickness, she polishes them with a wet shell.

When a number of *ollas* have dried, five to seven are fired at a time. They are prepared for firing by being placed on their side, mouth inward, near a fire made of wooden staves and branches. This careful procedure heats the *ollas* gradually and undoubtedly results in fewer losses during the actual firing. After they have been further preheated by being moved closer to the fire, the vessels are finally placed directly upon the burning wood. A long wooden pole is used to move the vessels during firing (pl. 260); then more firewood is placed over them and allowed to burn freely.

Overall production of domestic pottery is low. Women in a total of only eleven households were still making it in 1960, and their production was exclusively for their households.[14] No pottery is made specifically for trade in the informal market on the beach at Flores. Some vessels are sold to other San Joseños at a relatively high price. In 1960, large *ollas* cost as much as $4.50, and small vessels sold for between 25¢ and 50¢.

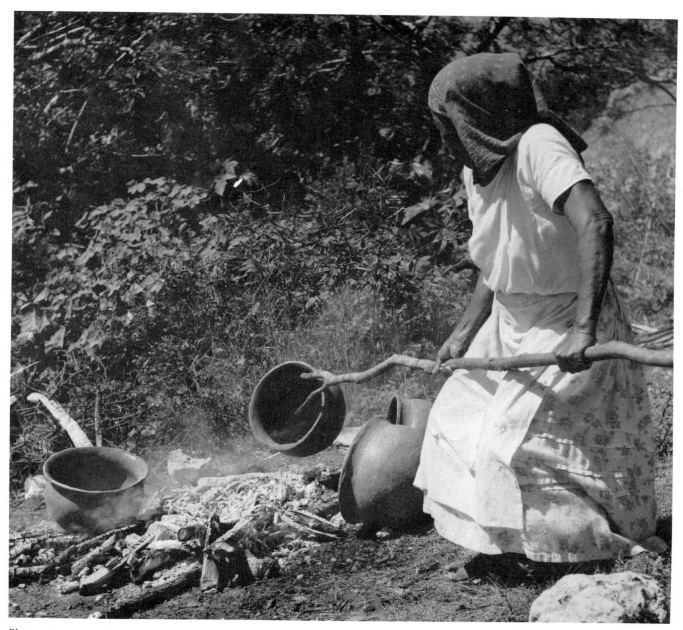

Plate 260

Map 6. Eastern region

6.

Pottery Production
The Eastern Region

This pottery region is located in the eastern lower highlands of Guatemala, commonly known as El Oriente (map 6). For many years this part of the country has retained a national reputation as a frontier. In contrast to the western highlands, Ladinos here are the dominant group and endeavor to maintain as much ascendancy over the Indians as possible. The social distance thus appears greater than it does in the west, to the extent that some social scientists in the past conceptualized the social structure on the basis of caste. With the exception of some Pokomam and Chorti enclaves, most people of Indian descent are well on the way toward Ladinoization, and few still speak a native language.

In contrast to the west, too, the climate is generally hot and, in some places, is dry enough to limit large-scale commercial activities to valleys where irrigation is possible. Livestock raising is an important source of income. The Pacific piedmont and the lower Motagua River Valley are rich agricultural areas given over mainly to *fincas* where coffee, bananas, and other cash crops are grown for export.

The prehistory of this region is complex and has not been fully explored. Various linguistic groups, among them the Pokomam, Chorti, Xinca, Pipil, and Popoluca, at different times controlled parts of the region; important sites, such as Asunción Mita and San Agustín

Acasaguastlán, have been reported. The detailed sequence of cultural development and population movements, however, is lacking. In postconquest times, the region was something of a backwater, and development begun in the last century still continues today.

Because of limited distribution of vessels from each of the pottery centers, this pottery region is further divided into three pottery districts: Zacapa, Jutiapa, and Cuilapa.

The Zacapa pottery district includes production centers in the departments of El Progreso and Zacapa (the middle Motagua area), as well as Chiquimula. A small number of pottery-producing settlements around Chiquimula were not visited. The district also receives large numbers of *tinajas* from the important center of San Luis Jilotepeque in the department of Jalapa. It is here, in the driest part of the Oriente, that successful agriculture depends on the irrigated river valleys. Aside from cattle raising and some mining, only a few traditional home industries are found, such as rope, mat, and pottery making. Indians speaking native languages live only in the *pueblo* of San Luis Jilotepeque and its *aldeas* (Pokomam) and in some *aldeas* of the mountainous eastern portion of the department of Chiquimula (Chorti). With the exception of these places, the settlements conform to the open noncorporate type of community social structure.

The Jutiapa pottery district includes the production centers of the Ladino *pueblo* of Zapotitlán and several Ladino *aldeas* directly south of Jutiapa, particularly Trancas and El Barrial. This district is more temperate than the Zacapa district. Basic agricultural crops grow well, and the livestock enjoys a national reputation. Speakers of native languages are almost nonexistent, even in the pottery-producing centers. At some point in the past, however, Xinca was spoken close to the department capital and to the west, and Popoluca was spoken in the far southeast. All settlements have Ladino-type open social systems with a trend toward socioeconomic differentiation based on skills, education, and wealth.

The Cuilapa pottery district includes the production centers of Casillas, Santa María Ixhuatán, and Guazacapán. Most of the pottery produced here supplies the workers residing temporarily or permanently on the many *fincas* of the piedmont and Pacific coast. While the upland portions of this district are dry, those in the coastal lowlands are tropical and are given over to sugar cane and coffee. With the exception of Guazacapán, these are typically Ladino *pueblos* with social divisions along socioeconomic lines. The potters appear to be at the lower levels of the social-class system, residing at the entrance to the town or in nearby *barrios* or *aldeas*.

The Zacapa Pottery District

San Agustín Acasaguastlán

San Agustín Acasaguastlán is located in the department of El Progreso near the confluence of the Hato and Motagua rivers. The extensive occupation of this area in pre-Columbian times has been documented by Smith and Kidder.[1] In colonial times, this town marked the eastern limit of settlement in the Motagua Valley. Today the town exists by virtue of agricultural activities on the irrigated bottomlands, as has presumably been the case in the past.

Of the 11,196 inhabitants in 1950, 2,548—including 515 Indians—lived in the Ladino *pueblo* proper. The rural population—living in eighteen *aldeas* and forty-four *caseríos*—was made up of 8,642 people: 5,000 Ladinos and 3,642 Indians. Their linguistic affiliation is uncertain. Miles believes there was a preconquest and a historical Pipil-speaking population in the valley.[2] She feels that there are two alternative interpretations: (1) the Pipil settled immediately subsequent to the conquest, or (2) the Acasaguastlán district was bilingual—both Nahuatl and Pokom were spoken. All these observations seem to suggest that the area where this unusual contemporary pottery is produced coincides with a special type of archaeological assemblage described by Smith and Kidder, as well as with a complex linguistic history observed by earlier writers and compiled and interpreted by Miles.

The people of this area today are of Maya descent but, as a Ladino informant declared, "they do not speak *lengua*." Spanish, with a distinctive accent, is their current language. The husband of a potter in the *aldea* of Los Llanos said, "We are half Indians because true Indians are those who speak their own language. We speak no *lengua* and therefore we are half Indians." Furthermore, being from an *aldea* reinforces an Indian's social stand-ing in this area. These people feel inferior to others, humble, and poor: like Indians, in other words.

Control of the semidesert environment is the chief concern of the men in this area, and success is measured by the crop of maize they can raise. In the nonirrigated areas the work is hard, and "the hillsides are not always willing to produce." Much of the time, reported an informant, "we work *por gusto* in our own land," that is, for nothing, particularly when no winter season brings rain.

Contrary to other areas of Guatemala, where rain seems to be more predictable, the winter in this area is less constant—"sometimes it rains and sometimes it does not." Nevertheless, after the slash-and-burn preparation, these people still venture to plant seeds and hope that the earth will produce food for themselves and their families. Even when a crop can be coaxed from this harsh environment, land used only once must be left fallow for many years. The people farm without modern fertilizers in the belief that the dryness of the environment, together with the power of the chemicals, will "burn" the plants.

The uncertainty of the crops from year to year and the rate of inflation that affects even minimal needs leave the people at a precarious subsistence level today. The population pressure has also hurt, making it necessary for all members of a household, particularly the adults, to do something that will add to the family income. Thus, for the past thirty-five years there has been a revival of pottery making, utilizing what appear to be the traditional techniques of the region.

The pottery identified as coming from San Agustín Acasaguastlán is not made in the town itself. This is another instance where pottery recognized as coming from the *pueblo* is in fact produced in some of the surrounding *aldeas* and *caseríos*, where the potters occupy small plots of inferior agricultural land far away from the river.

Pottery making and almost all the tasks related to it are exclusively the work of women. As a typical example, a potter between forty and forty-five years old was observed being helped by her daughter, who was in turn teaching pottery making to a daughter of her own.

The shapes produced in these *aldeas* are limited to *apastes*—here called *ollas* and *ollitas*—and *comales* (fig. 42). There are seven sizes of *apastes*, ranging from ten inches to three feet in diameter, with the larger sizes proportionately deeper. *Comales* are produced in two sizes: one and one-half and two feet in diameter. A very small *comal*-like piece, six to eight inches in diameter, is used as a *tapadera* for imported *jarros* and *tinajas*.

The vessels have an unusually slippery feeling due to the extremely high proportion of *chistún*—talc chlorite schist—that prevents sticking. They are moderately well finished and smoothed on the interior and around the rim but, because of the use of the full mold, the lower exterior is rough. This may be functional, however, for the smoothed interior is extremely slippery and difficult to hold on to. If the exterior were similarly smoothed, the vessels would be difficult to handle, especially when wet.

Clay is obtained without cost from the surrounding hills, as is the all-important *chistún*. The clay fires to a light brown. Over the years, cavelike mines have been opened at the clay and *chistún* deposits. Clay from the lower part of the deposit is believed to make better pottery. The potters carry on all activities associated with their craft. They mine the clay and *chistún*, gather the firewood, and carry all these materials home. Occasionally the men will help mine the clay and *chistún*, but it is still up to the women to carry the materials home.

The first steps in producing pot-

Figure 42. San Agustín Acasaguastlán *apaste* (*olla*). Scale 1:4. From the University of Pennsylvania Museum, Philadelphia, Reina-Hill Collection, 1973

tery in San Agustín Acasaguastlán are the preparation of the clay and the *chistún*. The clay, as it comes from the mine, is put into a large, old *apaste* with water, and the clods are allowed to disintegrate. The mixture is thoroughly stirred, and the clay settles out: the heavy stones and pebbles fall to the bottom, and the finer particles—used in making pottery—rise to the top. *Chistún* comes from the mine in chunks and must be powdered to make it usable. It is either milled in a corn-grinding machine, then ground on a metate, or the entire process can be done by hand on a metate. In the latter case, the rock-sized pieces are broken up into a coarse sandy consistency, then ground into a powder. The potter has a section of tree trunk two and one-half feet in diameter partly sunk into the kitchen floor for this specific use. An ordinary river cobble serves both as a hammerstone to smash the *chistún* and as a mano to powder it by being rolled back and forth on the surface (pl. 261).

The mixture used to make the vessels is prepared by combining the powdered *chistún* and clay (pl. 262). *Chistún* is by far the major element —the clay serves only to bind it together. The potter knows she has the correct proportion when the mixture no longer sticks to her hands.

The final step before construction is preparation of the full mold. The potter first spreads a thin layer of ashes on the interior of the mold, then sprinkles a little water on this so that both the ashes and a layer of powdered *chistún*, added after the water, adhere to the walls and keep the new vessel from sticking to the mold (pls. 263, 264). Both *comal*

and *apaste* molds are similarly prepared. This, like all the following steps in production, is carried on inside the potter's house. The potter sits on the floor, on her knees, with her work in front of her.

To make a *comal*, the potter takes a lump of the clay-*chistún* mixture from the *apaste* in which it had been readied and places it on the prepared mold near the edge opposite her, rather than in the center (pl. 265). After wetting her right hand with water from another *apaste*, the potter, drawing the tips of her fingers toward her, pulls clay from the bottom of the lump. Of necessity this step requires heavy pressure and leaves deep finger grooves in the clay. During this process, the potter's left hand steadies the mold (pl. 266).

After having spread only a few inches of clay around the lump opposite her, the potter rotates the mold approximately 45° and begins to work on the rim adjacent to the clay she has drawn out. The fingertips of her right hand push the clay up to and on to the top of the mold rim. The palm of her left hand, against the edge of the mold, both steadies it and acts as a guide to limit the rim size and overhang (pl. 267).

As she works on the rim, the potter has been drawing out more clay from the lump, thus covering more of the mold. After forming approximately one-third of the rim, she draws her right hand along this section, thumb outside and fingers inside, to smooth it. By this time, she has covered approximately two-thirds of the mold with clay.

Next the potter completes the area behind the clay lump and builds that section of the rim. She then draws more clay from the lump to

cover the remainder of the mold and form the rest of the rim, as before (pl. 268). The emphasis, as in all full mold pottery making, is on the rim, as this is the only area not directly formed by the mold.

At this time, the potter removes the last of the lump of clay, now considerably shrunken, a bit at a time with her right-hand fingertips. She continues scraping in this manner below the level of the surrounding clay, leaving deep grooves in the surface; she no longer uses her left hand, which lies on her knee (pl. 269).

To smooth out the roughened surface of the *comal*, the potter draws the palm of her right hand in a crescent-shaped motion back and forth, applying light pressure with her forefinger, while her left hand steadies the mold (pl. 270). After this step, the vessel is considerably smoother, although the process itself creates broad shallow grooves in the surface. The vessel by this point has attained the final shape of a *comal*.

The potter next gives the vessel a final smoothing with a small wet piece of cloth. She places the cloth over the rim—covering both interior and exterior—and her right hand, on the outside edge, draws the cloth along the rim (pl. 271). She does not rotate the mold during this process but manages to twist her body to reach the far side. At times she supports herself with her left hand on the ground as she twists.

The potter continues smoothing the rim with the wet cloth, but now she has her thumb inside the rim and her fingers outside, to apply more pressure without distorting the shape. Another sweep around the interior of the rim with the cloth, pressing with her right-hand fingers, completes construction, and she puts the mold outside to let the *comal* dry, first in the intense sun, then overnight indoors, after which she can safely remove the new vessel from the mold.

Before the firing, the vessel receives a cursory burnishing. The potter sits on the ground with her

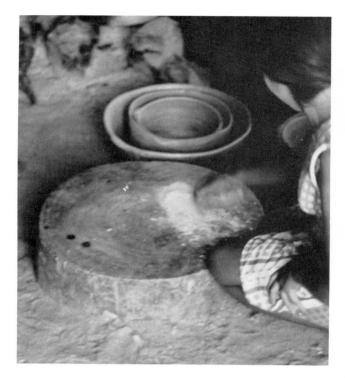

Plate 261

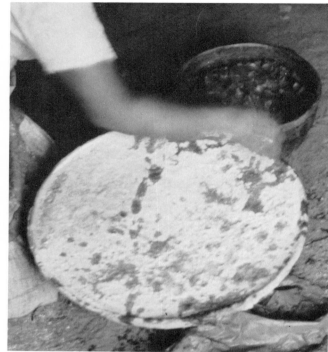

Plate 263

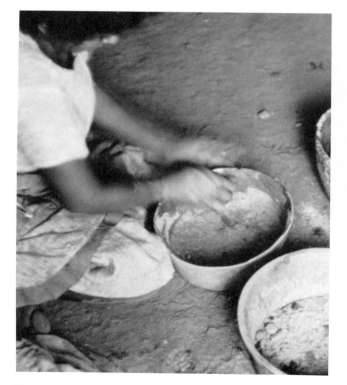

Plate 262

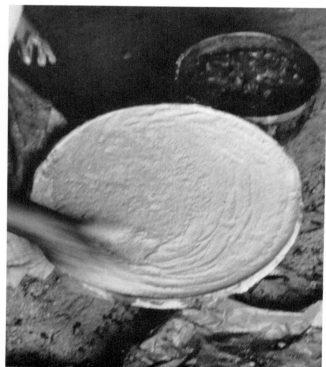

Plate 264

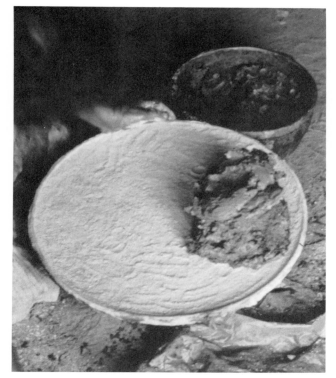

Plate 265

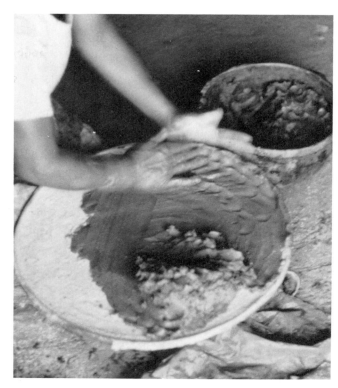

Plate 267

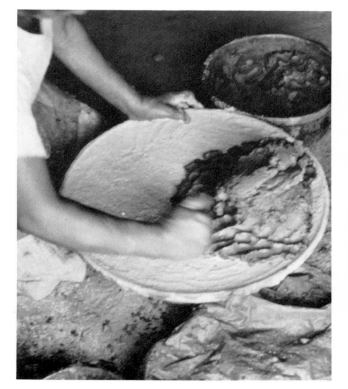

Plate 266

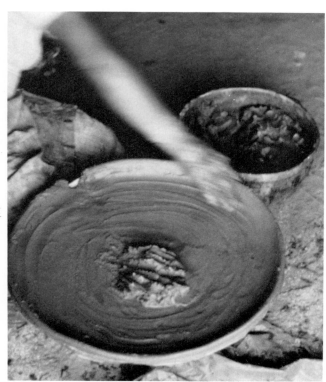

Plate 268

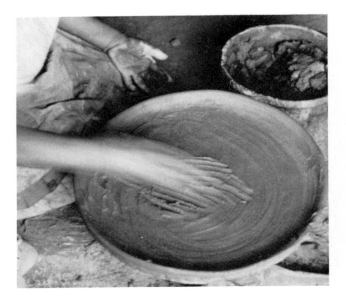

Plate 269

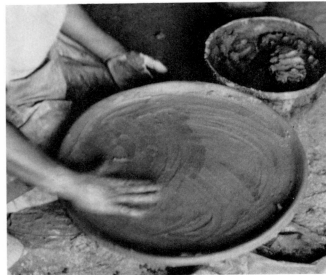

Plate 270

legs beneath her and to the right, with the *comal* placed on her lap. Using a small rounded river cobble in her right hand, the potter draws it back and forth across the interior of the vessel, leaving light crescent-shaped lines on the surface (pl. 272); shifting to the rim, she uses much shorter strokes, following its curvature.

In the construction of an *apaste*, the potter follows the same steps in sequence but builds the rim of the vessel approximately two inches higher than the rim of the mold. After it dries, she takes the new vessel from the mold and adds small lug handles. She scrapes the exterior with a metal bottle cap for a casual smoothing and finishes the interior as she does a *comal*.

On a good day, the average potter can produce a dozen *comales*—six of each size—or an equal number of medium and small *apastes*. A more ambitious potter may make as many as two dozen vessels in a single day, yet her weekly output, too, is limited by the time needed for gathering and preparing materials, firing vessels, and marketing vessels. The firing process for San Agustín is very similar to that of Lo de Mejía.

Most of the pottery is sold to mer-chants, who transport large quantities out of the area by truck. They pay between 10¢ and 15¢ for each *comal* and 12¢, 15¢, 20¢, or 35¢ for each *apaste*, depending on its size. The pottery is distributed widely to such areas as Zacapa, the south coast, the Verapaz, toward El Petén, and the banana plantations near Puerto Barrios. The small amount of pottery consumed locally is sold at the Sunday market in the *pueblo* of San Agustín Acasaguastlán itself. This is also where a number of merchants make their bulk pickups, probably one reason why the pottery is identified with the town. Other merchants go directly to the *aldeas* to buy.

San Vicente

San Vicente, with a population of 743 Ladinos in 1950, is classed as a Ladino *núcleo poblado* (politically less important than an *aldea* or a *caserío*). The settlement is relatively large for its *municipio* of Cabañas, in the department of Zacapa. The nearby *caserío* of El Arenal is under the administration of San Vicente. In 1950, the *municipio* had 6,738 inhabitants: 3,909 of these were

Ladinos, and 2,829 were Indians for whom no linguistic affiliation is given.[3]

The pottery identified as coming from San Vicente is made by two Ladino potters in the town proper and by an unknown number of potters in the surrounding fourteen *aldeas* and ten *caseríos*. The town potters live on the very outskirts, and their residences are more like *caserío* than town dwellings, being small plots of inferior land. Woman are the potters, and most of the leaders in this work are older married women. Young women, including the daughters of potters, show little interest in learning the technique; they entertain ideas of migrating to the larger towns or to Guatemala City. Some of these young girls "do not possess good fingers for this work," said an experienced potter.

The forms of pottery produced in the San Vicente area appear to be limited to *apastes* and *comales* (fig. 43). Six sizes of *apastes* are made, ranging from ten to thirty-six inches in diameter at the rim. Walls are vertical three-quarters of the way up, then flare out. Each potter appears to make only one size of *comal*. Although only roughly burnished, the pottery is smooth to the touch, but it

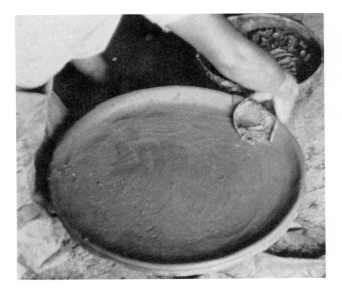

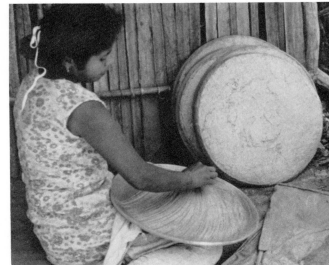

Plate 271 Plate 272

is not as slippery as that from San Agustín Acasaguastlán, due to the lower proportion of *chistún* used here. As is usual on full mold–produced vessels, the exterior is rather rough. Fired vessels always appear to be well oxidized.

Potters obtain *chistún* from a special source several hours' walk down the river, usually spending half a day mining and going to and from the site. San Vicente potters are also selective in their choice of clay, preferring clay from a particular location; explaining these facts, they convey the impression that potters from the more remote *aldeas* are less particular about the quality of their materials. The clay fires to a light red brown in color.

Before using it, the potters age the clay for several days by leaving it outside, exposed to the elements, in a large *apaste*. Water is then added, and the clay is stirred and allowed to settle out; only the uppermost sediment is used.

Chistún is brought home from the mine in chunks. The first step in preparing it is to crush these pieces into sizes small enough to grind on an old metate. After this, the *chistún* is of a granular consistency. Further grinding on a good metate reduces

the *chistún* to a powder, which is stored indoors until it is mixed with the clay. San Vicente potters use equal proportions of clay and *chistún*.

The potter works in back of her house, standing next to a rustic table or platform. Prior to the actual construction of an *apaste*, the full mold is prepared by applying ashes mixed with water to the interior. This mixture separates the walls of the mold from the clay and prevents sticking. In a small *apaste* set aside for the purpose, the potter wedges enough clay for the vessel she is about to begin. Steadying the *apaste* with her left hand, she takes a handful of clay in her right hand and makes a fist,

forcing the clay out between her fingers (pl. 273). She continues to squeeze handfuls until the clay reaches the desired uniform consistency.

In the first step of construction, the potter puts a large lump of the wedged clay into the bottom of the mold (pl. 274). Then, her left hand steadying the mold, she presses the clay up against its walls and over the rim with her right-hand fingertips (pl. 275). With this pressure, the potter can make two-thirds of the vessel, in a rough fashion, within the first few minutes of work. At this stage, the unevenly formed section has deep finger grooves around the interior walls. The potter then be-

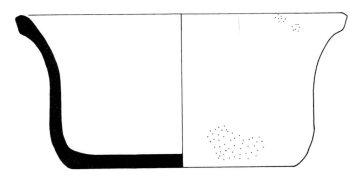

Figure 43. San Vicente *apaste*. Scale 1:4. From the University of Pennsylvania Museum, Philadelphia, Reina-Hill Collection, 1973

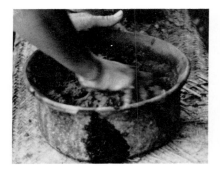

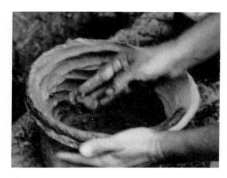

Plate 273

Plate 274

Plate 275

gins to thin these walls by scraping latitudinally around the interior with her right-hand fingertips, while her left hand continues to steady the mold (pl. 276). This leaves the interior with a decidedly granular surface. Enough of the clay lump remains in the bottom so that the potter can push up the last third of the walls, this time using the backs of her fingers; this process leaves deep vertical grooves in the surface while erasing the joints where the sections meet.

Now the potter shifts to using the palm of her right hand to smooth the vessel interior. With the heel of her palm resting on the rim and her fingertips at the bottom of the vessel, she sweeps her hand back and forth through a 180° arc around the interior (pl. 277). This is an awkward motion for her, especially at the opposite end of the arc. To reach, she must twist and bend to the left at the waist, while throwing her hips to the right at each stroke of her hand. At the same time her left hand, placed near the close end of the arc, steadies the mold. In addition to smoothing the vessel interior, she thins the walls, especially near the bottom. Here the clay accumulates readily on the tips of her middle and third fingers, which are also giving precise definition to the bottom of the interior. The walls now exhibit shallow, broad latitudinal grooves, while the bottom is still rough.

The next step is to smooth the bottom of the vessel. This the potter accomplishes simply by placing her

right hand on the bottom, palm down, and twisting it back and forth. A small flange of clay may develop on the walls near the bottom as her fingertips touch there (pl. 278).

To work on the rim, the potter shifts her position so that at times she is standing sideways, in order to work at either side of the mold. Holding the vessel rim between the forefingers and palm of her right hand, palm on the interior, she draws her hand around the top, pulling the vessel rim away from the mold rim, to shape it (pl. 279). To finish the rim, the potter grasps it between thumb and fingers of her right hand (pl. 280), thumb on the exterior, and, circling the vessel again, draws the rim up and away from the mold as before (pl. 281).

The vessel receives a final smoothing when the potter moistens her right hand and draws her fingertips lightly around the interior (pl. 282). After this she sets the mold in the sun to dry or, in the rainy season, inside the house for an entire day. After removing it from the mold, the potter burnishes the vessel by lightly wetting the surface and rubbing it with a stone. Wetting the surface insures an even burnishing with no rough patches.

All vessels are preheated in the sun before firing to remove any remaining moisture, which would cause them to break upon firing. The potter builds the firebed by making a round brick platform on the ground. On this she places the largest apastes, mouth down; the smaller apas-

tes, also mouth down, are placed above, over the spaces between the lower vessels. Over these, she piles pieces of cactus and scrub, and comales are placed on all this. The firing is similar to that of the aldea of Lo de Mejía. After firing, the vessels are considered ready for use without any curing process.

In this area, productivity is measured in cargas, each carga consisting of approximately six apastes in each of the six sizes, or thirty-six apastes, plus six comales. An average potter can produce enough vessels for a carga every two weeks. Most are handled by merchants at the pueblo of Cabañas, who in 1974 paid between $3.50 and $6.00 per carga, depending on the season and the demand. These merchants distribute the pottery to Zacapa, Chiquimula, the banana plantations, and, with the new road, to communities in the department of El Petén.

Lo de Mejía

Settlements in the aldeas of Lo de Mejía are under the jurisdiction of the municipio of Río Hondo in the department of Zacapa. In 1950, of the 6,585 inhabitants of the municipio, the 368 classified as Indians had no indigenous linguistic affiliation.[4] The aldea itself had a population of 24 Ladinos.

Vessel shapes produced in this area include apastes, tapaderas, ollas, comales, and tinajeras, locally called cántaros (fig. 44). The pottery is light red brown in color, and the

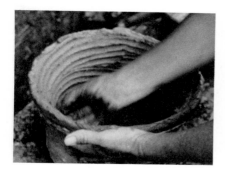

Plate 276

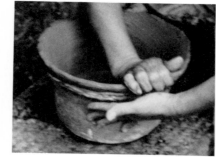

Plate 279

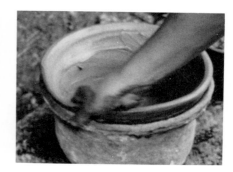

Plate 281

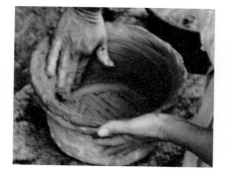

Plate 277

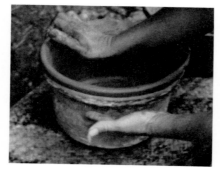

Plate 280

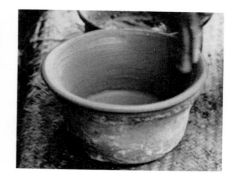

Plate 282

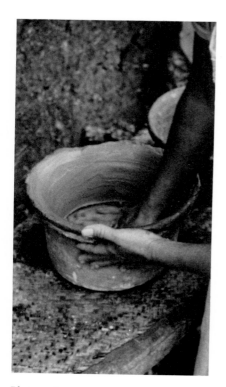

Plate 278

vessel exterior often has a carelessly applied light pink slip. Roughly burnished vessel interiors are still slick due to the high *chistún* content. Vessels show little, if any, fireclouding.

Apastes are produced in many sizes but appear to cluster in five groups, ranging from approximately twelve to thirty inches in diameter at the rim. They have slightly flaring walls built up several inches above the rim of the mold, as evidenced by a small flange below the vessel rims. A variation of the large *apaste* is elliptical and measures approximately three feet on its long axis. This form appears to be an attempt on the part of the potter to copy the industrially produced galvanized metal basins popular in the area. *Olla* walls are more vertical than those of the *apastes* but are not as tall, and the walls recurve above the rim of the mold to close over the vessel and form a somewhat smaller opening. Both *apastes* and *ollas* have lug

handles just below the rim. *Comales* are produced in two major sizes, one measuring approximately sixteen inches in diameter, the other twenty-four inches. *Tapaderas* are roughly the same size as the smaller *comales* and are made in the same manner, except that *tapaderas* have a massive loop handle and sloped walls. The *cántaro* has a lower section like an *apaste* but recurves above the mold rim to form a high dome with a narrow opening. Typically, *cántaros* are half buried in the house yard to cool the stored water. A potter—all the potters are women—makes water storage jars mainly for her own family and does not sell them outside her *aldea*.

The locally obtained clay is prepared in a manner similar to that of other centers using the *chistún*-clay mixture. The *chistún* is ground entirely on a metate, there being no mechanical mill in the *aldea*. Clay and *chistún* are mixed together in equal parts and moistened with a

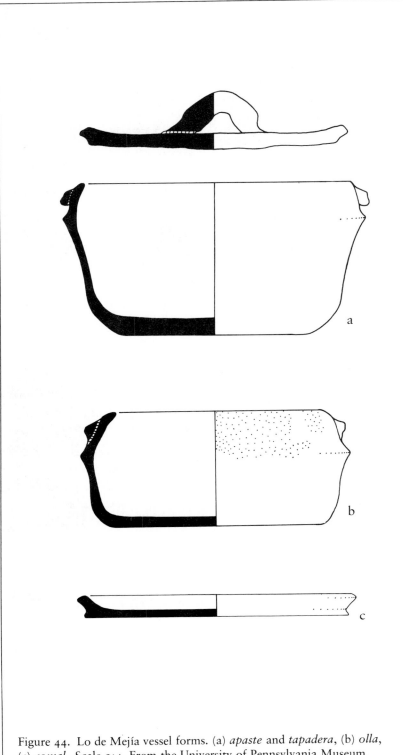

Figure 44. Lo de Mejía vessel forms. (a) *apaste* and *tapadera*, (b) *olla*, (c) *comal*. Scale 1:4. From the University of Pennsylvania Museum, Philadelphia, Reina-Hill Collection, 1973

suspension of a darker clay and water.

Production in full molds, known here as *hormas*, is comparable to that in other centers of the middle Motagua area using this method. In Lo de Mejía, however, the potter works with molds of different heights: the taller ones are for *apastes*, the shorter for *ollas*. *Comales* and *tapaderas* are made not in molds but in a simple circle of ashes on the ground. No full description of pottery making is necessary, since the techniques for Lo de Mejía are the same as those for San Agustín Acasaguastlán.

In the Lo de Mejía area, potters produce only three months out of the year. The rest of the time the female potters work as farm laborers, harvesting vegetables and tobacco on the large irrigated *fincas* along the Motagua River. The potters take their own vessels to market, keeping the inferior pieces at home for their own use. They travel by bus to sell their pottery at the market at Chiquimula on Thursdays and Sundays. As of 1974, *comales* and *tapaderas* sold for about 10¢ each, large *apastes* for $1.50, and small *apastes* and *ollas* for 20¢. At these prices, the women earn close to $3.00 for each trip to the market. About one-third of this goes for the round-trip bus fare.

The only opportunity to observe the firing of pottery made by the full mold technique in this area came at the *aldea* of Zapote Arriba, a settlement making pottery commonly identified as Lo de Mejía pottery. Because environmental and technological conditions are extremely similar throughout the *aldeas* of the middle Motagua area, the firing procedures are the same.

As in many other pottery centers, firing takes place at the time of day with the least danger of sudden gusts of wind, usually in the early morning or evening. The potter first makes a small fire of twigs and allows it to burn down to ashes. This action draws moisture out of the soil

in the immediate area, and the ashes serve as a base upon which to stack the pots for firing.

The next stage is the preparation of the firing lot. The potter places three to five of the largest *apastes*, close together and mouth down, on the bed of ashes. Smaller *apastes*, three to five more vessels, are placed mouth down on top of the larger ones, usually at spaces between the lower *apastes*. If the upper layer cannot fit between the spaces, the potter puts down one *apaste* at a space; then, the others are leaned against this *apaste*, their mouths toward the center and their rims touching its base and the bases of the lower vessels. The potter is especially careful always to leave air spaces between the vessels.

Around the stacked *apastes*, she now places a layer of *comales*, on edge, leaning against the *apastes*; the cooking surfaces of the *comales* face toward the center of the firing lot. After this comes a layer of small branches, the main fuel. The branches are all broken to about one yard in length and lean vertically against the firing lot, with one end in the ashes. A second layer of *comales* is set up outside this, in the same position as the first, leaving space between the layers for air circulation. After adding a few more odd pieces of wood outside these *comales*, the potter has finished preparing the firing lot (pl. 283).

She starts the fire by lighting some twigs at the base on one side of the firing lot. The fire spreads quickly—soon orange flames are leaping more than a yard above the stack, developing an intense heat so that anyone standing as far as ten yards away is uncomfortable (pl. 284). The potter may not retreat to a comfortable distance, however, as the fire requires constant care and feeding. In the course of the firing, the potter adds an amount of fuel roughly equal to the original quantity. She must stand as close to the fire as she can (about two yards) to throw armfuls at a time onto the top (pl. 285).

Plate 283

Plate 284

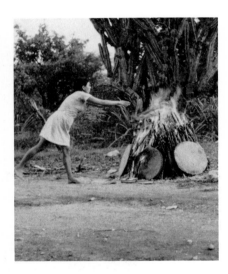

Plate 285

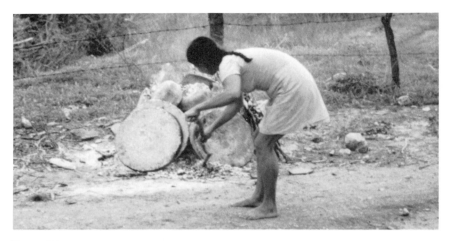

Plate 286

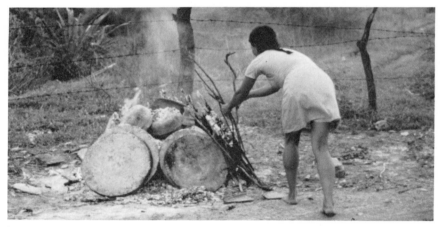

Plate 287

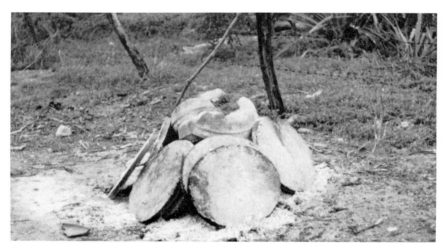

Plate 288

Although this is an inefficient system and heat loss is great, the potter can maintain the maximum temperature for twenty minutes.

The freely perspiring and clearly exhausted potter now stands off and allows the fire to burn down. As ashes start to accumulate in the spaces between the pairs of *comales*, she clears the openings with a branch about two yards long to encourage the flow of air (pl. 286). Still intently involved, however, she continues to study the lot carefully for signs of incomplete firing on any vessel. If she spots one, she moves up to the fire, which is still generating a fair amount of heat, and sets handfuls of branches up against the outside of the fire or throws them on top, depending on where the heat is needed (pl. 287). Now, except for worrying about the wind, she can relax and wait for the fire to die (pl. 288). After the pots have cooled enough, she takes them from the stack, *comales* first, and moves them into her house for storage.

Jocotán

Jocotán pottery is the product of *aldeas* around the *pueblo* of Jocotán, in the department of Chiquimula. This *pueblo* and a few others in this area are important administrative centers of the Chorti-speaking people. In 1950, the *municipio* of Jocotán, including its thirty-two *aldeas* and thirty-three *caseríos*, had a total population of 17,232, of which 16,182 were classified as Indians.[5] The *pueblo* itself had a population of 936 Ladinos and 152 Indians.

In the 1770s, Cortés y Larraz visited this region and reported 1,134 families, or 3,198 individuals, in the *pueblo* of Jocotán. He found the region very fertile—suited to the cultivation of wheat, maize, beans, vegetables, fruits, sugar cane, tobacco, and cacao—although the fields were badly tilled. The Chorti people lived in valleys near their fields then, as they do today.[6]

Wisdom studied the Chorti in the 1930s and reported that the *pueblo* had satellite *aldeas* that contained only Indians. These *aldeas* were the major production centers for many home industries and were more or less self-sufficient economic units.

Such industries as rope making, woodworking, lime burning, tanning, mat making, pottery making, drying fish, and hat and basket making are still located in *aldeas* around Jocotán, and each *aldea* distributes its products in the *pueblo* market. Pottery making is looked down on by *pueblo* people as something belonging to the *aldeas*.

Community rituals are in the hands of an Indian priesthood of *padrinos*, who lead the rituals related to the agricultural cycle, some of which coincide with the Catholic *fiestas* of the *pueblo*. Wisdom states that "in no case is there Indian consciousness of difference of origin of any religious or ceremonial elements in the culture."[7] For this area, in contrast to production centers in the central and western highlands, the social organization is characterized by small social units—multiple-household units and *aldeas*—the rigorous adherence to the community culture in the corporate Indian *pueblos* of the central and western highlands is not required here.

Pottery making in this area in the 1930s was included in Wisdom's descriptions.[8] Pottery has apparently declined as an industry since then but is still practiced in the more remote *aldeas* in the area. At least one *aldea*, Matasano, and its *caserío*, El Morral, still specialize in pottery production, and a number of potters are also scattered throughout the countryside.

The inventory of forms has also declined. Wisdom described vessel forms produced by the Chorti, as well as several forms imported from the Pokomam *pueblo* of San Luis Jilotepeque. Locally made vessels included cups (*batidores*), pots (*ollas*), *bongos* and *burnas* as specialized vessels, bottle-necked jars (*tinajas*),

pitchers (*jarros*), including the duck-effigy variety (see San Luis Jilotepeque), water jar supports for round-bottomed *tinajas* from San Luis Jilotepeque, *comales*, and incense burners (*incensarios*). In the Jocotán area, only *ollas* and *comales* continue to be made (fig. 45). The *ollas* are often large, thick-walled, and consequently very heavy. Vessel bases are flat, though irregular. The walls are curving, with two large, conical nubbin handles placed opposite each other just below the rim. The local *comales* are large—eighteen to twenty inches in diameter—and have a low raised lip; they are pressed out with the hands in a full mold and then burnished. No new or different forms are forthcoming. Production is geared for family consumption, and no innovations are required to fulfill present needs.

Pottery production in this area is the work of women. That not all women are potters is said to be due to the scarcity of and difficulty of obtaining clay. Potters use only particular clays, and sources are distant. In fact, one potter interviewed mentioned Olopa, nine miles away, as a source exploited by people in the Jocotán area. In addition, the potter herself must mine and carry the clay and other materials—sand for temper and fuel for firing—she receives no help from her husband. The clay fires to a reddish brown.

All the construction takes place in the potter's yard. She mixes sand with the clay as temper, the proportions depending on the properties of the clay being used. The sand has been sifted through a basket to remove the larger particles. The potter kneels in front of a board or a piece of plastic, placed on the ground to hold the clay, and wedges vigorously (pl. 289). When the clay satisfies her, she forms a rough thick disc eight to ten inches in diameter between her hands and, while standing, places this disc on an inverted *olla* previously dusted with fine ashes to prevent the clay from sticking (pl. 290). From this time on, she

stands, bending over the *olla*, to build the vessel. This is more comfortable, with the vessel raised off the ground; it also gives the potter an opportunity to move about, both to inspect the vessel and to work from different angles. This motion, however, is not continuous, as would be essential in centers where the orbiting technique is used.

Working with the disc she has placed on the *olla*, the potter slightly raises the edges by pressing them between both hands, the forefingers of her right hand on the exterior and the palm and fingers of her left in the interior (pl. 291). She raises the edges further by pinching them between the thumb and fingers of her right hand, with the thumb on the interior surface.

Next, the potter rolls a coil of clay between her hands and applies it to the work with her right hand, while the first two fingers of her left guide it into place and the thumb and final two fingers pinch it onto the vessel wall (pl. 292). Applying another coil immediately, in the same way, she raises these two coils by pressing and pulling them up between her hands, the whole way around the vessel (pl. 293).

After giving the vessel this crude shaping, the potter begins to employ a section of gourd to help give definition to its final form (pl. 294). This process consists of drawing the gourd, especially the edge, around the outside of the vessel with her right hand, while her left supports and pushes from inside (pl. 295).

After forming the vessel, the potter sets it aside to dry until it can support the massive nubbin handles. The handles are rough cones of clay placed high on the shoulders, near the rim, with additional clay smoothed down around the joints to strengthen them. After applying the handles, the potter takes the vessel inside her house to dry slowly for five or six days before burnishing and firing.

Burnishing is done with a smooth stone or a *zapote* seed rubbed back

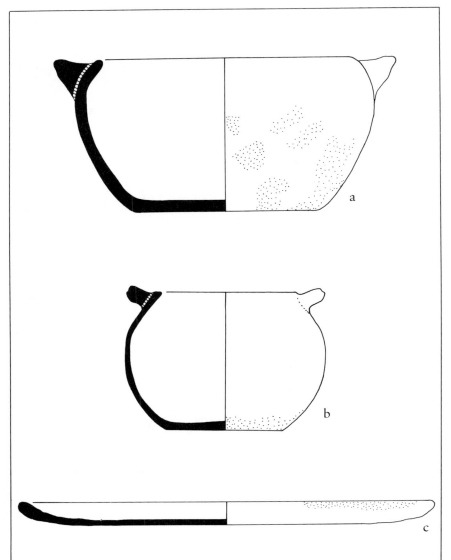

Figure 45. Jocotán vessel forms. (a) *olla*, (b) *olla*, (c) *comal*. Scale 1:4. From the University of Pennsylvania Museum, Philadelphia, Reina-Hill Collection, 1973

and forth across the interior and the exterior surfaces. Some potters favor *zapote* seeds because they are light in weight and have a slippery surface, which the potters attribute to an oil that can be imparted to the *olla* during the burnishing process, making it smoother and less porous.

With production at a low level, firing lots are small—sometimes only a single vessel is fired. Vessels to be fired are placed upside-down, resting on three stones, thus keeping space between the rims and the ground. The firing lot is covered with pine bark, used instead of other combustibles (such as straw, twigs, or dried dung) because it is believed to be responsible for the attractive reddish brown color of the fired vessels. In fact, this is more likely due to the effects this particular fuel has on temperature, intensity, and degree of oxidation-reduction. Much of the pottery is heavily fireclouded and shows signs of incipient surface vitrification in those areas. Before actual use, the potter cures the vessels by heating them in a fire and then dousing them all over with cool *horchata*, a mush made of maize and cinnamon.

Most potters produce only for their own use as needed, but they often make an extra vessel or two to sell, if they have the clay. As mentioned, one *aldea* is still reportedly specializing in pottery production to the extent of producing enough for local distribution. Pottery, some of it said to be painted, is still made in the Olopa area, *incensarios* and *jarros* being mentioned specifically. Local pottery is brought to the Jocotán Sunday market for sale to people who make none themselves, as well as to storekeepers who build up limited stocks for sale when demand rises. The main supplier of vessels to the Jocotán area, however, especially for *tinajas*, is San Luis Jilotepeque.

San Luis Jilotepeque

In San Luis Jilotepeque, the Indian sector—which remains a corporate community—constitutes the most important production center for *tinajas* in Guatemala's Oriente. The *pueblo* is located in east-central Guatemala in the department of Jalapa, in the relatively dry, dissected upland zone south of the Motagua River. An archaeological site near the *aldea* of El Paterno suggests continuity of occupation from pre-Columbian times. The Pokomam Indians of San Luis Jilotepeque were subdued in 1530 by a detachment of *conquistadores* led by Captain Hernando de Chávez. In 1950, out of the 9,517 inhabitants of the *municipio*, 5,743 were still classified as Pokomam speakers, while the remaining 3,774 were classed as Ladinos. Less than half the population of the *municipio* reside in the *pueblo*: the majority live in the surrounding twenty-one *al-*

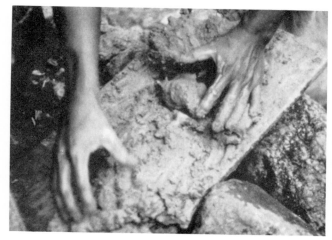

Plate 289

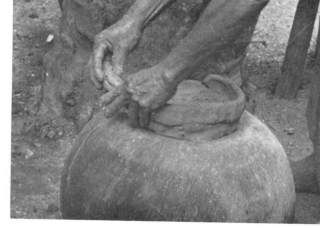

Plate 292

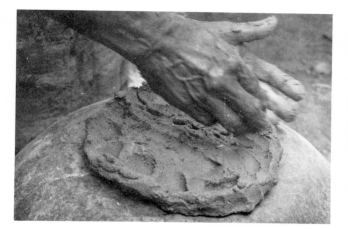

Plate 290

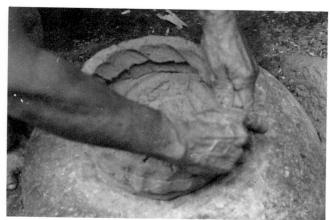

Plate 293

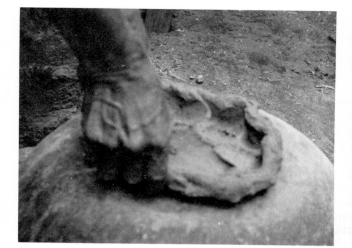

Plate 291

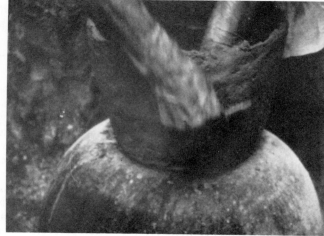

Plate 294

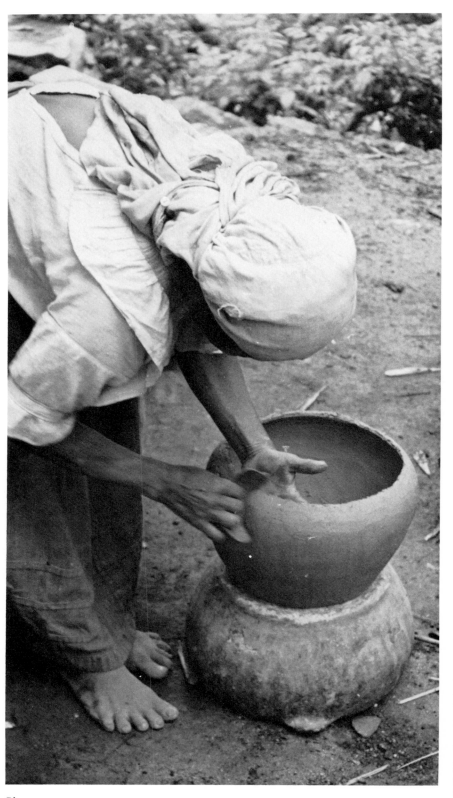

Plate 295

deas and thirteen *caseríos*.[9] In addition to agricultural activities and pottery making, these people also produce metates and manos, the grinding stones used in preparing corn. These items are indispensable to both Indian and Ladino households in a region where motor-driven mills are still rare.

In 1951, San Luis Jilotepeque was the subject of a pioneering anthropological study by John P. Gillin. While working there in 1942, Melvin Tumin, a sociologist, also collected some excellent data on pottery at the request of A. V. Kidder, particularly on forms produced and on marketing. The Arrotts visited the *pueblo* in 1951 and documented pottery production with an excellent photographic sequence. Our visits to the town in 1973 and 1974 served to verify the continuity of the technology and to investigate changes in forms and marketing practices.

The Ladino-Indian relations here have their own peculiarities. Compared to other areas, social relations between Indians and Ladinos here seem to be castelike. Ladino political domination has been forceful. To some extent, however, the Indian *cofradías* have counteracted the strong Ladino political leadership by controlling and maintaining the religious life.[10] It is our impression that, since Gillin's study, the religious-political organization has been accommodating itself rapidly to the national political changes.

All work connected with pottery is the province of women, except for marketing the finished product, which until recently was handled almost exclusively by men in the traditional style. Unusual for Guatemala, pottery production is centered in the *pueblo* proper. Potters are also located on the outskirts of the *pueblo* and in *aldeas*.

Tumin lists and describes fifteen "distinct pottery articles" in his report to Kidder: *cántaros*, decorated *cántaros*, *cantaritos*, decorated *cantaritos*, *ollas*, *cajetes*, *jarros*, *jarritos*, *floreros* (flower vases), *ro-*

sarios (censers), *pichingas grandes,* *pichingas chiquitas, tazas* (cups), *candeleros,* and *braseros.* (Tumin gave only English equivalents of Spanish and Pokomam words. He photographed all the vessels listed but, unfortunately, over the years these photographs have been lost.) Note that many of the vessels listed are larger and smaller versions, or decorated and undecorated versions, of a particular vessel form. According to Tumin, "the basis for this distinction, in both instances, is the differential price received in the marketing of the items."[11] The Arrotts' inventory is smaller, consisting of painted and unpainted *tinajas,* here called *cántaros, ollas, jarros, cajetes,* and *porrones,* called *pichingas.* They stated that a distinct duck-effigy *pichinga,* not specifically mentioned by Tumin, was on the verge of extinction. The present inventory, based on market surveys as well as interviews with potters, consists of plain and decorated *tinajas,* plain *cantaritos*—small *tinajas*—*jarros, cajetes, ollas,* plain and decorated *pichingas,* and the duck-effigy *pichinga,* which seems to have made a very successful comeback (figs. 46–48). Forms mentioned by Tumin but not by the Arrotts and ourselves are in all probability still made, but in limited numbers and probably only for such special occasions as *fiestas.*

When well executed, the San Luis *tinajas* have squat bodies, much like pumpkins in profile. A high flaring neck rises gracefully from the body, and three strap handles are attached at even intervals on the broad flat shoulders; a knob is sometimes placed at the side of the vessel neck. The best *tinajas,* in addition to the brilliant, highly polished deep red slip, are also decorated with designs painted in black on the neck, shoulder, and waist areas. Crosshatched geometric motifs are common, as are Ladino-style representations of flowers, monkeys, deer, and fowl. Less frequently one finds the representation of an urn or ewer, which the Arrotts felt was "unmistakably

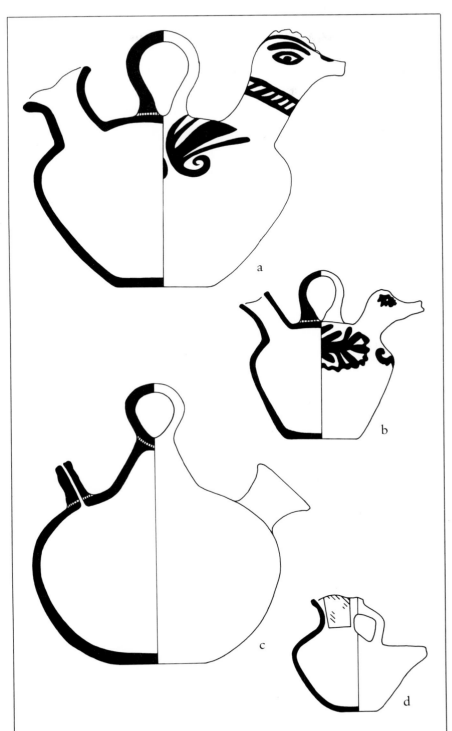

Figure 46. San Luis Jilotepeque vessel forms. (a) black-on-red duck-effigy *pichinga,* (b) black-on-red duck-effigy *pichinga,* (c) *pichinga,* (d) *pichinga.* Scale 1:4. From the University of Pennsylvania Museum, Philadelphia, Reina-Hill Collection, 1973

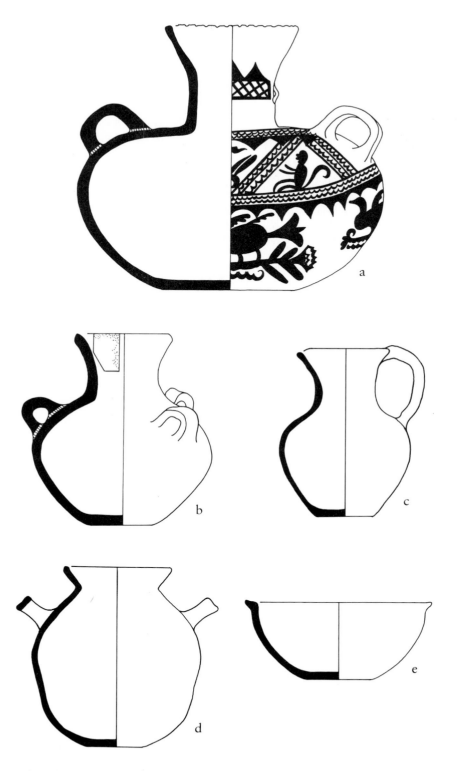

Figure 47. San Luis Jilotepeque vessel forms. (a) black-on-red *tinaja*, (b) *cantarito*, (c) *jarro*, (d) *olla*, (e) *cajete*. Scale 1:4. From the University of Pennsylvania Museum, Philadelphia, Reina-Hill Collection, 1973

Moorish in character." Inferior examples of this form have much more nearly spherical bodies and sloppier decoration, if any. *Cantaritos* have a similar form but, as the name implies, are a much smaller version.

The local *jarros* are small water jars, with bodies and necks similar to those of *cantaritos* but with only one long strap handle running from just below the rim to the shoulder. The rim itself has been modeled into a V-shaped spout. Some variants closely approach the western pitcher in form and proportions. The *cajetes* are small hemispherical bowls, usually slipped and polished inside, and have two tab handles at the rim.

Tumin did not differentiate *ollas* according to size, and the reason may be that this class of vessel is seldom marketed. These vessels generally have well-rounded bases and straight or only slightly curving walls. Two horizontal strap handles are placed opposite, at points just below the flaring rim. These vessels are crude on the exterior, although the interiors are well smoothed.

The interesting *pichingas* are produced in a number of centers in the Oriente. Those from San Luis Jilotepeque have nearly spherical bodies with a truncated cone of varying proportions attached on the top. This serves as the base for the single strap handle, bent into shapes ranging from a horseshoe to a circle. A short neck with a flaring mouth, like a miniature *tinaja* neck, is placed on one side in line with the axis of the handle, and a long thin spout is set opposite. The wide mouth is used for filling the vessel, then is plugged or covered; the thin spout keeps direct evaporation to a minimum and is used for pouring. Depending on the quality, these vessels may receive black painted decoration similar to that on *tinajas*.

The duck-effigy *pichingas* are attractive vessels that have been given a new lease on life by demands from the urban population and, especially, from the tourist trade. Examples photographed by the Arrotts look

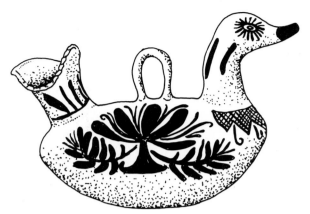

Figure 48. San Luis Jilotepeque duck-effigy *pichinga*. Scale 1:4 (approx.). Drawn from a photograph taken by Margaret Arrott

very much like duck decoys in ceramic form, except for the presence of a tall strap handle looped on the back of the vessel and a fill spout modeled by flattening a *tinaja*-type neck to resemble the duck's tail. Eyes and bill are painted on garishly, and the rest of the vessel may be painted with both floral designs and the animal's appendages. Recent examples have a more spherical body, like that of a regular *pichinga*. Aside from this, former and recent styles are extremely similar. Still another form of duck effigy reported by the Arrotts and ourselves, but not by Tumin, consists of a body shaped to resemble a duck's body, complete with a pointed tail. Instead of a head, however, the vessel has a *jarro*-type neck with a single strap handle running from below the rim to the back of the duck's body.

The production technique of at least *tinajas*, *ollas*, and *pichingas* involves use of the convex basal mold in the initial stages of construction. This technique is rare in Guatemala, and San Luis Jilotepeque is one of the most important centers where this method is followed.

Clays and pigment for painting are all found on a nearby cattle ranch. Although the clay for the vessels is free, the pigment, an iron oxide, and the slip clay, which fires to a deep red, must be purchased (in the 1940s, prices were 25¢ per pound and 4¢ per pound, respectively). After the potter gathers the

clay, she carries it in net bags back to her home, where it is ground on a special deep metate into a fine powder. This powder is placed in a pot with water and left to sit for five or six hours. The clay is then ready to be wedged on a workboard (pl. 296). No tempering material is added. Aside from the grinding of raw clay, most of the process takes place inside the potter's house (the potter is working outside here for photographic purposes).

Once the clay has been wedged to her satisfaction, the potter forms some of it into a large, heavy disc by patting it out on the workboard with the palms of her hands (pl. 297). She then carefully lifts the disc and places it over an inverted *tinaja*, which serves as the convex basal mold, carefully pressing and patting it into place (pls. 298, 299). With her wet hands and a piece of wet leather, the potter works the clay downward over the mold so that eventually it almost hides the inverted *tinaja* neck (pl. 300). Although the vessel is carefully smoothed at this time, the potter makes no attempt to remove excess clay, thus leaving the walls very thick. She then takes the newly formed vessel from the mold (pl. 301), covers it with damp cloths to prevent too rapid drying (pl. 302), and places it in the sun for over an hour.

At the end of this initial drying period, the potter places the vessel

upright in a collar made of straw and palm leaves (pl. 303). She now works the clay of the thick walls up and over, using a corncob under her left hand to roll and draw up the exterior, while supporting the walls with her right hand from inside (pl. 304). Gradually, she forms the vessel shoulders inward to a circular opening left large enough to permit the entry of a hand (pl. 305). A protracted and careful smoothing operation follows—she uses the corncob first, drawing it in diagonal strokes upward over the exterior (pls. 306, 307), then uses the wet leather similarly. She then sets the vessel aside to dry further.

The next operation consists of thinning the vessel walls by scraping the interior with a section of gourd (pls. 308, 309). This is a difficult task, usually taking a half hour's persistent work before the potter judges the walls sufficiently thinned. By the time she has finished, the shoulders have become dry and firm enough to support the neck.

The neck is made separately from an 8 × 3 × ¾ inch clay pad shaped on a workboard and rolled into a hollow cylinder (pl. 310). The potter slips this onto her left hand (pl. 311), while her right gently presses and rotates it to give it a crude flare at one end—this is done by pushing it back toward the base of her hand (pl. 312). Then she carefully joins the neck to the lower body. She blends clay over the joint on both the interior, using her right hand, and the exterior, using her left (pl. 313). Next she shapes and thins the neck with the corncob and the wet piece of leather, as she did the vessel body (pl. 314). Then, draping the leather over the rim and holding it between her left-hand thumb and fingers, the potter moves it back and forth, further bending and flaring the rim (pls. 315–317). After smoothing the vessel for the third time, she is ready to put on the three handles.

She forms the handles on a workboard from a coil of clay, fashioned into a long strap by drawing thumb

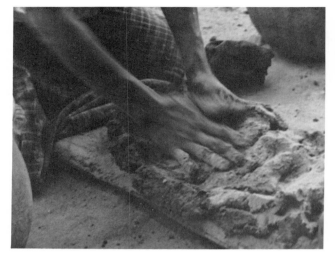

Plate 296

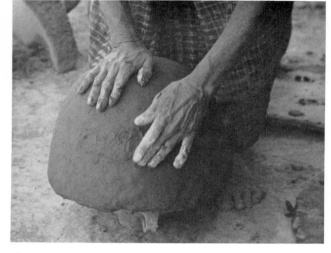

Plate 299

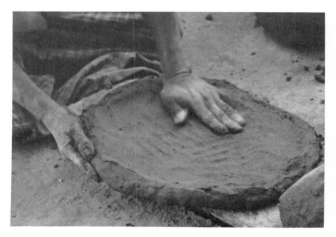

Plate 297

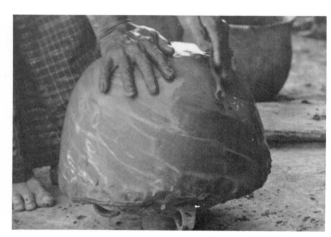

Plate 300

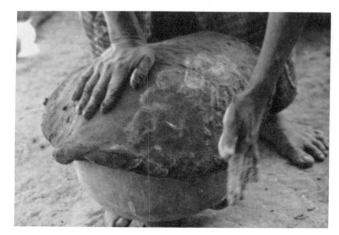

Plate 298

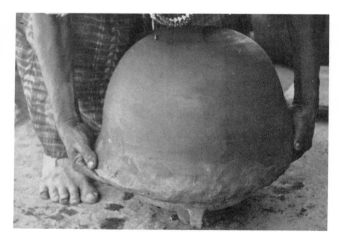

Plate 301

Plate 302

Plate 305

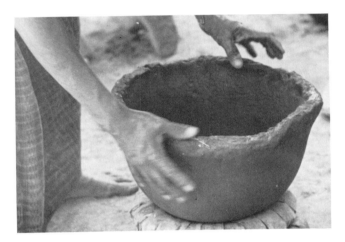

Plate 303

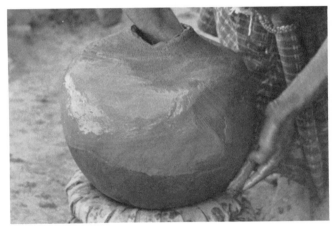

Plate 306

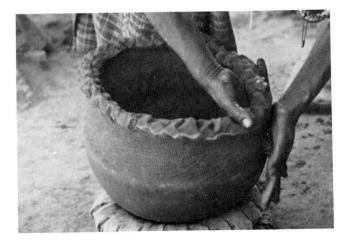

Plate 304

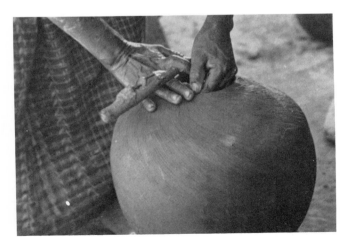

Plate 307

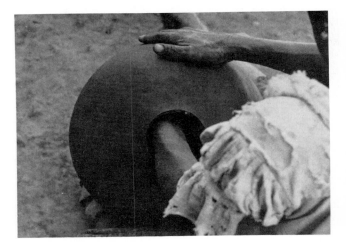

Plate 308

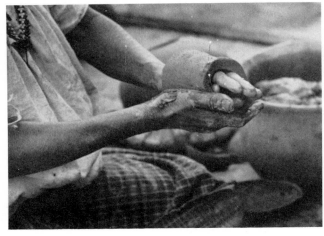

Plate 311

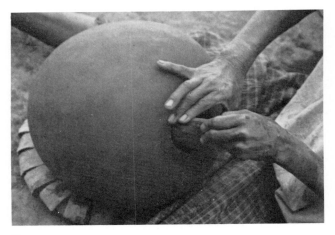

Plate 309

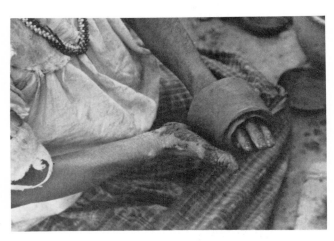

Plate 312

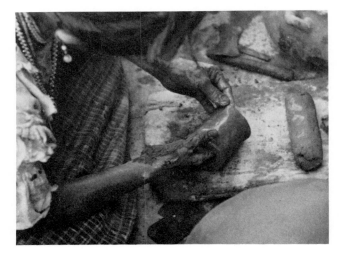

Plate 310

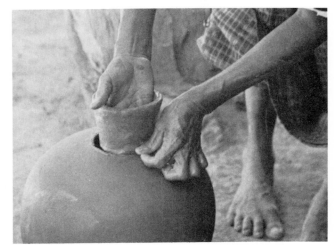

Plate 313

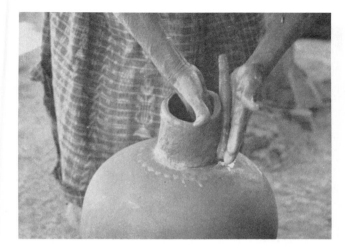

Plate 314

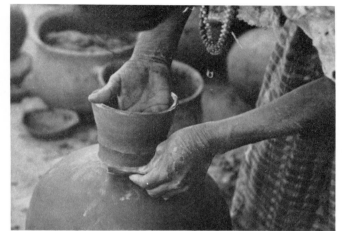

Plate 316

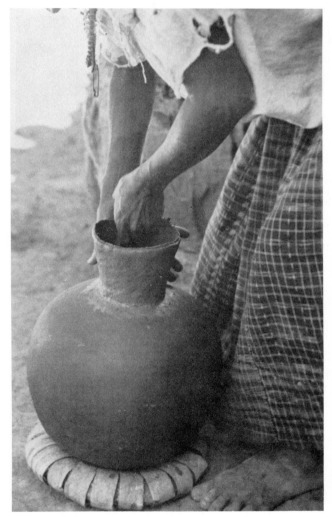

Plate 315

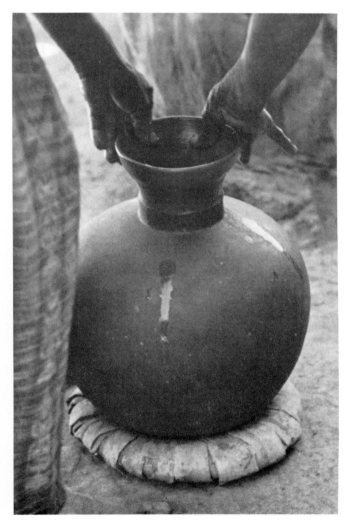

Plate 317

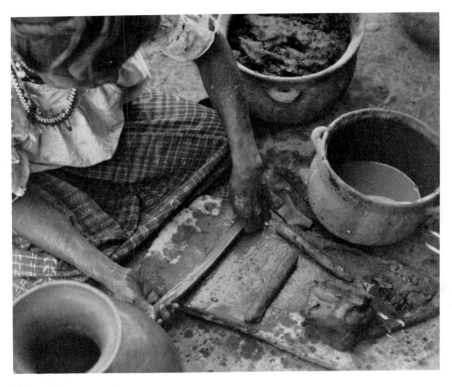

Plate 318

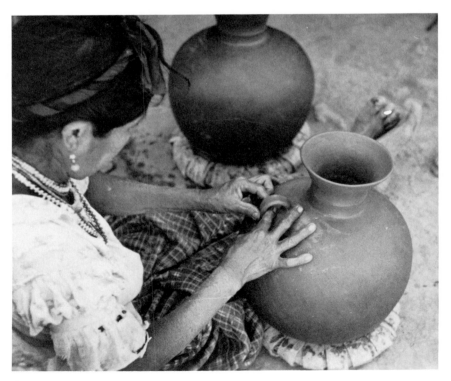

Plate 319

and forefinger of her left hand along its length and squaring off the edges (pl. 318). This strap is then divided into three equal parts, thus making three handles. Each handle is mounted high on the *tinaja* shoulders, attached at the highest point first, then carefully bent over into a tight curve and pressed on at the lower point (pl. 319). To make the handles equidistant, the potter measures with the span of her hands from forefinger to outstretched thumb, placing a handle at each point (pl. 320).

The red slip may be applied anytime from several hours to several days after the vessel is formed. Slipping is always done, however, before the vessel has dried fully, so the wet slip will adhere to it more readily. Polishing follows as, section by section, the potter repeatedly burnishes the surface with a buckeye seed. Black painted designs may be added with a chicken feather; this can be done anytime after burnishing and before firing.

The percentage of vessels decorated with black paint is far lower than an observer would think after watching the women as they fill their *tinajas* at the town fountain. They all carry decorated vessels, but this merely reflects the bearers' preference for the most elaborately decorated vessels. This is the way to advertise the potter's skill and the financial status of the bearer. Scarcely 20 percent of the vessels made in San Luis Jilotepeque are painted, and most of these stay in the *pueblo*. Because these women value them, and because the painted vessels bring only 5¢ in extra profit, most of the pottery produced for the regional markets is an undecorated monochrome red. A potter makes only six to eight fine *tinajas* or a slightly larger number of smaller or less fine vessels per week. The great care taken here keeps individual production low.

Vessels dry slowly from four to eight days before firing is attempted.[12] Dried cow dung and firewood are laid down as a circular base

about five feet in diameter, and the vessels are set upon it. The firing lot is then covered with straw and set afire. The firing continues for up to one hour, after which the vessels are left in the ashes until cool.

During Tumin's time, only men from San Luis Jilotepeque marketed pottery, primarily *tinajas*, out of the area. These men would carry a dozen or more *tinajas* on the traditional pack frames (*cacastes*) to many local and regional markets in the departments of Zacapa, Chiquimula, El Progreso, Jalapa, and Jutiapa, as well as to a number of towns in western El Salvador, including Santa Ana, Sonsonate, Atiquisailla, Chalchuapa, Coatepeque, Armenia, Metapán, Santa Tecla, and San Salvador. No vessels were traded farther east than San Salvador or farther west than Guatemala City.

Today, the pottery of San Luis Jilotepeque is still the most widely traded in the Oriente, but transportation by foot is rapidly being superseded by bus and truck. It is not unusual to see a vehicle packed full of bright red *tinajas* making its way along the unpaved road to Ipala, where it may turn north to Chiquimula, Zacapa, and the middle and lower Motagua, south to Jutiapa, the Pacific coast, and El Salvador, or west to Guatemala City. Due to opportunities presented by the tourist trade, one now sees San Luis *tinajas*, *pichingas*, *cantaritos*, and other small vessels in the market at Antigua and even in tourist stalls around Panajachel at Lake Atitlán. These vessels are for tourists only, however, as native residents prefer the Chinautla *tinajas*.

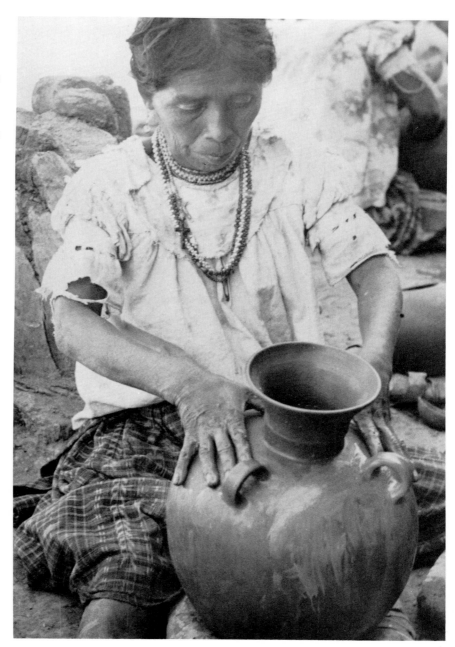

Plate 320

The Jutiapa Pottery District

Trancas and El Barrial

The pottery identified in the regional markets as coming from Trancas and El Barrial is produced in these and other small *aldeas* and *caseríos* that line the road south from Jutiapa. These two *aldeas* are about three miles from the department capital of Jutiapa. The population is culturally Ladino; in 1950, Trancas had 810 inhabitants, El Barrial, 670.

Although, out of the 28,119 people in the *municipio*, 13,362 of the rural population were classed as Indian, no indigenous linguistic affiliation is given.[13]

In these centers the Ladino wom-

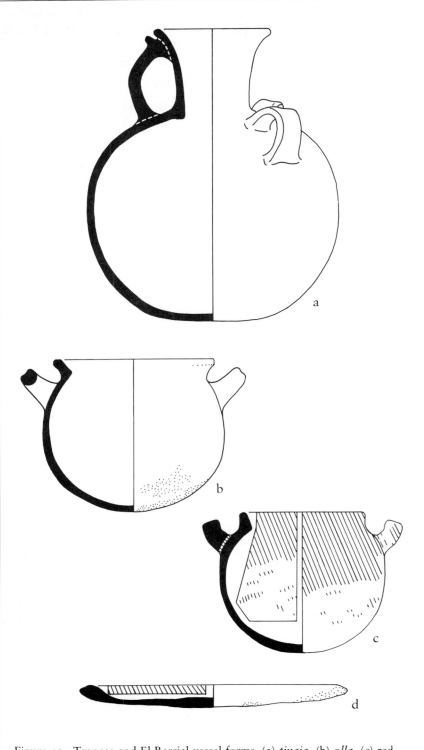

Figure 49. Trancas and El Barrial vessel forms. (a) *tinaja*, (b) *olla*, (c) red-slipped *olla*, (d) red-slipped *comal*. Scale 1:4. From the University of Pennsylvania Museum, Philadelphia, Reina-Hill Collection, 1973

en are the potters, and all women of these *aldeas* are thought to be capable of producing vessels. One potter interviewed could name twenty others offhand, and there is no doubt that the number is actually higher. She said, "There is no gain in this work, and therefore one needs much will to work." These Ladino potters, although proud of their accomplishments, feel that their specialization serves only to keep them occupied while their husbands are in the fields. They seem to consider this a temporary activity. Because of the apparent impermanency of *aldea* existence, women are abandoning pottery production to undertake another activity in the *pueblo*. Thus, the prospect of change does not disturb them.

Five basic forms are produced in this area: *ollas*, *comales*, *tinajas*, *apastes*, and *tecomates* (fig. 49). *Ollas* come in sizes ranging from eight, twelve, sixteen, to eighteen inches in diameter. They have spherical bodies, with low neck openings and two horizontally placed strap handles at the shoulders. They are given a cursory slipping and are burnished. The *comales* are of various sizes. The local *tinajas* are of one fairly substantial size. Their bodies are globular to spherical, with high flaring necks. One large strap handle with a small tab near the top reaches from below the rim to the shoulder, and two smaller strap handles are placed 120° apart on either side. The equidistant placement of the three handles is in keeping with the pattern of eastern Guatemala and western El Salvador, but the large handle from rim to shoulder is peculiar to this part of Guatemala. The vessels are completely slipped, except for the handles. A hemispherical *apaste* is produced with two horizontally placed strap handles below the rim. The unusual, though traditional, vessel known as a *tecomate* is a copy in clay of the local bottle gourd, used as a canteen. *Tecomates* are slipped all over and are well burnished.

Clay for pottery, readily available

locally, is free to the women, who gather it. A different clay for slip is obtained without charge from an area north of Jutiapa. The clay fires to a light brown color, the slip to a deeper red. Clay preparation is minimal. It is not weathered before use but, instead, is stored in plastic to keep it dry. To wedge it, the potter adds water and fine-grained sand for temper and, as she works, removes small roots and stones.

The basic technique used here is scooping. The potter works sitting on her knees on the floor of her house before a rectangular workboard, prepared with fine, clean sand. She wedges the clay on the workboard by rolling it back and forth with both hands for several minutes (pl. 321). Then she shapes it into a rough cylinder, lifts it, and forces her thumb into one end to make a small depression (pl. 322). Putting the clay back on the workboard with the depressed end up, she adds more sand at that end (pl. 323). Building commences when the potter begins to scoop and dig into the depression with her right-hand fingertips. She forces the clay to the sides and upward, while cupping her left hand around the exterior for support (pl. 324). Proceeding quickly, the potter has most of her right hand inserted in the clay and the walls built up high in very little time (pl. 325). She then changes her motion by flexing the fingers of her right hand and drawing them in short, powerful strokes counter-clockwise around the interior of the vessel, transmitting force through her forefinger. During this motion, her weight is thrown decidedly forward and down toward her work. As she continues this process, the vessel assumes a globular shape with a poorly formed shoulder curving inward to an opening. The potter next cups the vessel in both hands and carefully squeezes the exterior into shape (pl. 326). At this time, she also checks to see where the walls need to be thinned.

The potter thins the walls by scraping diagonally back and forth

Plate 321

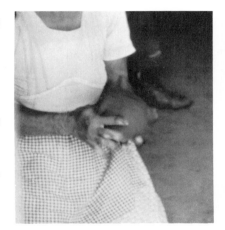

Plate 322

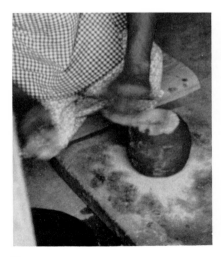

Plate 323

Plate 324

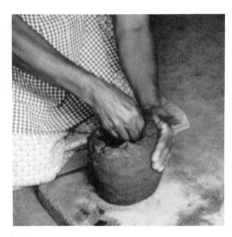

Plate 325

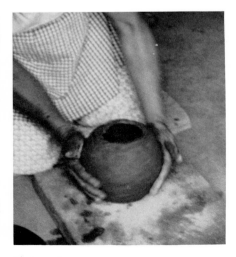

Plate 326

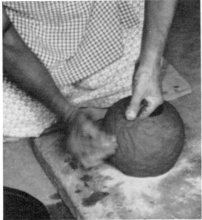

Plate 327

Plate 329

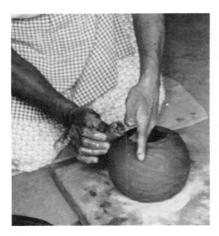

Plate 328

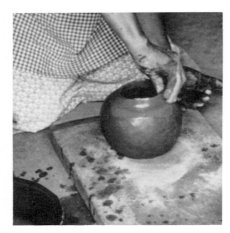

Plate 330

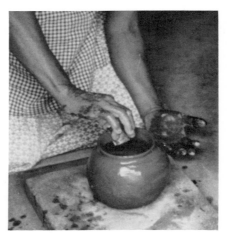

Plate 331

across the exterior with the forefinger of her right hand, while her left-hand fingers, inside the opening, support the shoulders (pl. 327). Continuing, the potter shifts the motion of her right hand from diagonal to horizontal. Now she places the forefinger of her left hand on the exterior, the other three fingers in the interior, at the opening, to check the thickness and uniformity of the walls; when she is satisfied, smoothing begins (pl. 328).

To smooth the completed section, the potter holds a moistened corncob in her right hand and draws it horizontally around the exterior as, with her left hand, she continues to support the walls. Because of the olla's spherical form, she must pick it up with her left hand to work on the lower half (pl. 329). After finishing, she returns it to the workboard and prepares to form the low neck and the rim.

For the neck, the potter first wets her hands in a pan of water nearby, where she keeps the corncobs, and then bends up the clay around the opening. To do this she places her right thumb inside the opening, with her fingers resting on the shoulder, palm down, and applies pressure through the thumb to turn up the clay, then draws her hand back and forth to build up a low neck (pl. 330). She raises the neck higher and thins it by pinching the clay between her thumb in the interior and her first two fingers on the exterior and drawing them all the way around. The potter now picks up the vessel to carefully inspect the newly formed rim. If it is satisfactory, she puts it back on the workboard to add the final touch by drawing a small juice can around the interior to give the rim a flare (pl. 331).

The vessel is put in the shade to dry, for the intense heat from the sun could cause it to dry too rapidly and thus crack. When it is leather-hard, the potter attaches the handles with wet clay and smooths the joints. At this time, she applies slip with her hands and, after more drying, she

burnishes the vessel with a smooth stone.

The same technique is used to produce *apastes*, *tinajas*, and *tecomates*. Although almost no modification is necessary for *apastes*, several variations are introduced for the other forms. *Tinajas* and *tecomates* are built in two stages: the lower part is built first, then dried overnight to strengthen it, and the upper section is raised by coiling the next day. During construction of the top, the potter places the base in a plastic and brush collar to hold it steady while she adds coils and turns the vessel. *Comales* are made freehand on the ground with no shaping guide other than the potter's eye.

When about twenty vessels have been completed, the potter has enough to fire and turns her attention to this next step. No special day is set aside for this task—it is undertaken when the weather permits. The potter first prepares the ground on the firing site by burning a low pile of straw. This heats the soil and dries it out, two conditions the potters believe to be critical. Four old, and usually broken, *comales* are laid in the ashes. Upon these, stones are spaced so that three support each medium-sized *olla*, placed mouth down with a fist-sized bunch of twigs under each. Thus a bottom, interior layer of vessels is built up, and outside these are put larger vessels. If these are *ollas*, their mouths will face toward the center, and a small number of twigs are put on these. Above this, smaller vessels are stacked, mouth down, usually in the spaces between the larger ones below (pl. 332). Over and around the whole, a large number of two- to three-foot lengths of sticks and small branches are laid (pl. 333), and the entire pile is covered with a thick layer of straw (pl. 334).

The fire is started at one side of the firing lot and allowed to spread and burn freely (pl. 335). The straw soon turns into black ashes, so the potter throws on more armfuls of the straw, staying as far from the intense

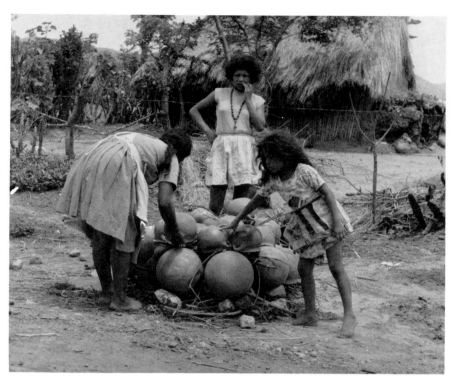

Plate 332

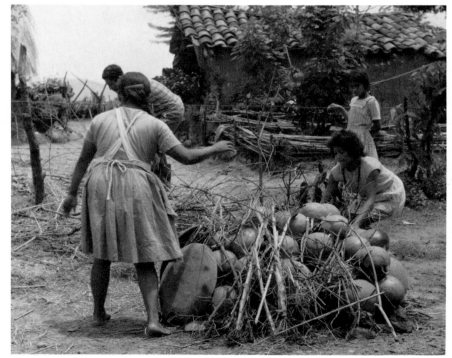

Plate 333

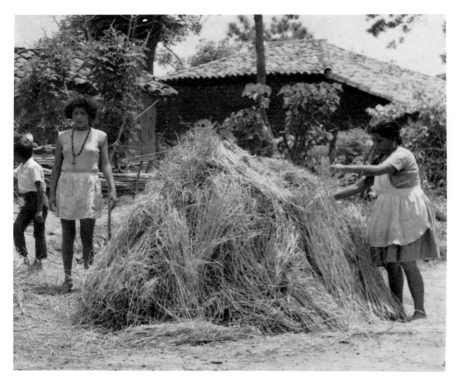

Plate 334

Plate 335

heat as possible (pl. 336). After this, the fire is left alone to burn. The potter checks the progress of the firing from time to time by probing and uncovering small portions of the lot with a long branch (pl. 337). When her probing turns up only light gray ashes, she knows the firing is completed, and she begins to pull ashes off the vessels a little at a time, to allow them to cool slowly (pl. 338). Pots are then removed from the pile with a long branch and taken into the potter's house for storage.

Productivity is difficult to estimate, as there is a great deal of variation among potters, both in ability and in the time spent working. In addition, production falls off markedly, here as elsewhere, in the rainy season. However, certain estimates can be made. As of 1974, an individual specializing in *tinajas* made between eight and thirty-five vessels per month, depending on the season. Firing lots of other vessels contained about twenty to twenty-five vessels per month. Production is said to have been greater years ago.

This pottery seems to have a limited distribution. Most is sold and used in the immediate Jutiapa area. *Tinajas* in particular are restricted, as they have to compete with those from Zapotitlán and San Luis Jilotepeque and are considered inferior to both. Prices in 1974 ranged from 30¢ to 40¢ per *tinaja*, though a potter could get 60¢ if she marketed the vessel herself in towns farther away. Much of the production is sold to merchants or to another potter, who will then sell the work of several of her neighbors. Through the merchants, some of this pottery does reach as far as western El Salvador.

Zapotitlán

The Ladino *pueblo* of Zapotitlán is the administrative center of its *municipio* in the department of Jutiapa, located in extreme southeast Guatemala. Aside from pottery making, agriculture and livestock raising are the principal industries.

In 1950, the *pueblo* itself had a population of 932 Ladinos; the remaining 3,179 Ladinos and 144 Indians occupied the seven *aldeas* and twenty-four *caseríos* of the area. No indigenous linguistic affiliation is given.

The pottery recognized as being from Zapotitlán is actually produced in the *pueblo*, as well as in the *aldeas*. Potters live in Ladino-style houses at the entrance to the *pueblo*. Pottery is exclusively the work of Ladino or Ladinoized women, although not all the women of the town know how to make pottery. Indeed, in 1974, there were so few potters that the best potter was well known and could be identified without hesitation. Although the particular potter observed was an older woman, this should not be taken as an indication that the craft is dying here, as many of her contemporaries could not make pots, whereas some younger women could.

The inventory of vessels produced here includes *tinajas*, *porrones*, *ollas*, and *tecomates* (fig. 50). *Tinajas* are produced in one basic large size, with spherical bodies and rather high necks. Placement of the three loop handles is the same as in Trancas and El Barrial, with one large handle running from the neck to the shoulder and two smaller ones spaced 120° apart on either side. *Porrones* here also have spherical bodies, though they are much smaller than *tinajas*. The *porrones* have two spouts, spaced 180° apart, one small and pointed, the other larger and slightly flaring. On top of the vessel body is a medium-sized neck with a nonfunctional lid, to which is attached a large loop handle. *Ollas* are produced in various sizes, averaging about ten to twelve inches in diameter. They range from hemispherical to globular in form and have two horizontal loop handles placed high on the body. They are well burnished though undecorated. The *tecomates* are modeled after the bottle gourd and are produced in as much variety as natural ones.

With their social position, these

Plate 336

Plate 337

Plate 338

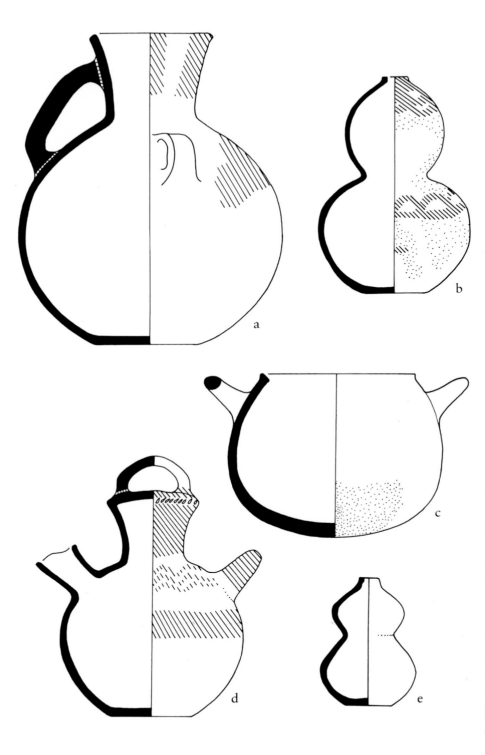

Ladino potters have an opportunity for individual expression in pottery decoration, and they favor a small number of motifs. The wing motif is usually painted with the fingers on the bodies of *tinajas*, three times, 120° apart; there is also vertical striping on the necks. *Tecomates* and *porrones* are often decorated with a bar and dot motif, which circles the vessels just above the widest diameter. Less common are fern and scallop motifs. In addition, the very finest vessels have some surface modeling, notably a snakelike motif.

The Ladino potters of Zapotitlán and their pottery are especially interesting for the amount of individual variation which occurs. Although the repertory of pottery forms appears well fixed, this may be due more to a lack of outside stimuli than to any community conservatism or creative limitations on the part of the potters. Variations include production of unusually large or small vessels (i.e., large *tecomates* or small *tinajas*), freedom in employing painted designs, and such modeling as scalloped spouts or appliqué decoration.

The pottery made today by Ladinos in Zapotitlán is practically identical in both form and decoration to Early and Late Postclassic pottery known from the archaeological site of Chalchuapa, El Salvador.[14] We may assume, therefore, that this type of pottery was originally produced by the Indians, probably in the same manner as it is made today. If so, the Indians may have passed this skill on to the Ladinos, then given it up or become Ladinos themselves. In a Ladino open community, individual action is given a freer rein, thus allowing for the variation in pottery produced there today. In addition, because the same basic technique is used regardless of the vessel to be built, any potter working in this tradition can theoretically produce any vessel in the inventory and can thus avoid the economic and creative limitations of specializing in only one form.

Figure 50. Zapotitlán vessel forms. (a) red-on-brown *tinaja*, (b) red-on-brown *tecomate*, (c) *olla*, (d) red-on-brown *porrón*, (e) *tecomate*. Scale 1:4. From the University of Pennsylvania Museum, Philadelphia, Reina-Hill Collection, 1973

Clay for pottery is gathered locally by the potters and is stored indoors. No special aging or curing treatments were noted. A different clay, used for decoration, also appears to be local. The clay used to make the vessels fires to a warm reddish brown color, which shows off the high mica content as sparkling gold specks against the brown background. Even undecorated cooking vessels receive a complete burnishing on both the interior and exterior that further enhances their appearance. The slip clay for decoration fires to a red color.

In Zapotitlán, the basic technique for all vessels is scooping. To make any vessel in the inventory, the potter begins by preparing a work surface—in one case observed, a large slab of rock was placed on a low wall; in another, a table in a kitchen was used. After sprinkling lime or dry clay on the work surface, the potter brings out some clay and begins to wedge it (the potter is working outside here for photographic purposes). During the entire construction process the Ladino potter remains standing, bending over her work. After working the mass of clay to a proper consistency, she shapes it into a well-defined, inverted, truncated cone by applying differential pressure through her left hand (a left-handed potter was observed) as she rolls the mass back and forth on the work surface. While her right hand supports the exterior walls of the inverted cone, the potter scoops out clay with the fingertips of her left hand (pl. 339), saving this clay to use again later in the construction process. As she continues to scoop clay from the vessel interior, the pressure from this operation begins to raise the walls and give the vessel a more hemispherical appearance. Next, the potter thins and shapes the bottom of the vessel with the fingertips of her left hand by drawing them heavily across that surface, while her right hand continues to support the exterior walls (pl. 340). Again she

scoops the interior walls with her fingertips to remove the clay that accumulates as she shapes the bottom (pl. 341). At this point, the lower portion of the vessel is essentially complete.

The potter now takes some of the scooped-out clay, rolls it between her hands into a long coil (pl. 342), adds it to the rim of the vessel with her left hand, and pinches it between thumb and fingers of her right hand all the way around to secure it (pl. 343). She adds several more coils in the same way, thinning the walls as she works with each newly added coil by scraping along the interior of the vessel with the bent forefinger of her left hand, while her right hand provides support from outside (pl. 344). The potter's attention now shifts to the vessel exterior, where she scrapes and draws up the clay with her left-hand fingertips, while her right hand supports from inside the vessel (pl. 345). The clay is very pliant at this time, and the walls are rising higher and beginning to fall over of their own weight. Thus, the potter is extremely busy shaping and scraping the vessel, trying at the same time to support the unstable walls. Continuing to work on the exterior, she begins to pull clay back toward the center, thus beginning to close over the opening to form the vessel shoulder (pl. 346). In *ollas* this shoulder is not pronounced. The potter forms the rim of the vessel by drawing the side of her left forefinger around the interior of the opening. She now smooths the interior with the fingertips of her left hand, still keeping her right hand cupped around the exterior in support (pl. 347).

Smoothing and some further shaping follow. Holding a wet corncob in her left hand, the potter rubs it back and forth on a steep diagonal across the exterior of the vessel, while the fingers of her right hand support the wall from inside (pl. 348). Having treated the vessel in this way, the potter smooths the entire surface with her moistened

Plate 339

Plate 340

Plate 341

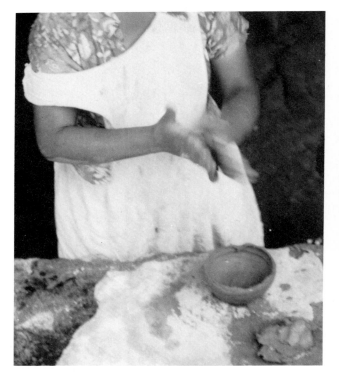

Plate 342

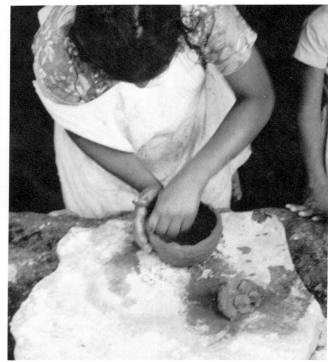

Plate 344

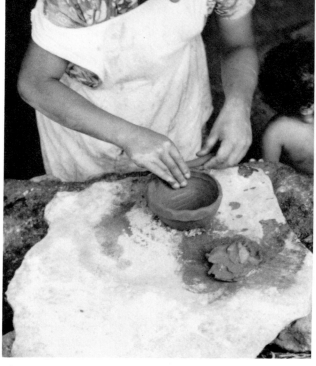

Plate 343

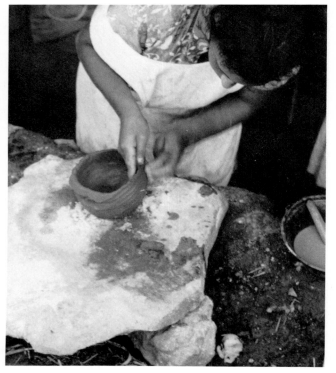

Plate 345

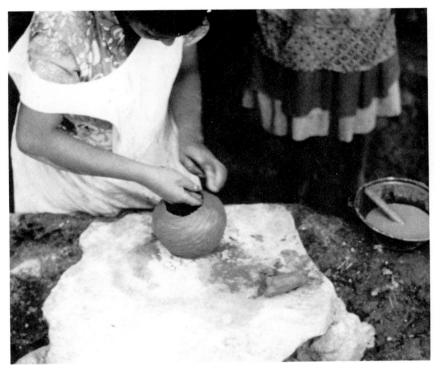

Plate 346

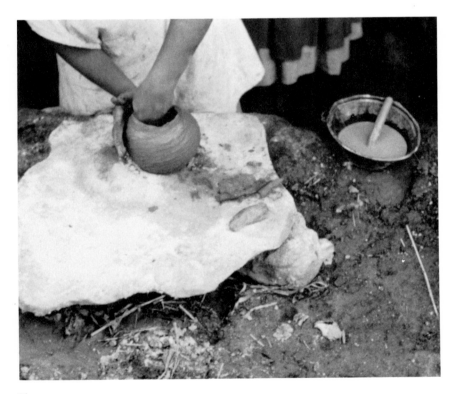

Plate 347

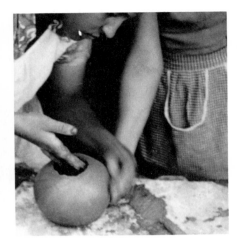

Plate 348

hands, then takes the vessel indoors to dry slowly. Later she may add a neck, handles, or spouts, depending on which type of vessel is being made. She forms these freehand, fastens them onto the body of the vessel with wet clay, and smooths over all the joints. The vessels are painted after the handles are attached and are then burnished, including the painted area. Although an actual firing was not observed, informants described a process that seemed similar to the method of firing for Trancas and El Barrial.

Figures are lacking for this center, but production here must be high, as Zapotitlán appears to be the major, if not the sole, center of pottery production in this remote region of Guatemala. A large amount of this pottery is used locally, and the rest is marketed. The most likely mechanism of distribution is the itinerant merchant, who, in this area of the country, relies more on mules than on the tumpline for cargo transportation. A number of vessels find their way to the market at Jutiapa, where they are preferred over the pottery from nearby Trancas and El Barrial. The major trade piece, however—the *tinaja*—runs into competition from those made in San Luis Jilotepeque, which are considered to be the best. Large amounts are also traded east to El Salvador.

The Cuilapa Pottery District

Guazacapán

The *pueblo* of Guazacapán, in the department of Santa Rosa, lies at the edge of the piedmont. In pre-Columbian times, this area was occupied by Xinca-speaking people, but today this language is on the verge of extinction, as only a few old men claim to know it. Guazacapán itself dates back at least to the early colonial period—records from 1584 mention it. In 1950, the municipality had 5,261 inhabitants, of whom 3,012 were classified as Indians. Of the total population, 3,366 people lived in the Ladino *pueblo*, while the remaining 1,895 occupied the one *aldea* and six *caseríos* of the surrounding area. The principal industries include raising cattle and growing rice and beans. There are, in addition, several small salt-making operations.[15]

The Guazacapán Ladinoized potters all live in the Indian *barrio* of San Pedro, one of the several *barrios* into which the *pueblo* is divided. It is locally known as the poorest section of town and is the most Indian. The potters are old women, who help support their extended families.

Forms produced are limited to three sizes of *ollas*—the largest being half a yard tall—and two sizes of *comales* (fig. 51). The *ollas* have vertical walls and only a small curve at the base. Large *ollas* have four evenly spaced nubbin handles below the rim; smaller ones have only two. *Comales* have *olla* bases without the high walls. All vessels are thoroughly burnished on the interior but receive no exterior treatment. The potters here feel their clay is of poor quality, unsuited to such complex forms as *tinajas*. Local consumers share the belief that Guazacapán pottery is inferior and import most of their vessels. Experimentation is therefore minimal, and new forms are not to be expected.

Clay occurs locally in the hills behind the *pueblo*, near the *caserío* of

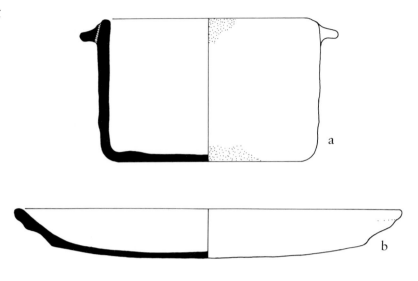

Figure 51. Guazacapán vessel forms. (a) *olla*, (b) *comal*. Scale 1:4. From the University of Pennsylvania Museum, Philadelphia, Reina-Hill Collection, 1973

El Astillero, apparently in limited quantity. The clay fires to a rust red. The potters buy it from other individuals by the pack load, paying 75¢ per load in 1974, enough for thirty *comales*. Potters complain that the clay they buy is of highly variable quality, often contaminated with sand or dirt. Yet they never search out or mine clay for themselves and expend little effort in preparing what they have bought. Raw clay is neither dried nor sifted, merely stored in water overnight before use, and small stones are left to be plucked out as a vessel is made. During wedging, a large amount of fine volcanic sand—as much as 50 percent of the final mixture—is added to the clay.

The basic technique in Guazacapán is that of the concave basal mold. The molds themselves are fashioned from adobe and are sun-dried only. Since they are unfired, they must be made very thick (two to two and one-half inches) and flat, with little concavity, to be strong enough to be handled (pl. 349). Although molds are made in different

sizes, all *comales* are made from the mold used for the largest *olla*. In this strongly Ladinoized area some potters work at a table, Ladino-fashion. Others, however, still work seated on the ground with their vessel in front of them. Potters are not at work every day, since they are frequently without clay.

The potter prepares the mold by coating its surface with some of the volcanic sand used as temper (pl. 350). She then puts a mass of prepared clay in the middle of the mold and spreads it out by vigorously flattening the clay with the palm of her right hand and pushing and drawing it with her fingers. When the clay is near the edge of the mold, the potter begins to raise low walls. This she does by placing her left hand along the narrow strip of uncovered mold, palm inward, and pressing clay up against it with her right hand (pl. 351). If the walls seem too low, the potter uses her fingertips to drag more clay from the center to the edges to raise them. After completing these low walls, she again uses her fingertips to

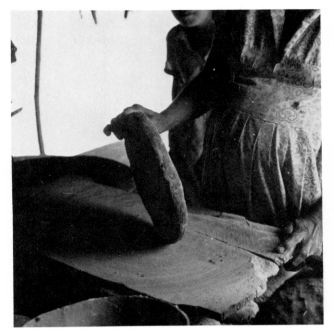

Plate 349

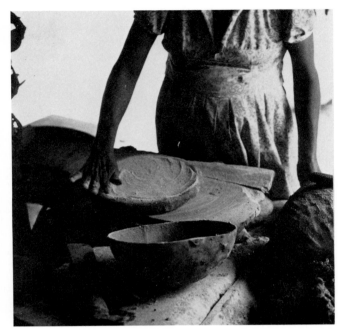

Plate 350

scrape the excess clay from the vessel interior, using her sense of touch and her experience to judge how much clay to remove.

If the vessel is a *comal*, all the potter need do to complete it is smooth the interior and flare the low walls with a corncob and a wet cloth. Holding the corncob in her right hand, she draws it across the surface, then gives the wall a flare by draping the wet cloth over it, holding it firmly in the crotch formed by the first two fingers of her right hand, and drawing it back and forth while gently pressing outward. She smooths this flared wall by wiping it with the corncob; then she sets the *comal*, still in its mold, in the shade to dry for two days before it will be ready to fire.

Olla construction begins like that of a *comal* but requires the addition of one or two coils of clay, depending on the size of the vessel being made. The potter shapes the coils between her hands, applies them to the inside of the rim, and blends them in with the rest of the vessel, raising the walls at the same time by

scraping up and down with her right-hand fingers (pl. 352). She completes the walls by using a corncob under the palm of her right hand, working it upward and rolling it along the exterior, while her left hand supports the walls from inside (pl. 353). As she works, she rotates the mold occasionally to reach a different section of the wall. During this stage of construction, the potter is preoccupied with the consistency of the clay. If the walls are too wet, they will collapse of their own weight; if too dry, they are hard to build.

To smooth the marks left on the walls by the corncob, the potter takes another cob, used for so long that it has an almost smooth surface, and draws it over both inner and outer surfaces. She further smooths the interior and rim area by wiping them with a wet cloth in the manner described for *comales*, but without giving the rim a flare (pl. 354). Addition of the nubbin handles follows immediately. The potter forms each one by rolling a small ball of clay between her palms, grasping it be-

tween the thumb and first two fingers of her right hand, and pressing it onto the vessel wall. Then, with her forefinger, she spreads out the clay to strengthen the bond (pl. 355). The drying procedure is the same as that for *comales*, and both *comales* and *ollas* are burnished prior to firing. This is done with smooth pieces of obsidian, only on the interiors.

Firing is typically open. The potters of Guazacapán use special stones of volcanic origin, called *tenamastes*, as supports for the vessels (pl. 356). The stones are treated with a bath, or baptism, of salt water. The potters believe that without this treatment the stones would shatter during firing, causing the vessels resting on them to break. The *ollas* are laid mouth down in two layers—each of the lower vessels is supported by three *tenamastes*, while the upper vessels are placed at the interstices between those below. Bunches of twigs are stuffed between the *tenamastes*, and *comales* are laid upon edge around the *ollas*, with their cooking surfaces facing in-

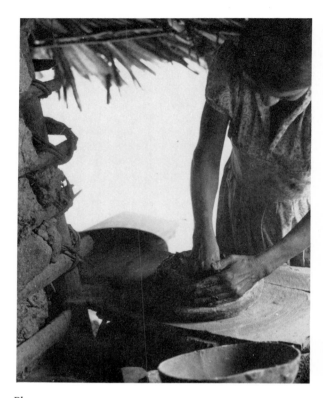

Plate 351

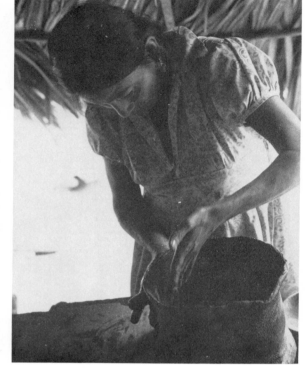

Plate 353

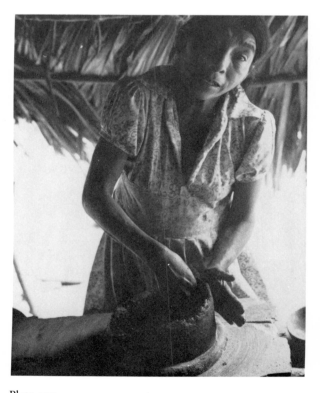

Plate 352

Plate 354

Plate 355

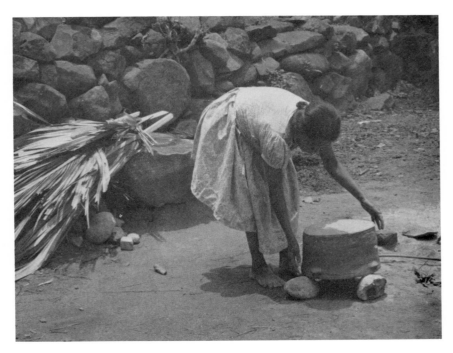

Plate 356

ward. The whole is then covered with straw and set ablaze. Potters report that they rarely lose vessels during firing. This takes place on Saturday morning, so merchants may pick up stocks of vessels for sale at the Sunday market.

Only about ten women still produce pottery in the *barrio* of San Pedro. The community culture that at one time may have fostered pottery making here has weakened to a point where women are free now, as artisans, to choose whether or not to learn. There is some tendency to vessel form specialization, although this is probably due more to the degree of effort individual potters are willing to invest than to any specialized techniques they use. The potters do not start work particularly early in the morning, yet they still manage to produce ten *comales* daily; three dozen *comales* appears to be an accurate weekly production figure. Six or seven *ollas* may also be produced, but there is much less demand for this vessel. Pottery making stops almost entirely during the rainy season, and the area then relies even more on imported vessels.

None of the potters takes her own products to market. The distribution of Guazacapán pottery is handled by merchants who live in another *barrio* of the town, San Miguel. In 1975, *comales* were sold to these merchants for between 10¢ and 15¢; a large *olla* brought as much as $2.00. Guazacapán merchants sell pottery primarily to people working on *fincas* along the coast. Smaller amounts are taken to the Chiquimulilla and Taxisco markets and to Cuilapa, as well as to the *pueblo* of Guazacapán proper. Consumers, however, have a low opinion of the pottery made in San Pedro; they prefer *comales* from San Raimundo and other vessels from Santa María Ixhuatán. Also in great demand are the half-glazed vessels from San Cristóbal Totonicapán and the *tinajas* from San Luis Jilotepeque.

Santa María Ixhuatán

The *municipio* of Santa María Ixhuatán is located in the department of Santa Rosa, in the southeast portion of the country. It is situated in the highlands, overlooking the piedmont and the coastal plain. The area is wholly Ladinoized, although formerly it may have been populated by Pokomam-speaking people. In 1950, the *municipio* had a population of 9,032 people, of whom only 17 were classed as Indians. 1,405 Ladinos lived in the socially open *pueblo*; the rest were scattered throughout the eighteen *aldeas* and fifteen *caseríos* of the outlying area. In addition to pottery making, the chief industries in the department include growing and processing coffee and sugar cane.[16] The *pueblo*, although only a few miles from the highway to El Salvador, remains isolated. A mountainous secondary road permits movement of people and products by a daily bus and by *finca* trucks to the Mercado La Terminal in Guatemala City.

Potters live both in the *aldeas* and in the lower-class part of the *pueblo*. The *aldea* of La Esperanza and its *caserío* of Cerro Chata are locally known to be the pottery centers of the *municipio*. Here again women are the potters, but men play an active role and gather most of the raw materials; they also serve as vendors for their wives' production.

Traditional forms are limited to *tinajas*, *tinajeras*—locally called *cántaros*—and *ollas* (fig. 52). The *tinaja* has a spherical body with a high neck and a flaring rim. Three handles are placed at even intervals, two being small strap handles on the shoulder, the other—a long one—falling from just below the rim to the shoulder. Plastic decoration includes regular nicks around the rim and, sometimes, along a ridge on the back of the large handle. The upper half of the vessel is slipped with a red-firing clay. *Tinajas* may be further embellished by the addition of Ladino-style floral designs painted in white over the red slip.

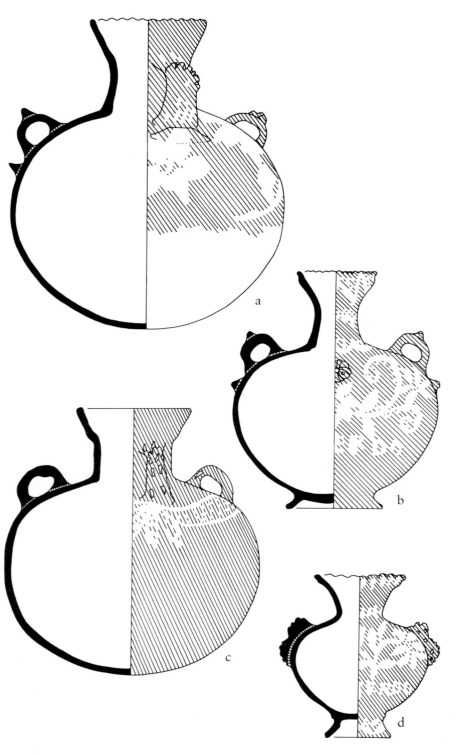

Figure 52. Santa María Ixhuatán vessel forms. (a) white-on-red *tinaja*, (b) white-on-red urban ware, (c) white-on-red *tinaja*, (d) white-on-red urban ware. Scale 1:4. From the University of Pennsylvania Museum, Philadelphia, Reina-Hill Collection, 1973

The best of these are always kept for the potter's own use, however, as in San Luis Jilotepeque and Santa María Chiquimula, and only rarely appear outside the *municipio*. A *cántaro* is produced with exactly the same form as the *tinaja* but with no decoration. Both vessels can be carried on the hip in the style of eastern Guatemala and El Salvador, as well as on the head. The local *ollas* have globular bodies with low, slightly flaring necks and rims and two strap handles attached 180° apart, vertically from the rim to the shoulders.

Demands for urban- and tourist-type vessels have stimulated *pueblo* potters to introduce new forms (fig. 52)—primarily miniature *tinajas*, *porrones*, and *floreros*, or flower vases—that they produce under *encargo*, or special order, to dealers in Guatemala City. The *aldea* potters, with a rural orientation, continue to produce the traditional forms.

Clay and sand must be purchased from a nearby *finca*. As of 1975, the clay cost $1.00 per pack load (under one hundred pounds); the price of the sand was $1.75 to $2.00 per pack load. The clay fires to a light brown. Clays for the red slip and white painted decoration are brought in by merchants from the *aldea* of Azulco, in the department of Jutiapa, further east down the highway to El Salvador. These two clays are sold by the clod, each 5¢ clod being described as about the size of a chicken egg. The clay is dried outdoors before use, and the sand is well sifted before mixing. Potters cited a fifty-fifty mix, when asked about proportions, but stated that they judge mainly by the feel of the mixture.

The basic method of pottery production here employs a convex basal mold, which in this case is an overturned *cántaro*. The potter works in her yard at a bench or platform, Ladino-style. She combines clay and sand, adds water, and wedges the mass by rocking it back and forth and slamming it down on the work surface (pl. 357). When it

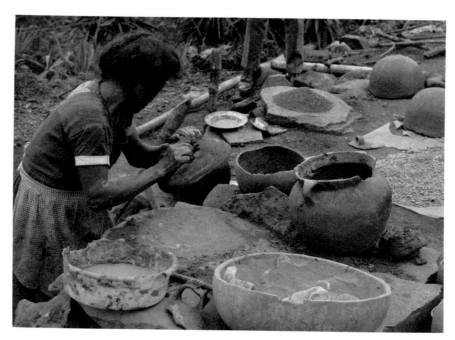

Plate 357

is ready, she forms a large, thick disc of clay by beating the mass out on the work surface with the palms of her hands (pl. 358); she scrapes off any excess clay with her fingertips, to store for later use (pl. 359).

With the disc thus suitably fashioned, the potter next places the inverted *cántaro* on the work surface, puts the disc on top, and presses it gently into place with her palms (pl. 360). When it is properly positioned, she begins drawing the thick disc out over the mold surface. At first she works the clay down with the wetted palms of both hands (pl. 361); she continues with this method until the disc roughly covers the *cántaro* mold to the break of its shoulder. Then the potter begins to use a wet corncob to further thin and draw out the clay (pl. 362). While the clay is thick on the mold, she must keep it wet enough to be pliable while she works with the corncob. She uses latitudinal and longitudinal strokes where needed to keep the growing form symmetrical. The strokes are always long to keep the clay moving toward the edges. In this way, she works the

walls of the new vessel down until they almost obscure the mold. When the new vessel has reached this length and a satisfactory thickness, the mold and the vessel are placed aside to dry (pl. 363). Several hours later the vessel may be removed from its mold and allowed to dry further, still in its inverted position. During this drying time, the potter starts other vessels or works at other stages of construction. When the vessel is dry enough, the potter turns it over and scrapes it on the inside with a piece of gourd. As the walls are still thick, this process takes a relatively long time. When they have attained the proper uniform thickness, the potter rolls out a large coil between her hands; she applies this coil to the vessel rim and pinches it into place. She draws this up with a burned corncob held in her right hand, on the exterior, while her left hand provides support from the interior; continuing in the same manner, she draws the clay over to form the vessel shoulders. The vessel must now be left to dry for the second time.

For the next step—building the

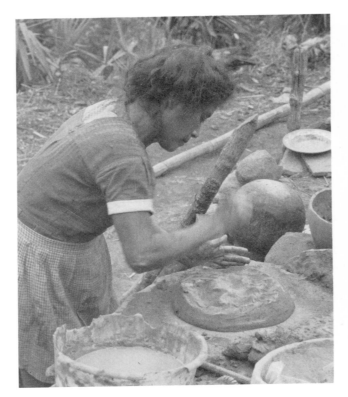

Plate 358

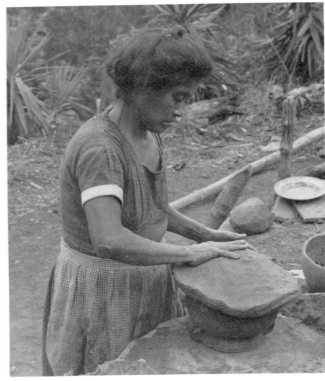

Plate 360

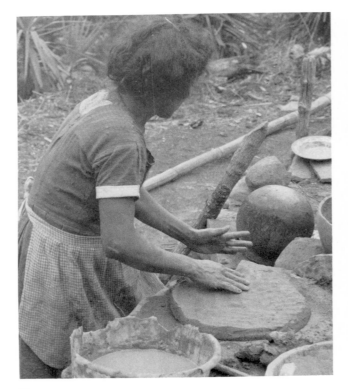

Plate 359

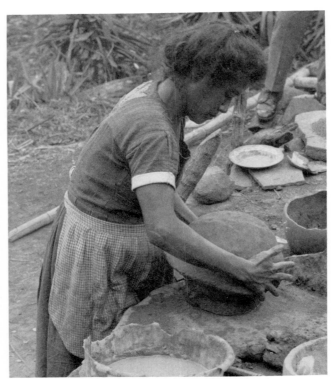

Plate 361

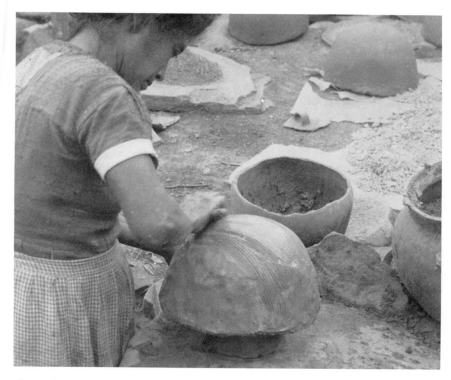

Plate 362

Plate 363

neck—the potter adds another, smaller clay coil and works it up into a neck as she did the shoulders. With her fingers, she forms and applies the strap handles, then smooths the vessel all over with her wet palms to remove marks left by the corncob and leaves it to dry thoroughly. She applies slip with her hands to the upper half of the exterior and, after it has dried, burnishes this area with a piece of obsidian. If white painted decoration is desired, she applies it with a chicken feather just before firing.

A special location is sought for firing. The preferred area is a spot in the yard where large stones naturally occur in quantities great enough to form a natural floor. A fire is built on this spot to form an ash and charcoal cushion. Split wood is then placed in a crisscross pattern on top of this. After being preheated in the sun, a week's production of vessels is placed mouth up in one layer among the wood. More wood and twigs are then packed in between the pots. The firing lot is made up of only one layer, for potters believe a second layer, to fire properly, would require such intense heat that any pottery on the lower level would be broken. The whole lot is then covered with straw and set on fire. It should be noted that, like the pottery clay, all fuel must be purchased. No consensus could be reached on the rate of breakage during firing. Some potters said large numbers regularly broke, others reported breakage of only about one per dozen.

Potters producing traditional forms make about four vessels per day, work three to four days a week, and usually fire on Saturdays. The potter's husband markets these traditional vessels. The men take them to the markets at Chiquimulilla, Barberena—an important market for *finca* workers—Casillas, Cuilapa, and even down on the Pacific coast as far as San José. In 1975, *tinajas* and *cántaros* sold for 45¢ to $1.00, depending on the fluctuations of the market. Santa María

Ixhuatán appears to be of secondary importance as a production center; vessels made there are limited in distribution by competition from San Luis Jilotepeque to the north, Trancas, El Barrial, and Zapotitlán to the east, and Chinautla to the northwest.

Casillas

Casillas and its pottery-producing *aldea*, El Rincón, are located in the department of Santa Rosa, in southeastern Guatemala. The *municipio* is twenty-three miles north of the department capital of Cuilapa, in a highly Ladinoized region with open noncorporate community structures. In 1950, only 116 of the *municipio's* 7,122 inhabitants were Indians, and these had no indigenous linguistic affiliation. Of the total population, only 994 lived in the *pueblo*; the remainder resided in the ten Ladino *aldeas*, of which El Rincón is one, and the twenty-six *caseríos* of the surrounding area. The principal industries are the small-scale growing and processing of sugar cane and coffee.[17] The isolation of this area has been reduced in recent years by construction of a new road leading to the El Salvador highway. The Ladino style of life is strong in both the *pueblo* and the *aldeas*. As in Indian *municipios*, *pueblo* people have a higher social position than those of *aldeas* and *caseríos*.

The six women still making pottery at El Rincón produce a number of forms, including *ollas, comales, apastes, apastillos, tapaderas,* a local variant of an *olla* called a *tortera,* and, rarely, *tinajas* and *porrones* (figs. 53, 54). The *ollas* may have either straight, flaring, or globular bodies with curving walls, which recurve three-quarters of the way up the body to a direct or flaring rim. This type of vessel has two strap handles affixed opposite at points below the rim and above the recurve. On straight-sided *ollas*, the two opposite handles are placed

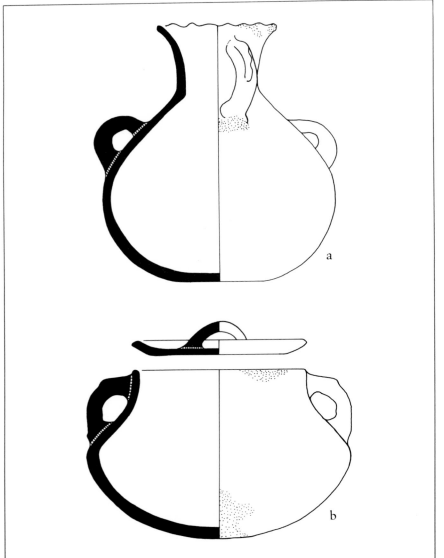

Figure 53. Casillas vessel forms. (a) *tinaja*, (b) *tapadera* and *tortera*. Scale 1:4. From the University of Pennsylvania Museum, Philadelphia, Reina-Hill Collection, 1973

midway up the walls. The local *apastes* have globular to subspherical bodies with low, slightly flaring rims and constricted mouths. Strap handles are attached horizontally at an upward angle, high on the body. *Apastillos* are small *apastes* with tab instead of strap handles. The *tapadera* has a central strap handle. The *tortera* is a wide vessel with a hemispherical body that recurves inward just above the middle. The rim has

an irregular flare, and the two vertical strap handles below the rim turn downward. Both *tinajas* and *porrones* are produced with squat, ovoid bodies. The *tinajas* have high flaring necks and three strap handles. Two of the handles, set on the shoulders, are small; the third is longer, reaching from below the rim to the shoulder, a typical arrangement in the extreme southeast. The *porrón* has the usual two spouts—

the large one for filling, the small one for pouring—placed high on the vessel, as well as a single long strap handle on top, across the axis formed by the two spouts.

Vessels are unslipped but are moderately well burnished. On *torteras*, *ollas*, and *comales*, much effort is made to smooth the interior, while the exterior is left crude. The people believe that food sticks less to smooth surfaces. *Tinajas* and *porrones* receive a thorough exterior burnishing and, sometimes, decorations of punctations and ridged appliqués on the handles.

Clay occurs locally but is reported to be scarce, accounting in part, at least, for the decline in production. It fires to a reddish brown color. The potters mine it themselves and carry it home in baskets on their heads. White sand for temper comes from nearby road cuts. Clay is stored with water in an old *olla* until needed, when clay and a small amount of sand are wedged on a table in the gallery of the potter's house (pl. 364). In fact, all production is carried out at this table, which is close to the yard where vessels are left to dry. In construction, the potter uses a modified version of the orbiting technique. This combination of the Indian orbiting technique at a Ladino table gives us an excellent example of a technology with a mixed cultural heritage.

After wedging the clay, the potter forms it into a roughly spherical shape. She pats it down and draws it out into a long strip with the crotch of her hands (pl. 365). She often uses a board for her work, holding it in place at the edge of the table by pressing on it with her pelvis. The potter grasps the heavy strip at both ends and drags it up onto the board (pl. 366). Leaving the strip on edge, she bends it into a ring, carefully joins and blends the two ends (pl. 367), and begins to work the ring upward with her two hands, the right inside, the left outside (pl. 368). Her fingertips actually draw up the clay, and this process causes deep depressions on the exterior (pl.

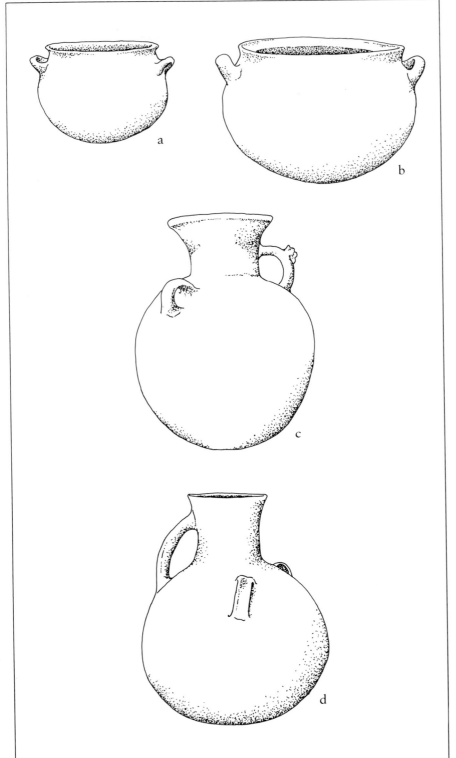

Figure 54. Casillas vessel forms. (a) *apaste*, (b) *apaste*, (c) *tinaja*, (d) *tinaja*. Scale 1:4 (approx.). Drawn from photographs taken by Margaret Arrott

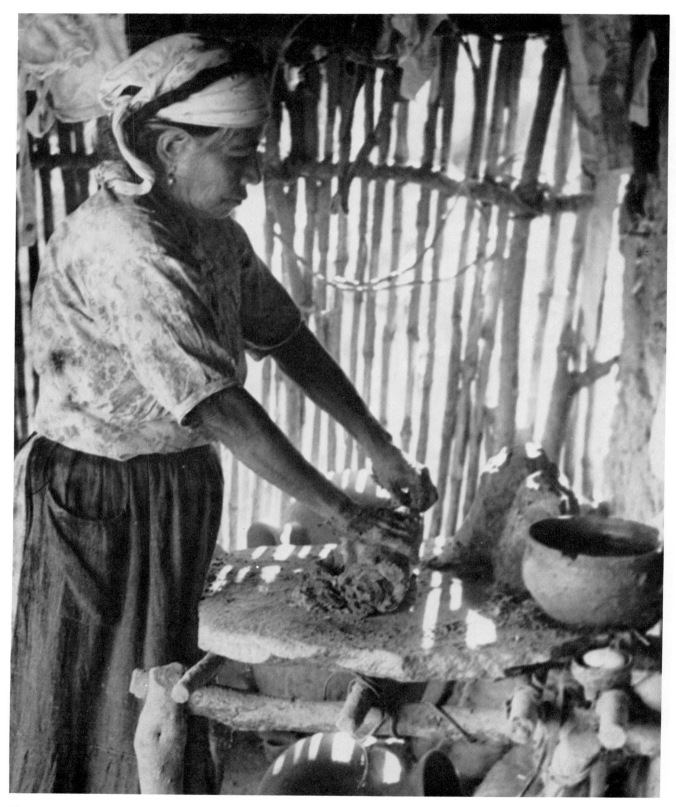

Plate 364

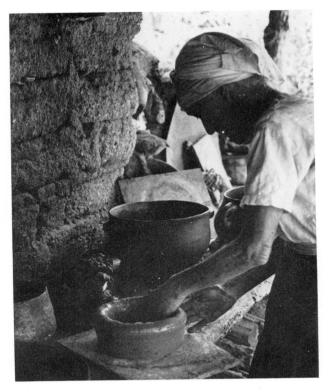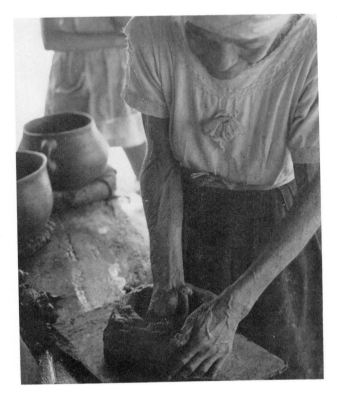

Plate 365

Plate 367

Plate 366

Plate 368

369). The potter moves back and forth in front of the table, twisting and shifting her torso to improve her working position. It is evident to the observer that, without the table in her way, she would be sidestepping around her work, orbiting-style.

When she has formed a hemispherical dome with an opening at the top only large enough for her left hand, the potter begins using a wet corncob (pl. 370). She holds this in her right hand and draws it upward over the exterior while, with her left hand, she parallels these movements from inside. She continues to draw clay up and toward the center—the aperture shrinks (pl. 371), until she finally closes it with a well-timed stroke of the corncob. With the

newly formed half still on the board, she puts it in the sun to dry for two hours.

When the clay is sufficiently dry, the potter places the work back on the table, with the base in a straw collar, and scrapes the thick walls with a section of gourd (pl. 372). Next she rolls out a heavy coil of clay between her hands and, while her left hand supports the coil, her right hand pinches it into place at the rim (pl. 373). She works up this clay with her fingers as she did the lower half (pls. 374, 375), switching to the corncob for the final shaping. All wide-mouthed cooking vessels are worked up more or less vertically, but the shoulders of the *tinajas* and *porrones* are carefully formed.

Excess clay is pinched from the rim area. The flaring rims of the cooking vessels are made by drawing the crotch of the hand, thumb outside, back and forth along the rim, pressing gently outward; on a *tinaja* opening, the thumb position is reversed, but the motion is the same. The vessel is then left to dry.

When the walls of the *tinaja* can support the weight of more clay, the potter forms the neck from a small coil of clay that she secures to the opening and works up with her hands and the corncob. Handles are also added to cooking vessels at this time. Flattening out a long coil on the table, the potter cuts it in half, pinches off the four corners of each piece, and presses the ends flat. To

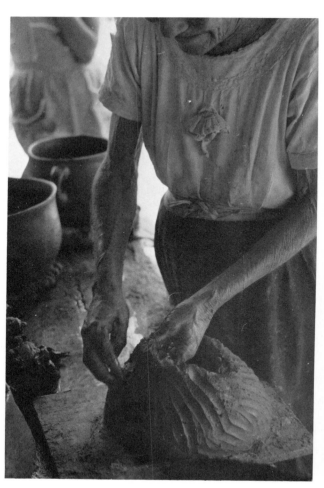

Plate 369

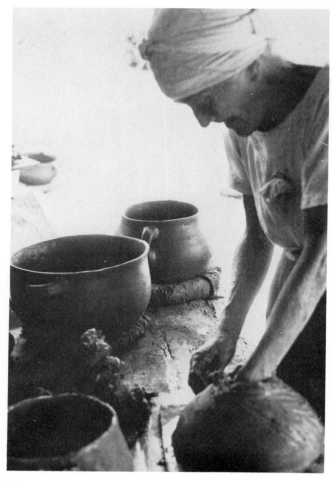

Plate 370

assure a firm joint, she puts small daubs of wet clay where the handles will go, attaches the clay straps, and smooths the joint area with her wet hands. Again, she sets the vessel out in the sun to dry. After it has dried, she burnishes it with a smooth stone, which from long use has worn into an ax shape. These stones are often heirlooms, and potters are extremely reluctant to part with them.

The technique of producing *comales* is unique. Using clay wedged as before, the potter first rolls out a thick coil between her hands, joins the ends to form a ring, and places it on a metal drum lid, which serves as a flat mold (pl. 376). Next, using her right-hand fingertips, she forms a deep groove around the top of the ring while, with her left hand, she turns the drum lid counterclockwise to keep the work area in front of her (pl. 377). Still using her fingertips, she spreads the clay out. While she works a dishlike concavity into the upper surface, the rest of the work remains thick in profile (pl. 378). After smoothing the clay of the interior surface (pl. 379), she gives the walls a flare by grasping them between thumb and forefinger of her right hand, thumb inside, then drawing her hand back and forth around the vessel (pl. 380). Leaving the *comal* on the mold, she sets it aside to dry for a short while.

After the initial drying, the potter removes the *comal* from the mold and, placing it on edge in her lap, begins to scrape excess clay from the exterior, first with a knife, then with a section of gourd—this gives the *comal* its form and proper curve (pl. 381). It is still wet, however, and as scraping continues the thinned vessel begins to sag, making it necessary for the potter to alternately scrape the exterior and pat the interior at the center to maintain the concave form. As she scrapes, she removes many small stones from the exterior and fills the resulting pits with fresh clay to even the surface. While scraping and patting the *comal*, the potter is constantly hefting the vessel to check its weight. For these potters weight, not wall thickness, is the main criterion for judging when enough clay has been scraped off.

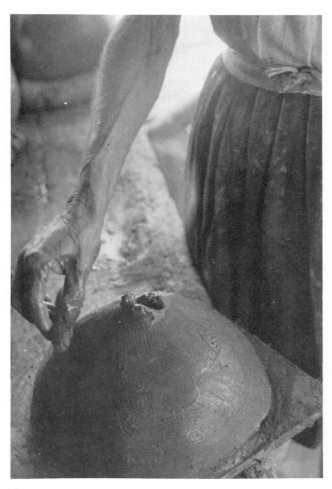

Plate 371

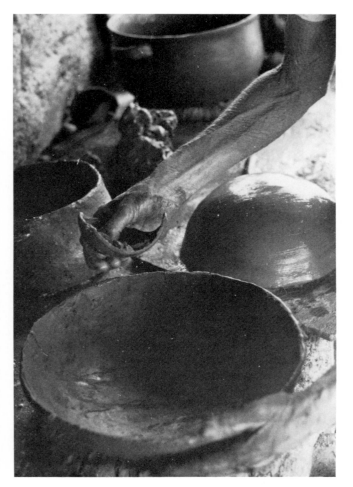

Plate 372

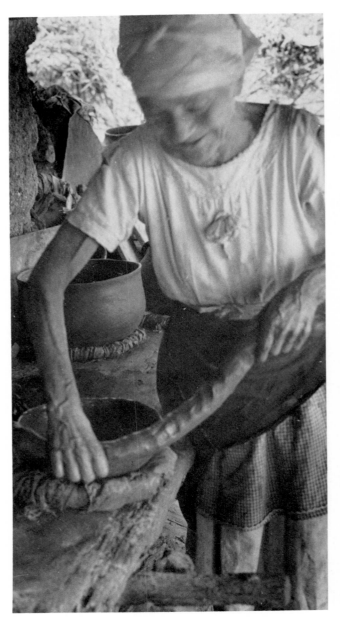

Plate 373

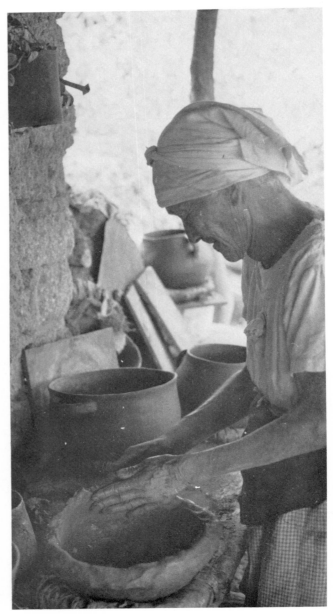

Plate 374

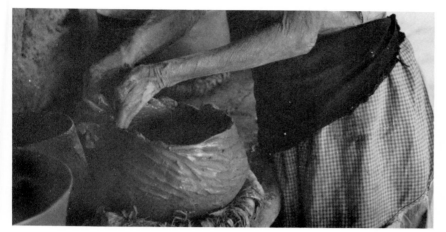

Plate 375

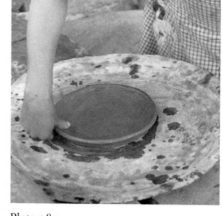

Plate 380

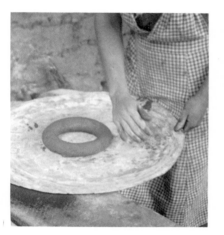

Plate 376

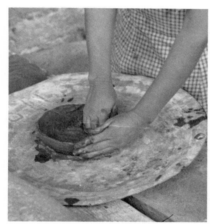

Plate 378

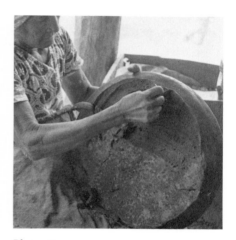

Plate 381

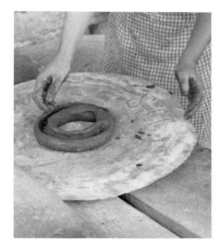

Plate 377

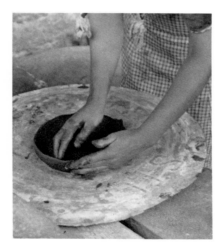

Plate 379

The potter needs almost a full half hour to scrape each *comal* to her satisfaction, after which she sets it out to dry. When it is thoroughly dry, she burnishes it vigorously on the interior, quickly and unevenly on the exterior. Even though this is an energetic activity, she considers it light work after the difficult scraping process.

When enough vessels of all types have been made, firing will be undertaken. The method is similar to that used by Guazacapán potters. Special stones of basaltic lava, locally called *tituntes*, are laid down on a base of brush in such a way that each *olla* or *tinaja* in the firing lot will rest on three stones. *Ollas* are placed mouth down on these stones; *tinajas* rest on their sides. Smaller *ollas* form a second level in the spaces between the larger vessels, and small twigs are jammed into all crevices between vessels and stones. *Comales* are laid around the pile on edge. In turn, they are surrounded by purchased branches, which are placed on end, close together, to lean against the pile. Straw, if available, is used to cover the fire after it is ignited.

As stated above, only six women are currently active in pottery making at El Rincón. They work mostly to order—*encargo* system—from a middle person, usually from the *pueblo* of Casillas. Potters, therefore, produce the number of vessels agreed upon. After an order is filled, they stop working on pottery, rest, and wait for the next order. When working, the potters usually make three or four vessels each day. Even though they believe they make no profit on pottery, they have no better economic opportunities, so they continue to produce.

Nearly all the pottery from El Rincón is consumed locally in the *municipio*. Middlemen sell some at the Casillas market as well as door to door in the other *aldeas*, *caseríos*, and *fincas*. Although the El Rincón pottery competes well locally, especially *comales* and *ollas*—which cost about half the price of imported pieces—it is not traded widely because of its limited production and relatively poor quality. *Comales* are brought in from San Raimundo, *tinajas* from Santa María Ixhuatán and San Luis Jilotepeque.

7.

Pottery Production
An Overview

The basic characteristics of the contemporary Guatemalan pottery-producing centers are presented in table 2. The data in this table show several interesting patterns. The production centers where potters employ a larger number of techniques are the sources of superior pottery—"superior" is used here from the consumers' viewpoint to mean that the pottery is of high quality and is technologically sound. It is apparent from the data that these same centers are predominantly Indian and that they also produce the greatest variety of forms (see table 3). On the basis of these patterns, it can be stated that potters of centers producing superior pottery are familiar with a larger variety of techniques. This in turn reflects the understanding these potters have of the basic properties of their clay, which allows them to fashion it more readily into a variety of vessel forms. Sociologically, these communities are also the strongest closed corporate Indian *pueblos*, with a definite community culture. This seems to demonstrate the importance of this type of social organization in the Guatemalan highlands for maintaining a vigorous pottery tradition and for retaining other elements—such as textiles, metates and manos, house types, dress—of Indian material culture.

To produce technologically sound vessels, some techniques are more important than others. The clay itself, by virtue of specific qualities—such as plasticity and yield point—may require or prohibit the use of certain techniques and may condition the forms produced. Since superior and inferior vessels are made in centers using the same basic technique, the differences in quality, aside from the skill of the individual potter, lie in the various supplementary techniques utilized.

Of the auxiliary techniques, vessel scraping appears to make the greatest difference between superior and inferior vessels. The resulting evenness of the walls indicates care in construction, and thinness makes for light weight. Burnishing is also a decisive factor among the finishing processes, with slipping being less important. The effect of both slipping and burnishing is to seal the vessel walls to some extent and make them less porous. The care with which these processes are carried out also affects vessel quality. Thus, in centers where potters are meticulous in their work, burnishing alone suffices. Here again, properties of the particular clay play a fundamental role in determining the need for one or both processes. In any event, a watertight wall is never achieved, nor is it desired. The ability of slightly porous vessels, particularly *tinajas*, to sweat and, by evaporation, to keep their contents cool is fully appreciated by potters and consumers alike, especially in the hotter regions of the south coast and El Oriente.

Technically, the painting of vessels is a purely decorative process that in itself does not influence the quality of the pottery. It should be noted, however, that this practice of further embellishing technologically sound vessels is common in the centers producing superior pottery. In addition, although painting does not affect the soundness of a vessel, it does slightly increase its value. Such embellishment—as opposed to that on urban ware made for purely decorative purposes—does not influence the use of these functional vessels. From the potter's point of view, painting does not make these vessels purely ornamental. Instead, *tinajas*, *ollas*, and the like, so treated, are in daily use as part of the household culinary ware, classified as utilitarian but nicer—*más lindas*.

Talc washing, although it adds a desirable quality to cooking vessels, is possible only where the raw material is available. Talc-washed vessels are of great economic importance—the talc-washed *comal*, for example, is always in demand. Middle Motagua area pottery made with *chistún* is in this category of specialized production, wherein potters exploit a differentially occurring natural resource to their economic advantage.

The presence or absence of particular traits in the firing technology of different production centers may, again, be related to the qualities of the specific clays used. Thus preheating, although it results in fewer broken vessels for the potters of those centers that employ it, does not prevent equally good vessels from being produced without this step. Raising the vessels off the ground, however, does appear to make a difference: air flow is improved, and the potter achieves better oxidation, more efficient utilization of fuel, and higher firing temperatures, along with a general decrease in fireclouding. Specific firing methods vary too much for us to make a general statement, as shown by comparisons among the centers of San Miguel Acatán, San Pedro

Table 2. *Distribution of Social, Cultural, and Technological Traits by Pottery-Production Center*

Region	Center	Indian	Ladino	Male potters	Female potters	*Pueblo* production	*Aldea* production	Spanish	Quiché	Cakchiquel	Pokomam	Mam	Other	Concave basal mold	Convex basal mold	Full mold	Orbiting	Scooping
Eastern	Casillas		●		●		●	●									/	
	Santa María Ixhuatán		●		●	●	●	●							●			
	Guazacapán		●		●	●		●						●				
	Zapotitlán		●		●	●	●	●										●
	Trancas/El Barrial		●		●		●	●										●
	San Luis Jilotepeque	●			●	●	●				●				●			
	Jocotán	●			●		●						●			/		
	Lo de Mejía		●		●		●	●									●	
	San Vicente		●		●	●	●	●									●	
	San Agustín Acasaguastlán		●		●		●	●									●	
Northern	San José Petén	●			●	●							●					
	Rabinal	●		●	●	●	●		●								●	
	Salamá		●		●		●	●						●				
	Cobán and the Alta Verapaz	●			●		●						●	●				
Northwestern	San Miguel Acatán	●			●	●	●						●	●				
	Chiantla	●	●		●		●	●				●		●				
	San Sebastián Huehuetenango	●			●		●					●		●				
Central	Comitancillo	●			●		●					●					●	
	San Cristóbal Totonicapán	●		●	●		●		●					●				
	Santa María Chiquimula	●		●	●		●		●								●	
	San Pedro Jocopilas	●			●		●		●								●	
	Santa Apolonia	●			●	●	●			●							●	
	San Raimundo	●			●	●	●			●							●	
	Mixco*	●			●	●				●						/		
	Chinautla	●			●	●	●			●					●			

* = No longer in production.

/ = Special situation —see text for explanation.

Traits: Social — *Language* — *Basic technique*

Basic technique, cont'd.	Flat mold	Auxiliary technique	Coiling	Surface rolling	Surface smoothing	Surface scraping	Finishing process	Vessel scraping	Slipping	Burnishing	Painting	Talc washing	Glazing	Firing technique	Stacked	One layer	Raised off ground	Preheated	Single vessel	Simple kiln
Casillas			●			●		●		●					●		●			
Santa María Ixhuatán			●		●	●		●	●	●	●					●		●		
Guazacapán			●	●	●	●				●					●		●			
Zapotitlán			●		●	●				●	●				●					
Trancas/El Barrial			●		●	●			●	●					●					
San Luis Jilotepeque				●	●			●	●	●	●					●				
Jocotán	●		●			●				●					●	●			●	
Lo de Mejía					●					●					●					
San Vicente					●					●					●			●		
San Agustín Acasaguastlán					●					●										
San José Petén	●		●					●		●					●		●			
Rabinal			●		●	●		●	●		●				●					
Salamá			●		●	●			●			●			●					
Cobán and the Alta Verapaz			●		●	●			●	●						●				●
San Miguel Acatán			●		●	●		●		●								●	●	
Chiantla			●		●	●							●		●					●
San Sebastián Huehuetenango			●		●	●			●	●						●				
Comitancillo			●	●	●	●									●					
San Cristóbal Totonicapán			●			●		●					●		●		●			
Santa María Chiquimula			●		●	●		●		●	●				●		●			
San Pedro Jocopilas			●	●	●					●	●					●	●			
Santa Apolonia			●	●	●			●	●	●	●	●			●			●		
San Raimundo					●			●				●			●					●
Mixco*												●				●				
Chinautla			●	●	●	●		●	●	●	●				●		●	●		

Table 3. *Distribution of Forms by Pottery-Production Center*

Forms	San Miguel Acatán	San Sebastián Huehuetenango	Comitancillo	San Cristóbal Totonicapán	Santa María Chiquimula	San Pedro Jocopilas	Santa Apolonia	San Raimundo	Chinautla	Mixco*	Rabinal	Cobán and the Alta Verapaz	Jocotán	San Luis Jilotepeque	San José Petén
Tinaja	●	●	●		●	●	●	●	●		●	●		●	●
Porrón									●					●	
Tinajera				●			●		●						
Apaste grande				●											
Apaste				●		●	●	●	●		●				
Comal	●		●	●	●	●	●			●			●		●
Olla	●	●	●	●	●	●	●		●		●	●	●	●	●
Pichacha	●	●	●	●	●	●									
Sartén				●											
Tamalero				●	●		●								●
Batidor				●			●		●		●				●
Cajete												●		●	●
Jarro	●	●	●	●	●	●		●	●		●			●	
Tecomate															
Tapadera				●											●
Brasero					●		●		●		●	●			
Incensario									●			●			
Figurines							●		●			●			

Forms	Ladinoized Indians and Ladinos									
	Chiantla	Salamá	Trancas/El Barrial	San Agustín Acasaguastlán	San Vicente	Lo de Mejía	Zapotitlán	Casillas	Santa María Ixhuatán	Guazacapán
Tinaja	●	●	●				●	●	●	
Porrón							●	●		
Tinajera						●				
Apaste grande	●			●	●	●				
Apaste	●	●	●	●	●	●		●		
Comal	●	●	●	●	●	●				●
Olla	●	●	●			●	●	●	●	●
Pichacha										
Sartén		●								
Tamalero										
Batidor	●									
Cajete										
Jarro	●	●								
Tecomate			●				●			
Tapadera						●		●		
Brasero										
Incensario										
Figurines									●	

* = No longer in production.

Jocopilas, and Trancas and El Ba-
rrial. It is apparent from our data
that, while not all centers produce
vessels of generally acknowledged
high quality, a number of centers
can produce vessels that are techno-
logically sound and, in a few in-
stances, vessels that can be consid-
ered artistic both for their symmetry
and their decoration.

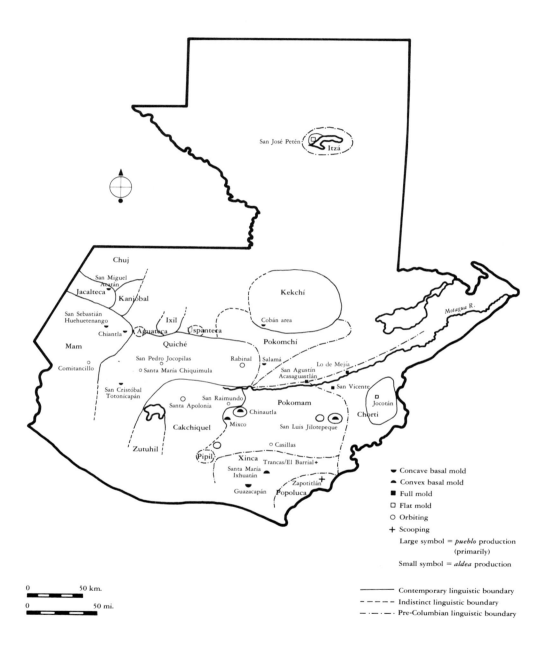

Map 7. Pottery techniques, linguistic groups, and contemporary production centers

Cultural-Historical Implications

In the Guatemalan highlands, there is a surprising correlation between specific pottery techniques and linguistic groups (map 7). Thus, the Quiché and the Cakchiquel use the orbiting technique almost exclusively.[1] The Pokomam use the convex basal mold technique. The present-day inhabitants of what was formerly the Popoluca area use the scooping technique. The flat mold technique used by the Chorti is peculiar to them as a linguistic group.[2] The Kanjobal, Mam, Pokomchí, and Xinca—or their Ladino descendants—all utilize the concave basal mold technique almost without exception.[3]

There are, however, two inconsistencies in these correlations: the Mam speakers of Comitancillo utilize the orbiting technique, and the Quiché speakers of San Cristóbal Totonicapán use the concave basal mold. We can offer the following historical explanation. The use of the concave basal mold in San Cristóbal Totonicapán is accounted for by a well-documented linguistic substitution. The Totonicapán area, Mam in the fifteenth century, was absorbed into the expanding Quiché state only shortly before the Spanish conquest.[4] Mam potters use the concave basal mold. In the centuries between the Quiché conquest of the area and the present, the Quiché language has become the dominant native language, but the descendants of the Mam potters have maintained their ancient technology.

It is interesting to note that a similar situation exists today with Ladinoized Indians who no longer speak a Maya language—only Spanish—but who continue to make pottery in the traditional manner of their Maya ancestors. It is very likely that the case of Comitancillo mentioned above may be the result of a similar linguistic shift, this time from Quiché to Mam, the result perhaps of a Quiché-speaking colony, like that of Sipacapa, adopting

a new language but retaining its old pottery-making technique. We have, however, no documentary proof of this at present.

The Quiché and Cakchiquel potters utilize essentially the same production techniques. Thus, the two groups are closely related with regard to pottery technology, as well as linguistically. A glance at the linguistic map 7 will show that these groups form a pocket both linguistically and technologically that appears intrusive into surrounding groups that use the concave basal mold. The fact that the Quiché and Cakchiquel claim to have come from elsewhere lends support to this interpretation.

The Pokomam, whether of the eastern or the central group, all use the convex basal mold, and this technique, as far as we have been able to discover, is limited to use by this linguistic group. Although apparently intrusive into the concave basal mold—using Guatemalan highlands, the Pokomam would appear to have preceded the appearance of the Quiché-Cakchiquel-Zutuhil speakers. The evidence for this is mainly ethnohistorical and has in large part been assembled by Miles.[5] Numerous references were made in the *Popol Vuh* to the Vuq Amak or "Seven Tribes." Although this appellation appears to denote at least two different groups, one of them is almost surely the Pokomam.[6] Native traditions hold that the Quiché speakers conquered the formerly Pokomam area around Rabinal in the Baja Verapaz.[7] In addition, the *Annals of the Cakchiquels* contain a reference to the "sons of Valil," Valil being the Pokomam name for Acasaguastlán.[8] Finally, the Pokomam make no claim of Toltec descent, as the Quiché-Cakchiquel do; neither are they afforded any by the latter groups. Instead, they are found by the Quiché-Cakchiquel intruders already settled and in control of large parts of the highlands.[9]

The technological evidence produced by our study indicates the exclusive use of the convex basal mold by the Pokomam. Both Lothrop[10] and Osborne[11] cite this technique as the only one used in western El Salvador, with Osborne giving a specific example at Paleca, near the national capital. The widespread use of this technique in that area would, by analogy to Guatemala, seem to indicate a considerable homogeneity of linguistic affiliation through a long period of time. The use of this technique in Guatemala appears intrusive, being surrounded by concave basal mold users, similar in this way to the orbiting technique of the Quiché and the Cakchiquel.

The pottery-making center of Zapotitlán is located in an area of indefinite linguistic association. Miles[12] places it geographically near both the Xinca and the poorly defined Popoluca, but in a narrow corridor of Chorti-speaking territory extending to the Pacific. Certainly, on the basis of pottery technology, Zapotitlán is neither a Chorti nor a Xinca community. Miles did not venture to associate it with the nearby Pokomam enclaves in western El Salvador, and our technological evidence would not support this.

Traditionally, the Popoluca area has centered on Conguaco and Moyuta, but its boundaries have never been defined.[13] The virtual extinction of this language will make that task next to impossible. Archbishop Cortés y Larraz cited Popoluca as the language of the parish of Conguaco, which included the towns of Moyuta and Pasaco to the southwest and Jalpatagua to the north on the Pululá River.[14] Curiously, the archbishop makes no reference to Zapotitlán in his detailed descriptions. Yet Zapotitlán is located only fifteen and a half miles from the parish across the valley formed by the confluence of the Paz, Chalchuapa, and Pululá rivers. The

town faces south across the valley, and the trade in ceramics seems to flow in that direction as well (see chap. 8).

There is a possibility, indicated by technological similarity (if one accepts the Zapotitlán technique as that of the ancient Popoluca), that Popoluca speakers were expanding northward at the time of the Spanish conquest along the Paz River drainage. This would account for the use of the scooping technique of pottery making in the *aldeas* just south of Jutiapa, a traditionally Xinca area. Alternative explanations include population shifts during the colonial period or in more recent times, at the demands of the *conquistadores* or another dominant social group.

The presence of pottery in the Early and Late Postclassic archaeological record of Chalchuapa demonstrating most of the modes of that produced today in Zapotitlán,[15] as well as the fact that large quantities of Zapotitlán pottery are still traded into Chalchuapa today, leads us to wonder about the connection between that site and the Popoluca speakers in the past. We might ask if the Popoluca were the "original" inhabitants of Chalchuapa and if Popoluca, now essentially extinct, is in some way related to Pokomam or Nahua instead of to Xinca or Mixe, as traditionally believed. Studies by linguists attempting to define this nebulous language will do much to further our understanding of this important, though neglected, area.

The concave basal mold is associated with the greatest number of highland Maya languages. Importantly, this is the technique used by the speakers of Mam, traditionally acknowledged as one of the earliest Maya languages to become differentiated from the parent stock.[16] Also important is its use among the Xinca, another group with a long history of occupation in Guatemala and, possibly, with linguistic affiliations to more southern groups.[17] The distribution of the concave basal mold in association with these linguistic groups indicates, on the basis of our assumptions, that this is the most ancient of the pottery-making techniques still extant in Guatemala. It should be noted that none of these groups claims Toltec descent. The survival of this technique is due to the same isolation from major invasion routes that protected some groups in the Cuchumatanes and in the Verapaz (i.e., Mam, Chuj, and Kekchí) for so long. Furthermore, the commonality of this technique—instead of one technique for the Quiché and the very closely related Cakchiquel, one for the Pokomam, and one for the Popoluca—indicates, if not a common origin, at least an extremely long and close association between these peoples. With this perspective, one clearly sees the Quiché-Cakchiquel and Pokomam techniques as intrusive into the highlands where, at one time, the concave basal mold technique was dominant and probably universal.

We would like to think that the correlation between pottery technology as a cultural phenomenon and Maya languages is not merely a research coincidence. It is a very unusual finding and demands the attention of specialists in the relationship of language and culture. Simply stated, one-to-one correlation between culture and language has not yet been established, much less a correlation between language and a particular category of culture. If our finding could be validated and the processes at work in this relationship fully explained, the data would reveal significant insights into an aspect of Maya culture, that is, technology, which can be noted for its antiquity. Important is the fact that such an aspect of culture has managed to survive in the hands of specific Maya groups through a long period of time. It is safe to dismiss the possibility that the correlation might be the result of the Spanish conquest, specifically, the result of the manner by which officials exercised control over the mobility of peoples throughout the highland area. It is more likely that the Spanish colonization could have had the opposite effect of reinforcing, at least in many regions, the language-technology configuration established before the year of contact, 1524.

These data on pottery technology as they relate to Maya languages seem, to us at least, to bespeak considerable antiquity for these techniques. There is no other way at this point to prove antiquity but, as we describe the contemporary production centers among highly acculturated or less acculturated Maya groups, we feel certain that we are dealing with an aspect of Maya culture hardly modified or displaced by conquest. The continuity of pottery technology should therefore be of significant interest to anthropologists, particularly Maya scholars, and it should promote further ethnoarchaeological studies.

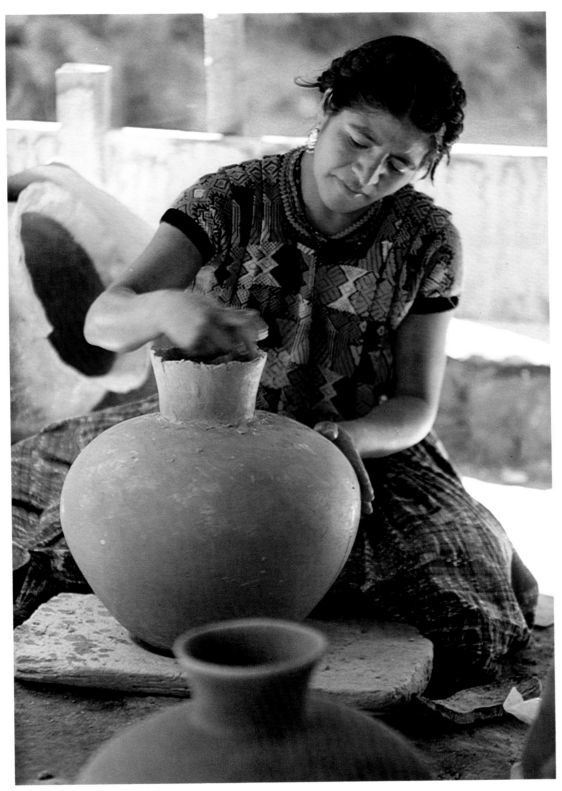

Chinautla potter working on the neck of a *tinaja*

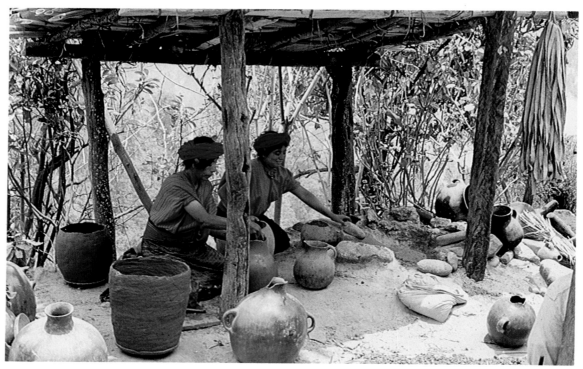

San Sebastián Huehuetenango mother and daughter making pottery under a shelter. The mother builds the *tinaja* neck while the daughter grinds clay

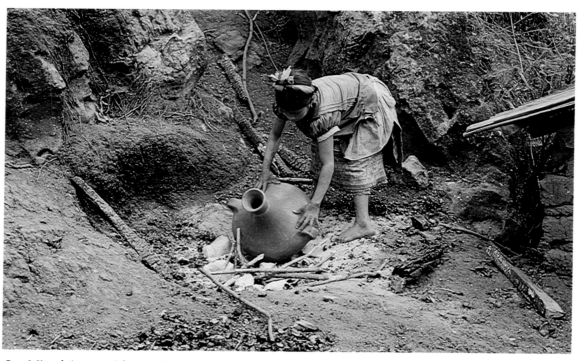

San Miguel Acatán girl preparing a *tinaja* for firing by preheating it

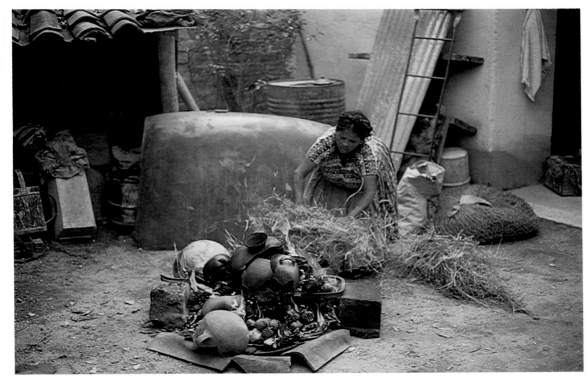

Chinautla potter firing urban ware using a new process. Preheated vessels are covered with large sherds and straw as firing begins

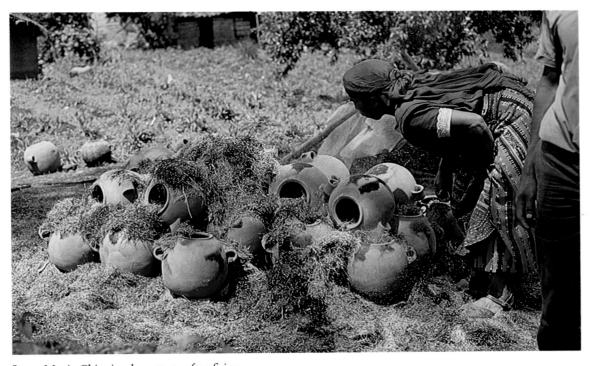

Santa María Chiquimula pottery after firing

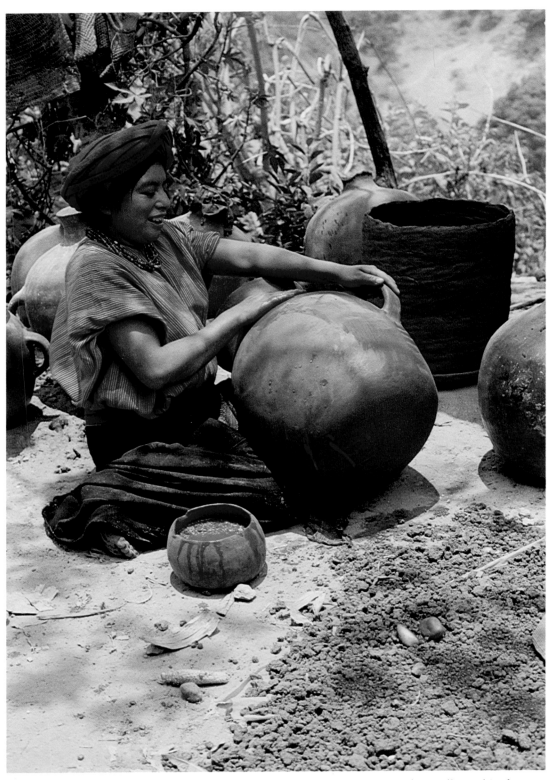

San Sebastián Huehuetenango woman applying slip to a *tinaja*. The slip is in the small vessel in the foreground

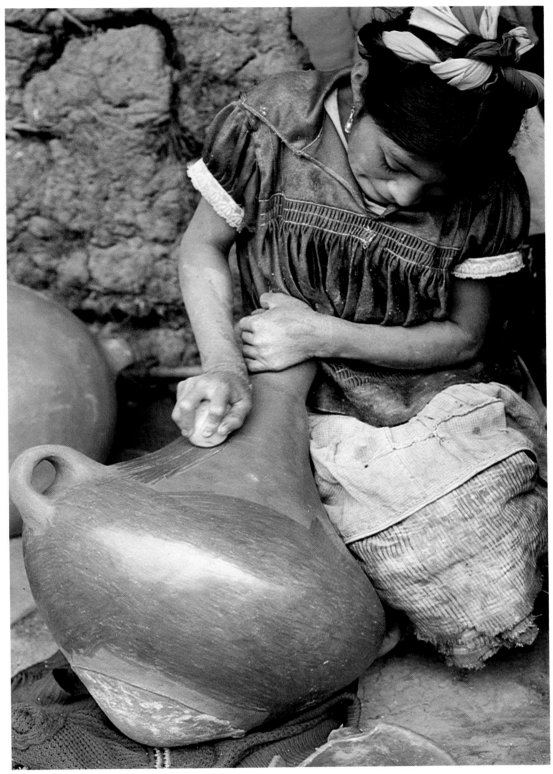

San Miguel Acatán girl burnishing a *tinaja* with a river-worn quartz pebble

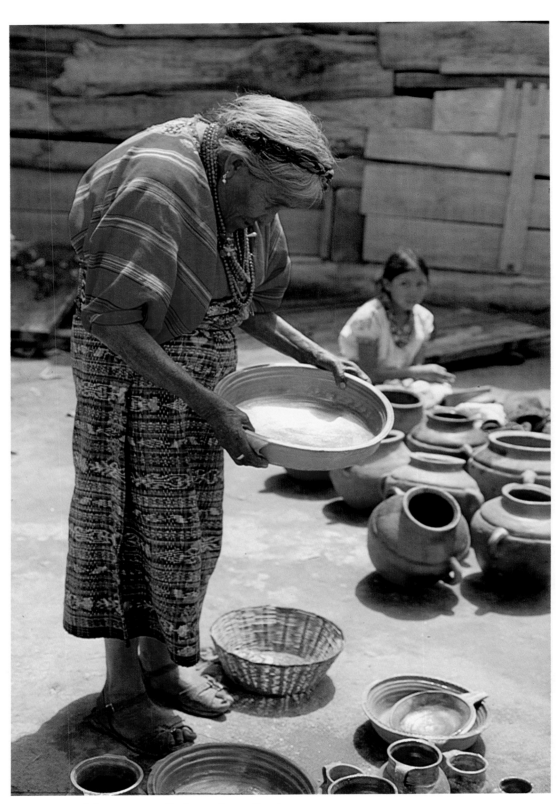

Woman examining an *apaste* in the market at Patzún

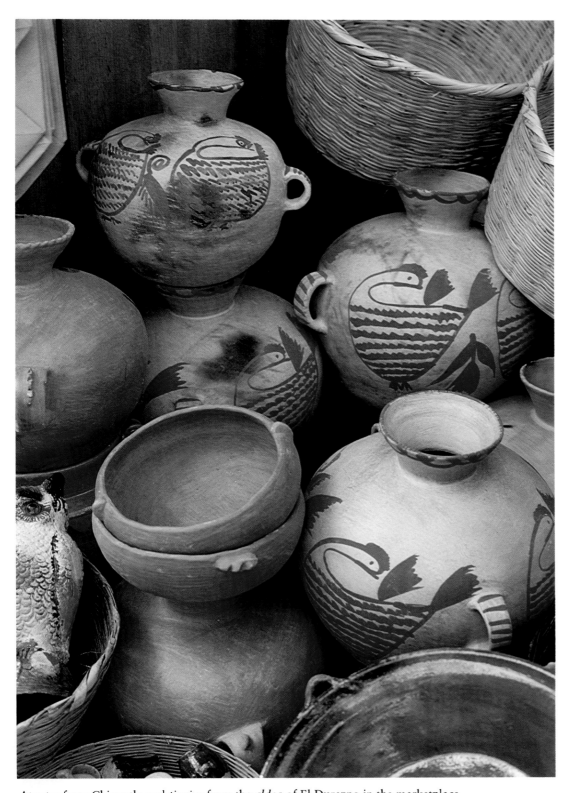

Apastes from Chinautla and *tinajas* from the *aldea* of El Durazno in the marketplace

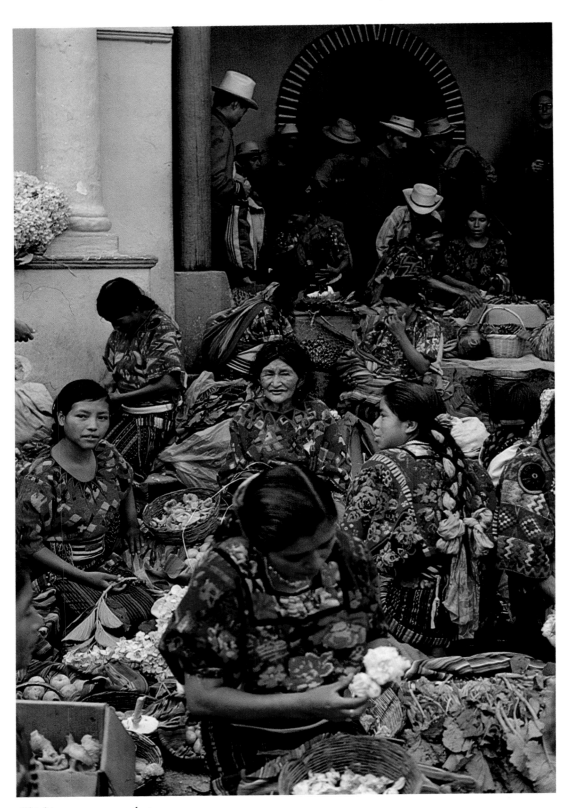

Chichicastenango market scene

8. The Marketing and Distribution of Pottery

Markets, as a central institution in the socioeconomic system of Mesoamerica, achieved great importance during the urban development in precontact times. Ever since the conquest by the Spanish in 1524, hundreds of specialized Guatemalan settlements have continued to provide producers and traders with a designated meeting place for the specific purpose of trading their commodities. Rural and urban people, Indians and Ladinos, rich and poor—in the roles of consumers, vendors, middlemen, and merchants—come together, in different proportions, in the various markets of the nation. The geographic variation in Guatemala has created many small ecological zones suitable only for particular agricultural or commercial specialization. Products come to markets from settlements where people cultivate particular food products adapted to their environment or specialize in transforming differentially occurring materials into manufactured commodities. Markets also relate Guatemalan settlements that have economic specializations at various political levels—*caseríos*, *aldeas*, *pueblos*, and cities. As noted, in the economic organization of the nation, most settlements, as production centers, are involved in the preparation of a marketable commodity. Commodities, particularly pottery, are usually named after the major political unit where the product is prepared—for instance, Chinautla *tinajas*, San Cristóbal Totonicapán *tamaleros*, San Raimundo *comales*, etc. The rationalization for community specialization is frequently explained with the general

statement: "It is the *costumbre* of such people, who knows, an old thing."

Community specialization is possible because the complex market system provides the mechanisms for the exchange of principal commodities at various levels of the nation's economic system. Although communities have distinctive cultural variations and each community is generally a socially closed entity, the need for exchange requires that people find a socially impartial area for the location of the market. This area is usually in the center of the town, near the church and the main plaza. Therefore, the market is not an institution "owned" by the *pueblo* or the *municipalidad*; rather, the political system acts as a custodian. An officer known as the *fiel* supervises activities, collects a daily fee from each vendor for the right to sell goods or to rent market stalls, and sees that everyone observes appropriate behavior.

The market is a central place where people with products meet in an organized fashion. Markets, contrary to communities, are not bounded socially—they are accessible to all. The people of the town, vendors from specialized communities, and buyers from other areas bring products according to their personal schedule of production. Their goal is to derive an economic profit from each transaction. Thus, the openness of the market permits anyone from any cultural or social background to interact and exchange commodities for cash. Particularly in Guatemala, the dynamic of this institution is nurtured by the existing economic and social differ-

ences in association with community specializations.

Frequently a specially constructed building centralizes the economic activities of the many hundreds of people who participate in the market day, known as the *día de mercado* or *día de plaza*. It is of interest that most of the population divides the week according to market days. Household routines and preparation of supplies by local entrepreneurs reflect market business cycles. The market organizes time and, furthermore, provides a livelihood for many thousands of people. In the minds of Indians and Ladinos the market, next to the church, plays one of the most important roles in the structuring of their life.

In hierarchical order, three market levels relate to the distribution of pottery. The three levels of economic organization are (1) local markets, (2) regional markets, and (3) interregional markets. The criteria for defining these markets are the extent of the geographical area served and, consequently, the size of the population served. Pottery distribution in this study constitutes the central criterion for market type. Therefore, this classification of markets may not coincide with other studies concerned with the movements of all commodities. However, it is important to point out that all markets provide their customers with a basic inventory of pottery for the kitchen (see chap. 9).

There are three types of sellers in these markets: (1) vendors, (2) *regatones*, and (3) merchants. Vendors are those individuals who sell their own pottery or the pottery made by a member of their family. Although

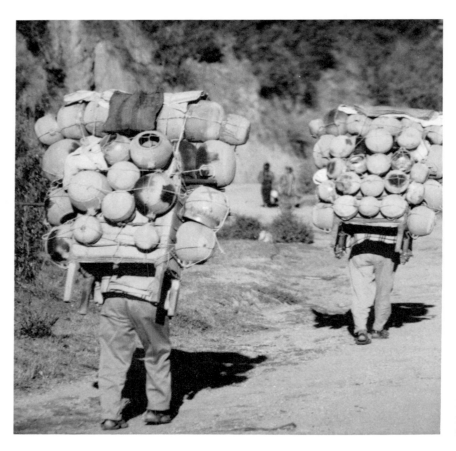

Plate 382. Merchants with *cacastes*, moving from the central highlands to the Pacific coast

vendors may be found in all market types, they are most active in local markets. *Regatones*, both males and females, are middle traders, with a permanently rented stall in a market. This group increases in number and importance in the regional markets. Merchants, the last group, are itinerant traders—usually referred to as *comerciantes*—moving in a specific route of their own, tying together different areas of the country in a distribution system. In the past, the *cacaste*—cargo container —on a tumpline was most commonly used for transporting pottery on foot, and the amount traded was usually determined by what an individual alone could carry (pl. 382). This method is still used by many conservative merchants, who hope to increase their profits by avoiding the expenses of motorized transportation or who have no choice but to continue with this system in order to reach isolated settlements. Most major commercial centers, however, are now linked by modern transportation and all-weather roads, and motorized transport has become the most efficient method for the modernized itinerant merchants.

The aim of this chapter is to survey both the mechanisms established to move pottery from its point of origin to the consumers and the ways in which production and products are affected by urban and rural cultural elements as they pass through the various levels of the market system. From a sociological viewpoint, some of this information should enable us to study aspects of the interpersonal relations between urban and rural Ladinos and Indians with respect to their dependence on the particular commodity of pottery.

The Local Market

The local market is usually situated in the *pueblo*, as the head of the *municipio*, and, with some exceptions, in important *aldeas*. Local markets may be differentiated into two types: those occurring within *municipios* where pottery is produced and those occurring where it is not. In pottery-producing *municipios*, the local market has a dual orientation toward selling, as will be illustrated below by the case of Santa María Chiquimula. The first is toward supplying local demand within the system of *aldea* specialization. The second orientation is toward supplying merchants with pottery for export. In both cases, pottery is sold by vendors, and it is this group which dominates the local market. In non-pottery-producing *municipios*, the orientation of the local market is toward importation, as in the case of Tactic. Here merchants who import pottery for local consumption dominate. Generally, local markets have no *regatones*, although a similar service is provided by the owners of private *tiendas* (small stores). They speculate in pottery purchased from merchants and keep small stocks for times of high demand due to an absence of pottery in the market.

The availability of pottery in the local markets may vary. The amount and diversity of pottery types and forms usually change according to the season, the distance from production centers, and the degree of the market's dependence upon merchants to supply its inventory. Some competition from metal or plastic containers may also influence the amount of certain pottery forms in the marketplace. But, again, the basic kitchen inventory is available at all local markets, supplied by one or a number of production centers. The residents of those non-pottery-producing communities located with easy access to regional markets or to local markets in pottery-producing centers will tend to frequent these instead of their own local markets,

at the expense of merchant activity there, as in the case of Zunil.

The local market has a dynamic of its own. It is a small business operation in the hands of vendors who know their own products well and are also deeply familiar with people's needs—their own people. *Comales, ollas, tinajas, pichachas, apastes, cajetes,* and *tamaleros* are all vessels related to a traditional diet and to specific ways of preparing food, and the association of diet and pottery vessel is intimate and enduring. The relationship of growing and processing food in domestic settings appears inseparable, and changes do not easily occur. Continuity, therefore, constitutes the overriding rule, and substitutions are rare. The overall pottery inventory is oriented to the pre-twentieth-century rural tradition, and the supply in local markets is oriented toward those Indians and Ladinos who depend upon this market for their daily needs.

While the local market is usually held once or twice a week, *tiendas* in *pueblos* are open daily (pl. 383). Most of the *tiendas* are run by Ladinos. Although their customers are primarily local persons, from time to time a greater profit may be made by selling to passing itinerant merchants. These merchants usually conduct business in a very small area, and their entrepreneurial activities are bounded by the number of people who use pottery from particular centers.

Although the local market breaks up at the end of the market day, trading of pottery continues through the *tienda* or on a personal basis. Women in need of a *tinaja* or an *olla* will find out who has vessels on hand, and a transaction will then take place in such public places as the street, the public fountain, or a *tienda*. A child may be sent to fetch a vessel, and it is assumed that the object does not require a great deal of examination. Sometimes people will make an *encargo*—an oral con-

tractual agreement for a specific amount of pottery to be ready at a designated time—of *tamaleros* or large *ollas* for a family celebration. There is little discussion of the value, since everyone seems to know the expected price. The transaction, occurring among friends, relatives, or cogodparents, is not impersonal as in regional markets. Consequently, the vessels represent the potter's best effort and the buyer's best price.

A merchant may also make an *encargo* agreement at a local market of a production center. This system assures him of a steady supply of pottery, so that he can fulfill obligations to individual clients. A merchant who becomes well acquainted with a potter with whom he deals may be invited to pick up the vessels at her home. By so doing, he can bypass the local market day and proceed directly to a more distant market.

An unknown merchant does not deal with a potter in her home. The market offers more opportunities, whereas in the home an absence of competition may not give a merchant the best price. Furthermore, due to social sanction, the home is not an acceptable place for economic transactions among strangers. For most merchants, the market is the arena for economic interaction.

Mondays, Tuesdays, and Wednesdays seem to be the most popular days for local markets. There are exceptions but, with this arrangement, there is no overlap with the regional market days, held later in the week. A few pottery merchants take the opportunity to purchase vessels in the local markets and then appear with their supply in other local markets or in regional markets for redistribution at a small profit. Producers themselves, if they live near a regional market, may plan production not only for the local market but also for the requirements of the regional market. No doubt, as far as pottery is concerned, the number of vendors in a local market is

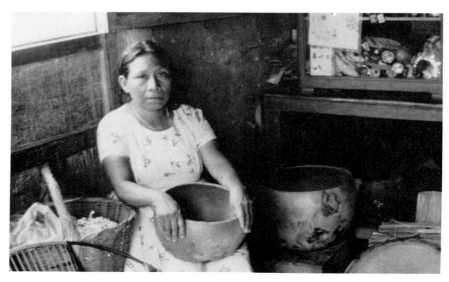

Plate 383. Chorti potter in a Ladino *tienda* in Jocotán

determined by local demand, and this varies from week to week and from month to month. Furthermore, the rainy and dry seasons affect demand and supply. Local vendors can sense the situation, and often some of them choose to take their vessels directly to regional markets rather than enter into competition at the local level. While this typology serves to categorize generally the local markets, differences between particular markets—based on environmental, economic, and geographic conditions—are great. Four specific cases, therefore, will be useful in illustrating the range of variation at the local market level.

Santa María Chiquimula

On Wednesday the central plaza in Santa María Chiquimula is filled with many hundreds of *pueblo* and *aldea* people bringing their products (pl. 384). As discussed in chapter 3 three nearby *aldeas* specialize in pottery, and some of the vendors hope to find customers among the residents of non-pottery-producing *aldeas*.

Poor, widowed, and elderly potters often bring small amounts of pottery to the Santa María local market. They have no choice but to retail throughout the day as many pieces as they have been able to manufacture during the week. On the other hand, the energetic young potters will undertake a more complicated expedition to the regional market of San Francisco El Alto with a large supply of vessels, usually representing the efforts of several members of an extended family. While the local market is underway, many producers are firing vessels prepared during a period of one or two weeks. Their intention is to produce a large load—*carga*—for the regional market. This market is held on Friday, and the abundance of both *regatones* and merchants presents vendors with greater business possibilities.

A section of the local market is assigned by the municipal officials to the few vendors. On one day, ten women came to sell their own vessels. One of the producers had ten *tamaleros*, retailing at an average of 30¢ each, a handful of *tinajas* at 25¢, four *pichachas* at 20¢, and five *ollas* at 15¢. Another vendor had a comparable assortment, with the addition of a dozen *comales*, and the rest of the vendors had small amounts of pottery. The *aldea* and *pueblo* people examined the vessels and purchased one or two at a time. Potential customers become familiar with the pottery supply, slowly and thoughtfully, and begin to select specific vessels from a distance. When they approach the vendor, the transaction is rapid. The approximate value of each vessel is traditionally established but, in the free interplay between buyers and sellers, variations in price may occur.

The local production inventory of carrying, serving, and cooking vessels forms the basic group of utensils for family kitchens in the area. Preparation of food for a large celebration, however, requires a vessel made in San Cristóbal Totonicapán, and this is frequently purchased at the regional market of San Francisco El Alto. Vessels from Chinautla, Santa Apolonia, and San Pedro Jocopilas are absent from the Santa María market.

Santa María remains a stronghold of the nineteenth-century rural Guatemalan life style, and it appears behind the times when compared to less isolated settlements. Indians are the dominant social group and are economically very independent. This is a strong corporate community, with a social organization that assists the residents in retaining a deep identification with the local pottery production. The *municipio* is large enough to maintain a sound and active local market.

The dual political organization of the town (an Indian and Ladino *alcaldía*) and the social etiquette outlined are significant in the context of the local market. The Indians' municipal organization supervises the market, while the officials of the Ladino organization are involved on department and national levels with application of the law.

Conventions, low competition, personalized trading, and an absence of disputes characterize the economic behavior in this setting. The potters' linkage to regional markets is more for selling than for buying. This type of community economic organization is without a doubt an old one, typified by a great deal of self-sufficiency.

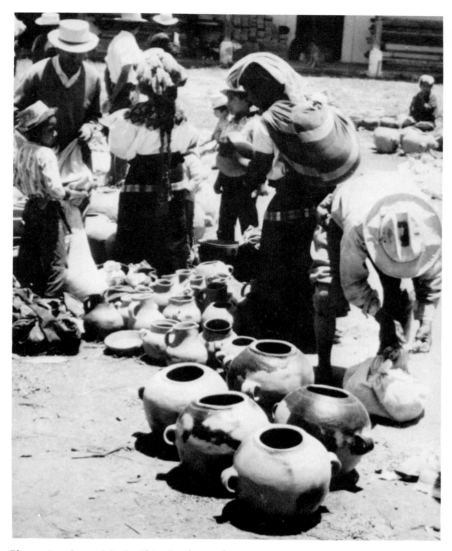

Plate 384. Santa María Chiquimula vendors

San Cristóbal Totonicapán

The San Cristóbal local market is held on Sundays; like Santa María Chiquimula, this is a local market with a pottery-production center of its own. It serves a densely populated area and is attended by a large number of vendors from the *aldeas*, who supply the basic kitchen inventory (pl. 385). The market is held outdoors in the street along the western side of the church buildings. Although the pottery supply is large, the demand is primarily local. However, local vendors enter into some competition with a few merchants, usually on their way to the Pacific coast, who take advantage of the excellent supply to restock their *cacastes*. San Cristóbal pottery, particularly the unglazed *tamaleros* and the half-glazed vessels, has a reputation that extends beyond the immediate area. Improved transportation nowadays permits the vessels to move far from the production center, primarily to individuals who have migrated from this region to other areas of Guatemala.

On a market day during our survey in 1974, there were eleven San Cristóbal vendors, each with a *carga* exceeding twenty vessels—one of the vendors had a *carga* of seventy-five vessels. All the vendors—nine women, two men—had come to the market on foot to sell their own products. Some of these vendors may carry a load made up of the whole inventory of an extended family.

San Cristóbal Totonicapán pottery forms available were primarily *ollas*, *pichachas*, *sartenes*, *comales*, *apastes*, and *tamaleros*. The prices varied according to sizes, so *ollas* and *pichachas* were priced at 5¢, small *sartenes* at 16¢, and the large sixteen-inch *sartenes* at 20¢. Glazed *comales* retailed for 20¢, 30¢, and 40¢, and unglazed *comales* sold for 8¢, 12¢, and 15¢, according to sizes. The unglazed *tamaleros* were available in small, medium, and large sizes and sold for 25¢ to 50¢.

With few exceptions, the pottery supply was made in the San Cristóbal area. A local merchant had imported Chinautla and Santa Apolonia pottery for many years, and another merchant had a small supply of Totonicapán glazed bowls, figurines, and whistles, as well as Jalapa glazed coffee mugs and bowls. The Chinautla *tinaja* retailed here for 55¢, considered a very high price. People tended, however, to examine these "foreign" pieces longer, to think about them a great deal, and to make a number of offers, based on the value of the local pottery, before making a purchase.

The San Cristóbal vessels sell well locally, particularly those related to daily domestic activities. Large *tinajeras* and *apastes* are more difficult to sell. Characteristic of a local market, compared to the other types, is the absence of an elaborate system of buses linking the production centers with the market. This is the case in San Cristóbal, where most of the vendors from *aldeas* travel by foot to the market, arriving after 8 o'clock in the morning. The volume of trade increases throughout the noon hours, but by midafternoon the market comes rapidly to

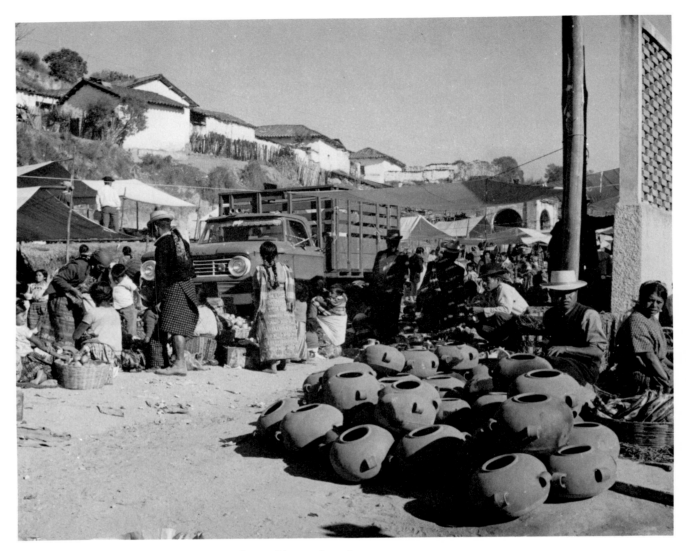

Plate 385. San Cristóbal Totonicapán vendors, with *tamaleros* in center

an end. Those vendors unable to dispose of their pottery supply face the alternatives of offering it to a local middleman with a warehouse or completing a transaction with a merchant who has patiently awaited the end of the market day to obtain surplus vessels at the lowest prices. Also, vendors with leftover vessels can pack up and return home to wait for another local market day or take their vessels to San Francisco El Alto on the regional market day.

In San Cristóbal the day-to-day purchasing of pottery is done by the merchant dealing with a privately established *tienda*. This middleman

has established a contractual arrangement with local producers, who deliver their vessels on a daily basis. There are times when the producers are visited by a wholesaler or his employees to contract for a *carga*. The vessels are then stocked in his warehouse and sold to passing merchants or retailed locally. This type of establishment handles such a large proportion of the local production that it sometimes weakens the demand on San Cristóbal market days.

The case of the San Cristóbal market illustrates what may develop when a pottery-production center

and a local market are near major trade routes. The constant demand for pottery on the part of merchants traveling to different areas—the Pacific coast, west, and east—necessitates the maintenance of large supplies of vessels and, thus, the warehouse arrangement. This dealing in large amounts of pottery distributed over a very wide area is reminiscent of the function of regional markets. In this particular instance, however, pottery from only one production center is heavily involved.

Zunil

Our next illustration is a local market in the Indian *pueblo* of Zunil, a strong corporate community and the head of a *municipio*. Zunil is important because, in contrast to the previous illustrations, there is no local pottery production. Zunil has, however, an advantageous location in that it is situated on the paved road to the Pacific coast, sixteen and a half miles from the second largest city in Guatemala, Quezaltenango. The people of the town have preserved a closed social system aided by the *cofradía* religious organization, and they remain highly endogamous. Men, and some women, are slowly becoming bilingual (Quiché and Spanish); their economic activities involve raising onions for export as well as growing typical Maya products—beans, squash, and maize —for home consumption.

The Zunil *pueblo* has a small local market on Mondays (pl. 386), and a few *pueblo* women come to the market to sell fruits, vegetables, maize, and beans to others of the town and to people from the nearby *aldea* of Chimucubal. While Zunil men rely on their agricultural activities on the mountainsides, the women remain at home, weaving for community consumption. Currently, under a German Catholic mission, a cooperative of weavers has been formed and is producing tourist items for export.

For many products from other specialized communities, Zunilences depend on the supply brought in by merchants to its Monday market. Many merchants from Nahualá, a few hours away, bring in vessels on *cacastes*. These merchants offer a small inventory of pottery from San Cristóbal Totonicapán, Comitancillo, and Santa María Chiquimula. Pottery trading is usually limited. People needing to replace a recently broken kitchen vessel attempt to buy one at a price equal or close to that in regional markets. Under these conditions, the outside merchant and the Zunil buyer interact

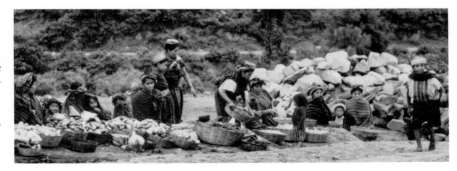

Plate 386. Zunil vendors

aggressively until they reach an agreeable price. In this setting, therefore, pottery merchants face intense competition with the daily Quezaltenango regional market and the Sunday San Cristóbal local market. Both places are linked to Zunil by a good daily transportation system.

Male Zunilences are the buyers for their households and feel that they will find better bargains and a greater selection if, on Sunday morning after the early mass, they take the bus to the San Cristóbal market. There, they know they can find vendors with their own products and, thus, can avoid paying a few cents more to the merchant. For purchases of several items, the trip is without a doubt economically justifiable. San Cristóbal Totonicapán and Totonicapán are primary sources for kitchen vessels, with additional *tinajas* coming from either Santa María Chiquimula or Chinautla and *jarros* coming from Comitancillo.

In summary, merchants come to Zunil to sell pottery from a small supply carried on foot with the aid of *cacastes*. These merchants meet only urgent household needs, since Zunilences recognize that, for substantial purchasing of pottery, trips outside their own *pueblo* are economically advantageous. In this manner, thousands of pottery vessels are brought into Zunil yearly, many of them being purchased primarily for ceremonial uses and *cofradía* celebrations.

It is evident that the Zunil market has little economic potential for pot-

tery because of its proximity to regional and larger local markets, aided by the public transportation system. These factors force pottery merchants and potential *regatones* to play only a minor role in the Zunil market. Since pottery merchants do not come to Zunil to buy local products, the town is, for all practical purposes, only a resting place on the way to markets in coastal towns. It is not unusual to see merchants, coming down the hills toward the lowland area, ignoring Zunil as a place to retail their wares.

Tactic

Tactic is an example of a large local market without a pottery-production center of its own. Because of the dispersed settlement pattern of the Verapaz and the opening of a paved highway in 1973, Tactic's local market is acquiring the characteristics of a regional market, particularly in regard to the distribution of pottery. This *pueblo* of Pokomchí-speaking people is located nineteen miles southeast of Cobán, the department capital of Alta Verapaz. Because of the similarity of Pokomchí to the Pokomam language, spoken in Chinautla, interaction among these people is frequent, particularly in the context of religious pilgrimages. Chinautlecos, for instance, visit Tactic's local shrine, Chi Ixim, each year in the month of May.

Indians bring a variety of prod-

Plate 387. Tactic vendors. The woman in the center is holding a *tinaja* and has several *incensarios* in her basket

ucts to the marketplace (pl. 387) on Thursdays and Sundays, many of them traveling as merchants, buying and selling their goods in different areas of the Verapaz. Most of the *tiendas* in the *pueblo* are outside the market and are run by Ladinos. During our visit, three Tactic men with their wives had returned from Salamá, Rabinal, and the middle Motagua area (referred to by them as *tierra caliente*) with a large number of cooking and storage vessels. They brought 36 *cargas* with a total of 370 *apastes* from San Agustín Acasaguastlán, 180 *ollas* from Salamá, and a handful of Rabinal *tinajas*. This supply is normally sufficient for about three weeks. These merchants dominate the trading of pottery vessels for the town, and most of the vessels are sold at twice their original price. The means of transportation for the *carga* is now the bus system, costing 50¢ for a *carga* of thirty-six *comales*. The trip is comfortable and rapid compared

to fifteen years ago, when it took three days to reach the *tierra caliente* on foot. Then, the amount traded was determined by the *cacaste* size.

While inside the market some merchants still had not unpacked their large nets full of pottery, outside the market about half a dozen potters, with flat baskets containing three or four *tinajas*, had come down from the *aldea* of Chiché to sell their own products. Before entering the market, many people stopped outside to purchase some of these well-known vessels. Whereas the merchants were able to use enough Spanish for trading interregionally, the Chiché women spoke only Kekchí.

Pottery merchants play an important role here. Tactic is too far from the southern pottery centers and too long and steep a walk from the remote Verapaz centers for the people to deal directly with potters. The merchants, combining pottery from several centers, offer a basic kitchen

inventory to both Indians and Ladinos of Tactic and its surrounding area. The amount of pottery, moreover, permits merchants from greater distances, such as the Lake Izabal area, to supply their own markets by purchasing many vessels in Tactic. The chain formed by merchants constitutes a significant organization in the redistribution of vessels from one region to another and from one political center to another.

Prior to the completion of the all-weather road to the Verapaz, the supply of pottery in this area was restricted to what merchants on foot could carry, with only occasional use of buses. The new road, opened in 1973, has allowed a considerable expansion of motor transport to Tactic (larger buses, trucks, and vans) and, as a result, has greatly increased the volume and diversity of pottery flowing into the Verapaz. Because of its favorable location astride the new road and at the head of the Polochic Valley, which leads

to Lake Izabal and the eastern lowlands, Tactic can now develop into a major distribution center for pottery in this region.

To summarize, with specific reference to the above examples, the conditions found at the local market level offer few possibilities for economic growth. There is a definite spirit of commercialization here, based on the import trade of pottery from a variety of production centers. The fact that these merchants have definite economic interests and strive for economic ascendancy is also significant. Yet, on the other hand, merchants observe *costumbre*; they limit their stock to an inventory acceptable to the community. Pottery merchants are not innovators—they maintain an unchanged inventory, taking little risk in choosing merchandise. There is little room for expansion here. During many years of experience, merchants have learned the requirements of the conservative local consumers.

The Regional Market

Regional markets are usually located in important centers, often a small city with the political leadership of its department. They can be distinguished from local markets in that a greater quantity and variety of products are purchased and sold, and a variety of people from many production centers come together. Contrary to the large number of vendors-producers at most local markets, *regatones* and merchants are the strongest economic group. In addition, the basic kitchen inventory is derived from more production centers than are found in the local market. The number of production centers represented in most regional markets ranges from three to six.

One could draw a parallel between the local markets with their vendors-producers and the regional markets with their merchants and *regatones*. The regional markets incorporate goods from many areas, all brought long distances, usually by merchants traveling on foot or by bus. For example, on Mondays or Tuesdays producers take pottery from an *aldea* to the local market, where merchants and *regatones* purchase a *carga* to take to a regional market on Thursdays. *Regatones* rent a permanent stall there, where vessels are stored and made available to towns and *fincas* farther away from the production center.

The regional market integrates a geographic area composed of diverse ecological zones—and usually containing several *municipios*—with a marketplace to control the trade and redistribution of many products. The intermediate life style of Ladinos influences this type of market. Regional markets, therefore, bring together both urban and rural populations of Ladino and Indian peoples of the region. A diverse assemblage of pottery is usually available; the urban glazed pottery and the traditional unglazed ware of the nearest production center are in equal demand by the distinctive social and cultural groups. Most of the regional markets are partially open every day of the week, serving the local urban population, but each is in full operation two or three days of the week. The market population on these days is usually at least double in size, and everyone is involved in intensive trading. Traditionally, those individuals attending regional markets made their trips on foot, and distances determined the size of their loads. The modern means of transportation have intensified the activity and especially the mobility of merchants and their customers everywhere.

With improved paved and all-weather roads and the availability of small trucks and buses, many modernized merchants have increased their sales. They purchase as much as possible directly from producers by means of *encargos*, and they are able to supply regional markets with a steady inventory of products. This can be seen, for example, in Escuintla and Retalhuleu. Parked outside the market, merchants sell to individual customers as well as to *regatones*, who in turn remain with a small supply to meet the day-to-day demands of the residents of the town. These modern merchants are serving the region at a faster rate, competing aggressively with the old conservative merchants, who formerly moved large amounts of merchandise throughout Guatemala on foot with their *cacastes* and tumplines.

Contrary also to the traditional pattern of twenty-five years ago, most people depart from their home community by bus and, after trading with regional merchants and *regatones*, return home by bus in the afternoon. Bus services are arranged to meet the specific needs of the rural people. To succeed in the market, rural individuals must transact their business rapidly, taking advantage of the best opportunities presented by supply and demand. Selling their own product comes first, after which they may buy items to use personally or, perhaps, to resell in small quantities in their own *pueblo*. The market day requires a great deal of physical and psychological energy. An understanding of how to go about the day's activities in the market is predicated on years of experience, usually beginning in childhood; this experience enables adults to carry out elaborate economic transactions. In these business situations, interpersonal relations are not necessarily based on those social principles of the home community. Nevertheless, there is

much order in a regional market among the apparent disorder and improvisation of stalls. Prices are predictable, and competition is based on knowledge of the fluctuation in quantity during the year and the geographic origin of the products.

As stated, pottery usually receives the name of the largest settlement of a production center, whether made there or in nearby *aldeas*. This custom hides information from buyers, and they seldom know the exact origin of vessels. This ignorance of complicated production techniques leads others, whether buying for themselves or for resale, to downgrade the skill and time involved in making these vessels. They hold potters and their vessels in low esteem. As a result, the fluctuations of pottery prices do not correspond to national inflation.

The regional market sets the pattern for distribution on a national scale because of its role as "middleman" for a large number of production centers. To document this patterning, a number of regional markets were studied in the summer of 1973, with two more being studied during the summer of 1975. Map 8 summarizes the results of this survey. As mentioned in chapter 4, San Miguel Acatán is the only production center that does not feed into at least one major regional market.

Based on our findings, it is possible to construct a hierarchy of pottery distribution at the national level. The hierarchy is composed of two interrelated networks: the pottery district and the pottery region. These are not simply heuristic devices but reflect the patterns of pottery distribution between production centers and regional markets. A pottery district, then, may be defined as the network formed by a regional market and the nearby production centers that supply it in areas where transportation systems are poorly developed, due to either economic or topographic factors (see the introduction to chap. 6). A pottery region

may be defined as a network composed of a production center or group of centers supplying a regional market or group of regional markets in areas of well-developed transportation systems.

The eastern region, for instance, consists of the area east of Guatemala City and south of the Verapaz. It has been further divided into three market districts which reflect the smaller distributional groupings within the pottery region. The Zacapa district consists of the Zacapa and Chiquimula markets and the production centers of San Agustín Acasaguastlán, San Vicente, Lo de Mejía, and Jocotán, as well as an undetermined number of small-scale production centers near Chiquimula, including the *aldeas* of Guior, Maraxcó, Shusho Arriba, and Shusho Abajo. The Jutiapa district consists of the Jutiapa market and the production centers at Trancas and El Barrial and Zapotitlán. The Cuilapa district includes the Cuilapa market and the centers of Casillas, Santa María Ixhuatán, and Guazacapán. The production center of San Luis Jilotepeque is not exclusively associated with any particular regional market, and its pottery is traded throughout the eastern region by bus and truck and on foot. It is this production center which serves to unify the area as a pottery region.

The northern region consists of the Cobán area regional markets, along with the production centers of Rabinal and El Rincón Grande, an *aldea* of Salamá, and the dispersed production in the San Juan Chamelco–Chiché–Cobán–San Pedro Carchá area.

The central region contains the greatest number of major regional markets and production centers and is so well integrated that pottery districts are superfluous. The markets include those in Escuintla, Chimaltenango, Tecpán, Sololá (pl. 388), Santa Cruz del Quiché, Chichicastenango, San Francisco El Alto (pl. 389), Quezaltenango, San Pedro Sacatepéquez, and Retalhuleu. The

production centers are San Raimundo, Chinautla, Santa Apolonia, San Pedro Jocopilas, Santa María Chiquimula, San Cristóbal Totonicapán, and Comitancillo.

The northwestern region has as its focal point the large regional market of Huehuetenango but also includes the Soloma district. Huehuetenango is supplied by San Sebastián Huehuetenango, Chiantla, and Santa Bárbara. The Soloma market is supplied by the *aldeas* of San Miguel Acatán.

It becomes clear that pottery-distribution networks cut across most environmental and cultural boundaries. Ecological boundaries are, by necessity, the most easily crossed. Within the pottery regions exist environments ranging from hot lowlands to coastal plains, to temperate piedmonts and mountain valleys, to high, cold plateaus and peaks. The very diversity of specialization made necessary by this ecological variation brought about the formation of distribution networks to cross these boundaries.

If ecological boundaries are the most easily crossed by pottery, contemporary political boundaries are a close second. Neither the national government nor the departments themselves place restrictions on commerce within Guatemala. The great number of pottery-production centers in the highlands is a function of this area's being the most densely populated of the country. Most pottery involved in a regional distribution system crosses at least one department boundary, and many cross several. As with the native languages, there is no correlation between the departments and the distribution of pottery.

Unlike the techniques of its production, pottery itself easily crosses linguistic boundaries within the region. As traders have become bilingual, Spanish has become the lingua franca for commerce. Economic transactions are simplified when both parties can bargain in a common language. Thus, Mam, Quiché, Cakchiquel, Zutuhil, and Pokomam

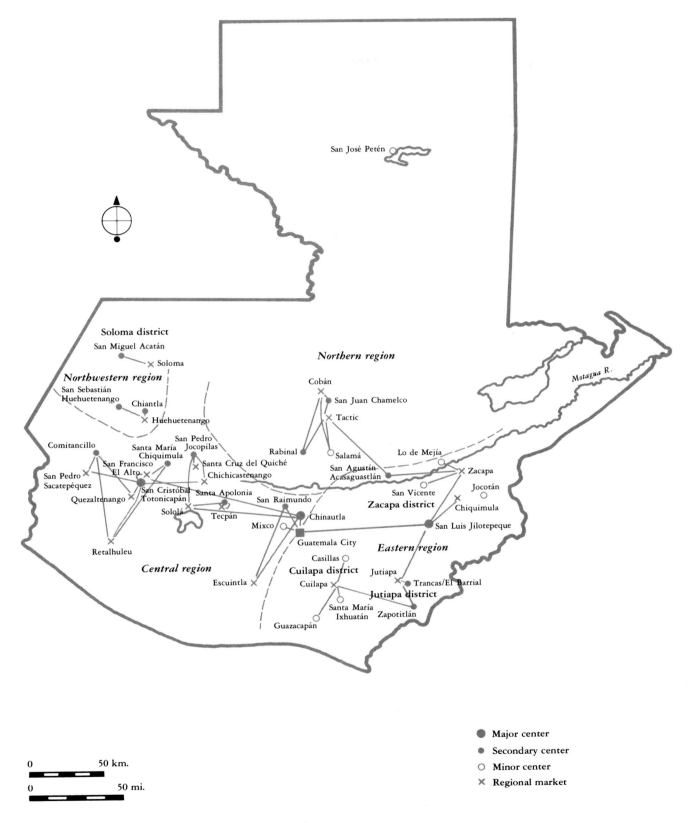

Map 8. Pottery-production centers and regional markets

Plate 388. Sololá regional market

Plate 389. San Francisco El Alto regional market

Indians are all involved in pottery trading in the central region. Quiché, Pokomchí, and Kekchí speakers all trade in the northern region. Pokomam pottery from San Luis Jilotepeque is in great demand in the Chorti and Xinca areas of the eastern region. Kanjobal pottery from San Miguel Acatán is purchased in great quantities by Chuj, Jacalteca, and Mam Indians in the northwest.

Even ethnic boundaries within the region are crossed. For the rural population—both Indian and Ladino—pottery is an absolute necessity. Its low cost, utility, and availability make it the preferred alternative to cast iron, plastic, porcelain, and galvanized steel vessels. When rich Indians and rural Ladinos can afford these items, the pottery vessels are still preferred because of the "taste" they impart to substances cooked or stored in them. Even middle-class urban Ladinos will purchase native vessels for the preparation of special dishes.

Vessels do not generally travel far or sell well outside their regions, however. Here the styles of specific vessels (body shape, handle placement, etc.) are too well established culturally through the concept of *costumbre*. The *tinaja* in particular is extremely sensitive to this factor. It is almost always used by women, who, in traditional communities at least, tend to be the most conservative group due to their general isolation from change. The way in which this type of vessel is used is also culturally reinforced, and this directly affects the *tinaja*'s style. For example, one would not find a *tinaja* from San Luis Jilotepeque for sale to Indians or Ladinos in the San Francisco El Alto market, as will be more fully explained in chapter 9. Thus pottery, particularly *tinajas*, serves to define specific regional cultures through the effects of the style preferences embodied in the *costumbre* concept.

Guatemala City Markets and the Interregional System

The Transformation of City Markets

The modern capital of Guatemala must have, by its overall centralized role, a market for the transshipment of products to all regions of the country. The development of this type of market and the transformation of the old city markets from regional to local are related primarily to the last two decades of rapid development of Guatemala City and to the modernization of the country's transportation system (fig. 55).

Two traditional local markets—Mercados La Parroquia and Calle 18—receive a weak supply of traditional pottery, mostly for sale to Indians residing in the *barrios* of the city. Of the large traditional markets in the city, the Mercado Central, behind the cathedral, is the oldest (pl. 390). The building extends over one square city block, with space for traders both inside and out. Customers come daily, and a permanent group of *regatones* supplies center city residents with the necessities for everyday life. Because of its location in the center of the city, this market also attracts tourists lodged in downtown hotels and, consequently, a large portion of the market is now devoted to products made exclusively for the tourist trade. For these new customers, Chinautla potters have developed a large inventory of new forms (see chap. 10). Figurines representing angels and saints, miniature animals and crèches, ashtrays, traditional forms with appliquéd decorations, incense burners, and many other imitations of urban Ladino objects pile up in the stalls of the Mercado Central. Ladino *regatones* aggressively seek business transactions with urban customers and tourists. The objects are sold not as pieces of art but, rather, as curios.

In the past, when the Mercado Central served the population of the entire city, many itinerant merchants—their *cacastes* on their backs—linked it to other areas of Guatemala. It was then, by present standards, a small regional market. The business there now is only local, and traditional *ollas* and *tinajas* find few customers. *Regatones* stated that there is no longer *vida*, meaning profit, with an inventory of traditional pottery—the current demands in this market have shifted from traditional vessels to forms that appeal to city residents and tourists.

When the Mercado Central began specializing in pottery for tourists and city residents, the Mercado Colón, built at what was then the city's entrance, took over its former regional role. By the 1950s, the Mercado Colón was a strong regional market for traditional vessels. Hundreds of producers from nearby pottery centers came weekly to one of the streets outside the market building to sell their vessels (pl. 391). They found strong competition between *regatones*, itinerant merchants, and city customers. The Mercado Colón *regatones* were the middle persons between merchants and producers and literally fought to maintain this control—these *regatones* enjoyed the reputation of being very aggressive.

The role of this regional market can be documented by the information on map 9, prepared with data from 1955.[1] Chinautla vessels then passed exclusively through the Mercado Colón to the many areas of the central region, where people valued them for their form and quality. Hundreds of potters came from Chinautla to the Mercado Colón as vendors. They were unconcerned with the apparent confusion of the market: marketing in the city

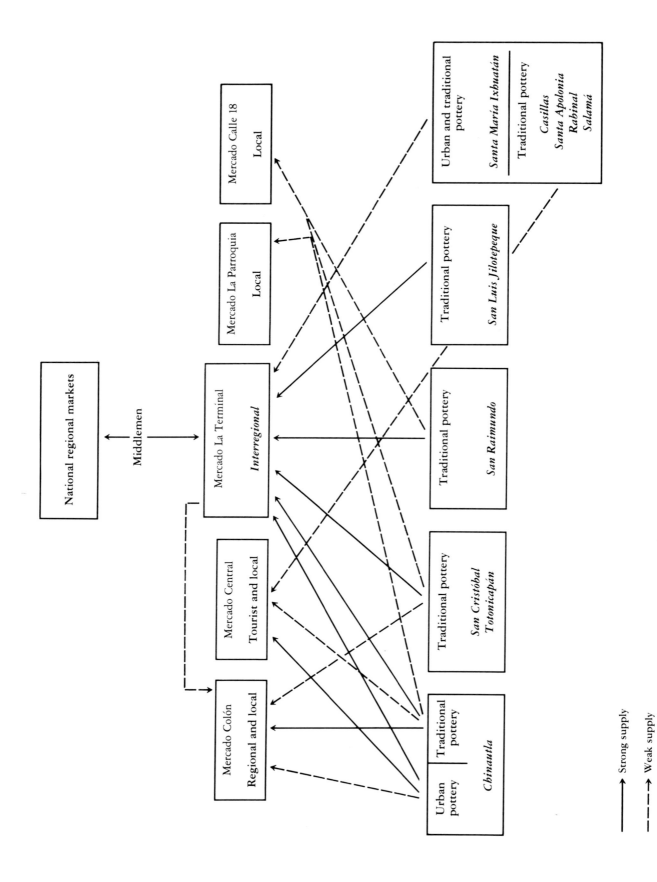

Figure 55. Pottery transactions in the markets of Guatemala City

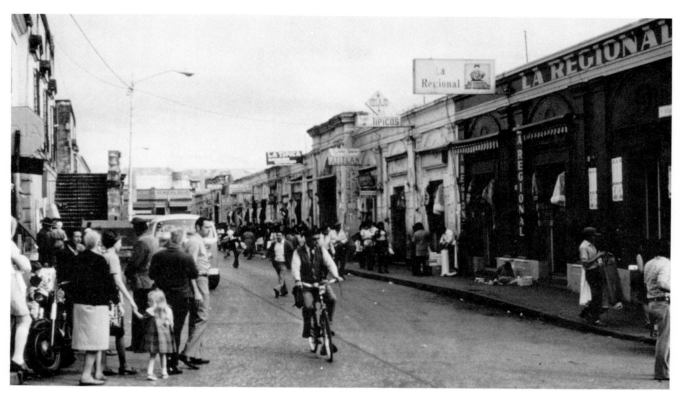

Plate 390. Mercado Central

was a matter of *choice*. Potters seldom invited merchants to the *pueblo* to buy directly and, without an invitation, merchants knew producers would not sell pottery from their homes. Potters-vendors, with their desirable Chinautla pottery, preferred to make transactions in the Mercado Colón, as they considered these transactions more satisfactory.

In the last decade, however, the modernization and expansion of the city, as with the Mercado Central, have changed the role of the Mercado Colón. With the city's decision to build the Mercado La Terminal, the Mercado Colón lost its function as a strong regional distribution center—it became instead a large local city market (pl. 392). Only two *regatonas* continued to carry an inventory of the traditional pottery from Chinautla, Santa Apolonia, and San Cristóbal Totonicapán, as well as Totonicapán and Antigua glazed vessels. One of the Mercado Colón *regatonas* declared that "mixing is necessary nowadays, in order

to make a profit. Most of our customers moved to the Mercado La Terminal—it is now the market for large transactions in pottery. Vendors from many more centers deliver their full load of vessels to La Terminal; they are seeking the best business opportunities."

It is interesting to notice the accommodations these two *regatonas* made when the Mercado La Terminal took away their clients. Although in the past they were oriented to the rural group of the central region, they now aggressively advertise the same forms to middle-class city customers. The *tinajas* from Chinautla, for example, are offered to city dwellers for use as planters; the small *tinajas*, when placed upside-down on mannequins in clothing displays, simulate heads; and miniature figurines are painted in school art classes or serve as party decorations. In two decades, the Mercado Colón pottery trade has changed radically. Only a handful of itinerant merchants, who are old-

time friends, continue to restock their *cacastes* here. "There is still some business, but profit is very small compared to a few years ago. . . . All has changed, it is not the same," complained one of the *regatonas*.

In sum, in the mid–nineteen forties, the regional position of the Mercado Central was bypassed by the rapid growth of the Mercado Colón, coinciding with the development of the city, modern roads, and transportation. The Mercado Colón was built at what was then the city's entrance. With the further expansion of the city in the nineteen fifties, this market was unable to accommodate additional changes, particularly the expanding demand for transshipment. The Mercado La Terminal was then planned by the city council farther from the city's center, at a place easily accessible to the hundreds of rural trucks and buses. At present, all kinds of pottery pass through La Terminal, and this market backs up the supply of

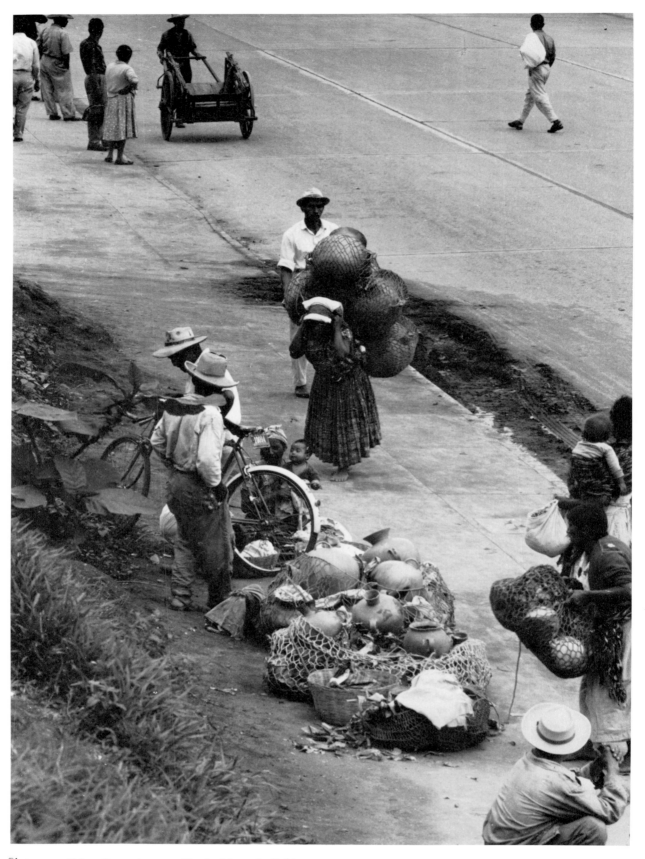

Plate 391. Sidewalk vendors outside the Mercado Colón, 1955

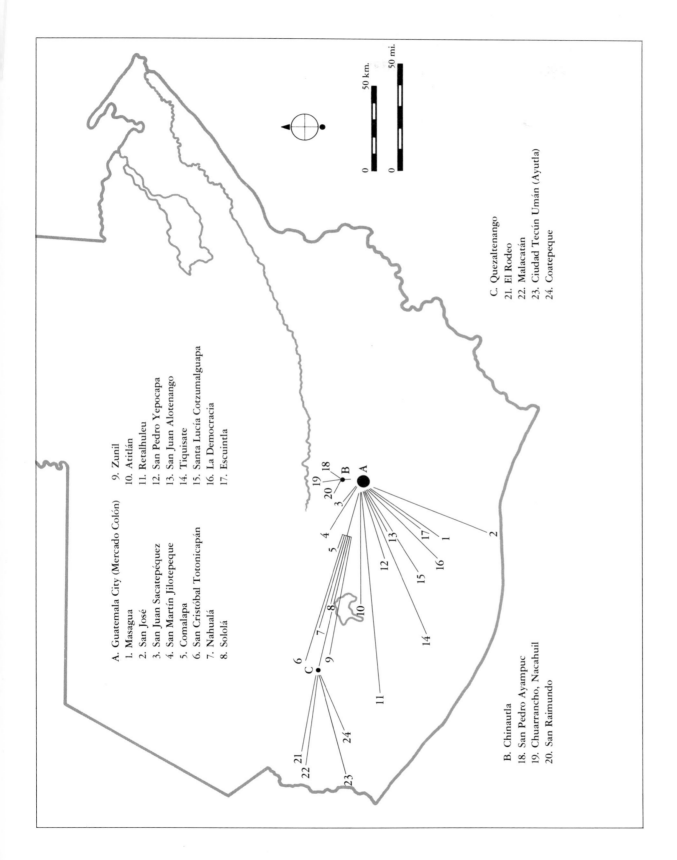

A. Guatemala City (Mercado Colón)
1. Masagua
2. San José
3. San Juan Sacatepéquez
4. San Martín Jilotepeque
5. Comalapa
6. San Cristóbal Totonicapán
7. Nahualá
8. Sololá

9. Zunil
10. Atitlán
11. Retalhuleu
12. San Pedro Yepocapa
13. San Juan Alotenango
14. Tiquisate
15. Santa Lucía Cotzumalguapa
16. La Democracia
17. Escuintla

B. Chinautla
18. San Pedro Ayampuc
19. Chuarrancho, Nacahuil
20. San Raimundo

C. Quezaltenango
21. El Rodeo
22. Malacatán
23. Ciudad Tecún Umán (Ayutla)
24. Coatepeque

50 km.
50 mi.

Map 9. Distribution of Chinautla pottery in 1955

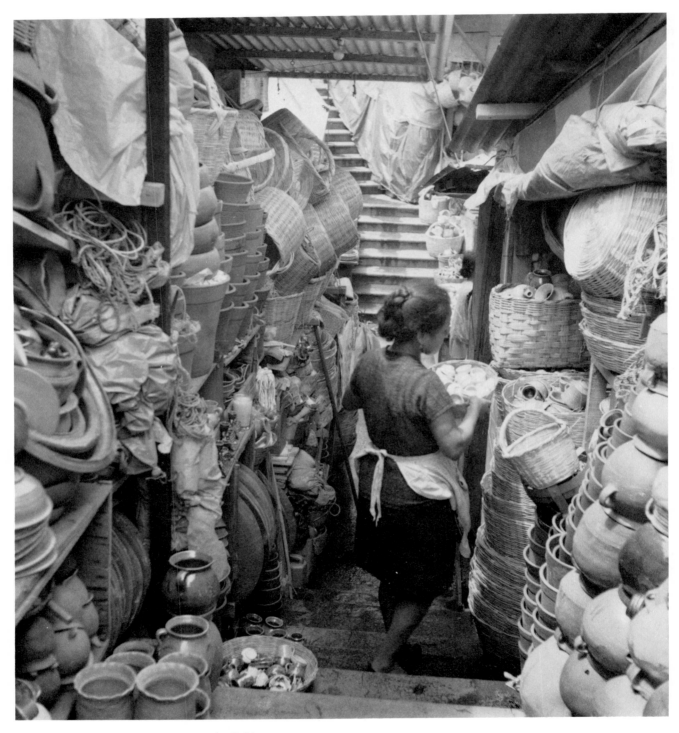

Plate 392. *Regatona* inside the Mercado Colón, 1973

the regional markets, particularly those far away from production centers. The dramatic development of this strong interregional market in the city has strengthened and expanded the function of regional markets in the nation and, at the same time, has changed the function of the old and well-established city markets from serving both urban and rural people to reaching only local urban customers.

The Interregional Market, La Terminal

As already stated, this market connects many regions and at present has a decisive influence upon the regional market system of pottery in the sense that it provides many regional markets with a steady inventory, even though some markets are far removed from production centers. It may be argued that there are several such market centers in the country and that some of the regional markets, such as Quezaltenango, Escuintla, or Cobán, are becoming interregional. However, these large markets in secondary cities connect only two or three regions. The only representation of a national interregional market is found in Guatemala City's Mercado La Terminal. This complex market incorporates a large inventory of rural goods mixed with the products of modern industries. Here both technologies coexist, providing abundant and constant supplies for redistribution throughout the nation.

The most important characteristic of this market is its transshipment function, accomplished through a complex network of economically strong regional middlemen. Using modern transportation, these middlemen can serve a complicated and socially heterogeneous population with pottery to suit each segment of the nation. The market's capacity to also serve as a warehouse aids tremendously in the redistribution and exchange system by acting as a buf-

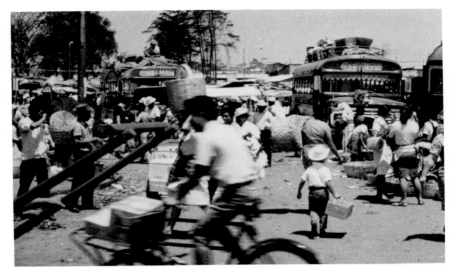

Plate 393. Buses arriving at the Mercado La Terminal

fer against seasonal fluctuations in pottery production. Added to this, the urban Ladino control of the market displays all the business mechanisms typical of a highly urbanized center. The market is, therefore, for rural, *pueblo*, and city residents alike, an important national institution.

Daily hundreds of buses with merchants, middlemen, and producers from *pueblos* and *aldeas* arrive at the market, designated in the city as the place for most bus routes to end (pl. 393). Rural people conduct most of their business in this market area, where the one-day rural visitor to the city can find most services. If some services—health, social, etc.—cannot be found within the market area, *regatones* direct people to the proper sector, which is frequently not far from the market area.

Social and economic differences are in part overcome by the general use of Spanish as the market language, and well-established *regatones* offer their products with elegant phrases to catch the attention of Indian and Ladino customers from diverse areas of the nation. People from different walks of life have little time to bring their personal or community prejudices into the open. The bustle of the place is not conducive to personal social

interaction. This market is, after all, an urban institution, characterized by formal and impersonal interaction.

Mercado La Terminal has become a national meeting point of the rural *pueblo* Indians and Ladinos, the Indian and Ladino city residents, the *chapinos*—Guatemala City residents—and the industrial world. For all these people, many of them merchants, the Mercado La Terminal acts as a "super middleman," combining traditional and industrial products and capable of supplying people from all community traditions and different styles of life.

Mercado La Terminal, with approximately fifty pottery *regatones*, centralizes pottery-trading activities for the entire city (pl. 394). *Regatones* daily receive large quantities of traditional vessels for redistribution, and the complexity can be overwhelming, as middlemen serve each other and thousands of rural and urban customers. As a consequence of this centralized business operation, a large percentage of the pottery business is in the hands of a few individuals, who are nationally powerful and strongly motivated by profit.

As buses from production centers arrive in the morning, each finds a place to park among many hundreds

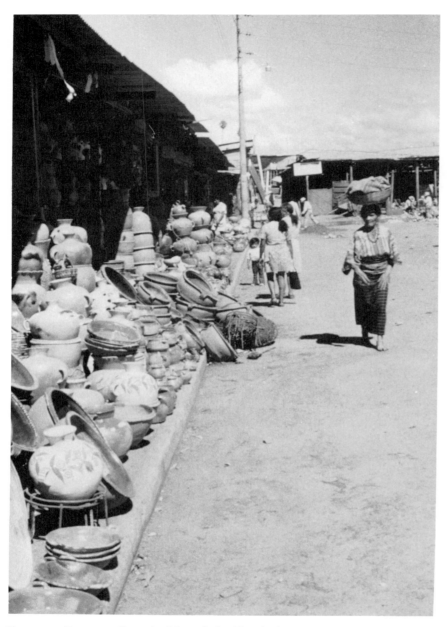

Plate 394. Pottery stalls at the Mercado La Terminal

of other buses; and their *cargas* are rapidly unloaded (pl. 395). *Regatones* await their arrival to transact business before the supply and demand of the day affect the producer's price. Before long, nets filled with *ollas, tinajas, comales,* etc., are transferred to the market stalls or from the top of one bus to another. In the afternoon, the pottery will leave the city in a direction probably very different from its point of origin.

As an illustration, bus transportation into the remote El Petén region has recently begun. Although the region is at least twelve hours away from the Mercado La Terminal, some merchants will risk a load of Chinautla, San Raimundo, and San Luis Jilotepeque traditional vessels or Jalapa wheel-made glazed vessels on the rough roads, in order to retail the vessels at a large profit to the Guatemala City immigrants and other colonists of El Petén. These merchants find no competition, since the one production center of San José Petén makes pottery primarily for the community religious occasions in November. Another example is the agricultural area of the piedmont and the Pacific lowlands. The development of this area has had an important effect on pottery distribution. In the past, only individual Indian merchants with their *cacastes* regularly brought pottery and other highland products to the sparsely settled coast. However, many itinerant merchants now purchase large supplies of different kinds of pottery in La Terminal to redistribute through local and regional markets of these pottery-poor areas. Fundamental to the business activities of these merchants is their respect for *costumbre*, a concept that defines what will be accepted or rejected by their customers. The traditional role of all types of markets is not to direct changes but to harmonize with the established norms. Thus, one of the major functions of the Mercado La Terminal is to maintain an active redistribution of vessels from all traditions, making large

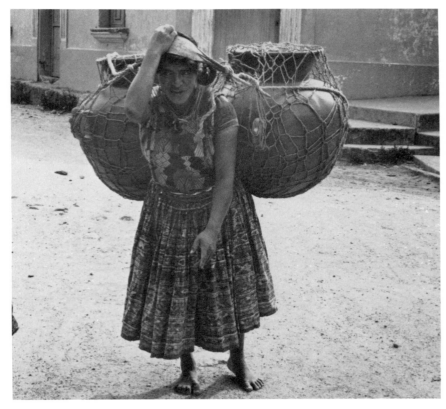

Plate 395. Vendor of traditional pottery from Chinautla, with pottery weighing about eighty-five pounds, supported by a tumpline

Summary

Overall, the distribution of pottery vessels through the economic interdependence of the local, regional, and interregional market system constitutes an organization of fundamental importance for major and minor pottery-production centers. All levels are intimately interrelated, and together they form a complex rural-urban economic system (fig. 56).

The market system for utilitarian pottery maintains an economic equilibrium for all participants. Through this institutional arrangement, producers, middlemen, and merchants are assured of a constant demand and a predictable return for their efforts. Consumers, on the other hand, are certain to find a reliable supply of the proper kind of vessels —as defined by their community culture—at prices fluctuating between known limits. This socioeconomic balance is supported by a cultural equilibrium that allows producers to continue making utilitarian vessels in the traditional manner, thus preserving their community specializations as an integral part of their community culture. By the same token, consumers observe their community norms by purchasing vessels of community-defined value, thus preserving a part of their value system in the midst of the national trends toward modernization and economic development.

Interesting also is the close relation between dietary preferences and pottery forms, reinforced at the consumer level. Merchants, with their sensitivity to these community specializations and preferences, assure themselves of a steady livelihood. So the interaction between potters-vendors, middlemen, and merchants, and consumers forms one of the most basic and strongest socioeconomic networks in the nation.

While maintaining these traditional patterns, however, the market system also possesses the ability to adapt to new pressures and opportunities. The growth of urbanism and

quantities available for transaction through an elaborate organization of middlemen.

In La Terminal, *regatones* specializing in traditional vessels adjust their business operations more rapidly to changing conditions than do *regatones* at other market levels. La Terminal *regatones* are willing to trade innovative forms in response to the demands of their socially diverse customers. These *regatones* have a wide business viewpoint as a result of the comparisons that can be made with items in nearby stalls, where merchants sell industrially produced vessels made of plastic, cast iron, galvanized steel, and porcelain. In turn, these industrial products have frequently copied traditional pottery vessel forms.

This, then, is the national market level, where traditional and innovative forces meet with equal strengths. Diversity is one of the main characteristics of this market. The successful operation of the market is tied not only to an extensive system of interregional socioeconomic reciprocity but also to the continuing respect middlemen have for traditional social principles, which shape community specialization, as well as their sensitivity to such cultural concepts as *costumbre*. This orientation, basic to the overall dynamics of the interregional market, continues even though marketing activity has expanded greatly as the function of interregional service has passed from the Mercado Colón to La Terminal. Thus, the interregional market continues to operate in harmony with the former regional markets.

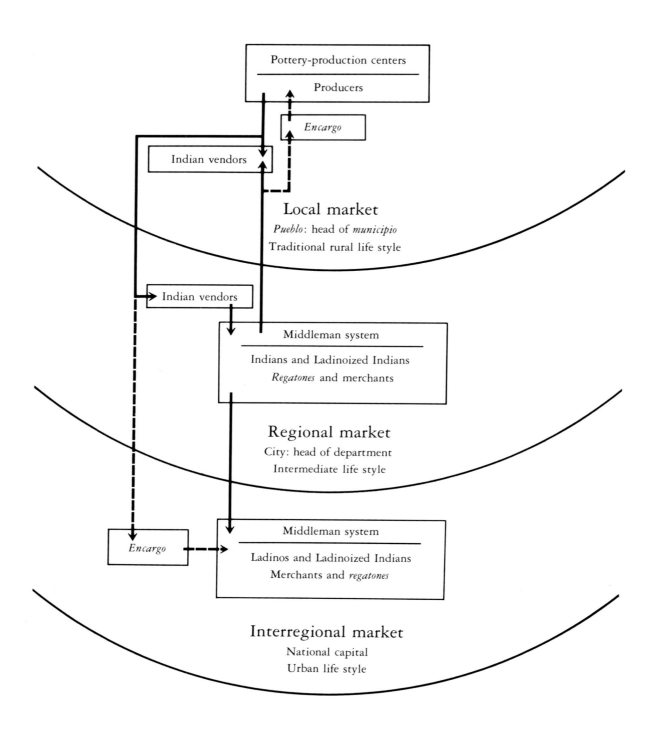

Figure 56. Pottery marketing levels

modern transportation is particularly closely linked to the development of the interregional market. In this type of market, middlemen dominate the transactions, involving hundreds of vessels at a time. As both cause and effect of these developments, buses and trucks carry large quantities of pottery to and from regional and interregional markets.

The market takes into account the tourists, the growing urban upper middle class, and the elite, exploiting them as new consumers for traditional and innovative forms. Producers, middlemen, and merchants are constantly interpreting the demand. Therefore, the social heterogeneity characteristic of the nation is accepted by the market system, which in turn profits from it.

As pottery crosses ecological, political, linguistic, ethnic, and social boundaries by way of the institution of the market, it serves to maintain a significant degree of cultural unity among Indian and Ladino, rich and poor, highland and lowland, and urban and rural Guatemalans. While continuing its traditional role of supplying utilitarian vessels, the market system, at least in the case of pottery, is also capable of expansion to include new forms, with little change in its well-established structure and operation.[2]

9.

Costumbre
A Control Mechanism

The production of pottery, its distribution, and people's appreciation of it reveal a surprising regularity in the face of national transformation in other aspects of Guatemalan life. There are cultural reasons for this persistence in the social system. Spanish *conquistadores* and colonizers would have been greatly handicapped without the Maya-produced pottery, and Maya utilitarian pottery was assimilated into the service of the emerging postconquest social order. Pottery for the Maya and their descendants relates to their code of ethics. As in most preliterate societies, the Maya feels one with nature, "acting on it, getting his living, taking from it food and shelter."[1] Much of this orientation is manifested by the concept of *costumbre*.

Within the closed corporate form of social organization, *costumbre* is applied to the overall community tradition. It appears as a forceful cultural concept that both coordinates and determines people's thoughts and actions. Potters in this type of social system refer to their specialization as an *oficio*, assigned to them by the *costumbre* of their birthplace.[2] All women born in a pottery-producing corporate community have the same *oficio* and, in this respect, all women are equal. According to statements made by

Indians and some Ladinos, *costumbre* refers also to aspects of pottery production, distribution, and consumption. It functions as a principle in the ethnic system, indicating what must and must not be done. *Costumbre* is hence an integrating principle that, without a doubt, influences Guatemalan cognitive structure. The producer, the middleman, the merchant, and the consumer of traditionally made pottery are joined to each other as their respective roles are defined by *costumbre*.[3] In contrast, among Ladinos or Ladinoized Indians in open social systems, *costumbre* is restricted in its meaning; it refers primarily to the repetitiveness of an activity. The activity is frequently viewed as old-fashioned, ancient, but needed for survival. It is evident that, particularly among the Indians, actions explained by the *costumbre* concept can seldom be changed: changes are made only by substitution. The term is therefore used in reference to the most persistent elements of the society. *Costumbre* stresses emulation and conformity.

Costumbre in our study is central to an understanding of the dynamics of pottery. It carries a deep emic interpretation of the social distinctions that are real and meaningful to the Indians themselves. Levels of thinking and actions people find

difficult to verbalize are attributed to *costumbre*. When merchants of regional markets plan their business strategy, they carefully take into account the communities and their *costumbres*. The use of functional pottery vessels, particularly *tinajas*, is a good example of a behavior pattern which may appear to be inconsequential but has, in fact, social and aesthetic importance. Merchants in the regional market carefully choose vessels of the forms and styles that correspond to the *costumbres* of the people they serve. They are attuned to the balance achieved by the individual production center, the people's functional and aesthetic values, and their pottery style and form. The merchants' economic success depends on their sensitivity to all these differential behaviors. *Costumbre* draws people together and maintains a definite subcultural boundary for their business activity. To observe *costumbre* is to preserve the collective consciousness of the group. Individuals' reactions to imitation, to the uses, and to the care of vessels clearly document the way *costumbre* interconnects the people, the community, the technology, and the economic system. This phenomenon can be observed at work in the three basic contexts of production, distribution, and consumption.

Costumbre and Producers

In closed corporate *pueblos*, *costumbre* encompasses all that is most permanent in the way of life; it is at the center of the community culture (see fig. 60). As long as potters keep

to *costumbre*, the quality of their vessels is sustained. *Costumbre* brings constant reaffirmation of established practices without intent or need to innovate. *Costumbre* in pottery-production centers brings social and economic stability.

All questions about routine performance in the production of traditional vessels are answered rapidly

by "who knows, it is *costumbre*." The reply presumably explains why individuals are involved in the craft and why the producers carry their work to market. Potters strive first of all to meet the *costumbres* of their own *pueblo* but, if their forms and styles also meet the *costumbres* of other *pueblos*, the vessels may not only be shared, but they must also be made available to people there. This is not happenstance. Only a few *pueblos* make pottery. Others must accept the style and, through time, it becomes *costumbre* in non-pottery-producing *pueblos*. Thus a pottery region develops.

Production of pottery, preparation for marketing, market days, and religious observances are related differently throughout Guatemala. In some places, production and religious ritual cannot be separated from market days. Beliefs that are part of *costumbres* are the grounds for this relationship. In the potter's mind, offering a candle in the church or in another sacred place may help increase production and bring economic success. Therefore it is important to consider the production schedule and the market days in relation to *costumbre*. The degree of congruence stands in direct relation to the degree of physical and social isolation, the amount of acculturation, and the current effect of the national Ladino urban culture's efforts to direct social change.

At least three models of production schedule regulated by local *costumbre* clearly emerge from our ethnographic survey of pottery. In each, the relationship of these variables can be seen in the context of a week's activity. Although the models have emerged from specific places, the names should be considered as types.

Pottery-production centers of the Jocopilas type are composed of families in which the women are busy with the various stages of production each day of the week. Firing of pottery is carried out on Monday and Thursday, in preparation for the Tuesday and Friday local market

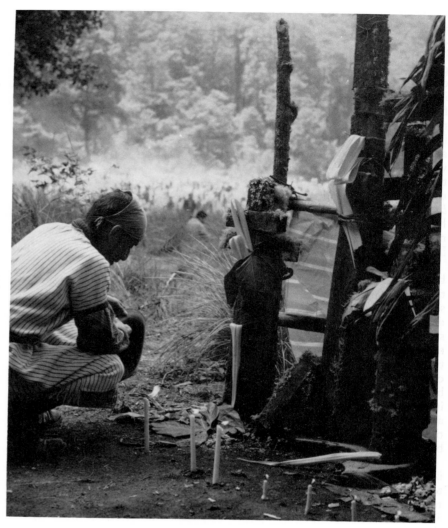

Plate 396. *Chimán* of the central highlands, conducting a ritual of personal *costumbre* in the mountains

days. If the potter has not succeeded in preparing a sufficient number of vessels during the week, then the two market days become days for production. When enough vessels are ready, the potter chooses to fire on Mondays. Early in the morning, before the firing, the potter will walk into the countryside to visit a specific sacred site in the mountains, and there she will conduct a ritual of personal *costumbre*. She may proceed alone or may seek the help of a *chimán* (shaman) (pl. 396). She attempts to maintain a balance with the elements of the universe. Potters believe that, if these personal rituals are observed, Nature will provide the raw materials for pottery production. Thus, devotion, reverence, and offerings enter into this experience and, through the ritual, the potter relates to the universe in submission and feels herself a part of all life. She takes her transformed clay ("clay without life"), now a vessel, to the market and, with her profits, she buys food produced by other people. This assures her own and her family's survival.

The intensity and frequency of the potter's ritual may vary with the degree of economic necessity. For example, three female potters lived

in precarious economic circumstances. An elderly and ill woman and her two middle-aged daughters lived alone, dependent for their support on cooperative efforts to produce vessels. The absence of a man in the household to cultivate the fields, bring in wood, and assist with marketing the pottery placed them in an economically and socially disadvantaged position. During the week of our visit in January, the three potters were anxious, and the ritual was significant. The *costumbre* ritual brought comfort to the household and should help with the many uncertainties in their difficult life.

On market days, before trading begins, one of the daughters visits the church and offers candles to selected Catholic saints. On Monday she fulfilled her individual responsibility according to an ancient tradition associated with production, and on Tuesday morning, in church, she has asked for success in business. Now, with great tranquility, she sits in a space in the market and waits for customers, secure that the observance of these rituals will bring her some reward.

In the Jocopilas model, the organization of the week has no relation to Sundays, the Christian day of rest. From the potters' viewpoint, Sunday mass is for the Ladinos of the *pueblo*; for these traditional Indian potters, it is another working day—the day to terminate the week's activity of production. On Sunday, while the Indian potters are at their regular work, Ladinos and Ladinoized Indians attend mass and rest from the "boring" routines of the week. For Indian potters, religion and economics are not separate categories. Rather, they have become one: there is religion in pottery making, in selling, and in all aspects of existence. For potters, all these things together constitute *costumbre*.

Production and marketing can be arranged differently by *costumbre*, and a second model is here referred to as the Santa Apolonia type. Under

this type, Thursdays and Sundays are the market days. Sunday, in particular, is designed as a major market day on a regional basis, being also a day for religious observances as established by the Catholic church. Producers-vendors perform their individual rituals, also on Sundays, on specific mountainsides or in the church itself. This type of ritual is combined with institutional observances in the church; vendors use Sunday for both their economic activities and their religious obligations. The market and the church appear to be part of an integrated whole; people move from stalls to mass or to individual rituals inside the church. On Sundays, *chimanes* are active in the general setting of the market and the church, assisting individuals with prayers and frequently sharing the church space with the priests. For the *chimán* and his client, the ritual is an individual action and contract, while the mass is of and for the group.

Pottery is fired on Wednesdays and Saturdays, in preparation for market days. Thursday, as a secondary market day, is less active, but more merchants come to trade vessels from other centers. On this day, the individual ritual is more common; in many places the church does not hold mass or holds one service at a very early hour, before merchants arrive at the market.

During the active Sunday trading, on a day designated by the Catholic church to pay homage to a saint under the care of a *cofradía*, it is not uncommon for vendors, *regatones*, and merchants to make way for passing *cofradías*, as a small group of men moves in a procession through the streets to the plaza, where the market is established. *Cofradía* officers, with much dignity and reverence, guided by men with a drum and a small flute, carry the statue of the saint to the church. Unique to this type is the fact that Sunday is seen as a day set aside from all other days of the week, not only for delivering products to the market and for individual ritual but

also for church. The open plaza is set aside for economic transactions, while the church provides a place for individual rituals and group services. In this Santa Apolonia type, much of people's world view is organized around Sundays (time) and the center of the town (space). In rituals, the potter reflects about herself and about those elements of the universe upon which she depends for survival. For potters, their own relation to clay, firewood, water, and health is of central concern. The special world view associated with the Santa Apolonia type is basic to the potters' cognitive structure. Both religious and economic variables bring people into intensive and predictable interaction, and both traditions meet without conflict. The selling of pottery on a Sunday is therefore an act related to a religious experience in which both the services of the church and the personal rituals with the *chimanes* contribute to the Christian day of rest. Potters of this type refer to the structure in time and space as *costumbre*.

The third model may be referred to as the Chinautla type. In contrast to the former models, the working days are Mondays through Saturdays, and these are also the market's active days. Saturday is the busiest day, known as the market day, and on this day potters-vendors sell their vessels. The market may be open for a few hours on Sunday, to sell essential food supplies to local residents.

For pottery-production centers of this type, Friday is a major firing day in preparation for the Saturday market. Wednesday stands as a secondary firing day, used chiefly in case of economic emergency, such as illness. The important contrast with the other two types is that religious and market activities have been assigned separate days of the week. Sunday is the day of rest, for attending church or for engaging in *cofradía* activity. On a Sunday morning, a producer will seldom be seen in the market selling pottery or at

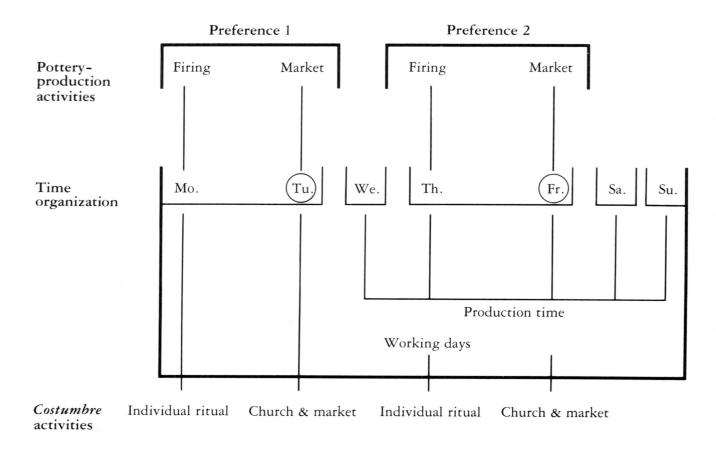

Figure 57. Weekly production schedule: Jocopilas type

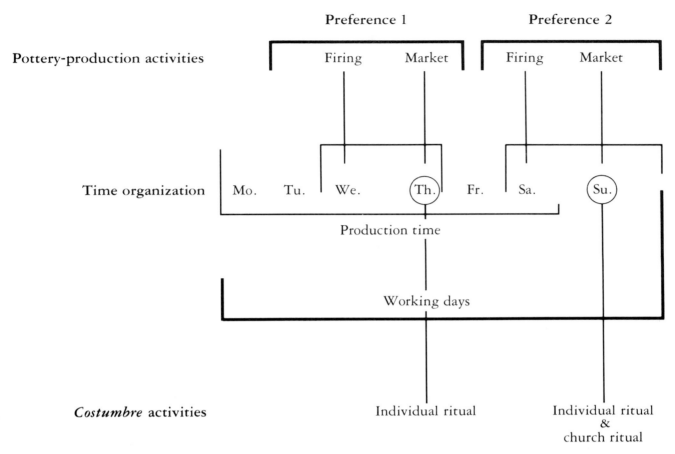

Figure 58. Weekly production schedule: Santa Apolonia type

home working on pottery. If it does happen, it will be socially disapproved and charged as an act of ignorance.

During the week potters—responding to their own needs—approach the altar of a market patron saint, before or after trading, to offer prayers, flowers, or candles. The potters of this Chinautla-type orientation feel that they must pray to God for assistance in life. The overall style of this model is characteristic of highly urbanized modern organizations and is most suitable to the business and religious cycle of an interregional market system, where the national culture defines group activities and public behavior. Some potters have become Ladinoized—their world view appears to be as compartmentalized as that of westerners. But even these potters will still explain the production of pottery as *costumbre* within the rules of this type. This is supported by the manner in which potters—Indians or Ladinos—conceptualize and express their own understanding of their craft specialization.

Traditional Indian potters conceptualize their *oficio* as an intimate process of nature. This approach is true *costumbre*. Ladinos or highly Ladinoized Indians have become part-time artisans; as such, they confront the production of pottery from a matter-of-fact point of view. These potters' actions are practical; only because of long use are they referred to as *costumbre*. The definition of the word as used by each group reflects their cultural standing.

Indian potters without exception explained that the "clay does not let itself" (*el barro no se deja*) be manipulated; the "clay is alive." Therefore, "the clay is hard to dominate. It is a *lucha*, a struggle, but once it is fired the struggle ends and *se logró*, success follows. We potters must be able to dominate the clay as it resists its transformation." Where *costumbre* strongly underscores the social system, the inorganic elements of nature take on the qualities of life and, more specifically, of humans.

The vocabulary of Indian potters clearly reflects a folk way of thinking, where the "Moral Order" prevails over the "Technical Order."[4] To explain the transformation of clay into forms, potters remarked that the clay wants (*quiere*) sun or rest (*reposar*), that it has its character (*modo*), that its state is unripe

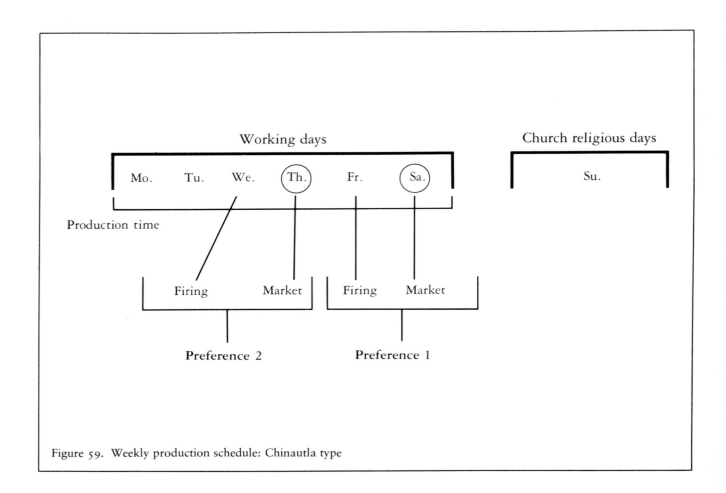

Figure 59. Weekly production schedule: Chinautla type

(*verde*), that it must become healthy (*componerse*). The process of pottery making is fragile (*algo delicado*). To think in this specific personalized manner is *costumbre*, and it is the way to understand the element of nature that these potters confront. Indian potters are led to order, to stability, and to unity with and submissiveness to nature through *costumbre*.

Ladino potters have taken a step away from the *costumbre*-dictated way of reasoning. Their terminology manifests a separation from nature, and technical facts underlie the process of transforming the clay. They speak of mixing (*batir*) the clay, stirring (*revolver*), sifting (*colar*), exploding in the fire (*reventar*), grinding (*machuchar*), repairing (*arreglar*), bringing the clay to a point of workability (*dar el punto*), wedging (*amasar*), and cleaning (*limpiar* or *despulgar*). The basis of the Ladino potters' thought is an attempt to mechanically change the nature of the clay. *Costumbre* is not used by Ladinos as a philosophical explanation of an overall way of living. For them, it refers to a routine process inherited from a strong "Moral Order." In the hands of Ladinos, the humbleness of the operation can be overcome in part by the use of a series of concepts borrowed from the "Technical Order."

Costumbre and Merchants

An experienced merchant in the town of Totonicapán, typical of many hundreds of other merchants, gave us his understanding of their entrepreneurial activities and their relationship to cultural elements. Pottery is a product he admires, respects, and makes available to people.

His statements reflect a personal comprehension of community differences and, through the *costumbre* concept, he shows an understanding of the relationship of the individual's aesthetic and economic values and technology. Clearly, the preservation of pottery form and style cannot be explained simply from the point of view of the producers. Merchants have always been aware of basic and subtle cultural variations, and their respect for these differences takes them beyond economic exploitation. Merchants understand that *costumbre* is central to consumers' demands; the concept delimits the boundaries for distribution of specific kinds of vessels. For centuries, Guatemalan merchants have, in a quiet manner, successfully connected and coordinated consumers' and producers' *costumbres*.

Juan Sop is a well-established merchant in Totonicapán. He cannot hold a competitive position unless he travels, as his father did, in search of his product. Periodically, he travels to regional markets, where he comes in contact with other middlemen and merchants and a variety of pottery vessels. In Chichicastenango, he buys vessels from merchants who systematically bring pottery directly from such centers as San Pedro Jocopilas, Chinautla, San Raimundo, and Santa Apolonia. However, he considers the Tecpán market a more economical place to buy Santa Apolonia pottery. Depending on the time of year, he plans trips to the interregional Mercado La Terminal in Guatemala City, in order to find a larger supply of those vessels most wanted in the Totonicapán area. On Saturday, in the Mercado La Terminal, he seeks patiently and quietly for the very best buy of Chinautla pottery from producers-vendors, as well as Jalapa glazed vessels and San Raimundo *comales* from regional merchants. During the last five years, it has become increasingly difficult to find Chinautla potters with large *cargas* of *tinajas*. Changes of the production pattern in Chinautla and competition from other merchants have begun to affect his own business. His supply is low, and frequently he cannot bring the best *tinajas* to his area, but he knows that the Chinautla *tinajas* meet the *costumbre* of his customers in Totonicapán, and he will work hard to find as many *tinajas* as possible.

Sop considers the Chinautla pottery very fine. For him, the line and weight of these vessels have truly aesthetic value. He feels that Chinautla clay is excellent and unique. Experience has taught him that vessels from Jocopilas and Santa Apolonia do not meet with his—or his customers'—highest standards. "They are not as fine," he said, and consequently "there is no profit from Jocopilas and Santa Apolonia vessels in this area. Bargaining for this pottery is difficult, because one must talk about a nonexisting quality. . . . Only necessity makes one sell pieces other than Chinautla vessels." Chinautla *tinajas* bring a 20 to 30 percent profit in Totonicapán, whereas the profit from the pottery from the other centers is considerably less.

The Jalapa glazed pottery also enjoys a good reputation in the Totonicapán region, and Juan Sop deals proudly with this product. It competes well with the long-established Totonicapán glazed pottery. As with the Chinautla *tinajas*, Jalapa wheel-made vessels are considered fine household utensils. In the Mercado La Terminal, Sop finds a large quantity of Jalapa ware. Although purchasing prices do not vary according to the season, and the supply is constant throughout the year, he plans carefully so that between November and January his own stock is sufficient to meet the high demands brought about by the festivities held at this time. The Jalapa success in Totonicapán has

caused some of the Totonicapán families to imitate forms, styles, and the light yellowish glaze of Jalapa vessels. They are, however, using Totonicapán clay, and the glazed ware of Totonicapán is easily recognized by its dark brownish color. The imitation is good, but the merchant explains that the weight, feel, and quality cannot be duplicated. The Totonicapán clay is different; it produces a rather heavy vessel with granulated walls—it is not fine. Sop objects to selling imitation Jalapa ware and prefers to disappoint his customers when he does not have true Jalapa ware in stock. His attitude is supported by a strong respect for legitimacy. For him pottery, like people, has membership in a specific settlement, and production itself cannot and should not be transplanted. The explanation is that *costumbre* stays in its place, and each place has its own *costumbre*.

He offered another example of the San Cristóbal Totonicapán potter who tried, on one occasion, to copy Chinautla *tinajas*: "It just did not look right." It appeared heavy, weak, and inappropriate. It was an object without the proper aesthetic value and, therefore, had no economic potential. The attempt to imitate was, he said, a failure.

Merchants are aware that the *tinaja*, as a useful and aesthetic object, has a relationship to social standing. This constitutes a dominant factor in the planning of their own business. They contend, therefore, that a specific vessel cannot and should not be imitated. "It is not right to take an object away from its place of birth." It loses its real identity, and an adoption of this kind destroys the functional value of the object. Thus, a vessel should not pretend to possess a quality of other places. Significantly, clay is not found in markets as a commodity that can be sold to producers from different centers—each center uses its own raw materials. This fact in itself reinforces the sense of belonging; when Sop was asked to give a specific reason for this, he answered, "It is *costumbre*." If, in the name of *costumbre*, an imitation is not accepted by merchants, innovation is rejected by socially well established members of communities for the same reason. Introducing changes in his inventory does not interest Juan Sop, for his ways, as a merchant, also fall under the category of *costumbre*. His entrepreneurial activities are carried out within a specific *costumbre* boundary. When discussing the Chinautla urban ware—ashtrays, decorative *braseros*, candle holders, figurines, etc.—available in the Mercado Central in Guatemala City, he remarked, "There is a place for each thing, but there is no *costumbre* in Totonicapán for these objects." Therefore, he has few Chinautla urban items in his stock.

Of the urban items, Sop had two distinctive incense burners from Chinautla, placed casually behind some glazed Totonicapán pottery. During the interview, Reina placed them within reach of passing buyers. Soon the items were examined by customers. The comments of some were not complimentary: the color was not proper, and the form was awkward. To these people the vessels were items of curiosity and were left behind with little regret. The merchant manifested some degree of embarrassment at having any urban ware in his Totonicapán display, and he gently placed them back behind other items. Suddenly an itinerant merchant discovered them and made an offer, and Juan Sop sold them without bargaining. He stated, "I did not make a profit, but this woman will sell them somewhere else." He was relieved and seemed proud to have only utilitarian pottery in his stock.

Urban forms so far have not begun to be accepted away from the Guatemala City area. The work is still new and has not yet appealed to the aesthetic values of the Totonicapán people. Basically this form does not connect the merchant and his customer with their historic past; thus these urban objects, lacking *costumbre*, have no economic value among his clients.

In summary, the distribution of pottery by merchants in regional markets is carefully related to *costumbre*. Any imitation of traditional forms, or any innovation of forms, calls for changes of *costumbre* that relate to such things as diet, social values, etiquette, and aesthetics. Middlemen are highly sensitive to regional and community differences, for they must respect cultural and social variations in order to succeed economically. In the regional market, hundreds of *regatones* and merchants bring in large quantities of proper—that is, traditional—types of pottery. Because these are proper, their economic value is stable. Merchants, in particular, are nowadays concerned about the real or potential changes in some production centers. A merchant like Juan Sop depends on centers for his supply and, if the supply does not meet the demand of the area he serves, he will face bankruptcy. The merchant places pressure upon a production center in the name of *costumbre*; after all, he must make the right pottery vessels available to his clients. He is the link between the production center and the consumer.

Costumbre and Consumers

Although many pottery vessels look alike to an outsider, they are distinctive in appearance from the user's point of view. Map 10 shows the distribution of the different forms of *tinajas* and the methods of carrying them for the Guatemalan highlands. The forms, or styles, from Chinautla, San Luis Jilotepeque, Cobán,

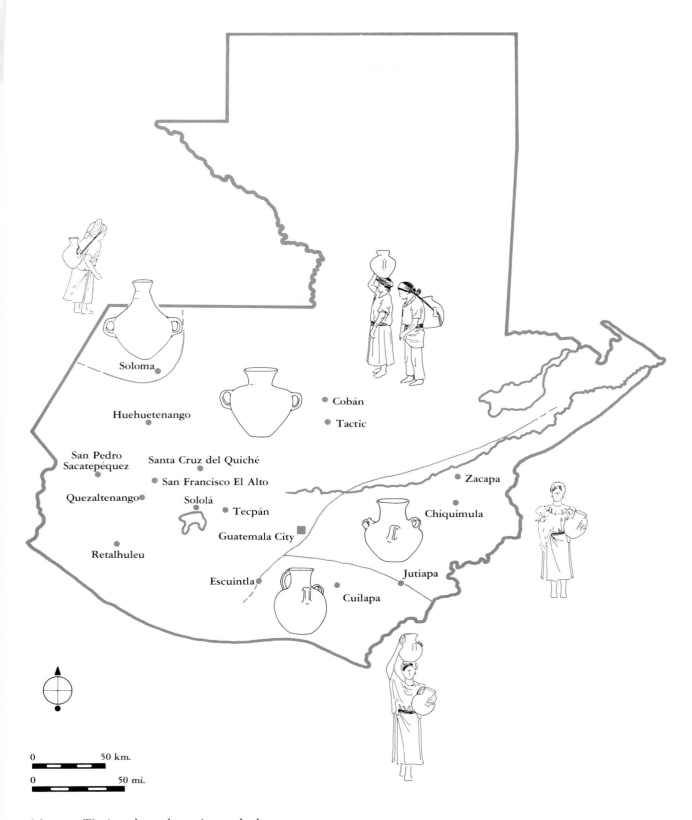

Map 10. *Tinaja* styles and carrying methods

Plate 397. Chinautla girls with a *tinaja*, which weighs five pounds when empty, thirty-five pounds when full

and San Miguel Acatán all occur within areas whose borders are extremely well defined.

Style, as influenced by *costumbre*, is important in the selection of a water vessel; for example, the pottery center of Chinautla is widely known for a specific type of *tinaja*, valued by a particular group of people within the country. These people form a distributional area and consequently, by *costumbre*, they accept the Chinautla *tinaja* not only for its quality and beauty but also as a socially appropriate vessel for a woman. As already stated, merchants and *regatones* are very sensitive to these established boundaries. Within a region, people learn the appropriate way of handling an empty or a full vessel, meeting in this way the *costumbre* of the place. This regional preference is not recent and, through time, the women's strength and the topography of the land have been fundamental reasons for the consideration and acceptance of a particular type of vessel.

Chinautla *tinajas*, together with similar *tinajas* from Santa Apolonia, Santa María Chiquimula, San Pedro Jocopilas, Rabinal, Cobán, San Sebastián, Comitancillo, and Chiantla, are produced for local use in each of these production centers and in sufficient quantity to sell in regional markets. People inhabiting the western, northern, and central highlands carry these water vessels on their heads (pl. 397). They will not consider carrying *tinajas* on the hips or back, because these are unsuitable areas of a woman's body upon which to hold a water vessel. Their reason is, as might be expected, that any way other than on the head is not their *costumbre*. Western Pokomam, Cakchiquel, Quiché, Kekchí, Ixil, and Mam Indians and Ladinos residing in this area carry their *tinajas* on their heads.

Chinautla-style water vessels have the handles located in the middle of the vessel body. By placing the palm of her hand underneath the handle and securing her thumbs above, a

woman can lift a heavy *tinaja* to the top of her head without assistance, simply by extending her arms and flexing her knees. The rapid operation seems simple. She gracefully and cautiously places the vessel upon a coiled piece of cloth, which lessens the discomfort the weight of the *tinaja* may cause when placed directly on her head.

The style of water vessel produced in San Luis Jilotepeque, on the other hand, is preferred by people of the southeastern region of Guatemala, composed of eastern Pokomam and Chorti Indians, Ladinoized Indians, and rural Ladinos. The important center of San Luis Jilotepeque produces a *tinaja* with three small ear-like handles placed on the shoulders (pl. 398). These "ears" and the vessel's long neck permit a woman to hold the vessel in her arms, securely against her body, after it is placed on her hip (pl. 399). There is frequently a knob at the side of the vessel neck for a firmer grasp. A woman would find it awkward, almost impossible, to attempt to place this type of *tinaja* on her head by using two of the three handles. The *tinaja* would tilt to one side and, if the woman attempted to lift it as far as her arms would permit, most of the body of the vessel would be in the woman's face, and her arms would be unable to support the heavy vessel in such a clumsy position. On the other hand, if she attempted to place the palm of her hand on the slippery bottom of the vessel, she would risk dropping it, since balance is difficult to maintain. The vessel is therefore aesthetically pleasing and satisfactory when placed on the hip. A woman can keep the *tinaja* vertical while she holds her torso to the side, at an angle.

Zapotitlán, Santa María Ixhuatán, Trancas and El Barrial, and Casillas produce *tinajas* combining the properties of the first two types (pls. 400, 401). In these centers, *tinajas* have a less globular body; two handles are placed as in San Luis

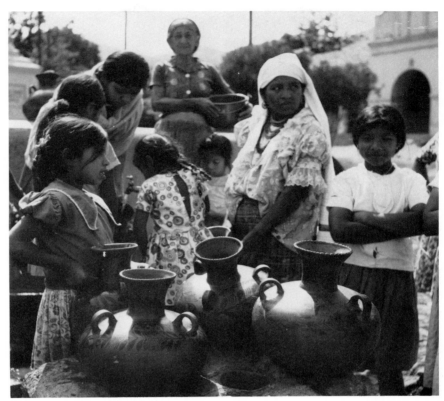

Plate 398. Indian women and *tinajas* at the town fountain, San Luis Jilotepeque. The Ladina in the background is using a steel *olla* as a *tinaja*

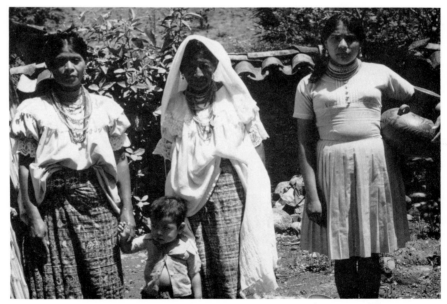

Plate 399. Three generations of Indian women, San Luis Jilotepeque. The woman on the right, in western dress, is carrying a *tinaja* in the traditional manner. The *tinaja* weighs four pounds when empty, twenty-four pounds when full

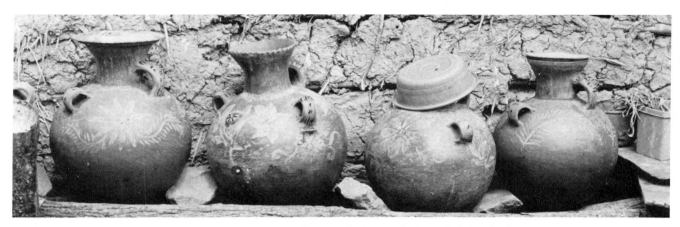

Plate 400. *Tinajas* in Santa María Ixhuatán. Women usually carry the larger *tinaja* on their heads, the smaller one on their hips. The larger *tinaja* weighs five pounds when empty and twenty-six pounds when full; the smaller one weighs four pounds when empty and eighteen to twenty pounds when full

Jilotepeque, with a vertical handle attached at the neck of the vessel. This arrangement allows the women to place the vessel either on the hip or on the head. A woman may carry two *tinajas* simultaneously, one on the head and another on the hip — she might also carry a San Luis vessel on her hip and one from Santa María on her head.

The pointed-base *tinaja* produced in the *aldeas* of San Miguel Acatán is used in the rugged Cuchumatanes Mountains. This *tinaja* has the longest neck of all, and two strong handles are placed just above and below the middle part of the vessel. The pointed bottom prevents a woman from carrying the vessel on her hip or head — thus, she puts the strap of a tumpline through the handles and carries the *tinaja* on her back (pl. 402). This *costumbre* no doubt correlates with the topography, for these Chuj, Kanjobal, and Jacalteca women must travel over high mountains on rough paths each time they fetch water. In the area of San Mateo Ixtatán, women carry salt water from a deep ravine to their houses to boil it down into salt. With this type of vessel, a woman's body bends forward and her arms swing freely, while the *tinaja*, adjusting itself to the contour of her back, remains vertical. A woman can thus proceed over the hills with minimal

risk of spillage or breakage. Also, with this arrangement, she can place her child in a sling supported from her neck and freely attend to its needs.

As previously stated, regional merchants recognize the distribution of *tinaja* types and do not wish to interfere with *costumbre*. Through these merchants, consumers are able to find the style that meets their own *costumbre*. In the same way that it is *costumbre* for potters to produce a specific type, it is *costumbre* for consumers to use a given type and, for the merchant, it is *costumbre* to sell according to the *costumbre* of the region. Boundaries are always clear.

The improbability of diffusion of a vessel form from one region to another can be illustrated by a conversation with a *regatona* in the Mercado Colón of Guatemala City. For two generations, her inventory has consisted of *tinajas* from Chinautla. With the changes of the market's role in the city, she now stocks a wider variety of vessels in order to meet the demands of immigrants to the city, who search for the *tinajas* of their own area. In the course of a conversation, it was suggested that she expand her business aggressively by adding a large stock of the excellent and attractively decorated San Luis Jilotepeque

tinajas, thus introducing this vessel among people in the Cakchiquel region who prefer the Chinautla *tinaja*. The regatona was puzzled; the question seemed out of place. After a pause, she explained that the San Luis three-handled *tinaja* was available in her stall for the tourist trade and a few city customers. As to introducing this piece of pottery to the Cakchiquel people, the problems were beyond words. Filling a San Luis *tinaja* with water, she quickly demonstrated the difficulty a Cakchiquel woman would have placing this type over her head. In addition, if a Cakchiquel woman were to learn to carry the *tinaja* properly on her hip, it would be very awkward socially, she indicated. "It would be as bad as a San Luis Jilotepeque woman carrying a Chinautla type over her head. *Las costumbres están muy arraigadas* — are deeply rooted — and do not change. In the business of pottery, one must understand *costumbres*." Individual quality can vary and some conservative innovations may be expected, but the forms are, by cultural definition, stable.

The relationship of consumers and *costumbre* can be seen clearly in the Pacific coast area. Migrant laborers temporarily residing here bring their own vessels from home. Merchants arrive from the various

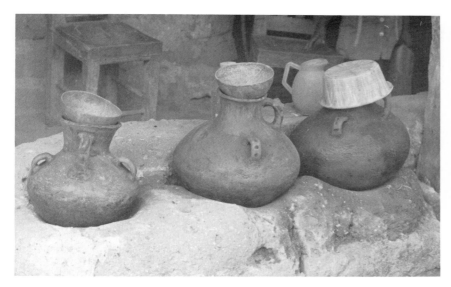

Plate 401. *Tinajas* in Casillas. A special platform is built outside for *tinajas*

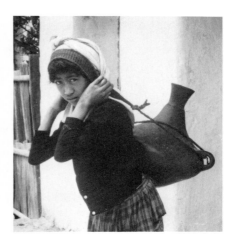

Plate 402. Fourteen-year-old girl from San Miguel Acatán. When empty, her *tinaja* weighs eight pounds; when full, it weighs thirty-three pounds

pottery centers with vessels to replace those broken during a stay in this area. A Cuchumatanes woman faces special problems—it is hard for her to find a replacement for her *tinaja*, so she is forced to adopt other styles. The Chinautla *tinaja* is frequently available, and she may learn to use it. As she carries water in this new way, her movements are awkward and insecure. Worse, the vessel is not, from her point of view, aesthetically pleasing. If she resides for a long period of time on the coast, she will eventually secure, by the system of *encargo*, a *tinaja* from her own region, and the Chinautla vessel will be relegated to water storage in the kitchen area.

With regard to cooking or storage vessels, *costumbre* is again given as the rationale for preference. It is *costumbre*, for instance, to prepare *atole*—a nonalcoholic drink made from maize—tamales, maize, black beans, and coffee in traditional burnished *ollas*, *tamaleros*, and *apastes*. Those produced in one's own pottery region are preferred, of course. In contrast to *tinajas*, however, *ollas*, *tamaleros*, and *apastes* from other regions can be adopted, although "they are not too good for cooking." *Comales*, on the other hand, generate stronger feelings: those from some regions are con-

sidered more desirable and durable than others, which are unacceptable.

Ladinos of rural areas and *pueblos* share many preferences for a specific pottery style with Indians. Although they may appear more willing to accept changes, their choices for cooking, carrying, and storage vessels are very similar to those of the Indians of their own *pueblos*. For their aesthetic evaluation, Ladinos use the same criteria as Indians. Ladinos, however, as they adopt modern ways, use a different cooking arrangement, set off the ground. They may add industrially produced *sartenes*, *ollas*, and *batidores* to their kitchen inventory. However, they continue to cook tamales, tortillas, *atole*, maize, and particularly beans in the traditional vessels produced in a local pottery center.

Through the centuries the domestic work of Ladino and Indian women has been lightened by the availability of pottery vessels. As long as the economic situation of the household permits, families will construct a room next to the sleeping quarters for cooking and eating. Among Indian families, this type of room is usually separated from the major house building and is constructed in the traditional Maya style. Sometimes old habitations are converted

into kitchens. Gaps along the walls permit the heavy smoke from the open cooking fire to escape. The fire in Indian households is on the floor, usually marked by three stones in a corner or side of the room. The stones serve to keep vessels, particularly the *comal*, above the fire. Here traditional Indian women, assisted by their children, prepare food, and here the family congregates to eat (pls. 403, 404). Temporary outdoor kitchens are also built in markets (pl. 405).

Tortilla making dominates meal preparation; usually younger daughters or daughters-in-law take charge of preparing maize (pl. 406), then making and cooking tortillas. A basket is usually nearby, containing a napkin for wrapping the tortillas to keep them warm. The grinding stone, also an important object in the kitchen, is usually placed next to the person preparing the tortillas. Everything in the kitchen is exclusively for the women to use, and most of the kitchen utensils are made by women in nearby pottery centers and are traded or purchased in the local market. In response to the question of why food is prepared in a specific vessel, the ready answer is, again, *costumbre*.

Women learn early in life to differentiate vessel quality and to care

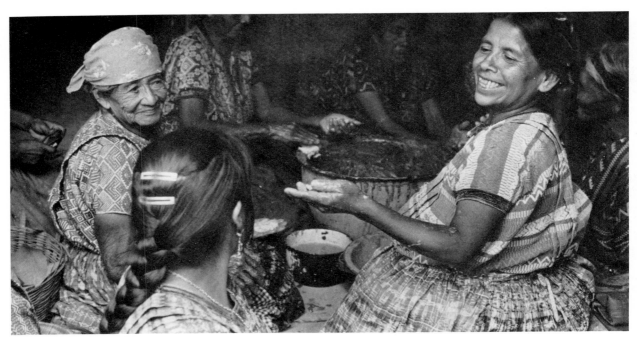

Plate 403. Chinautla women preparing tortillas for a wedding. The San Cristóbal
Totonicapán *apaste* in the center contains tortilla dough

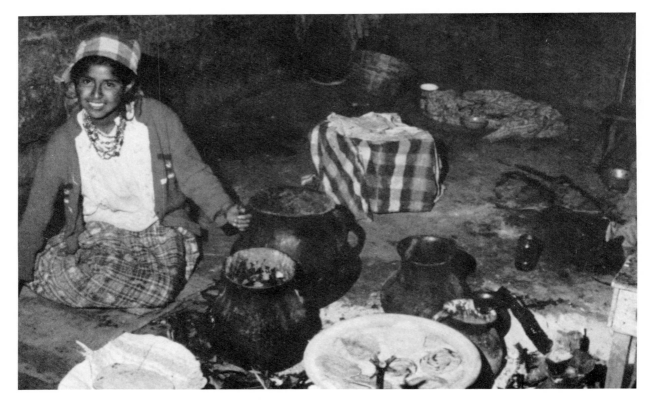

Plate 404. Soloma woman cooking tortillas. The vessels were made in the *aldeas*
of San Miguel Acatán

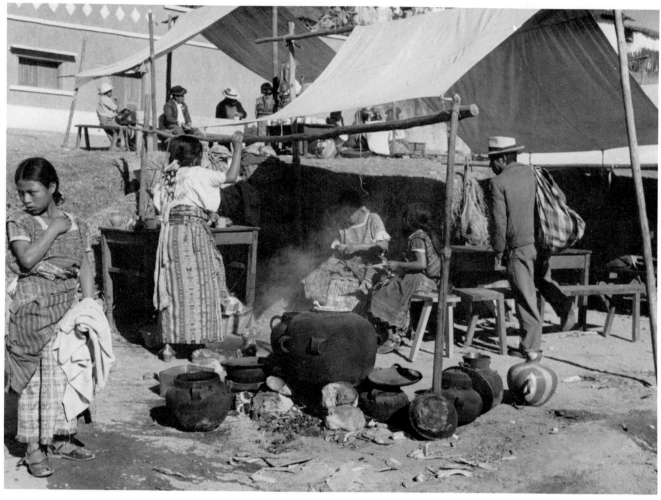

Plate 405. Outdoor kitchen in the market of San Cristóbal Totonicapán. A *tamalero* is on the fire, with *ollas*, an *apaste*, a *sartén*, and *tinajas* nearby. The plastic *tinaja* on the right, from San Salvador, is used to carry water

for each vessel specifically. They also learn to react to the aesthetic value of each object; such words as "fine," "pretty," and "good" go hand in hand with the amount of time women usually take to examine a vessel they find functional. A survey of a typical kitchen in an Indian *pueblo* near Quezaltenango showed that 90 percent of the cooking vessels were pottery—the rest were plastic or steel vessels. Vessels were carefully selected by the oldest women of the extended family, and each vessel was assigned a special function. Some *ollas* looked very much like storage vessels, but small details in

the handles or neck were enough to give the vessel a different name and to assign it a different use. Storage vessels usually had thicker walls and were not suitable for cooking.

By *costumbre*, after making a purchase the consumer must help the vessel acquire its final quality. Lime is used for curing, a procedure done soon after the pottery is brought home. For example, a *tinaja* is partially filled with lime water, heated slowly, and tilted in all directions, so the lime water swirls around and penetrates the walls. The lime is "received by the clay, the walls are thus hardened, and the *tinaja* ac-

quires more life," said the head woman of the household. The Chinautla *tinaja*, in particular, is considered a "pale" vessel here. This means that, although it is desirable for its quality and style, it is fragile as it comes from the production center. The walls, darkened by the lime treatment, take on luster and beauty and have a better quality. After treatment, the vessel is expected to last longer under normal use. To cure storage vessels, the outsides are treated with banana peels or soap. Burnished *comales* are also cured with water and lime over the fire, where the temperature is

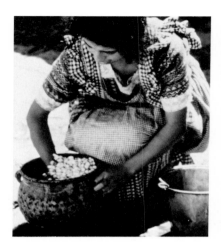

Plate 406. Woman from a central highland *pueblo* washing maize in a *pichacha* from San Cristóbal Totonicapán

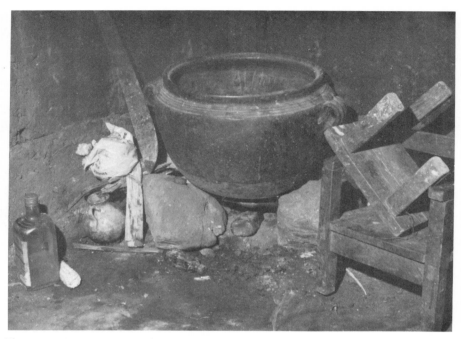

Plate 407. Large San Cristóbal Totonicapán vessel, made at the beginning of this century. The vessel is carefully stored in the corner of the kitchen and is used only occasionally, for weddings or funerals

brought to the boiling point. However, glazed *comales* and *ollas* may be used as they come from the market. The appearance and quality of glazed vessels cannot be improved; the potter has improved the vessel as far as possible by applying glaze.

Vessels are cleaned with ashes and hot water. Women are careful not to place cold water on a hot vessel when cleaning or cooking, for the shock will crack the vessel. If one begins cooking with cold vessels, cold water must be used and, if water is added later on, it should be preheated. It is socially prestigious to make a vessel last for several years, and much pride is shown when large and expensive household objects, originally bought for four or five dollars, have been handed down for several generations (pl. 407). The care and attention given the vessel are therefore precise. Replacement at certain times of the year can be rather difficult—a short supply in the local market or, for poor families, lack of ready cash may prevent a purchase.

A new kitchen in a Quiché household in Zunil, in the central highlands, was equipped with the assistance of the young wife's mother-in-law, whose help was welcomed (pl. 408). The local names of the utensils described below are in Spanish, and each item also has a name in Quiché—usually a descriptive term. The experienced woman referred to the inventory of the kitchen as "our *costumbre*," and she was very proud that the young couple had been able to purchase all the vessels necessary for cooking traditional food. A kitchen is not a place for experimentation or innovation, for diet is also a matter of *costumbre*. The kitchen inventory of nineteen vessels is listed below; prices are as of 1970.

Tamalero. A medium-sized San Cristóbal vessel for cooking twenty-five tamales. The tamales are placed over a cushion of straw and water in the bottom of the vessel. The steam generated by water and the heat from the walls gives the best conditions for cooking tamales. 35¢

This household was not yet equipped with a large *tamalero* for cooking four hundred tamales or one hundred pounds of maize, but the couple was looking forward to the time when this item would form part of their kitchen inventory. When needed, a large *tamalero* was borrowed from the mother-in-law's kitchen.

Sartén. Made in San Cristóbal Totonicapán, with glazed inside walls. This vessel is used for frying meat. It is cleaned with hot water and ashes after use. 35¢

Jarros. Two unglazed pots from Comitancillo, used daily for heating water and preparing coffee. 35¢ each

A glazed *jarro* from San Cristóbal is usually placed on an improvised shelf and used upon occasion to deliver *atole* to relatives. 45¢

Cazuela. A small San Cristóbal *olla*, used for stewing meat. It is also used to prepare *atole*. 40¢

Ollita. A small San Cristóbal *olla*, used daily to cook black beans. 20¢

Batidor. A San Cristóbal vessel, used on special occasions to deliver cooked food to godparents. It will be used for cooking as it becomes old; it will then be considered an *olla*. 20¢

Ollita. A small *olla* from Santa María Chiquimula, used for warming leftover food. Food from the evening meal is kept in this vessel and is heated the following morning for breakfast. 17¢

Ollas. Two vessels from San Cristóbal, used to cook meat and soup. These two objects were in storage and were considered as replacements in case of breakage. 20¢ each

Cazuela. A San Cristóbal vessel, used to boil maize with lime for tortillas. 20¢

Pichacha. A vessel from San Cristóbal, used to wash maize. 20¢

Bombala. A large, heavy vessel, made in San Cristóbal and used for water storage. On festive occasions, the vessel is used to serve *atole*. $2.20

Tinaja. A Chinautla vessel, used to bring water from the town fountain. 45¢

Bowls. Two serving *cajetes* (approx. 12¢) from Totonicapán and an *apaste* (approx. 18¢) from San Cristóbal.

Comal. A large San Cristóbal vessel, used for festive occasions. 45¢

Outside the kitchen and along its walls were five broken vessels, used for garbage disposal (pl. 409). The damaged *tamalero* contained ashes, which were eventually sold to individuals preparing soap. A broken *cazuela* contained some leftover food. The rest of the damaged utensils were empty.

The inventory lacked a small *comal*. Tortillas were cooked on a flat tin surface until an itinerant merchant with a good selection should pass by. Economic circumstances obliged the couple to use this temporary arrangement. They did have a large *comal* for use on festive occasions. However, such a *comal* requires a great deal of wood for heat. Tortillas made under this temporary arrangement, said the young housewife, are not very good.

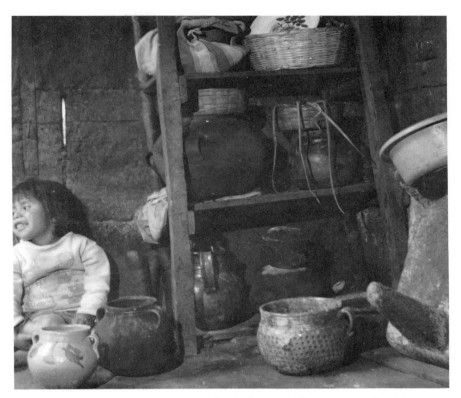

Plate 408. Traditional kitchen in Zunil. The large grinding stone on the right supports a plastic *apaste*

A Ladino kitchen in the same *pueblo* differed in some ways from this traditional kitchen. Cooking was done by Ladino women on a platform off the ground, and the kitchen contained rustic shelves, tables, and chairs. The housewife referred to this arrangement as "our *costumbre*." This kitchen was equipped with some industrially produced vessels, but over 50 percent of the utensils were produced in the San Cristóbal Totonicapán pottery center. *Comales*, *pichachas*, *ollas*, *tamaleros*, and glazed bowls formed part of the inventory of this Ladino kitchen. The preparation of Ladino-Hispano food was preferably done in industrially made vessels, leaving the San Cristóbal glazed vessels for the preparation of traditional beans, tamales, maize, and *atole*. There were some Jalapa and Totonicapán glazed pottery items, but the housewife planned to replace them as soon as possible with industrially produced utensils. If in the past the Indian pottery vessels were part of the furnishings of a Ladino household, at present they are less in demand. One reason is that they do not last as long as the industrially made vessels. However, if water is to be stored, Ladinos prefer to use the pottery *tinaja* of the region, although they may fetch the water with a plastic *tinaja* made in El Salvador. For Ladinos, *costumbre* can easily change, and modernization has presented them with alternatives: the possibility of additional vessels for new types of food. Preparation of traditional food, however, requires traditional pottery, regulated by *costumbre*.

In Guatemala City and Quezaltenango and in other large towns or cities, many traditional families prefer to maintain their kitchen with a rural orientation. Sometimes such urban people go to market to purchase a large San Cristóbal Totonicapán *olla*, costing three or four dollars in 1971, for the specific

Plate 409. Broken vessels outside a kitchen in Zunil

for cooking different types of food, and for serving is necessary. Women have a great interest in utensils. During a market day, they like to admire vessels by tapping them, judging their quality, and looking at them from an aesthetic point of view. When a good vessel meets with *costumbre*, bargaining becomes aggressive, and the consumer tries as quickly as possible to reach an agreeable price. Such vessels sell rapidly, while inferior objects are left for harder bargaining. But these too are part of *costumbre*, and an individual with less money, in urgent need of a cooking or storage vessel, will feel satisfied that she too complies with *costumbre* on a more humble level.

purpose of making fried lard. A *regatona* explained that it is *costumbre* to use this specific vessel, because the taste is right. Prepared in a large iron vessel (*peról*), fried lard is not good the following day. This belief may have some degree of validity, and it serves to retain the element of *costumbre* even in the context of a modern city.

In sum, in varying degrees it is socially desirable to keep *costumbre*; for this, a wide assortment of vessels for storing food and water,

Costumbre and Ritual Pottery

Maya-descent people are constantly preoccupied with *fiestas*, which take up approximately one-third of the year. The *fiestas* are believed to be beneficial, and seldom does a month pass without one of some kind. These celebrations require a great deal of planning and preparation. Guests must be invited, new cooking vessels must be purchased, food must be properly cooked, and censers must be available. Celebrations fall into three types. One is the personal ritual, known in some areas as "to make *costumbre*." This ritual is frequently conducted by a specialist, a *chimán*, at the request of an individual who, for personal reasons, is in need of assistance. The second type is the *fiesta de costumbre*, a celebration arranged in corporate communities by officers of a *cofradía*, an organization that repre-

sents the people and the *pueblo costumbre*. The third type comprises the *fiesta titular* of the *pueblo*, in which the *cofradías*, the civil-political organization, both Indians and Ladinos of the *pueblo*, and visitors from nearby *pueblos* participate.

Especially made pottery plays an important role in the preparation of food for the *fiestas*, as do the ceremonial vessels used for the most sacred moments. For the ritual of personal *costumbre*, the specialist provides the items needed, usually including a pottery censer in which to burn copal. At other times, a small *apaste* may be converted into a censer for the copal. Censers, carried by women participating in the *pueblo* procession, are the pottery pieces most used during the *fiestas* of many *pueblos*. Commer-

cial incense is burned as an offering to the patron saints.

It is in the *fiesta de costumbre* that an assemblage of ritual pottery plays a significant part. Usually through *encargos*, pottery from different centers has been brought to one place. These items seldom pass through the middleman's hands. A *cofradía* with newly elected officers seeks both functional and ritual vessels appropriate for the fulfillment of their obligations. For example, in Chinautla potters prepare a special *apaste*, with painted decorations, for their husbands when they have been appointed to serve in the apostles' *cofradía* at Easter. Each apostle has an assistant who ritually washes the apostle's feet in the *apaste*, which is filled with water especially prepared with orange leaves and blossoms.

In Rabinal, a male potter who is a member of the potters' *cofradía* carefully produces *tinajas* for all the *cofradía*'s new officers. The ceremonial food is presented to the other members of the *cofradía* in a *pueblo* ritual.

In San José Petén, a special effort is made each year to produce new vessels for cooking ritual food. At the beginning of the year the *prioste*, an elder in the *pueblo* in charge of the celebration of "the soul," is informed of those families willing to receive the visit of the human skulls, signifying the arrival of the souls of dead family members. Three skulls are kept permanently on the church altar and, for this ceremony, one skull is removed from the altar at midnight and received with much emotion by the host. Tamales, rolls made of black corn, and *atole*, all prepared in new vessels, are served. The San José potters work hard to produce vessels for this event, then abandon production until the following year (pls. 410–413).[5]

When possible, the organized community rituals require the use of new vessels, for instance, *tinajas* highly decorated with flowers (pl. 414). In such family rituals as weddings, *tinajas* filled with drinks are presented by godparents to the "owner of the wedding." It is *costumbre* that forces people into proper preparations for the specific observances; pottery vessels for these special occasions are required in order to complete the cycle of traditional group rituals. To possess new, sound, and superior vessels is part of the social etiquette. To observe the appropriate behavior—in this instance with regard to pottery—as prescribed by *costumbre* is to satisfy those forces beyond themselves, and one can therefore expect rewards in life.

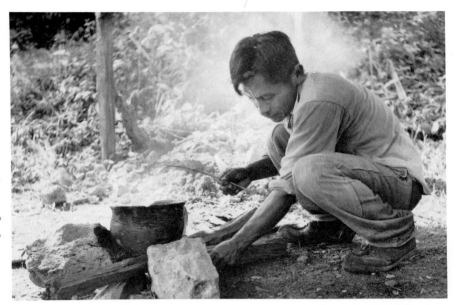

Plate 410. San José Petén man boiling beeswax in an old *olla*, prior to making candles

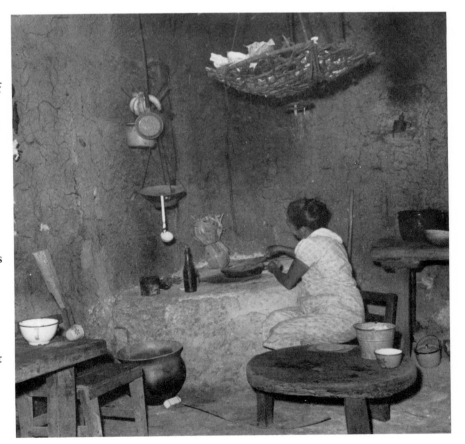

Plate 411. San José Petén woman preparing ceremonial food for the home ritual of the human skull. A new *olla* is next to the cooking platform

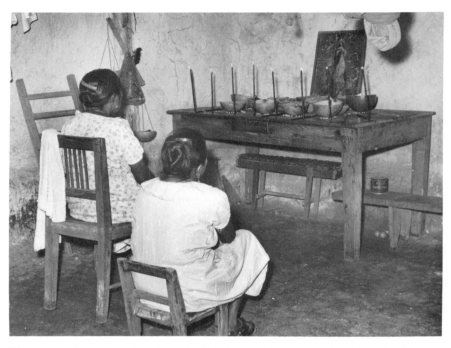

Plate 412. Sisters awaiting the arrival of the skull and the souls of their dead husbands. The altar holds homemade candles, *jícara* gourds with food, and a picture of a saint. Maize is placed around each gourd

Summary

Pottery plays an important role in ritual, particularly in the context of closed corporate Indian communities where *costumbre* serves as a guide. People's constant concern with maintaining traditions necessitates adherence to a traditional technology. The theoretical rationale for such maintenance lies in the fact that *costumbre* is central, for it holds the community together and fosters continuity in the Moral Order of the community culture.

Costumbre is the expression many Indian and Ladino Guatemalans use to account for permanent elements of culture held in lasting equilibrium within the social system. The concept has value for them: a high level of stability is derived from it, and it reduces a potentially complex economic situation to a degree of simplicity and predictability. Guatemalans in general are strongly

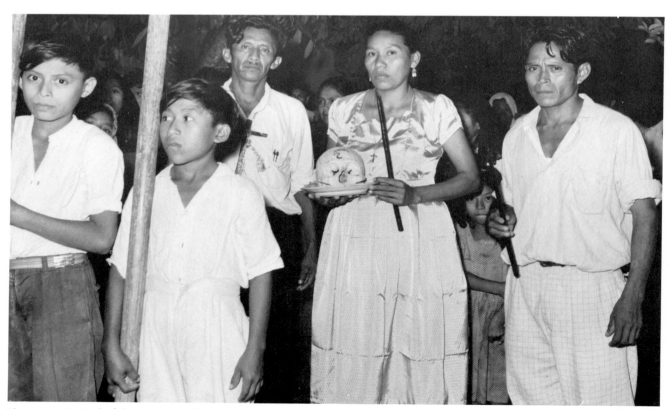

Plate 413. Arrival of the skull at midnight

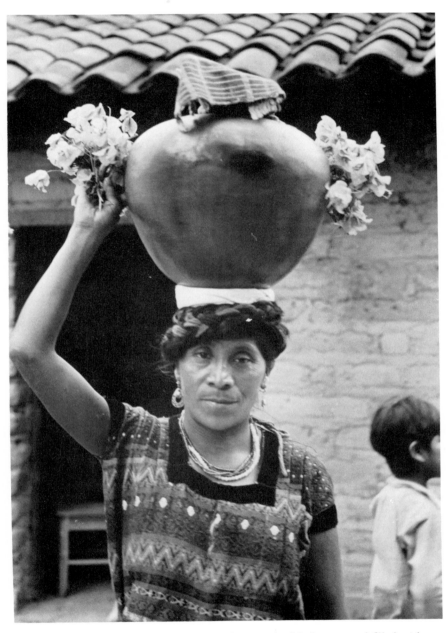

Plate 414. Wedding gift of a new *tinaja*, decorated with flowers and filled with *atole*

bound by *costumbre* to a past in which pottery has always been fundamental to their survival. It is doubtful whether their ancestors viewed life very differently. The term is all-encompassing: their ways are explained as *costumbre*, and both the pottery use and its rationale are *costumbre*. It is a concept for the people as a whole within cultural boundaries rather than an explanation for individual distinctions. Among Indians in particular, the use of the concept of *costumbre* results in less economic competition and exploitation at an individual level and, above everything else, it brings them respect for each other within a well-defined etiquette of interaction. Because the materials for the production of pottery, and pottery vessels themselves, are conceptually in "short supply,"[6] all the parties involved in pottery realize that to work through *costumbre* is a way to sustain life, although it does not create wealth. The utility and function of all vessels lie in *costumbre*, choices are not random, and any changes may become extraordinarily costly for those participating in such a system. With this network so tightly woven, no one disturbs the existing order of society but, at the same time, people realize that it restricts innovative changes. Conservatism is the visible result.

10.

Chinautla and Its Cultural Processes
Pottery Innovation

The reader is now familiar with Chinautla. The thousands of *tinajas* produced annually in this important production center of Guatemala's central highlands are well known throughout a large area of the country. Many Indians and rural Ladinos, because of *costumbre*, prefer these vessels and value them for their high quality. As to their antiquity, Chinautla vessels take us far into the past with few discontinuities.

Since the 1960s, however, Chinautla has been gaining a reputation for its production of figurines and vessels for home decoration—table lamps, nativity scenes, bowls, flower pots, bells, and more. This city-tourist ware had a difficult beginning when, in the 1950s, an innovative elderly widow in much economic need, with her orphaned grandchild, went against *costumbre* to create new forms.[1] The stimulation and inspiration came chiefly from foreigners, admirers of traditional ware as part of a folk tradition. Urban ware has not, so far, superseded the traditional forms. Rather, they co-exist in the *pueblo* and, at present, both are known as the "pottery of Chinautla." Although specific to Chinautla, we feel the variables related to pottery dynamics in this social setting are significant elsewhere.

Chinautla is, as we know, a well-established Pokomam community, once part of a larger linguistic group, conquered and transformed by the Spanish, dominated by a political system, overridden by the capital of the country, and surrounded by the

Plate 415. Chinautla church, destroyed by the 1976 earthquake.

modernization and industrialization of a developing nation. These events have affected the culture of this Indian *pueblo* (pl. 415). The Chinautla case, then, provides us with an opportunity to study conditions that operate in association with transformations, changes, and additions in a technology and a community.[2]

Aspects of the Social Structure

Plate 416. Niño de Otocha

Plate 417. Chinautleco in his *milpa*. Black beans are growing below the maize

The Chinautlecos' way of life is the result of the forceful period of acculturation during and following the Spanish conquest. The political concept of "*pueblo*" links Chinautla to the national structure, while the concept of "Chinautleco" links the people born there to specific cultural features of the community. Ancient tradition as well as the local reaction to national pressure brings the "community culture" into existence.[3] Within the framework of community culture, as shown in area 1 of figure 60, Chinautlecos use the fundamental concept of *costumbre* to explain their shared actions and thoughts. People derive their social image and self-identification from the institutional structure of the corporate organization. It is within this area that the sources of the community social stability and cultural continuity lie. The "law of the saints," which refers broadly to all the inherited cultural contexts in the *pueblo* community culture, links people to the basic concepts of "naturalhood" and all that makes a "good Chinautleco." These deeply rooted and highly respected orientations are symbolized by the patron saint and guardian of the community *costumbre*, the Niño de Otocha (pl. 416). He represents the "law of the saints" and forces each generation of Chinautlecos to observe the community rituals and pay proper respect to their ancestors. In this way, Chinautla can continue to have "good Chinautlecos." The corporate organization of the *pueblo* supports the style of life of the native population of the nation. Culturally, this is the Little Tradition as practiced by the nonliterate Chinautlecos. It is tradition preserved by the "law of the saints" and supported by an elaborate local religious-political organization.

The organization for administering the community culture is entrusted to the *principales*, elders who have served many years in the religious-political organization.

Their experience and wisdom place them next to the most important counselor and mediator, the *tatahpish*, and his female counterpart, the *tutahpish*. Together they see that all community rituals are preserved, and under their guidance all is expected to remain the same. Ninety-two officers of the *cofradía*—*mayordomos* and *capitanas*—are chosen to serve for one year. This complex and elaborate *pueblo* power structure is active with the ritualism of the "law of the saints," and the political officers—*regidores* and *alguaciles*—along with the mayor, officially assist the members of the *cofradías* by participating in rituals when *costumbre* calls for it. Their daily activity, however, has to do with the translation and application of the national legal system at the community level.[4]

With regard to this study of pottery, it is important to note that the basic economic activities of Chinautla-born people are clearly defined by the corporate structure. Pottery for women and *milpa* and charcoal production for men are well-defined community specializations (pl. 417). These activities are centrally placed within the community culture of area 1 and, by definition, are considered an *oficio* to be practiced by all those born in Chinautla. Life there is an insulating process, leaving the individual in psychological solitude with the tasks ordained for her or him. The creative spark has little room in this system, which binds past and present generations. The Pokomam language is used to transmit the most intimate thoughts and knowledge from one generation to another.

Pottery fulfills an important local need. Women produce their own utilitarian vessels for food preparation and serving. Chinautla vessels have characteristic and unique forms, regulated by the "law of the saints." Chinautlecos feel that they have been especially favored with the occurrence of the proper natural

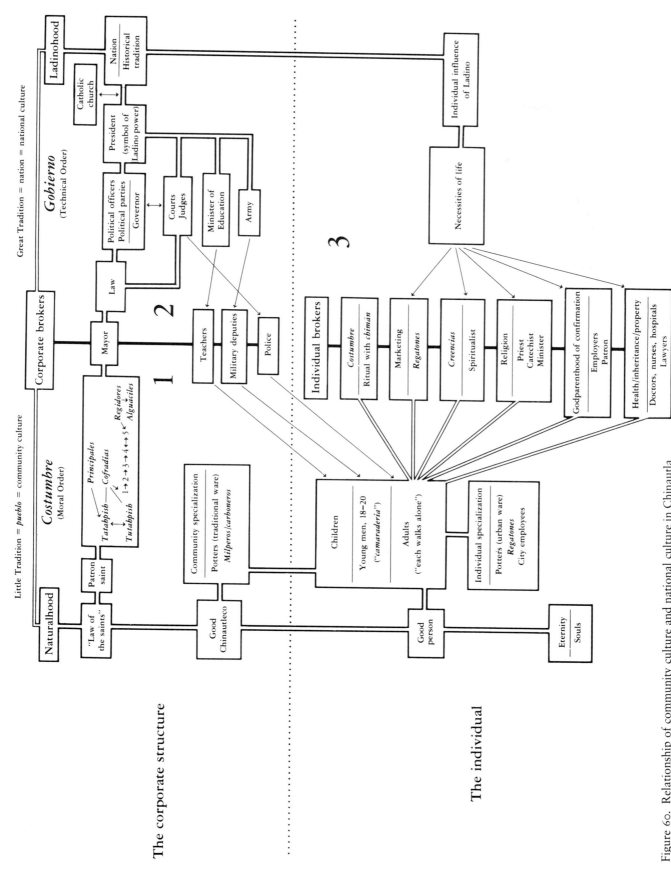

Figure 60. Relationship of community culture and national culture in Chinautla

resources for this specialization. In their version of the creation, Chinautlecos are at the center of the world and, with these resources to administer, they have a very important function to perform for other people. The vessels created for their own use can and should be shared with Indians who lack the resources to produce clay vessels for food preparation and serving. The ceramic tradition, which was created *once* —in the beginning—is the "property" of the corporate structure in area 1 of figure 60. Therefore, individual Chinautlecos have no right to change the technology . . . it is an intricate part of their *costumbre*. A producer may become a "good Chinautleco" as long as he or she respects and is submissive to *costumbre*. This is the way to achieve harmony with the elements and the forces of nature.

Chinautlecos, by an accident of history, have become part of the national political system. The national culture stands for *gobierno* (government), instead of *costumbre*, and for the sole support of the Ladino-Guatemalteco population (fig. 60, area 2). This area represents the Great Tradition of Guatemala in the twentieth century. It is the cultural tradition of the reflective literate few and is supported by the heterogeneous urban center of Gua-

temala City. The Little and Great Traditions have been held together with some degree of understanding by the development of national politico-religious institutions. The complex national political organization meets the *pueblo* and the Little Tradition of Chinautla through the local political organization headed by the mayor. The community corporate structure, however, has served through the years as a strong buffer to changes imposed from outside. In the course of events, the *pueblo* and the nation have tested each other's power, and as a result some national cultural elements have been added to the *pueblo*, indicating a trend toward national integration at the expense of community culture. "Young people find it difficult to serve in the *cofradías*; they have obligations in the city and have less time for our things," stated an elderly Chinautleco.

The process of accommodation by Chinautlecos can be traced to a combination of events at the national (external) and local (internal) level. One of the main factors at the national level was the radical political reform after the 1944 fall of the dictatorship of Jorge Ubico.[5] The people's participation in the major national decisions through electoral procedure changed the overall election process of the government at

the national level (fig. 60, area 2). The administrative affairs of the country are now run by the multi-party political system. Political campaigns advancing economic welfare programs for the *pueblo* people, at first believed, turned out to be idealistic promises. Chinautlecos, like other rural people, can now discriminate between idealism and realism in politics. The last three decades have provided these *pueblo* people with experience in such matters. They now know their position better, and they consider themselves Indians with constitutional rights and some power.

National economic expansion, industrialization centering around national products and resources, modernization of the city, its expansion due to the arrival of thousands of *pueblo* immigrants, and inflationary trends for most staple foods have all affected the *pueblo*'s economic stability. Furthermore, through national legislation to control natural resources, government agencies have begun to participate in community affairs. Representatives, planning for the *pueblo* with little local consultation, have confronted the Chinautlecos and their municipal government with delicate situations.

The *Pueblo* and Modernization

As we have noted before, some aspects of the national culture have aided modernization in the community without causing abandonment of the traditional ways. Internal events have also affected the style of some *costumbres*. One of the crucial events in the Chinautla corporate structure was the recent death of the *tatahpish*. The death of this wise man, highly respected and trusted for his knowledge, marked the end of an era, for his strong faith in the "law of the saints" had maintained

the community culture. He took every opportunity to remind the people of their history and obligations during *cofradía* rituals and marriages. But, because he was unable to find a qualified person, he left no one to succeed him. Following his death, another Chinautleco tried to imitate him, but the results were poor and he too recently died. Various splits along political and religious lines have caused confrontations—for and against accommodation—resulting in radical internal

opposition. The absence of a *tatahpish* and the death of one of the important *principales* have left a significant gap in the community leadership, particularly in the realm of *costumbre*. As a result, Chinautlecos are now forced to explain differences between past and present and to change their once strict attitudes toward the world outside the *pueblo*. In recent years, the maintenance of *cofradía* obligations through cooperative community effort has become difficult. People find

less time to serve in the many *pueblo* celebrations and perceive the traditional rituals of the *cofradías* as an economic drain.

At the individual level, depletion of the natural resources and the lack of land for *milpas* have affected the traditional roles of the males. They now search in Guatemala City for employment, and daily commuting has increased. The expanding city environment, the constant contact at work and outside the traditional markets, and the social plurality of the city have heightened the Chinautleco's self-awareness. He has learned that he is a person—a citizen—outside the community culture. In addition, many religious traditions—catechist, Protestant, or spiritualist—have raised fundamental theological questions. Some Chinautlecos wonder who has the right answers to questions about the Unknown. This expansion of the self, particularly on the part of the males, is the result of a realistic self-appraisal against the background of people and situations from other cultures. With psychological, physical, and theological boundaries widening, individuals are seeking new ways to meet their needs.

National institutions are represented today in the *pueblo* structure by teachers, urban planners, nurses, doctors, politicians, and social workers. They are the "brokers" among the Chinautlecos. On the community level, their services are not necessarily rejected by individual Chinautlecos. Chinautla's overall structure today provides individuals with an area of action in which they can exercise their personal choices and initiative (fig. 60, area 3). There is no doubt that the present Little Tradition, represented by the community, and the Great Tradition, represented by the national government, have influenced each other since the time of the conquest. The mediation between the Little and Great Traditions is not always directed by the formal broker of the community; as in-

dividuals of the Little Tradition, Chinautlecos can find "literate" mediators in the Great Tradition to support personal action related mostly to their own survival.[6] These individual brokers intercede between the Chinautleco and the specific institutions of the national culture. Ladinos and Chinautlecos meet in economic, religious, and health areas as they take care of the necessities of life.

At this individual level, actions are predicated on *change*, rather than on stability. Therefore, a man can become successful economically, build his own home with whatever materials he selects, become highly proficient in Spanish, and practice economic activities not defined by the community culture as long as these things do not affect him as a Chinautleco under the "law of the saints." If he uses these changes to separate himself from the group, others may find it necessary to use corrective measures—gossip, witchery, social discrimination, even physical punishment—to bring about changes in attitude and behavior. It is our assumption that the production of urban forms by Chinautla potters must be placed in the context of this individual freedom (fig. 60, area 3) allowed by the closed social system.

Again, a closed corporate community constitutes a "bounded social system with clear-cut limits in relation to both outsiders and insiders. It has a structural identity over time. Seen from the outside, the community as a whole carries on a series of activities and upholds certain collective representations. Seen from within, it defines the rights and duties of its members and prescribes large segments of their behavior."[7] In times past, when the community boundaries were stronger, individuality and individual action were limited, and the community corporation (area 1) strongly controlled a greater part of people's lives. In the last three decades, however, the expanding national democracy has

provided opportunities to make many more choices in life, and numerous Chinautlecos have taken advantage of this potential as they find support in elements external to the community. Lately, there has been a quiet struggle between many individuals and the corporate structure, and some Chinautlecos, influenced by their personal brokers, have become socially uncomfortable. A number of aspects of the national economic and political life and many urban services are accepted nowadays by individual Chinautlecos. Consequently, many individual variations exist, particularly with regard to personal health, economics, politics, and beliefs (*creencias*). For instance, there are now different ways to solve personal and domestic problems. Among them is the use of the well-established technical tradition of pottery making to produce new forms for decorative use by city people, primarily those of foreign descent as well as Guatemaltecos of an upper social class, that is, Guatemaltecos of the Great Tradition.

The way Chinautlecos explain personal events is now no longer totally dictated by the "law of the saints," as it was in the past. There is a new feeling that there are additional aspects of life that demand the services of people with specific scientific, as opposed to folk, knowledge. Each Chinautleco realizes that, at a group level, his behavior is directed by the corporation and by *costumbre* but, as an individual "son of the *pueblo*," he has some personal rights to make his own plans and decisions. Although the elements of *costumbre* are important to fulfilling the duties of the group dynamics, individual management of one's body and mind is not necessarily woven into the group situation. Persons carrying out their responsibilities successfully (area 3) earn the reputation of being a *good man* or a *good woman*. When an individual has been a *good Chinautleco* through life (corporate structure area 1) and a *good per-*

son (individual area 3), his or her achievements are considered ideal. He or she may become a permanent leader in the *cofradía* structure and with that status has achieved the right to a good place in the universe after death.

The Effects on Potters and Pottery

While traditional pottery, as defined by *costumbre*, belongs to the structural category of community life, urban ware belongs to the Chinautleco's individual sector. In 1953, when a young orphan and her grandmother began to make small figures of people and animals instead of traditional Chinautla vessels, particularly *tinajas*, their social problems began (pls. 418–421). For years Margarita and her adoptive family could not bring her marriage arrangements to a successful conclusion. One day—after her grandmother had died and after a great deal of pressure from her aunt—Margarita decided to change her public image and began to work on *tinajas* only. Within six months she was properly married.

The importance of this case lies in the fact that, by 1955, several more progressive potters were making new forms using the traditional technology, without realizing how deeply this innovation went against the community culture (pl. 422). In retrospect, it seems clear that Chinautlecos in general needed time to learn to adjust to and appreciate this new pottery. It would seem that changes in aspects of private culture, such as religion and politics, caused no concern or confusion, but the new pottery activity raised serious problems. The traditional concepts of *costumbre* and these women's *oficio* had been separated, and the artistically oriented Chinautlecas had no place within the corporate system and *costumbre* of the community. A potter's personality could be evaluated publicly by the quality of her production—the ability to make traditional *tinajas* was a public announcement of being a good Chinautleca. Making figurines, however, was questioned by hus-

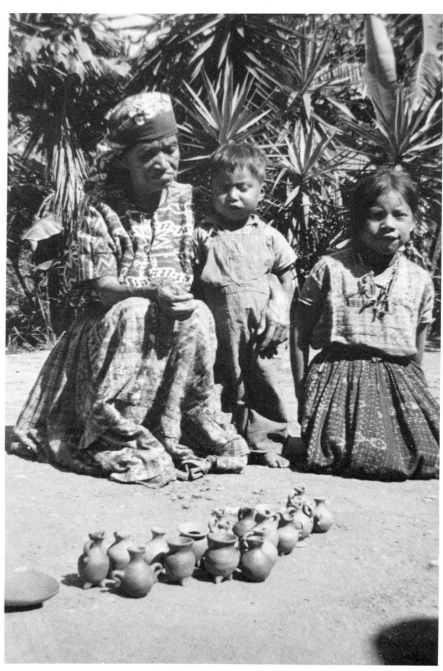

Plate 418. Margarita with her grandmother in 1953. Miniature traditional vessels and a *molde* for traditional *tinajas* are in the foreground

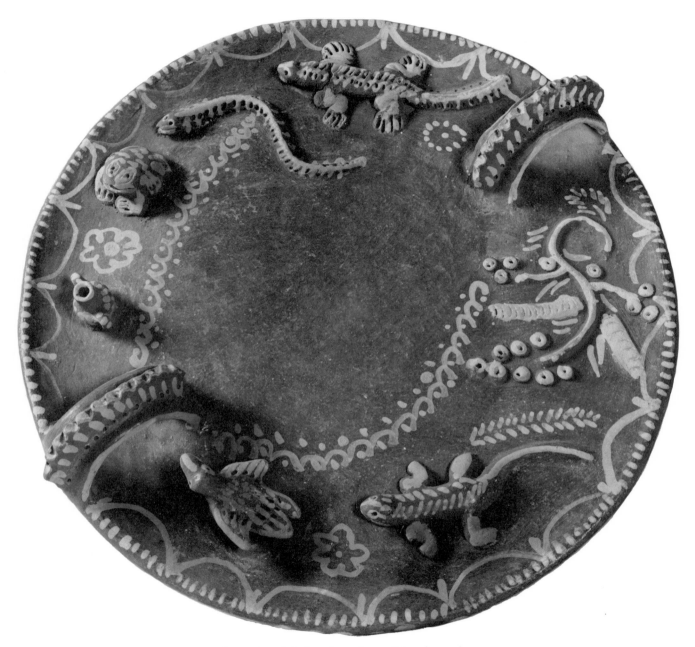

Plate 419. Margarita's 1955 creation of a serving dish, based on the traditional *comal*

bands, brothers, and sons, who saw a departure from tradition. Yet national inflation in combination with the absence of productive land for expansion and a lack of capital had created, among many families, very difficult economic conditions. Their survival even on a day-to-day basis was severely threatened.

Thus, the necessities of life (area 3) have demanded a higher income and, through the manufacture of urban items, gifted potters have felt they could increase their contribution to the household (pl. 423). To maintain the balance between the demands for stability imposed by the "law of the saints," or *costumbre*, and the demands for change imposed by the national culture, the people must work arduously and judiciously. The strengthening of elements in area 3 of figure 60 was due, for the most part, to economic necessity. Accommodation has become an acceptable manner of handling changes. This accommodation to an expanding city market could take place only after the death of the *tatahpish* who so effectively defended the charter of *costumbre* (area 1). As he arranged marriages during long and frequently hard bargaining processes between two families, he had particularly stressed the potters' role as producers of utilitarian vessels. However, the man who replaced him as *tatahpish* was weak in his leadership, and an expansion of individual actions resulted.

Plate 420. Figurine, four inches high, copied from a drawing in 1953

Plate 421. Six-inch-high figurines, made by Margarita in 1955

Plate 422. Miniature vessels, made in 1955

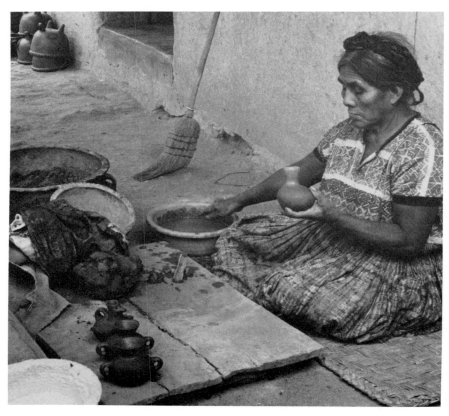

Plate 423. Former traditional potter, now specializing in planters and miniature vessels

Potters of Urban Ware

Currently there is an intellectual excitement among those potters producing urban ware. They feel strongly that the steps in the production of traditional Chinautla ware are too repetitious. "In the process of *tinaja* production," remarked a young, creative potter (pl. 424), "one does not have to think, because one knows from early childhood what must be done next. All is decided; one must only pay careful attention to scraping the walls so they come out thin and clean. The polishing is all very repetitious." The production of urban ware—figurines, planters, censers, lamps, Christmas crèche scenes, etc.—she remarked proudly, requires

a great deal of thinking. One must plan ahead for a specific form; and

furthermore one needs knowledge to make the adjustment in the preparation of the clay, to place holes in each piece to allow the air to escape during firing, and to prepare the firing as if one had a kiln. Slowly, step by step, one moves on, hoping that the process is under control. Figurine making is free from repetition; each piece is a different work. Because of all these new ways, our older relatives and friends here are beginning to think that some of us potters are "intelligent" and educated. But each form we create, how much one needs to think until one succeeds! Just think about making a chicken with all its feathers . . . each single feather is placed on the body, and they must stay on after firing. It requires patience and careful control of the humidity. Firing is a delicate

thing. And, even as one is finishing an order, one begins to decide what will be the next form. To think and to decide are sometimes very tiring . . .

This statement summarizes well the potters' understanding of the new ways of creating urban ware vis-à-vis traditional ware. Clearly the focus of attention has changed. Utility was of primary concern in the past, but now each piece for the urban market is evaluated for its artistic merit. A concern for the object per se has emerged (pl. 426).

Indeed, a potter finds that a different thought process is necessary for the production of urban ware, and this in itself brings some social differentiation at the individual level. The most creative potters, who have made some of the best and most interesting pieces, have completed the four or five years of schooling available locally; from the Ladino viewpoint, these potters have become more "civilized." With this impact of the national culture and emerging individualization (area 3), a more complex cognitive structure is being formed. Young potters are manifesting this more complex structure in their ceramic production; their experimentation constitutes a new and competitive undertaking, greatly stimulated by the expanding tourist market and by local city residents (pl. 427).

To succeed with the production of urban ware, the potter realizes the clay must receive very careful attention; the "white sand"—volcanic ashes—must be carefully chosen, and all particles which could "jump" with the heat and "break a nose or a finger" of a figurine must be removed. As she carefully forms each piece, the potter uses her hand in a different way, letting her wrist control its motion. Figurines receive extra coats of white slip. They dry very rapidly, contrary to traditional vessels, so frequently the dry pieces are completely submerged in water for one or two minutes before the potter completes some of the finest

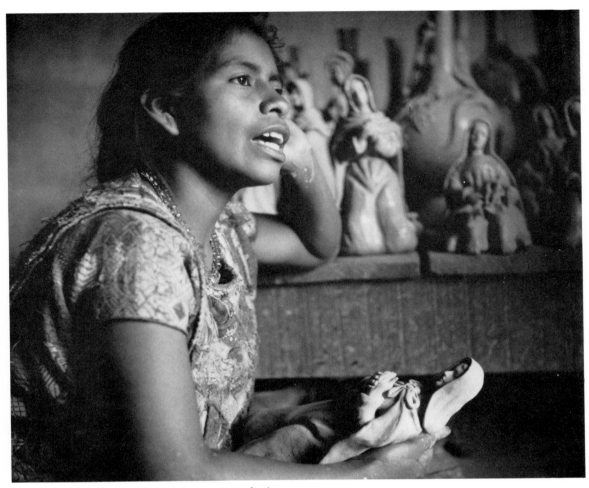

Plate 424. Maruca Luis, with her creations of urban ware

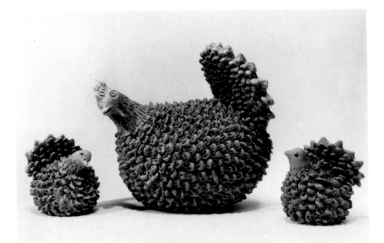

Plate 425. Urban-ware chickens, with individually placed feathers, made by Maruca's mother. The small chickens are two and one half inches tall; the large one is six inches tall

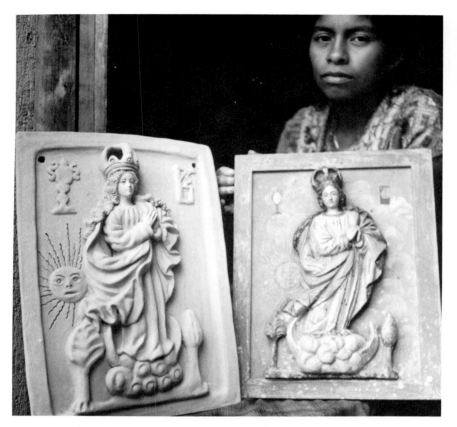

Plate 426. Plaques, copied by Maruca from a lithograph in 1974

features, such as feathers, fingers, noses, heads, or hair. With wet walls, grooving is possible, as well as appliquéing of flowers, branches, leaves, etc. (pls. 428, 429). Freehand modeling is necessary for this step.

For the firing, the selection of kinds of straw has acquired an added importance in relation to the types of figures and the effect desired (pl. 430). Most potters think white straw gives the best results but, with the changes in the environment, it is now difficult to find. Preheating in a fire, instead of depending upon sunlight, has become an important step with the smaller pieces (pl. 431). A potter explained that at first she tried "preheating the figurines in the sun as we did with *tinajas*, but the loss of a great many pieces made us think of another procedure. It must have been because I could not scrape each piece; some parts of the figures were thicker than others and, since the clay is still alive, the walls shrank differently and consequently the piece broke." There is a further economic advantage: firing urban ware does not require as massive a fire as, say, a dozen *tinajas*. The urban pieces may number as many as fifty, including different sizes and qualities; by comparison with traditional pieces, the mound is smaller, as the urban figurines are carefully placed on the firing pile in what might be called a kiln. For outside firing, the draft is controlled through a cement block with a square hole in the middle and the upper part of a broken *tinaja* on top of the pile (pl. 432). The base for the firing lot is a cushion of carefully selected pine needles and cow dung, while the thickness of the straw and the proper-sized air vent are all part of the kiln-type firing (pls. 433, 434). These steps have been perfected by some of the best potters and are kept secret by the family. So, each potter involved in the production of urban ware finds out on her own how to succeed. "Intelligence is needed," remarked a potter, "before these innovations take place." In the solitude of each household, and in the

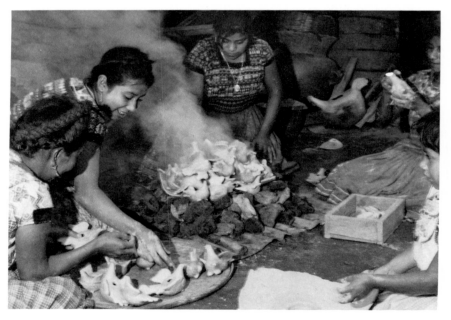

Plate 427. Members of an extended family firing figurines, after the 1976 earthquake

conservative ways of the community, each family guards their findings jealously. Producing urban ware is, after all, an individual pursuit, not yet a community tradition.

Plate 428. Urban ware made by Maruca's mother for the Mercado Central, 1975

Plate 429. Urban-ware crocodile, purchased in the Mercado Central in 1975

Plate 430. Straw for firing urban ware

Plate 431. Preheating urban ware indoors on an old car trunk

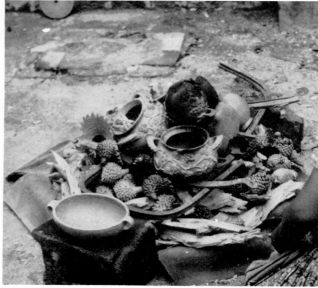

Plate 432. Urban-ware firing lot

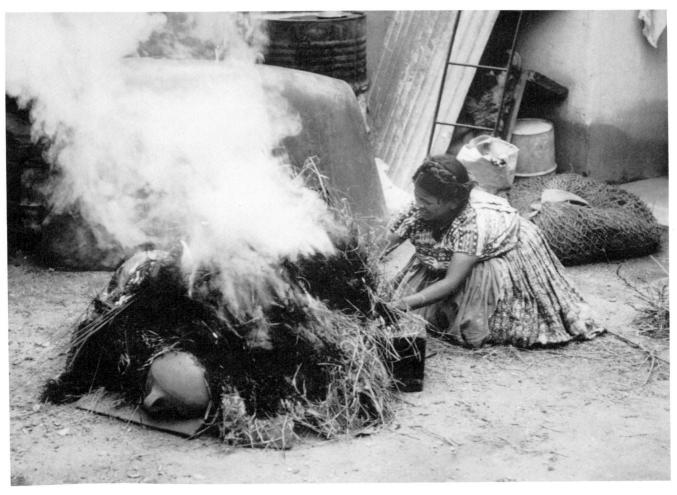

Plate 433. Firing urban ware

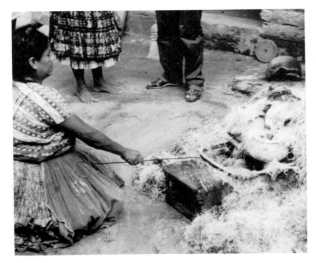

Plate 434. Removing ashes from fired urban ware

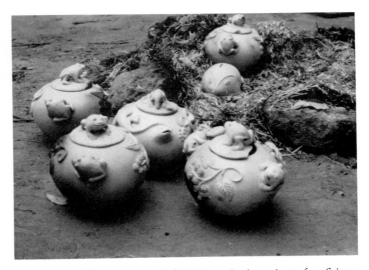

Plate 435. Urban ware, made by Maruca's sister, just after firing

Community Social Accommodation

Local Ladino residents of Chinautla who have witnessed these changes predict the total disappearance of the traditional Chinautla ware—they feel that the urban ware will totally replace the traditional vessels. For them, the most creative and Ladinoized potters will succeed. These predictions may be correct in the long run. Ladinos do not realize, however, that both kinds of pottery have found a place in the established social system of the community. Furthermore, a potter's individual reputation, based upon the kinds of pottery produced, results in an internal social differentiation that supports the new specialization.

Pottery making remains, as in the past, a women's activity. Although new forms are constantly evolving, all Chinautlecas, with very few exceptions, know how to produce the traditional *tinajas*, *ollas*, and *apastes*. Young girls are progressively introduced to traditional ceramic technology as they grow older.

Approximately 250 women—half the women of the *pueblo*—are exclusively engaged in traditional pottery making. These traditional potters are older, and most of them remain active in the *cofradía* rituals, either as wives of the officers or as members themselves. Approximately ten families are producers exclusively of urban ware. This group is more progressive in outlook, more Ladinoized in their ways of thinking, and, at present, less concerned with serving in the local *cofradía*. They are, however, very respectful of *costumbre* and assist other relatives financially, or with their own labor, to fulfill community obligations. One potter specializing in urban ware went as far as permitting her creative daughter to marry in a Guatemala City church in full Ladino-style dress, although the intimate household wedding ceremony, as established by *costumbre*, was performed later by the *tatahpish*.

Another group of potters falls between the conservative and the innovative potters. This transitional group shifts production from traditional ware in the dry season to urban ware in the wet season. These people are aware of the economic opportunities offered by both kinds of pottery and, by not specializing, they are able to adapt their production to the more profitable market.

Traditional potters have, in the past, considered themselves to be socially equal; individual prestige was achieved by producing pottery of higher quality. Now, the production of urban ware adds another dimension. Chinautlecos are beginning to make social distinctions based on their innovations. As a result of the expanding interaction with a new clientele, these urban-ware potters exhibit less rigidity of manner and seem to live with a sense of freedom rarely noted among the traditional potters. The determinism of the conservative group, dictated by the corporate community system, provides a strong contrast to the creative dynamism and relative optimism of the urban-ware producers. On the basis of this new ceramic production, then, there is the beginning of a local social differentiation based, Ladino-style, on individual achievement: the success of Chinautlecas in copying urban forms depends upon their level of education and their understanding of Guatemalteco-Ladino cultural orientation.

These Chinautlecas have also successfully expanded their individual marketing activities. Buyers now come to Chinautla, permitting the urban-ware potter to realize a better profit while conserving her energy by not having to spend a day in the market. While demand for the urban ware increases, traditional potters, particularly in the rainy season, find it difficult to sell their *tinajas* in the city markets. Occasionally, a traditional potter has been known to return from the city with most of her *carga*—the prices offered by *regatones* were too low. Yet urban-ware potters have the pressure of dealing with an urban middleman who shows little concern for the Indians' economic needs. Stated a potter of urban ware:

Unfortunately, many Guatemalteco Ladinos and regatones *do not want to recognize our work, and many times one does not feel like producing something new because Ladinos do not want to pay well for our work. They always try to find defects, excuses to take our work cheap. A nice piece takes a long time, and one must spend much time thinking and working carefully. We have to prepare things that the La-dino* regatones *want. Knowing how Ladinos are, we just go ahead with production of many pieces even though we do not think they are very pretty. We try to please them and to produce according to what we think is their way. I would like to do things my way, but who knows if they would like them? I don't think they would buy them.*

This was the position of a mother and her two daughters, who produce the finest pieces of urban ware in the *pueblo* (pl. 436).

As stated in chapter 3, the technological richness of a ceramic tradition permits the production of a large inventory of decorative forms, particularly given the potential for innovation caused by the stimuli of urbanism and tourism. This is the special case in Chinautla. The innovative potential resulting from an expanding individual initiative and a decreasing rigidity in the corporation has enhanced Chinautla's reputation as a dynamic pottery center. This is considered by Ladinos as something very Guatemalteco—this progress achieved by the "Indians" is a development to be very proud of. Thus, urban ware constitutes a significant development in the history of pottery in Chinautla and, for that matter, in Guatemala, and the role of women in this development

has been fundamental. The addition of urban ware to the best utilitarian ware has opened excellent economic possibilities, and the Chinautlecos have become aware of them. It has strengthened the role of women and, among successful potters, the excitement caused by the production of urban ware is evident. In sum, Chinautla potters, through their traditional and urban production, serve both urban and rural areas in Guatemala, meeting the demands of a dually structured society.

This accommodation by potters is analogous to the political accommodation of the late 1940s and the 1950s by traditional, Catholic, male Chinautlecos.[8] The adjustments made in the social system in both periods have been characterized by the respect accorded to *costumbre* and derived from the "law of the saints." So far, however, these people have met changes successfully, without losing their identity as Chinautlecos and as potters. Their strength can be illustrated by recent events.

Chinautlecos have been faced with the possibility of forced relocation in a Guatemala City *barrio*. In 1974, the national government proposed that inhabitants be moved because of unhealthy living conditions in the *pueblo*. Recently many landslides have been caused by unusually heavy rains. In addition, periodic flooding is common because of the constant expansion of paved areas in the city, increasing the runoff into the river that passes through Chinautla. Yet another factor affecting the *pueblo* is Guatemala City's uncontrolled dumping of raw sewage into this Chinautla river. The thought of relocation is abhorrent to both traditional and progressive potters. From the potters' viewpoint, clay should not be exported and sold in the market as a free commodity. "To lose this place is to lose our clay; to leave the clay behind is to leave life," stated a potter's husband. To remain in Chinautla is the only answer—there is meaning in life, based on their clay.

Plate 436. Urban-ware virgin, eleven inches high, made freehand by Maruca in 1976

Other Maya Pottery-Production Centers

The developments in Chinautla become theoretically significant when compared to other production centers. For instance, whereas Chinautla has developed its urban ware and, at the same time, kept its traditional line of production, the important Pokomam center of San Luis Jilotepeque in the eastern pottery region has not changed its vessel inventory. Removed from direct city influence by a distance of about sixty miles, relatively free from regular contact with the outside world through visitors and travelers, and with a social structure supporting a castelike ethnic separation, pottery production here remains traditional. There has been no attempt to produce new forms for Ladinos. This stability may be related to San Luis Jilotepeque's unique historical development. Much of life here is based on the cultural aspirations of Ladinos vis-à-vis Indians.[9] Ladinos of this eastern region maintain all available mechanisms to keep the traditional social distance from the Indians, without compromises and with much discrimination. The presence of Indians in the *pueblo* assures the Ladino of a higher social standing, and the economic development of Indians would constitute a threat to many Ladinos if any real improvement were to take place. Therefore, the Ladinos in the *pueblo* keep the Indian group powerless and subordinate, to the extent that this is economically and politically possible in the 1970s. The present traditional structure of this community's social system—based on the inflexible definition of being Indian or Ladino, of an inferior or superior "race" respectively—remains, and the traditional vessel forms are preserved, as all other conditions in the way of life remain constant. The attractively decorated San Luis *tinajas* are mainly for local consumption, and some of their designs are reminiscent of those of precontact vessels. The three-handled, undecorated *tinajas* are marketed through-out the eastern region, an area which still belongs to the "old" social order of Guatemala.

The *pueblo* of Mixco, also a Pokomam-speaking community, presents us with an entirely different process. The total disappearance of ceramic production here constitutes a case of dramatic technological death.[10]

The Arrotts, during their visit in the 1950s, sensed the deterioration of pottery making. In their field notes, they stated:

. . . half of the potter's craft in Mixco may be expected to fall into accelerated decline and disappear from the landscape. To watch the comal *makers of Mixco at their work is to come to feel that perhaps and, indeed, probably these women are unconsciously aware of the imminence of such a destiny. For, in contrast to the attitude of their sister Pokomam-speaking potters of Chinautla, where all is vigorous, purposeful, and alive with obvious feeling for both clay and form, the women of Mixco disseminate a sense of lethargy which amounts, it would seem . . . to a peculiar imperceptiveness, or frank indifference, toward the quality of their product. This attitude becomes evident in the manner of their first dealing with the raw clay after it has been brought from the bed.*

As discussed in chapter 3, Mixco people were relocated near what became the entrance to Guatemala City in colonial times, and recently the *pueblo* became well linked to the city by the Pan-American Highway. Easy accessibility to this large urban center and expanding urbanization have resulted in the sale of *milpa* land to urban developers. This in turn has depleted the natural resources necessary for the continuity of the native technology. Furthermore, Mixqueños experienced the fluctuating profit derived from traditional ceramics and, in 1955, the tourist market had not yet developed.

On the other hand, the community corporate structure (similar to area 1 of the Chinautla figure) was modified with the transformation of the traditional *cofradías* into Ladino-type brotherhoods—*hermandades*. Under this condition, Mixqueños took the opportunity to break away from the rigid community-prescribed behavior and began to advance socially; through their individual actions and economic efforts, they rapidly became Ladinoized. Changes by substitution resulted in the rapid cultural cessation—the death—of the ceramic tradition and the fall of the closed corporate social system.

The *pueblo* structure in Mixco was enveloped by external forces after the 1944 revolution. A local social differentiation based on ceramic production did not evolve here as it did in Chinautla. Ceramic production in Mixco was strongly associated with Indianness, and Mixqueños wanted Ladinoization. The fastest way to reach this stage was by abandoning an Indian activity. As Mixco moved rapidly toward an open community system, potters did not innovate to accommodate to the new social setting. Instead, pottery production dissolved and disappeared. Potters literally abandoned their *oficio* and pursued employment in the city as domestics, as washerwomen, or as *regatonas* in the city markets. The replacement was total: no one became an artisan to retain the *pueblo*'s specialization in another, urban way.

In Chinautla change was built on the basic ceramic technology of the past, but in Mixco transformation was based on the specific reaction—replacement—of the local social structure to the national discontinuities. Thus, Mixco lost its past identity, its language, its ceramics, and, therefore, its Indian people. It emerged as a suburb of Guatemala City, wanting to move along the

path of modernity. The remaining
elements of the past community cul-
ture are now woven into a new type
of community culture.

The rest of the production centers
in Guatemala are traditionally ori-
ented and still produce utilitarian
vessels, with the exception of Santa
Apolonia, where one family of Cak-
chiquel-speaking potters residing in
the center of town has attempted to
develop urban vessels, through imi-
tation of Ladino items, while main-
taining the local technological tradi-
tion (pls. 437, 438). However, no
technological innovation has yet
evolved. These two potters are not
directly acquainted with the city
environment and, by the same token,
their low level of Ladinoization is
reflected in the few items produced.
Making urban vessels began under
the sponsorship of an American
priest and Ladino primary school
teachers from the capital, who were
aware of Chinautla urban ware and
its economic success. The situation
is symptomatic of potential change,
and its direction will be determined
in the years to come. The traditional
inventory described in chapter 3
remains unchanged, and the socio-
cultural orientation remains very
stable. However, the nation is no
longer undergoing the transforma-
tion of the fifties, and modernization
is already a fact under a different
political system. Thus, there is today
a distinctively different political and
social situation for the young potters
in Santa Apolonia, compared with
Chinautla in the 1950s. Perhaps, in
years to come, Santa Apolonia will
become another Mixco as far as the
oficio of pottery is concerned. But,
as in Chinautla, if the young potters
become successful with urban ware
and a local class differentiation
emerges on the basis of education,
Guatemala may develop another
traditional-progressive pottery
center.

In sum, the production of pottery
is tightly bound to the community
culture through the *oficio* role as
defined by the *costumbre* concept.
This being the case, stability, change,

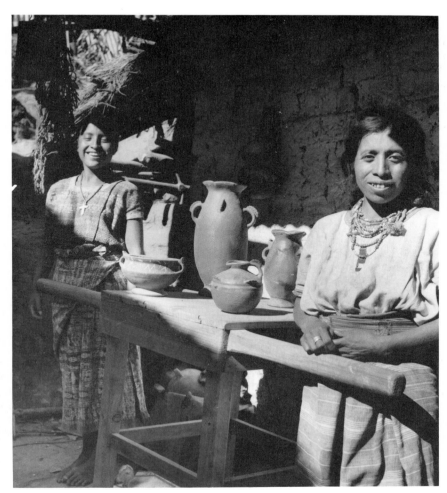

Plate 437. Santa Apolonia potters with their urban ware

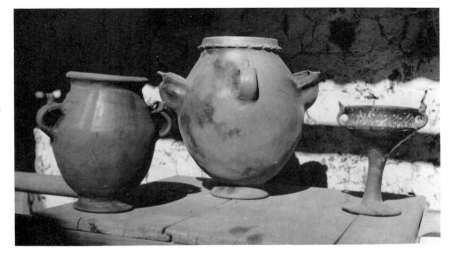

Plate 438. Santa Apolonia urban ware

and cessation of ceramic production are indicative of other processes operating on the community social system. Stability in the production of traditional forms is more than the simple achievement of a technological equilibrium: it needs the presence of a strong corporate social structure with mechanisms that maintain the overall society where pottery production plays a central role. Changes in pottery tradition, on the other hand, manifest modifications in the material and nonmaterial cultural elements of those people directly involved with production. Innovation, as an aspect of change in pottery techniques and forms, seems to coincide also with a situation of cultural innovation, or modernization, and experimentation. Thus, the emergence of a new cultural orientation may break down or alter those barriers that maintain strict individual adherence to traditional cultural norms. In such a situation, potters appear free to copy or invent new forms. Such experimentation may encourage these potters to incorporate successful forms into a revised pottery tradition. This is particularly feasible when these forms prove to be economically and environmentally adaptive to the new cultural surroundings where they developed. In light of these conclusions, cessation of pottery production is the result of fundamental processes of cultural change and psychological reorientation of individuals where this activity is no longer adaptive. When the people of Mixco abandoned the community *costumbre* through a conscious desire to change their cultural affiliation, a rapid cultural death occurred. On the other hand, Chinautlecos, by retaining the concept of *costumbre*, have accommodated themselves to changing conditions without losing their central guiding principle. The Chinautla experience is notable because its pottery innovation has been supported by the interweaving of both national and community cultures, fostering expansion and continuity without the breakdown of the "law of the saints."

11.

Potters, the Community, and the Nation
A Summary

It is important to understand that in Guatemala today there is a strong contrast between the urban and the rural ways of life. In the larger sociopolitical centers, primarily the cities, we find the concentration of activities which represents not only an urban style of life but also the elements of the twentieth-century Great Tradition. Scattered throughout the country, the thousands of *pueblos*, *aldeas*, and *caseríos* are the rural backbone of the nation. They represent the contemporary Little Tradition, frequently retained by people of Maya descent living in a closed corporate social system. It is significant to note that the urban centers, such as Antigua, the old capital of the audiencia of Guatemala, Totonicapán in the west, and Jalapa in the east, are production centers of wheel-made ceramics, glazed and fired in kilns as in Spain. These centers supply the utilitarian pottery and the decorative items used in the colonial-descent urban tradition, although nowadays the competition with industrialized culinary utensils is acute. We did not incorporate the wheel-made pottery tradition into our present survey, since our focus was on traditional native techniques of pottery making. But we might indicate in passing that this *artesanía*—artisanship—is practiced, in small factories, by a few families in each of these cities (pl. 439). These factories are operated in the open community system and are symbolic of Ladino status. The product goes to the same market as the traditional Maya pottery, but it is handled by *regatones* who special-

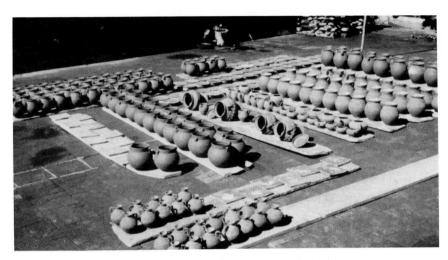

Plate 439. Ladino wheel-made pottery drying on a patio in Antigua

ize in this line. Ladinos are the primary consumers, but Indians also use wheel-made vessels, most often at such celebrations as weddings, baptisms, the end of one year's mourning, and *cofradía* rituals.

In contrast, we chose to study the traditional utilitarian vessels produced by the rural people: ideally Indians who live in *pueblos* with a closed corporate system or in *aldeas* closely linked to such *pueblos* by tradition, as in Santa María Chiquimula, San Cristóbal Totonicapán, or Chinautla, or in closed corporate *barrios* within the boundaries of formerly closed corporate *pueblos*. Good examples of this type were found in Rabinal, Guazacapán, and San Luis Jilotepeque. Because of our generalized anthropological interests in the continuity of pottery from the archaeological Maya, the contemporary Indian pottery-

producing centers interested us a great deal more than the Ladino pottery centers. It was of great interest to find that, contrary to our expectations, rural Ladinos of open *pueblos* and *aldeas* were using Indian technology for the production of pottery.

Overall, we have found that, in Maya pottery centers, the sociocultural structure as it relates to pottery technology offers interesting possibilities for further anthropological work, both for the degree of its stability and for its orderly, self-controlled progress toward modernization.

Indian Potters

Indian potters in particular can be placed along a continuum based on

the changes due to contact and the degree of acculturation. Those Indians residing in corporate *pueblos* and *aldeas* near a city are well acquainted with both the local tradition and the national political culture. Culturally distinctive to this group is a high level of bilingualism in Spanish and a Maya dialect. Indian potters with the least amount of acculturation are residents of isolated *aldeas*; their cultural orientation is mostly local and traditional. These people speak a Maya dialect only. Regardless of their position along the continuum, Indian *pueblo* and *aldea* potters participate in a community specialization and frequently are bound together by a community culture. It is evident though, from this survey, that the *aldea*'s social system per se does not circumscribe the potters as much as does the *pueblo*'s, which has all the institutional elements for the maintenance of the corporate social system.

As we know, a Maya *pueblo* with a vigorous corporate community culture is sustained by a unique arrangement of religious, political, and economic institutions, and each household complies with the community specialization. All potters will produce the same vessel forms in a single style from the "community-owned" clay. Their collective activity prevents potters from feeling that they, as individuals, own their production. Instead, the members of the household units practice the technology owned by the community. As may be expected from the analysis of Chinautla and other comparable Maya *pueblos*, production is uniform, marked by a high degree of continuity. The raw material, clay, is not to be exported as a commodity and sold through the market system; however, Maya *pueblo* potters sense a moral obligation to share their finished products with others. Excellent illustrations for this type of community culture are the *pueblos* of Chinautla, Santa Apolonia, San Luis Jilotepeque, and Rabinal.

Although more rare today, it is expected that in the past, under such social systems, the sources of pottery clay would have been owned by the community and used by all its potter members. Conceptual ownership of clay sources continues today. *Aldeas*, because of their partial cultural affiliation and dispersed rural settlement pattern, can use a number of different clays, without such clearly defined ownership of the sources. Thus, in *pueblos* producing traditional utilitarian pottery, one clay may predominate, at least in the construction of the vessel bodies, while in *aldeas* several clays might be used.

Similarly, the local style of the particular vessel forms is owned by the community. A local style is composed of such elements as overall vessel shape as well as neck, rim, and handle forms, all within a very small range of variation. Thus, in corporate *pueblo* communities such as Rabinal and San Luis Jilotepeque, all potters use the same clay for vessel construction and produce very similar vessels among themselves. On the other hand, in Indian *aldeas* such as those around Santa María Chiquimula, vessels that are clearly within the same local style are produced from different clays.

In many Indian pottery centers named after a *pueblo*, pottery is produced by people in traditional *aldeas*. These centers include San Sebastián Huehuetenango, San Miguel Acatán, Jocotán, Cobán, Comitancillo, Santa María Chiquimula, San Cristóbal Totonicapán, and San Pedro Jocopilas. The potters here have an overall orientation similar to that of corporate *pueblo* potters; the *aldeas*, however, as sociocultural units, lack the formal religious-political organization and the strong community culture which enforce total compliance with the established tradition. Pottery making represents an economic advantage in the face of unfavorable agricultural conditions. Thus, in contrast to the corporate *pueblo* potters, the traditional *aldea* potters feel the social

system leaves them with more individual freedom. The supply of clay gives them, as *aldea* potters, added economic potential, and sometimes they share their clay resources with *pueblo* potters. In such cases, the *aldea* potters feel strong cultural bonds to the corporate *pueblo*. For example, in the *aldeas* of El Rancho in Santa María Chiquimula, El Durazno in Chinautla, Xecanchavox, Xesuc, and Pacanac in San Cristóbal Totonicapán, Chuantonio, Chiquex, and Parajbey in Santa Apolonia, Chichicana, Xil, and others in San Sebastián, each *aldea-pueblo* relation appears to form a single social unit with a community culture.

Moreover, an important similarity among Maya *pueblo* and *aldea* potters is the manner in which they conceptualize their task. From their own viewpoint, the work is an *oficio*, a task defined by the community culture. Such *costumbre* is deeply rooted in their cultural history, which therefore results in a high degree of stability, in both the potters' assigned role and their production. Through the *oficio* concept, potters are mainly concerned with the utility of the vessels they produce.

In the realm of traditional utilitarian pottery, decoration is noninnovative in terms of techniques, motifs, and their utilization on different vessel forms. These are thought of as owned by the community, particularly in the case of closed corporate *pueblos*, in much the same way that vessel forms and techniques of production are conceptually owned by the community. Therefore, decoration as seen in this context is an integral, though optional, part of vessel design, serving to express the individual potter's skill in terms of motifs owned, recognized, and valued by the community. Thus, a potter's best decorated vessels are kept at home in such traditional communities as San Luis Jilotepeque and Santa María Chiquimula. With this emphasis, the small additional profit to be made by selling decorated vessels is of secondary importance. Here the potters' specific

objective is to maintain production of a noninnovative inventory of utilitarian pottery in order to meet the functional demands of the community culture. Related to this attitude among Indian potters is the community's specific interest in keeping its status as a production center—maintaining trade, a well-defined social network, and a balance in natural resources. From a general standpoint, the potters accomplish this through their strong orientation toward a *costumbre* that stresses their *oficio* as potters. This task means survival for themselves as individuals, for their families, and for the corporate social entity. Many consumers come from other *pueblos* or *aldeas* where, having well-established *costumbres* themselves, they understand and respect the potters' values. They do not act as individual patrons with personal demands, as do Ladinos. However, when urban patrons find proficient *pueblo* potters at a suitable moment for change —caused by a state of disequilibrium in the system—innovations can be and have been initiated. This situation has been illustrated more fully by the case of Chinautla. In the last few decades the existence of both *oficio* and *artesanía* concepts in this Indian *pueblo* has been documented. While *oficio* here relates to the production of traditional pottery, *artesanía* does not. Rather, the latter relates to the production of decorative items for the elite Guatemalteco patronage of the city. The continuity of *oficio* in the old structure of Chinautla and the addition of *artesanía* in the realm of individual privileges constitute a recent accommodation of the traditional community system to the national political-economic forces pressing on the people.

Hypothetically, if every Indian *pueblo* and *aldea* produced traditional utilitarian pottery, there would be a great number of small, local, closed production systems, with no need for exchange between them. However, this is not the case. As we know, suitable clay for pottery occurs differentially and, inferring from our work, so do potters. Because of this, not every community can be expected to produce pottery and, in fact, very few do; so, most communities must import pottery.

As has already been shown in chapter 8, intercommunity relations are handled primarily through the levels of the market system. Most vessels are purchased at markets. These markets can be placed by type in the folk-urban continuum and, under this arrangement, Indian potters may choose the extent of their interaction and contact with people outside their own *pueblos* or *aldeas*. Many Indian potters do not venture beyond the local market; they remain within neatly definable social boundaries that coincide with the community's physical boundaries. The social system of the corporate Indian *pueblo* and its traditional *aldeas*, although it has economic ties to the nation, finds *cultural* support only within its own boundaries. With the same mechanisms for the maintenance of cultural stability operating in the importing communities, the style of vessel forms should be fixed, but within less narrow limits, as these people have no direct control over pottery production. Their choices are definite and stable, however, and reflect functional preferences and cultural values. In such circumstances, only vessels which conform closely to the nonproducing communities' values will be imported. As has been shown, this demand and the mechanism of exchange—the market—cause all vessel forms within an area of trade to resemble each other, creating the phenomenon of the regional style. Here we are concerned with such generalized elements of vessel design as the number of handles, their placement and orientation on the vessel body, or a general resemblance of forms throughout a region. The similar styles of *tinajas* in the contemporary pottery regions of highland Guatemala are examples of this. The horizontal placement of two handles opposite each other high on the bodies of *ollas* in the Jutiapa pottery district is another. While the regional vessel styles do not necessarily conform to linguistic groups, as pottery technology does, they are real and indicate a regional variation in the Little Tradition which is the result of interaction of significant numbers of individuals at this level of culture.

In summary, community, in the social structure of the highland Maya society, acts as a forceful principle of social organization. Technical specialization belongs to the community, and there members find security and both social and legal services. Without community, Indians feel that life in general would be chaotic, and *costumbre* would have no meaning. Pottery technology owes its continuity and its very existence to this social principle.

Ladino Potters

Ladino potters emerge from a very different social context. However, significant differences among them also permit their placement along a continuum from rural to semiurban. The Ladino potters are members of politically defined *pueblos* or *aldeas* but, in contrast to the corporateness of closed Maya *pueblos*, these Ladino social units are part of an open community system which emphasizes continuous interaction with the national culture and "ties its fortunes to outside demands."[1] In such communities, the members' affiliation is conditioned by a variety of socioeconomic opportunities. Ladino potters vis-à-vis Maya potters are basically concerned with their own prestige, socioeconomic mobility, and wealth. These potters in the Ladino *pueblos* and *aldeas* must expand their cultural boundaries and hope for outside support.

The Ladino *pueblo* potters, in contrast to all other Guatemalan potters, are involved in a social

game based upon the acquisition of economic status symbols. Santa María Ixhuatán, Casillas, and Zapotitlán have potters eager to convert their products into wealth and equally eager to find a specific urban patron through whom they may enter into the prestigious *encargo* system. The interaction of these individuals is characterized by an ostentatious display of material culture. Therefore, any economic instability has a great impact on the potter's psychological state and, consequently, on her general performance. These aspects are, as we know, usually absent among potters of typically strong corporate communities.

To support their social aspirations, Ladino potters rely on their concept of *artesanía*. The concept brings out the importance of an *individual* specialist as opposed to a *community* specialization. Through the *artesanía* concept, a different approach to decoration becomes evident. Innovation in order to make a larger profit appears to be more important than expressing the potters' competence in their craft. Moreover, the competition in the market for their "artistic" vessels places individual innovation at a premium. In such a situation copying of other potters' successful techniques and designs is common, often making all the vessels produced in a Ladino *pueblo* very much alike. While this result makes production of Ladino pottery appear similar to Indian pottery, the major difference—aside from the diverse cultural orientations of the two groups—lies in the rapid change and variability permitted in Ladino-made pottery, compared to the stability of decorative techniques and motifs among traditional Indian pottery.

The general interaction of these Ladino *pueblo* potters with outsiders can be characterized as aggressive, in response to their constant search for new economic avenues, primarily through city-oriented patrons. Their public display of

"knowledge" about their work is frequently referred to as "artistry," as a way to impress people with the quality of their production. Contrary to traditional Indian potters, they appear receptive to outside ideas and, in their eagerness to please, they will frequently promise "works of art" they cannot properly execute, which has a negative effect on their contractual relations with patrons. Regardless of the business outcome, however, interaction with outsiders enhances the social prestige of Ladino potters in their *pueblo*. They frequently claim to be in control of "greater things." From our data, we received the clear impression that these potters are ready to step out of their technological specialization if a new opportunity should offer them more rapid economic and social advancement, a step hardly entertained by potters of an Indian *pueblo*.

The Ladino *pueblo* potters stand in contrast to the less sophisticated Ladino *aldea* potters, who feel more bound to their *artesanía* and to a style of life from which they cannot easily escape. The further removed they are from an urban orientation, the greater their social shyness and humbleness. Social conservatism and personal resignation to their life as potters characterize this group.

The last group of potters for our consideration is made up of Ladino squatters with an *aldea*-like organization. Their settlements are referred to as *caseríos* or *núcleos poblados*; some are old enough to be known locally as true *aldeas*. In the absence of a community culture, members of entire households are not expected to make pottery—production here is one of several individual economic pursuits, depending strictly on one's personal inclination to work with clay. It is interesting that such an attitude can lead to further specialization, to the reduction of inventory, or to total abandonment.

Good illustrations of this situation are the *aldeas* of the middle

Motagua River area, where people are classified as Ladinos but feel like Indians. Paradoxically, these types of settlements are a relatively recent development in the national political climate of this century, yet their pottery-making techniques very likely come from a pre-Columbian tradition.

In summary, contrasted to members of closed corporate communities, members of open communities are encouraged to accumulate individual prestige and wealth. In the process each potter, from time to time, reshapes her social network. Characteristic, therefore, of this type of community are rapid changes, usually made at an individual family level in response to the urban center of the national society.

Conclusion

In the process of studying each center, particularly during the pleasant interaction with potters and their families, we have become aware of the potentials these data present for exploring the very point where anthropologists—archaeologists and ethnographers—might find a fruitful area for integration. Our ethnographic studies of the ways pottery and potters behave in time and space constitute a significant document from which archaeologists may derive new insights into their methods and generate new interpretations of technological processes in prehistory. It is our hope that this work will have given readers an overall idea of what it means to be a potter, a merchant, a middleman, or a consumer in the modern nation of Guatemala, using a technology handed down from Maya ancestors. We hope also that readers will have gained an impression of the stability of pottery as well as how and under what circumstances it changes. Our work focused on the people, the products, and their relationships through community. To

think of these people without their communities is to ignore one of the most important elements in Guatemalan society today. As a principle, community is pivotal to the social organization and trade network that characterize much of the structure of the nation. To our way of thinking, corporateness may be—in its most fundamental aspects—a pre-Hispanic principle through which, long ago, these people adapted to their unique environmental conditions. People used the principle of community for their acculturation process during the Spanish conquest, and it continues to give coherence to contemporary behavior. How potters will emerge toward the end of the twentieth century depends both upon the strength of the community culture and upon the attitude the potters themselves hold toward their specialization.

Notes

Introduction

1. Kroeber 1948: 1.
2. Murdock 1949: vii.
3. Redfield 1962: 14.
4. Ibid.: 15.
5. Reina 1973: xviii.
6. These reflections represent Reina's more personal view of ceramics in relation to the individual, society, and culture.
7. Reina-Jiménez collection of six-teenth-century documents from the Archivos General de Indias (here-after referred to as AGI), microfilm in American Philosophical Society Library, 1975.
8. These statements manifest Hill's current interest as he personally thinks about pottery among Maya-descent people.
9. Ehrich 1965: 3.
10. Arnold 1971, 1975.
11. Redfield 1955.
12. Kluckhohn 1949: 52.

1. Guatemala: Its Roots

1. Readers interested in a thorough treatment of this subject should consult Whetten 1961; Adams 1970; McBryde 1945; and Wauchope, vol. 1.
2. Reina 1967b.
3. Adams 1970: 221–222.
4. For a general synthesis, consult Wauchope, vols. 2 and 3.
5. O'Flaherty n.d.: 97.
6. AGI Guatemala, 39-3, 1535. Trans. by authors.
7. Ibid., Juan Pérez, actuary, 1536. Trans. by authors.
8. Ibid., 111-9, 1556–1557.
9. Rodríguez Becerra 1974; chap. 4.
10. MacLeod 1973: 45.
11. Ibid.: 109.
12. For a thorough ethnohistorical interpretation, see Sanchiz Ochoa 1974.

13. Helm 1975: 288.
14. *Transformación económica de Guatemala* 1951: 140. Trans. by authors.
15. Adams 1970: 178.
16. Ibid.: 179.
17. Ibid.: 184.
18. Reina 1966: 22.
19. Ibid.: chap. 2.
20. Ibid.: 39.
21. Adams 1970: 201.
22. Ibid.: 237.
23. Reina 1965a: 227–233.

2. Pottery Production: An Introduction

1. Many travelers and students of the Maya have briefly commented in print on the production of pottery in highland Guatemala. In addition to those specifically cited in this work for their contribution to the understanding of technological processes, see Morelet 1871; Sapper 1897; Osborne 1943; Smith 1949; and Shepard 1957.
2. Wolf 1955: 461.
3. Reina 1966: 52–57.
4. Wolf 1955: 456.
5. Gillin 1952: 206.
6. Wolf 1955: 463.
7. Ibid.: 462.
8. Ibid.: 463.
9. Smith and Kidder 1943: 2.
10. In Arrotts' field notes, 1949.
11. Hill 1973.

3. Pottery Production: The Central Region

1. There are some current arguments as to the real identification of the archaeological site currently known as Chinautla Viejo—see Carmack 1975.
2. Cortés y Larraz 1958, 2:207.
3. Reina 1958: 243.

4. Gage 1958: 200.
5. Cortés y Larraz 1958, 2:203. Trans. by authors.
6. Ibid.: 204. Trans. by authors.
7. Palacios 1927: 80. "Hácese en él la mejor y mas galana loza, al modo de los indios que hay en estas provincias. Principalmente la hacen y es oficio de mujeres, las cuales la labran sin rueda ni instrumento alguno, de manera que hacen muy bien cualquier vasija que les mandan."
8. *Diccionario Geográfico de Guatemala* 1962, 2: 228.
9. Cortés y Larraz 1958, 2: 172.
10. Ibid.: 173. Trans. by authors.
11. *Diccionario Geográfico* 1962, 2: 242.
12. Ibid.: 216.
13. Ibid.: 144.
14. Ibid., 1: 96.

4. Pottery Production: The Northwestern Region

1. La Farge 1947: 36.
2. La Farge and Byers 1931: 56–57; La Farge 1947: 28.
3. La Farge 1947: 28.
4. Ibid.: 5.
5. Cortés y Larraz 1958, 2: 121.
6. Fuentes y Guzmán 1932–33.
7. For a fuller ethnographic account, see La Farge and Byers 1931: 56–57; La Farge 1947: 28.
8. Consult La Farge 1947.
9. Siegel 1954: 172.

5. Pottery Production: The Northern Region

1. Cortés y Larraz 1958, 2: 12.
2. King 1974: 275.
3. Ibid.
4. *Diccionario Geográfico* 1962, 2: 110.
5. Ibid.: 86.
6. Ibid.

7. Cortés y Larraz 1958, 2: 26.
8. Roys 1933: 177.
9. Chamberlain 1948: 251.
10. Thompson 1930: 95.
11. Reina 1965a: 233–236.
12. Reina and Schwartz 1974: 169.
13. Reina 1962: 29–30.
14. Reina's field notes, 1960.

6. Pottery Production: The Eastern Region

1. Smith and Kidder 1943.
2. Miles 1957: 470.
3. *Diccionario Geográfico* 1962, 2: 238.
4. Ibid.: 47.
5. Ibid.: 1961, 1: 350–351.
6. Cortés y Larraz 1958, 1.
7. Wisdom 1940: 18.
8. Ibid: 138–144.
9. *Diccionario Geográfico* 1962, 2: 188.
10. Gillin 1951: 81; see also Tumin 1952.
11. Personal report to Kidder, 1946.
12. Firing description from Tumin's field notes, 1942.
13. *Diccionario Geográfico* 1962, 2: 360.
14. Sharer 1978.
15. *Diccionario Geográfico* 1961, 1: 311–313.
16. Ibid. 1962, 2: 266.
17. Ibid. 1961, 1: 72.

7. Pottery Production: An Overview

1. This orbiting technique of pottery making is known in other communities of Central America. Lothrop (1927) describes it with photographs from Guatajiagua in eastern El Salvador. With little evidence, he speculates on the linguistic association of these Indian potters before they abandoned their native tongue. These people, like the Quiché and Cakchiquel, may have been pre-Spanish invaders, deriving ultimately from the same starting point. Another possibility is that they were moved to their present location during the Spanish colonial period as part of a resettlement project, perhaps from the Gulf of Fonseca area. As Lothrop's report is the only mention of these potters, and since both the prehistory and the history of this region have been little explored, no further speculation can be made. The possibilities are intriguing and deserve further linguistic, archaeological, and ethnohistorical study.

2. The flat molds of San José Petén bear no technical or historical relationship to the flat molds used in the Chorti area.

3. In addition to these basic techniques, several supplementary techniques also appear unique to this technological tradition when compared to other areas of the New World. While coiling or some use of coils appears nearly universal in non-wheel pottery making, the process of welding the coils into one solid mass seems to vary geographically to some degree. In much of Mesoamerica and perhaps all of native South America, coils are fused together by scraping. In parts of North America, however, coils are fused through the use of a paddle and anvil. The potter holds the anvil against the interior surface of the vessel and pats the exterior section with a spatula-shaped paddle.

4. Edmonson 1971: 235, fn. 7847.
5. Miles 1957.
6. Ibid.: 743.
7. Ibid.: 754.
8. Ibid.: 743.
9. Ibid.
10. Lothrop 1927: 116.
11. Osborne 1965: 207–209.
12. Miles 1957: 737.
13. Mason 1940: 75; Johnson 1940: 110.
14. Cortés y Larraz 1958, 1: 59.
15. Robert J. Sharer, personal communication.
16. Swadesh 1967: 99–100.
17. Mason 1940: 75; Johnson 1940: 110.

8. The Marketing and Distribution of Pottery

1. Reina's field notes, 1955. Redrawn from Reina 1966: 56.
2. For a wider coverage of research on Guatemalan markets, see McBryde 1938, 1945; Tax 1953; Smith 1972; and Swetnam 1975.

9. *Costumbre*: A Control Mechanism

1. Redfield 1971: 106–107.

2. *Oficio* is a well-established Maya concept found among most traditional Maya groups. Munro S. Edmonson, in a personal communication, indicated that among Quiché-speaking people the concept of *oficio* (*chak*) appears central to the specialization of specific groups.
3. Reina 1966: 133–172.
4. Redfield 1971: 20, 48, 73–74.
5. Reina 1962, 1965a: 229.
6. Foster 1965: 297–302.

10. Chinautla and Its Cultural Processes: Pottery Innovation

1. Reina 1963. In Reina's private collection of Chinautla urban ware are two human heads decorated in a Classic Maya style. The late archaeologist, Stephan F. de Borhegyi, brought a drawing to a widowed potter, from which she made an excellent copy. In 1955, Reina requested from the widow's daughter a replica of a Chinautla woman carrying a load of *tinajas* and a man with a typical charcoal net suspended from his forehead by a tumpline. Other North American city residents ordered angels as candle holders . . . The list of *encargos* from then on is too long and complex to reconstruct. Currently the middlemen trading with tourists have surpassed orders taken individually. The largest orders in 1976 were from a Cuban, residing in Miami, who has trained the brother of an urban-ware-producing family to be his middleman. Since 1976 many potters deliver their traditional and decorative wares to his home, thus saving a trip to the city markets. Luis has learned to prepare the packing according to regulations, and each month he sends many hundreds of Chinautla vessels to Miami by air. Thus, the Cuban buyer no longer needs to make a trip to Guatemala.

2. These data from the particular case of Chinautla can be of further theoretical use when seen in the general context of Barnett 1953, particularly chaps. 4 and 12–14.

3. Figure 60 does not claim to be complete: it represents a community viewpoint as of 1965.

4. For a full description of the community structure, see Reina 1966.

5. Silvert 1954: chap. 1, pt. 1.
6. For a discussion of the application of the Great and Little Traditions, see Redfield and Singer 1954.
7. Wolf 1955: 456.
8. Reina 1959: 14–18.
9. For a full ethnographic description, consult Gillin 1951; Tumin 1952.
10. Kroeber 1948: 382, 385.

11. Potters, the Community, and the Nation: A Summary

1. Wolf 1955: 462.

Bibliography

Adams, Richard N.
1970 *Crucifixion by Power: Essays on Guatemalan National Social Structure, 1944–1966.* Austin: University of Texas Press.

Arnold, Dean E.
1971 "Ceramic Variability, Environment, and Culture History among the Central Pokomam, Guatemala: A Test of Assumptions." Unpublished ms. from American Anthropological Association meeting, New York.
1975 "Ceramic Ecology of the Ayacucho Basin, Peru: Implications for Prehistory." *Current Anthropology* 16 (2): 183–206.

Arrott, Charles R.
1953 "La cerámica moderna, hecha a mano en Santa Apolonia." *Antropología e Historia de Guatemala* 5 (1): 3–10. Instituto de Antropología e Historia.
1967a "Cerámica actual de Guatemala (Mixco Nuevo)." *Antropología e Historia de Guatemala* 19 (1): 65–70. Instituto de Antropología e Historia.
1967b "Cerámica actual de Guatemala: San Luis Jilotepeque." *Antropología e Historia de Guatemala* 19 (2): 38–47. Instituto de Antropología e Historia.

Arrott, Margaret
1972 "A Unique Method of Making Pottery—Santa Apolonia, Guatemala." *Expedition* 14 (4): 17–26. Philadelphia.

Barnett, Homer G.
1953 *Innovation: The Basis of Cultural Change.* New York: McGraw-Hill.

Carmack, Robert M.
1968 "Toltec Influence on the Post-Classic Culture History of Highland Guatemala." Middle American Research Institute 26. New Orleans: Tulane University.
1972 "Ethnohistory: A Review of Its Development, Definitions, Methods, and Aims." *Annual Review of Anthropology* 1: 227–246. Palo Alto, Calif.
1975 "La verdadera identificación de Mixco Viejo." Ms. for *Sociedad de Geografía e Historia de Guatemala.* Guatemala City.

Chamberlain, R. S.
1948 *The Conquest and Colonization of Yucatan.* Pub. 582. Washington, D.C.: Carnegie Institution.

Coe, M. D., and K. U. Flannery
1967 *Early Cultures and Human Ecology in South Coastal Guatemala.* Smithsonian Contributions to Anthropology 3. Washington, D.C.: Smithsonian Press.

Cortés y Larraz, Pedro
1958 *Descripción geográfica: Moral de la diócesis de Goathemala.* (1768–1770) 2 vols. Guatemala City: Sociedad de Geografía e Historia de Guatemala.

Dirección General de Cartografía
1961 *Diccionario Geográfico de Guatemala.* Vol. 1 (A–O). Guatemala City.
1962 *Diccionario Geográfico de Guatemala.* Vol. 2 (P–Z). Guatemala City.

Dirección General de Estadística Oficina Permanente del Censo
1950 *Sexto censo de población.* April 18, Guatemala City.

Ediciones de Estrella de Centroamérica
1951 *Transformación económica de Guatemala. Hacía una reforma agraria.* Guatemala City.

Edmonson, Munro S.
1971 *The Book of Counsel: The Popul Vuj of the Quiché Maya of Guatemala.* Middle American Research Institute 35. New Orleans: Tulane University.

Ehrich, Robert W.
1965 "Ceramics and Man: A Cultural Perspective." In *Ceramics and Man,* ed. Frederick R. Matson. Viking Fund Publications in Anthropology 41, Wenner-Gren Foundation. Chicago: Aldine.

Foster, George
1965 "Peasant Society and the Image of Limited Good." *American Anthropologist* 67 (2): 293–315.

Fuentes y Guzmán, Francisco Antonio de
1932–33 *Recordación florida, discurso historial, y demonstración natural, material, militar, y política del reyno de Guatemala.* 3 vols. Guatemala City.

Gage, Thomas
1958 *Thomas Gage's Travels in the New World.* (1648) Edited and with an Introduction by J. E. S. Thompson. Norman: University of Oklahoma Press.

Gillin, John P.
1951 *The Culture of Security in San Carlos: A Study of a Guatemalan Community of Indians and Ladinos.* Middle American Research Institute 16. New Orleans: Tulane University.
1952 "Ethos and Cultural Aspects of Personality." In

Heritage of Conquest, ed. Sol Tax. Glencoe, Ill.: Free Press.

Helm, Mary W.
1975 *Middle America: A Culture History of Heartland and Frontiers*. Englewood Cliffs, N.J.: Prentice-Hall.

Hill, Robert M., II
1973 "Patterns in the Distribution of Modern Guatemalan Pottery." Unpublished paper. Anthropology Department, University of Pennsylvania.

Instituto Geográfico Nacional
1968 *Suplemento del Diccionario Geográfico de Guatemala*. 2 vols. Guatemala City.

Johnson, Frederick
1940 "The Linguistic Map of Mexico and Central America." In *The Maya and Their Neighbors*. New York: D. Appleton–Century.

Kelley, J. Charles
1966 "Mesoamerica and the Southwestern United States." In *Handbook of Middle American Indians*. Vol. 4: *Archaeological Frontiers and External Connections*, ed. G. F. Ekholm and G. R. Willey. Austin: University of Texas Press.

Kidder, A. V., J. D. Jennings, and E. M. Shook
1946 *Excavations at Kaminaljuyu, Guatemala*. Pub. 561. Washington, D.C.: Carnegie Institution.

King, Arden
1974 *Cobán and the Verapaz: History and Cultural Process in Northern Guatemala*. Middle American Research Institute 37. New Orleans: Tulane University.

Kluckhohn, Clyde
1949 *Mirror for Man: The Relation of Anthropology to Modern Life*. New York: McGraw-Hill.

Kroeber, Alfred
1948 *Anthropology: Race, Language, Culture, Psychology, Pre-history*. New ed., rev. New York: Harcourt, Brace.

La Farge, Oliver
1947 *Santa Eulalia*. Chicago: University of Chicago Press.

La Farge, Oliver, and Douglas Byers
1931 *The Year Bearer's People*. Middle American Research Series 3. New Orleans: Tulane University.

Lardé, Jorge
1926 "Lenguas indianas de El Salvador." *Revista de Etnología, Arqueología, y Lingüística* 1 (5): 281–286. El Salvador.

Lothrop, S. K.
1927 "The Potters of Guatajiagua, Salvador." *Indian Notes* 4 (2): 109–118. New York: Museum of the American Indian.

McBryde, Felix Webster
1938 "Maya Vendors of Guatemala." *Travel* 71: 11–15, 52.
1945 *Cultural and Historical Geography of Southwest Guatemala*. Smithsonian Institution, Institute of Social Anthropology 4. Washington, D.C.: G.P.O.

MacLeod, Murdo J.
1973 *Spanish Central America: A Socioeconomic History, 1520–1720*. Berkeley & Los Angeles: University of California Press.

Mason, John Alden
1940 "Native Languages of Middle America." In *The Maya and Their Neighbors*. New York: D. Appleton–Century.

Matson, Frederick R., ed.
1965 *Ceramics and Man*. Viking Fund Publications in Anthropology 41, Wenner-Gren Foundation. Chicago: Aldine.

Miles, S. W.
1957 *The Sixteenth-Century Pokom-Maya: A Documentary Analysis of Social Structure and Archaeological Setting. Transactions of the American Philosophical Society* 47, pt. 4. Philadelphia.

Morelet, Arthur
1871 *Travels in Central America, Including Accounts of Some Regions Unexplored since the Conquest*. Translated from French by Mrs. M. F. Squier. London: Trubner & Co.

Murdock, George P.
1949 *Social Structure*. New York: Macmillan.

O'Flaherty, Edward
n.d. "The Role of the Church in Sixteenth-Century Guatemala." Unpublished ms.

Osborne, Lilly de Jongh
1943 "La cerámica indígena en Centroamérica." *América Indígena* 3 (4): 351–358.
1965 *Indian Crafts of Guatemala and El Salvador*. Norman: University of Oklahoma Press.

Palacios, Licenciado Diego Garcia de
1927 "Relación hecha por el Licenciado Palacios al Rey D. Felipe II, en la que describe la Provincia de Guatemala, las costumbres de los indios y otras cosas notables." (1576) *Anales de la Sociedad Geografía e Historia de Guatemala* 4 (1): 71–92.

Redfield, Robert
1955 *The Little Community*. Chicago: University of Chicago Press.
1962 "Human Nature." In *Human Nature and the Study of Society: The Papers of Robert Redfield*, ed. Margaret Park Redfield. Chicago: University of Chicago Press.
1971 *The Primitive World and Its Transformations*. (1953) 12th printing. Ithaca: Cornell University Press.

Redfield, Robert, and Milton Singer
1954 "The Cultural Role of Cities." *Economic and Social Change* 3 (1): 53–73.

Reina, Ruben E.
1958 "La continuidad de la cultura india en una comunidad Guatemalteca." *Revista de Ciencias Sociales*

2 (2): 243–259. Puerto Rico.

1959 "Political Crisis and Cultural Revitalization: The Guatemalan Case." *Human Organization* 17 (4): 14–18.

1961 "The Abandonment of Primicias by Itzá of San José, Guatemala, and Socotz, British Honduras." In *Tikal Reports*, pp. 213–225. Museum Monographs 10. University of Pennsylvania.

1962 "The Ritual of the Skull of Petén, Guatemala." *Expedition* 4 (4): 26–36. Philadelphia.

1963 "The Potter and the Farmer: The Fate of Two Innovators in a Maya Village." *Expedition* 5 (4): 18–31. Philadelphia.

1964 "The Urban World View of a Tropical Forest Community in the Absence of a City, Petén, Guatemala." *Human Organization* 24 (4): 265–278.

1965a "Cultural Duality and Behavioral Integration." In *Context and Meaning in Cultural Anthropology*, ed. Melford E. Spiro. Glencoe, Ill.: Free Press.

1965b "Town, Community and Multicommunity: Theoretical Implications of a Guatemalan Case." *Estudios de Cultura Maya* 5: 361–390. Mexico City.

1966 *The Law of the Saints: A Pokomam Pueblo and Its Community Culture*. Indianapolis: Bobbs-Merrill.

1967a "Annual Cycle and Fiesta Cycle." In *Handbook of Middle American Indians*. Vol. 6: *Social Anthropology*, ed. M. Nash. Austin: University of Texas Press.

1967b "Milpas and Milperos: Implications for Prehistoric Times." *American Anthropologist* 69 (9): 1–20.

1973 *Paraná: Social Boundaries in an Argentine City*. Latin American Monographs 31, Institute of Latin American Studies, University of Texas at Austin. Austin: University of Texas Press.

Reina, Ruben E., and Alfredo Jiménez
1975 "Guide to the Collection of Documents from the Archivos General de Indias Pertaining to the Audiencia de Guatemala." Microfilmed documents in the American Philosophical Society Library, Philadelphia.

Reina, Ruben E., and Norman B. Schwartz
1974 "The Structural Context of Religious Conversion in Petén, Guatemala: Status, Community, and Multicommunity." *American Ethnologist* 1 (1): 157–191.

Rodríguez Becerra, Salvador
1974 "La encomienda en Guatemala: Análisis de una sociedad en formación." Ph.D. dissertation, University of Seville.

Roys, R. L.
1933 *The Book of Chilam Balam of Chumayel*. Pub. 438. Washington, D.C.: Carnegie Institution.

Sanchiz Ochoa, Pilar
1974 "La familia en la sociedad Guatemalteca del siglo XVI: Análisis del sistema de valores del conquistador." Ph.D. dissertation, University of Seville.

Sapper, Karl
1897 *Das nördliche Mittel-America nebst einem ausflug nach dem hochland von ana Luac, neisen und studien aus den jahrzen 1888–1895*. Brns. Vieweg.

Sharer, Robert J.
1978 *The Prehistory of Chalchuapa, El Salvador*. Vol. 3: *Pottery and Conclusions*. Philadelphia: University of Pennsylvania Press.

Shepard, Anna O.
1957 *Ceramics for the Archaeologist*. Pub. 609. Washington, D.C.: Carnegie Institution.

Siegel, Morris
1954 "Culture Change in San Miguel Acatán, Guatemala." *Phylon: The Atlanta University Review of Race and Culture* 15 (2): 165–176.

Silvert, Kalman N.
1954 *A Study in Government: Guatemala*. Pt. 1: *National and Local Government since 1944*. Middle American Research Institute 21. New Orleans: Tulane University.

Smith, A. Ledyard, and Alfred V. Kidder
1943 "Explorations in the Motagua Valley, Guatemala." Pub. 546, contribution 41. Washington, D.C.: Carnegie Institution.

Smith, Carol
1972 "The Domestic Marketing System in Western Guatemala: An Economic, Locational, and Cultural Analysis." Ph.D. dissertation, Stanford University. University Microfilm, 72-30, 705.

Smith, Robert E.
1949 "Cerámica elaborada sin torno, Chinautla, Guatemala." *Antropología e Historia de Guatemala* 1 (2): 58–61. Instituto de Antropología e Historia.

Swadesh, Morris
1967 "Lexicostatistic Classification." In *Handbook of Middle American Indians*. Vol. 5: *Linguistics*, ed. N. A. McQuown. Austin: University of Texas Press.

Swetnam, John
1975 "The Open Gateway: Social and Economic Interaction in a Guatemalan Marketplace." Ph.D. dissertation, University of Pennsylvania.

Tax, Sol
1953 *Penny Capitalism: A Guatemalan Indian Economy*. Smithsonian Institution, Institute of Social Anthropology 16. Washington, D.C.: G.P.O.

Thompson, J. E. S.
1930 "Ethnology of the Mayas of Southern and Central British Honduras." Field Museum of Natural History 274, Anthropological series 17 (2): 23–213.

Tumin, Melvin
1952 *Caste in a Peasant Society: A Case Study in the Dynamics of Caste*. Princeton: Princeton University Press.

Wauchope, Robert, series ed.
1964– *Handbook of Middle American Indians*. Volumes 1– Austin: University of Texas Press.

Whetten, Nathan L.
1961 *Guatemala: The Land and the People.* Caribbean
 series 4. New Haven: Yale University Press.

Wisdom, Charles
1940 *The Chorti Indians of Guatemala.* Chicago: Univer-
 sity of Chicago Press.

Wolf, Eric
1955 "Types of Latin American Peasantry: A Preliminary
 Discussion." *American Anthropologist* 57 (3):
 452–470.
1959 *The Sons of the Shaking Earth.* Chicago: University
 of Chicago Press.

Woodbury, R. B., and A. S. Trik
1953 *The Ruins of Zaculeu, Guatemala.* 2 vols.
 Richmond: Byrd.

Index